John Flaxman

John Flaxman

Edited by David Bindman

with 430 illustrations, 4 in color

Thames and Hudson

This book has been published simultaneously in paperback
as a catalogue for the exhibition
John Flaxman, R.A.,
at the Royal Academy of Arts, London,
26 October – 9 December 1979

Library of Congress Catalog Card Number 79-5160

Color illustrations printed in West Germany
Text and monochrome illustrations printed in Great Britain
by Balding and Mansell Ltd, Wisbech, Cambs.
Bound in Great Britain

Contents

Hugh Casson P.R.A.	6	Foreword
	7	Colour plates I-IV
David Bindman	13	A note on the selection of works and editor's acknowledgments
Werner Hofmann	14	The Death of the Gods
	22	Chronology
David Bindman	25	John Flaxman: Art and Commerce
	30	Ludwig Schorn's visit to Flaxman
	33	Extracts from C. R. Cockerell's diaries
	35	**The catalogue**
David Bindman	37	Flaxman's early drawings, 1768-87
Bruce Tattersall	47	Flaxman and Wedgwood
	49	A note on Wedgwood and Jasper
Gaye Blake Roberts	65	A selection of works by Flaxman's contemporaries working for Wedgwood
David Bindman	70	Italian drawings, 1784-94
Mary Webster	100	Flaxman as sculptor
David Bindman	112	Designs connected with sculpture
David Bindman	120	Drawings not connected with sculpture
David Irwin	131	Flaxman as Professor of Sculpture
David Bindman	133	Drawings connected with Flaxman's Lectures to the Royal Academy
Graham Pollard	135	Flaxman and designs for medals and coins
Shirley Bury	140	Flaxman as a designer of silverwork
Michael Snodin	149	Drawings for silverwork
Sarah Symmons	152	Flaxman and the Continent
Sarah Symmons	156	Section I: Themes and Variations
Sarah Symmons	164	Section II: France and Spain
Bjarne Jørnaes	169	Section III: Denmark Flaxman, Thorvaldsen and some Danish artists
Hanna Hohl and Sarah Symmons	175	Section IV: Germany
	183	Acknowledgments
Detlef W. Dörrbecker	184	A survey of engravings after Flaxman's outline compositions 1793-1845
Detlef W. Dörrbecker	186	Bibliography of works quoted in the text

Foreword *Hugh Casson P.R.A.*

In 1874, some 50 years after his death, a statue of John Flaxman was placed on the facade of Burlington House alongside not only Reynolds but also Leonardo, Michelangelo and other great heroes of ancient, medieval and modern art. Value judgements have changed since then, and now we may find it hard to justify Flaxman's position in such exalted company. Yet his name still evokes more perfectly than that of any other artist the age of Neoclassicism in England. We think of his monuments in churches large and small which express both the pious Christian and the classical spirit. We think too of those outline drawings, illustrations of Homer, Aeschylus, Dante and so on which were engraved and reproduced in edition after edition throughout Europe, and which shaped a visual image of literature that is even now by no means erased from our minds. Indeed we can still buy Wedgwood porcelain for which Flaxman was an important designer. There are yet other sides to Flaxman's multifarious talents and interests, including the designs for the patriotic and extravagant silvergilt commissioned by George IV and which Her Majesty The Queen has so graciously consented to lend to this exhibition.

To make sense of all this is a task which this exhibition sets out to achieve. As an English visual artist Flaxman was an especially rare phenomenon, for his influence abroad was genuinely widespread and deep. How appropriate that the idea and realization of this exhibition should come from the Kunsthalle in Hamburg, one of the most distinguished museums in Europe. It is the belief of Professor Werner Hofmann, whose series of exhibitions in Hamburg commencing in 1974 entitled 'Art Around 1800' have made a most significant contribution to the reassessment both of the artistic and intellectual achievements of the visual arts in this period, that Flaxman was not merely an artist of considerable quality but also one who provided an early example of the possibilities open to the artist in a modern society. Flaxman's engagement with both industry and mythology is not as contradictory as it might at first appear. Rather it is an example of an ambitious artist responding to the circumstances of his society.

In its determination to reveal the full extent of Flaxman's work and influence, the exhibition has grown to encompass not only a comprehensive showing of all sides of his work but also to include a section which demonstrates his influence on European art throughout the nineteenth century. Thus artists such as David, Ingres, Delacroix, Runge and Goya are included in this exhibition.

Many scholars in Germany, Denmark (the exhibition has also been seen at the Thorvaldsen Museum in Copenhagen) and Great Britain have contributed to the catalogue, which is the most comprehensive study of Flaxman that has ever been published. We are grateful to Dr David Bindman who coordinated the work of scholars as well as providing notable contributions himself. The British Council assisted considerably with the organization of the exhibition in Hamburg – this assistance also contributed materially to the realization of this ambitious exhibition in London. Wedgwood, who were Flaxman's first patron and who paid for his trip to Italy in 1787, have very generously contributed towards the cost of staging the exhibition and of producing the catalogue. The Arts Council of Great Britain also have made a substantial contribution.

We are very grateful to the many lenders, led once again by Her Majesty The Queen, for allowing us to show this exhibition in all its various demonstrations here in London. There are contributions from museums and private collections throughout Europe and indeed from the United States also. We are grateful to Professor Hofmann for giving us this unique opportunity to pay tribute to one of the Royal Academy's most distinguished members.

I John Flaxman, *The Trafalgar vase*, 1805-1806
London, Victoria and Albert Museum (No. 191)

II John Flaxman, *The apotheosis of Homer*, vase 1778
London, Trustees of the British Museum (No. 32b)

III John Flaxman, *The apotheosis of Homer*, plaque 1778
Barlaston, Staffs., The Trustees of the Wedgwood Museum (No. 32a)

IV Jean Auguste Dominique Ingres, *Venus wounded by Diomedes*, 1805
Basle, Kunstmuseum (No. 231)

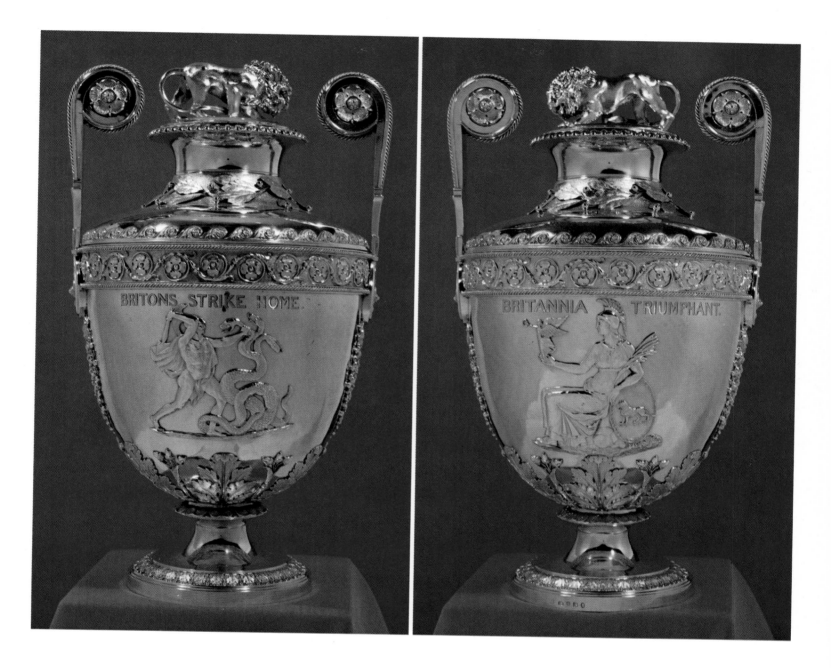

I

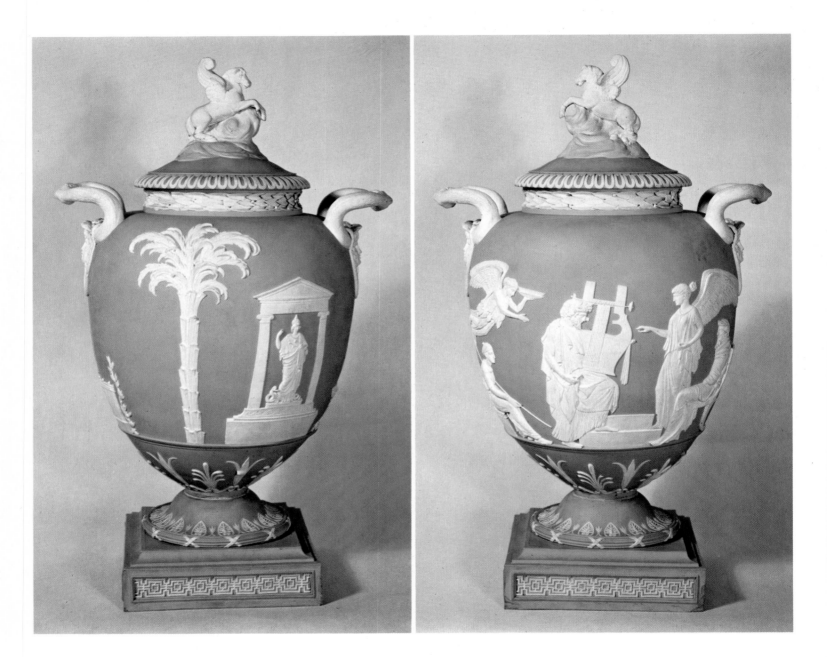

II

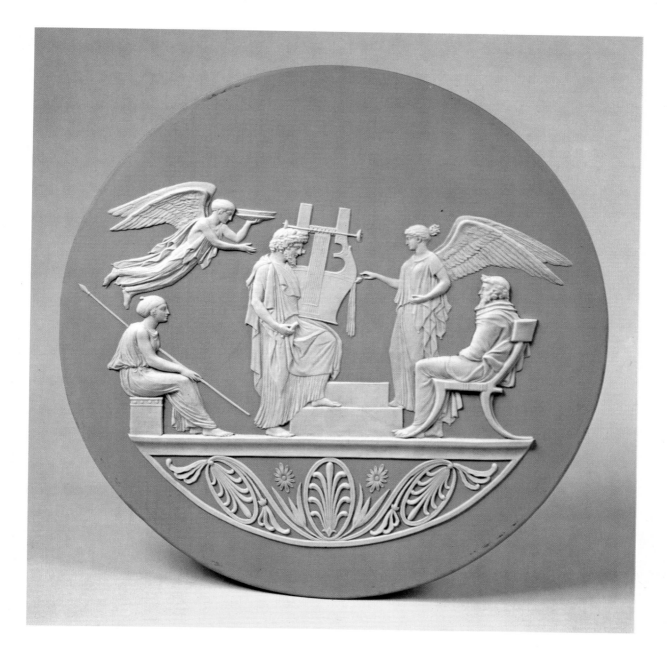

III

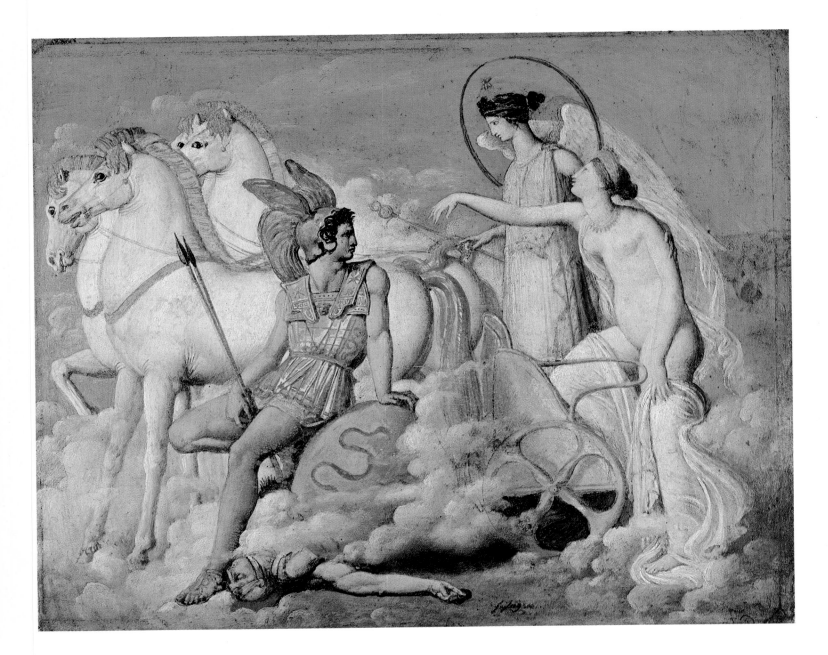

IV

A note on the selection of works and editor's acknowledgments

Every exhibition must inevitably fall short of the compiler's dream and contain compromises. In the case of Flaxman the very diversity of his activity creates its own special problems. The greater part of his life was spent in making monumental sculpture, and it goes without saying that any work on the scale of the Nelson monument in St Paul's could not be moved from its place. On the other hand we have been fortunate in being able to borrow for the exhibition the George Steevens monument from the church of St Matthias, Poplar, to which it is hoped the monument will eventually return, and a fine selection of the plaster models for church monuments at University College, London. With a number of drawings and large photographs it has been possible to give a sense of Flaxman's activity as a sculptor, but with three sections, Wedgwood pottery, medals and silverware, we have been able to achieve something which approaches a complete representation of all his designs and finished works in these fields.

The drawings in the exhibition make up only a tiny proportion of an enormous oeuvre and they have been chosen both to illuminate the other sections and to give an impression of the range and quality of his draughtmanship without claiming completeness. The greatest problems of selection, however, were presented by the section dealing with Flaxman's influence on the Continent, which was both extremely widespread and often diffuse. It would be possible to show copies and tracings by most of the great 19th-century artists of Flaxman's line engravings, for they were as much part of an artist's training as Le Brun's work on physiognomy had been in the 18th century. It was felt, however, that this would have led to a very dull section of the exhibition, and the decision was taken very early to show only cases where the creative nature of that influence could be demonstrated, or where the line engravings had played a seminal part in the development of a particular composition. For obvious reasons many of the major examples of his influence, like Ingres' *Apotheosis of Homer* and David's *Sabines*, could not be shown, but efforts have been made to exhibit original studies wherever appropriate.

It was also decided at an early stage to confine the coverage of Flaxman's influence to the Continent, although a few English drawings have been added to the *Themes and Variations* where they made a special point. Flaxman was extremely influential in England, indeed so much so that it seemed to us that this subject requires a separate exhibition in which it could be explored in more depth, and that a cursory selection would be self-defeating.

The exhibition at the Royal Academy is essentially the same as that shown at Hamburg earlier in the year, with the exception of a small number of items which could only be lent to one place or the other, and the section dealing with Flaxman's contemporaries at Wedgwood, which has been given a different emphasis in the London showing. The catalogue entries are much the same, but a number of essays in the Hamburg catalogue, dealing mainly with Flaxman's reception in Germany, have been omitted in the English version for reasons of space.

The making of the exhibition and the catalogue can hardly be separated, but I would like, on behalf of all the contributors, to thank a number of people apart from those who have so generously lent items to the exhibition. The first must be the staff of the British Council, especially Gerald Forty, David Fuller and Edwina Sassoon, and the staff of the Hamburg Kunsthalle, whose director, Werner Hofmann, was entirely responsible for conceiving the exhibition in the first place, as part of his great series 'Kunst um 1800'. We also owe an especial debt to: Mr Neil Stratford, Mr Reginald Williams, Miss Frances Carey, Miss Giulia Bartram and Mr Jim Andrews of the British Museum; Professor Michael Jaffé, Mr Duncan Robinson, and Mr David Scrase of the Fitzwilliam Museum, Cambridge; Dr Charles Avery, Mr Stephen Calloway, Dr Michael Kauffmann and Mr Robert Skelton of the Victoria and Albert Museum; Mr Norman Rosenthal and Miss Annette Bradshaw of the Royal Academy of Arts; Mr Martin Butlin and Mrs Judy Egerton of the Tate Gallery; Mr P.M. Doran and Mr John Sunderland of the Courtauld Institute; Mr Francis Hawcroft of the Whitworth Art Gallery, Manchester; Mr Derek Halfpenny and Mrs Lynn Miller of the Wedgwood Museum, Barlaston; Mrs Joyce Jayes and Dr Malcolm Colledge of Westfield College; Mr Julian Halsby and Mr John Green of the Department of Monumental Stone Conservation of Croydon College of Art, and Dr Dyveke Helsted of the Thorvaldsen Museum, Copenhagen.

DAVID BINDMAN

Werner Hofmann **The Death of the Gods**

I

Mythology and Industry: each of these words evokes contrasting ideas and associations. Mythology conjures up an atavistic universe in which men feel helpless in the face of nature, which they personify as deities. Industry, on the other hand, evokes modernism, the triumph of reason and the ability to transform the process of nature into productive operations, which can create an endless supply of material goods and ensure wealth and luxury for every-one. Could anything unite such completely disparate ideas? The answer is yes, and John Flaxman's work for Wedgwood is an example, for it reveals in an exemplary fashion the way in which mythology and mass production can be reconciled. This seemingly paradoxical union can be related to the intellectual context of the time in various ways, and I would like to begin by establishing certain intellectual notions of the period:

1 The return to the forms and ideas of antiquity which we call Neoclassicism is not just concerned with ideal beauty, the academic dogma of 'noble simplicity and calm grandeur', but with a view of humanity in which the ancient world inspires man to self-realization in the contemporary world.

2 A sense of the 'loss of wholeness' of man in all his relationships with society (dealt with by Schiller in the sixth of his letters *On the Aesthetic Education of Man* (1793-94)) creates a desire for a community which frees the individual from isolation and places him in relation to society without limiting his possibilities of unlimited self-realization: as Rousseau says in *Emile*: 'en sorte que chaque particulier ne se croie plus un, mais partie de l'unité, et ne soit plus sensible que dans le tout.'[1]

3 'Aesthetic education' can show man the way to this harmonious society, in which art can serve the creation of a popular taste, and hence reach the general public in as easily accessible a form as possible. But mass education must depend upon mass production, whence arise inevitably the problems of commercial exploitation, marketing and display. These are issues, then, with which we are still struggling today: whether it is possible to reconcile absolute standards with individual creation of form is a question which was first adumbrated 200 years ago, when the fine and applied arts seemed to converge. As today, some saw this situation as desirable, others as reprehensible. Because of the international distribution of Wedgwood pottery, sometimes with Flaxman designs, we can see the issue as one that confirms national stereotypes of England as a practical down-to-earth trading nation and Germany as the home of intellectual speculation which avoids practical consequences.

In Greek mythology archetypes can be found of the notion of man as both inventor and maker of artefacts. Talos, the nephew of Daedalus, invented the potter's wheel, the saw and the compass, and Prometheus, who seized the fire of the gods and made men of clay and water, was honoured by the craftsmen of Athens, especially the potters, as their protector. In each case the idea of creation is linked inevitably with the production of a potentially mass-produced object. This led Goethe to sound a warning, which, not coincidentally, occurs among some strictures on dilettantism.[2] According to tradition, Daedalus, the first sculptor, envied his nephew's invention of the potter's wheel (the legend is that Daedalus threw him off the Acropolis) but Goethe claims that 'envy was not the motive but that with divine foresight he realized that technology would prove fatal to art'. The significance of this remark emerges from the short essay on 'Art & Handicraft' ('Kunst und Handwerk') which in reality should be called 'Art & Industry'.[3] Goethe appeals there to 'true art' (a characteristically defensive stance!) against the tendencies he believes have led to the absolute ruin of art itself: mechanization, over-refined craftsmanship and the factory system. His censorious gaze turns upon England, and implicitly upon the Wedgwood factory: clever manufacturers and entrepreneurs have employed real artists to provide models for clever imitations and have thus forced tribute from connoisseurs. 'The burgeoning taste of the public has been perverted and destroyed by false experiences. In this way the English, with their modern "antique" pottery and wares made of paste, their gaudy black and red art, gather piles of money from all over the globe: but if one

1 See Charles Rilis, *Les philosophes utopistes – le mythe de la cité communautaire en France aux XVIIIème siècle*, Paris 1970, p. 53.
2 *Schriften zur Kunst*, publ. by Christian Beutler, Zurich and Stuttgurt 1954 (2 A. 1965) p. 320.
3 MS from posthumous works, appeared after 15 September 1797 (*Schriften zur Kunst*, pp. 126ff.).

is truthful one gets no more out of antiquity than from a porcelain bowl, pretty wallpaper or a pair of shoe-buckles.' Perhaps Goethe was already thinking of Wedgwood when he wrote in Venice on 8 October 1786 his celebrated verdict on the applied arts of his times: 'art, which gave the man of antiquity his mosaic floor, and vaulted Heaven for the Christian [Goethe was writing under the influence of a recent visit to St Marks] has now been reduced to snuff boxes and bracelets. These are worse times than one realizes.' [4]

The essay 'Kunst und Handwerk' is on the track of this realization. As the force of change 'rushes on with unstoppable power' Goethe realized that he was already in retreat. It is that which gives his warning the force of certainty. 'The merely mechanical artist' is for him a second rate being because 'after he has made a thousand things he has still only made one'. The 'true artist' on the contrary, imparts to his material an 'inner and eternal value'. Thus the timelessness of the unique work of art is contrasted with the fleeting charm of the ephemeral object. Goethe sees the shift from the fine to the mechanical arts as a drying-up of 'pure inspiration' in favour of 'the proliferation of the mechanical': in other words the triumph of quantity over quality. What had already almost triumphed in the plastic arts, would, according to Goethe, begin its assault on painting: 'Soon there will arrive the large-scale painting factory, in which, so we will be told, any painting can be quickly and easily imitated, so that everybody will be fooled, and even a child will be able to master the process. It is true they will only be really deceiving the *eyes* of the crowd but in the end they will rob artists of their means of advancement.'

The art-pontiff of Weimar was not the only one to be perturbed by this phenomenon. Even Caspar David Friedrich, although remote from the world, uses up-to-date terminology and speaks of the 'factory' (*fabrik*) when he wishes to draw a contrast between individual creations and mass-produced wares: he despises 'mechanical practices' and is angered when paintings are displayed like 'commodities'. He also remarks disparagingly upon English ingenuity: 'this steel engraving keeps the tone very well and must surely have been produced by an Englishman on a machine. A German, thank God, would be incapable of such a thing, yet the British are proud of the fact that they are the only ones who can do it.' [5]

This disdain for the mechanical and repetitive is guided by a fear that real art might be degraded and secularized to mere commodities, and contains also a fear that art by mixing with luxury might become merely decorative. But when Goethe balances true art against luxury he is not protesting against wealth itself, but arguing for its commitment to higher values. In order to experience works of art one does not have to own them, but it is as well that they are at the disposal of persons of taste: 'Prince Borghese has what no one else has, indeed things that no one else can hope to possess, and he and his family throughout generations will enjoy them the more, the more pure are their thoughts, the more sensitive their feelings and the more correct their taste; and thousands of educated and enlightened people will share their enjoyment through the centuries.' [6] One cannot restrict the spread of good taste by exclusiveness, but neither can one explain away Goethe's fear of the whole world being flooded by attractive objects.

In a different key this deep-felt cultural pessimism had already, a few years before, been penetratingly analyzed by Schiller in his letters about aesthetic education, but the latter has little to say about the problems of art and manufacture. Instead Schiller points to the estrangement between the artist and that true representative of the age, the merchant.

For Schiller art is the noblest instrument of man's fulfilment, but it is constantly thwarted by the true idols of his time: profit and the craze for novelty. This division appears not only in art; in everything else signs of fragmentation and decay can also be observed. Intuitive understanding is cut off from speculative thought, imagination from the analytic, and form from content. Schiller also identifies the process of alienation which distances man from what he produces: 'Work and enjoyment have been divorced from each other, as have ends from means, and rewards from effort. Bound eternally to a single small fragment of the whole, man himself develops as a fragment: dulled by the monstrous sound of the wheel he turns round, he never develops the true harmonies of his being. Instead of his humanity being governed by nature, he becomes merely the imprint of his business or science.' Schiller applies this metaphor of the wheel as representing eternal monotony to the materialistic pursuits of the 'business spirit', while the 'speculative spirit' renounces the object and withdraws totally into a world of ideas. 'The business spirit, enclosed within this materialistic circle, must thrust out everything to do with freedom, and thus become even more impoverished.' This leads to further polarities between restriction and loosening, feeling and action, and knowledge and productivity: 'the abstract thinker often, therefore, has a *cold* heart because he tends to analyze feelings which only touch the soul in an undivided state; the businessman often has a *nervous* heart because

4 From the point of view of art for art's sake Baudelaire scolds the sculptors in the XVIth section of his 'Salon de 1846': 'Ils transformeraient volontiers les tombeaux de Saint Denis en boîtes à cigares ou à cachemires . . .'. Loos argues in a similar way against the Jugendstil aesthetic and he closes his essay 'The Degeneration of Art' (1908) with the quotation from the Italian Journey (Adolf Loos, *Complete Works* I, Vienna and Munich 1962, p. 275).

5 *Caspar David Friedrich in Briefen und Bekenntnissen*, publ. by Sigrid Hinz, Munich 1974, pp. 85, 102-04.

6 'Kunst und Handwerk', *op. cit*. p. 127.

his powers of imagination are confined within the relentless circle of his profession and thus cannot extend to alien ideas' (sixth letter).

In terms of mythology this can be seen as the separation of Mercury, the god of trade, from the spiritual élite, and this pinpoints in another way the difference between Germans and English. Because the Germans look back to the Greek ideal with religious awe ('with tenderness and energy we see the youth of imagination unite with the manliness of reason to form a magnificent humanity' (Schiller)) they cannot conceive of a pact between art and business, or mythology and industry; in England on the other hand, artist and entrepreneur transform their common admiration for antiquity into new forms of production which draw in 'massive amounts of money from every land'. Benjamin West painted one emblem of this union (ill. 3, p. 25) and Flaxman's *Mercury uniting Britain and France* was specifically meant to encourage trade and commerce (no. 52, a-e). Goethe, on the other hand, in a dramatic sketch praises Prometheus, who dismisses Mercury, for he does not want to make compromises with the gods: he will not submit mankind to being in their pay. The equivalent of this arrogant refusal would have happened if Flaxman had said no to Wedgwood's proposals. Equally Flaxman in the end preferred his own self-realization to collaboration with Wedgwood and as soon as he could he withdrew from the constraints of industrial production. 'They are mine, for my use only', asserts Goethe's Prometheus, who had not yet heard of the division of labour.

Minerva-Athena, the goddess of the arts and crafts, stands helpfully by the side of the rebellious Titan's son, giving life to his clay figures, but this does not imply conciliatory gestures to the gods. For the youthful Goethe Prometheus is a metaphor of his own unbridled will: he is a rebel and bringer of culture through his own strength. He seeks to be completely human, but exists eternally as the artist who had the courage to found a 'Third Dynasty'. Goethe got this idea of Prometheus from Shaftesbury who thus foreshadowed one of the main heroes of the *Sturm und Drang* movement. (In Byron and Shelley this idea of Prometheus, of course, returns to England.)

When Goethe wrote his dramatic sketch, which was to remain a fragment in 1773, he could not foresee that he would soon find himself in the same servile state which his hero had defiantly refused, for in 1775 he entered the service of Charles Augustus in Weimar. Several decades later, early in 1820, he was disturbed that the newly rediscovered *Prometheus* manuscript might have a harmful influence: 'Do not let the manuscript become too public or appear in print. It would be all too timely as a gospel for our revolutionary youth, and the authorities in Berlin and Mainz might look askance at my youthful indiscretions' (letter to Zelter, 11 May 1820).

About 1770 Flaxman came to Wedgwood. While the young Goethe was proclaiming the autonomy of the creative artist, the attributes of Daedalus the archetypal sculptor were divided essentially between a team of two persons: Flaxman the artist contributes formal ideas, while Wedgwood the inventor organizes their productions. Both have resigned themselves to Schiller's idea of fragmentation: they are the descendants of Talos and Prometheus who have adapted themselves to capitalist division of labour, using earth and fire for an industry that in 1785 employs some 15-20,000 men. Just as Flaxman the artist was dependent upon the 'business spirit', on whose independence Schiller was reflecting at the same time, so the workers concerned with manufacture were beginning to confront the problems buried in Schiller's letters under the phrase 'the divorce of work from enjoyment, and reward from effort'. Josiah Wedgwood and his circle were committed to the enlightened goal of 'human happiness' and the factory produced in 1787 a medallion making a plea for the abolition of slavery (ill. 1). These noble sentiments were not, however, directed towards conditions at home.

It might be that this dilemma could only be resolved at the time in the way that Schiller did in the last of his letters. There he invented an 'aesthetic state', an empire of beauty in which 'all men are equal, and which the idealist would like to see fulfilled in real life'. But the freedom which governs art is a 'treasured delusion', a mere palliative. 'Even the humblest and most servile art can rise up from the dust, and its fetters fall away, from the dead as well as the living.' In this vision the German idealist finds a meeting point with the philanthropy of 'Etruria'; the aesthetic state is literally utopia, i.e. nowhere.

II

In order to portray the dark side of industrialization, the miseries of the city, writers turned to myth and poetry. The third volume of *Les Français peints par eux-mêmes* (Paris 1840) has a chapter on the circles of Hell in the modern city. The author invokes Dante because he also took his own times as a model for the *Inferno*. Richard Wagner, in the mid-1850s, says in a letter that 'in complete despair I threw myself into readings of Dante whose Inferno has become an unforgettable reality to me through the atmosphere of London'. Rosenkranz[7] also talks at

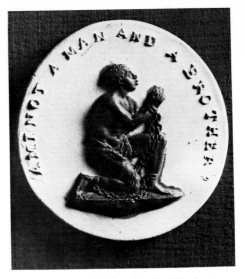

Ill. 1 Wedgwood Medallion, inscribed 'Am I not a Man and a Brother?' 1787

Ill. 2 After J. Gillray, *The Marriage of Cupid and Psyche*, etching with aquatint and watercolour

Ill. 3 After G.C.B. Cipriani, *The Marlborough Gem*, engraving

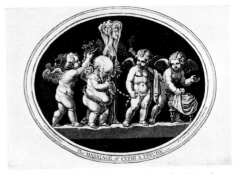

7 Karl Rosenkranz, *Asthetik des Hasslichen*, Königsberg 1835 (reprint Stuttgart 1968), p. 415.

the same period of the London Hades, which Blake had already commemorated in the *Songs of Innocence and Experience* (1794) (I wander thro' each charter'd street . . .). Marx laconically ends his description of working conditions in a match factory: 'Dante would find in this match factory his cruellest fantasies of hell surpassed.' He compares night work with 'a vampire's thirst for the blood of living workers', workers chained by capital to Prometheus, and the massed ranks of labour 'of each profession, age and sex' with the souls of the slain who beset Ulysses.[8] In his metaphor of employers and the employed being like an ever-turning wheel, Schiller may have been thinking of the punishment of Ixion who is bound to a wheel of fire and transported through a whirlwind, from which he is only freed in the underworld.

In his illustrations to Homer, Dante and Aeschylus, Flaxman avoids such topical references but, ironically, he was himself a victim of such exploitation, for he was, in ways which are still unclear, deprived of the profit from them despite their 'best-seller' status. So he is a good example, from the beginnings of the industrialization of art, of Schiller's observation that the cunning 'business spirit' ensnares the artist by making 'the rules of *his* activity apply to all, even artistic, activity' (sixth letter). (See Sarah Symmons' account of Flaxman's experiences on pp. 152-55.)

The influence of Flaxman's outline engraving can be observed in artists one thinks of as opposites, such as Ingres and Goya. When designing for Wedgwood, Flaxman provided designs which could be realized in many different contexts – as David Bindman argues in his essay in the present catalogue – and equally one could argue that his compositions could be adapted for different genres of graphic expression, even parody. Indeed it is possible that Gillray's *Marriage of Cupid and Psyche* of 1797 (ill. 2) was intended to refer not only to the famous Marlborough gem (ill. 3) but also to Flaxman's version for Wedgwood (no. 25a).

Flaxman's outlines combine clarity of construction with a strong sense of abstract structure: they are highly formal and although extremely spare they are not in any way unrealized, nor do they affect the spontaneity of the sketch. There are 'no superfluous lines' or 'dashing strokes', A.W. Schlegel remarks, and he goes on: 'Everything is done with minimal means; his outlines combine the briskness of the first thought with the care and delicacy of the most consummate finish.' Schlegel also points out the connection between an artistic approach which is concerned to be sparing in its use of materials, with the economic attitude such discipline might imply: in 'the cultured simplicity of a taste which does not make a point of overcoming useless difficulties, but achieves its goal in the simplest possible way', he sees also an economic reason for recommending outline, namely the saving 'of much labour and cost'.

Such economy of form must depend upon a system of abstraction. Flaxman articulates the surfaces in such a way that they are defined equally by the interior forms and the space which surrounds them. Thus the space in which the objects are set is not a void, but is part of the overall formal interplay in the picture. In this sense Flaxman anticipates the formal consciousness that resulted in Post-Impressionism: figure and ground are equivalent. The distribution of shapes on the surface has analogies with a musical score; men are placed in relation to each other like notes on a stave.

This extreme linear reduction allows the motif to remain embedded within quite different layers of expression. Thus Danby (whom Goethe listed as one of the 'nebulous' English) in his *Vision of Revelation* (ill. 4) borrowed the old man of Crete (ill. 5) from the *Inferno* but dissolves it in a haze of colour, and Goya transforms the harpies in the wood (ill. 6) into a gloomy band of nocturnal monkey-like spirits (ill. 7); and Rude, full of impetuous feeling, still looks back to Flaxman's *Odyssey* (ill. 8) in the *Marseillaise*.

8 *Das Kapital* Vol. I., Section 3, Chapt. 8: 'Der Arbeitstag: Section 7, Chapt. 23.

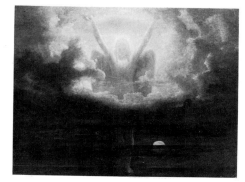

III. 4 F. Danby, *Vision of Revelation*, 1821

III. 5 Flaxman, *The Old Man of Crete*, engraving

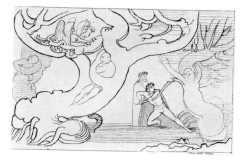

III. 6 Flaxman, *The World of the Harpies*, engraving

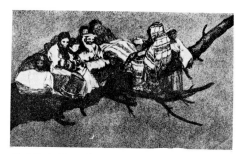

III. 7 F. de Goya, *Strange Folly* (from *Los Proverbios* 1815-18), etching

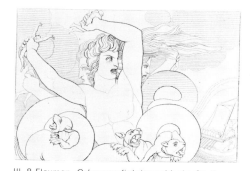

III. 8 Flaxman, *Odysseus fighting with the Scylla*, engraving

III. 9 Flaxman, *Virgil and Dante at the Flaming Abyss*, engraving

III. 10 Flaxman, *Redeem the Prisoners*

Flaxman's Dante and Virgil can be seen as archetypes of the pairs of friends which often appear in nineteenth-century painting. This notion of two friends wandering through a threatening yet transforming landscape is realized most profoundly in the paintings of Friedrich. Are his *Two Men Looking at the Moon* (Börsch-Supan, 261) an answer to Flaxman (ill. 9)? This suggestion may be lent support by Friedrich's conscious rejection of Italian models. His 'answer' would thus have an essentially confessional meaning.

Flaxman's drawings unite strength with delicacy. The former quality comes out most strongly in the linking together of cube-like groupings of figures (ill. 10, nos. 72, 103, 115, 147, 156, 158), and the latter quality in flowing rhythms (ill. 11, nos. 96, 108, 111, 112). This range of expression makes Goethe's lukewarm comments of 1799 all the more extraordinary: 'pretty and light – not badly placed' – 'violent – too grotesque' – 'well and adventurously placed'. Only once does Goethe penetrate to the formal ideas. He writes of engraving 29 in the *Iliad*: 'Achilles fighting in and with the two rivers. Very beautifully conceived and composed. The rivers roll the bodies on top of the waves, opening up a space where Achilles stands.' This bowl-like space appears again and again in Flaxman, giving a rising and falling rhythm to the frieze-like composition. By this means symmetry and verticality may also be given their full force. The economy of means is also maintained by what Schlegel calls 'squared movements of the body', derived from a study of the trecento and quattrocento. Most powerful of all are those figures whose positions relate to the horizontal and vertical directions of the picture-edge (ill. 14, nos. 74, 82, 97, 117, 119, 150). When Runge used Flaxman's *Achilles* for his version of the subject, he disregarded to his cost exactly these ways of achieving clarity and economy.

The approval that Goethe gave to Flaxman's *Achilles* is surprising in the light of the warning in the announcement of the 1799 Weimar competition. In discussing the theme of *Venus bringing Helen to Paris* he cannot resist taking a critical sideswipe at Flaxman's version, which he claims is 'in fact cleverly conceived, but composition and drawing are very faulty, facts which are only meant to be relevant to those who have seen or even own the engravings.'[9] What else could the competitors do but avoid the contamination of Flaxman? This was clearly no problem to the prize-winner, F.A. Hartmann, later Professor at the Dresden Academy, for the construction and articulation of his figures betray his obvious inability to benefit

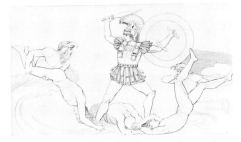

III. 11 Flaxman, *Young Women returning to Thetis in the Flood*, engraving

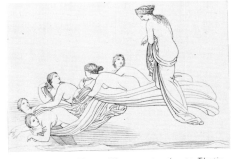

III. 12 Flaxman, *Achilles Fighting with Scamander and Simois*, engraving

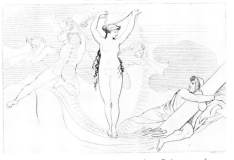

III. 13 Flaxman, *Leucothea rescuing Odysseus from the Shipwreck*, engraving

III. 14 Flaxman, *The Punishment of the Greedy*, engraving

III. 15 Flaxman, *Venus bringing Helen to Paris*, engraving

from Flaxman's sophisticated simplicity (ill. 16). The space in Flaxman's engraving can be seen as tending to the concave, acting as a kind of bowl which encloses the figures. Here the figures sit on the paper like notes on a sheet of music, while the curvature of the furniture clings closely to them. Within this shell-like space is prefigured the erotic union of Paris, in Schlegel's words 'the seductive weakling', and Helen with 'a chastely lascivious face'. But Venus' role remains ambiguous: is she leading or led by Helen?

The influence of Flaxman on Goya is fully substantiated by the examples in the present catalogue given by Sarah Symmons (see nos. 240 ff.). Beyond these there are analogies which raise a number of interesting questions. In terms of general composition it is worth pointing out that both artists, although starting out from completely different assumptions, reached the most extensive restructuring of space in 'Art Around 1800', the theme of this series of exhibitions initiated by the Hamburg Kunsthalle. Space is no longer defined as a continuous progress through the planes of the picture but through disconnected groups of bodies in an elastic or infinite depth (ills. 17, 18). The corollary to this fragmentation of space, as Theodor Hetzer observed for the first time in Goya[10], is that figures form groups which can be envisioned not as 'crowds' but as 'masses'. Flaxman's compressed human chains have an 'earthbound' reflection in Goya; impacted groups entwined with and clawing each other (ills. 19, 20). The pathos of these crushed-together bodies is different from the falling groups of Giulio Romano or Rubens, for it contains an ambivalent metaphor of fate which perverts freedom into another set of fetters. This can be seen by comparing a page from the *Caprichos* (ill. 21) with Flaxman (ill. 10) and Blake (ill. 22).

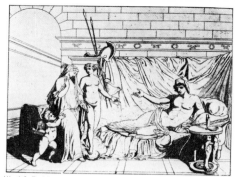

Ill. 16 F. Hartmann, *Venus, Helen and Paris*, aquatint, 1799

9 *Schriften zur Kunst, op. cit.* p. 255.
10 Theodor Hetzer, *Francisco de Goya and the crisis in art around 1800* in *Aufsätze und Vorträge*, I Leipzig 1957, pp. 191ff.

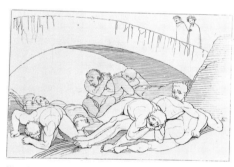

Ill. 17 Flaxman, *The Pit of Epidemics*, engraving

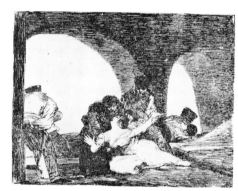

Ill. 18 F. de Goya, *Bitter Present* (from *Los Desastres de la Guerra*, 1808 - 14), etching

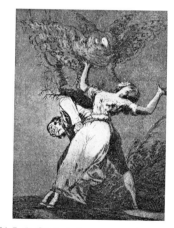

Ill. 21 F. de Goya, *Is there anyone to set us free?* (from *Los Caprichos*, 1797 - 99)

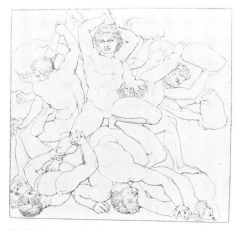

Ill. 19 Flaxman, *The Giants and the Titans*, engraving

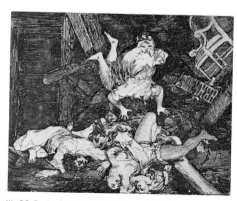

Ill. 20 F. de Goya, *Devastation of War* (from *Los Desastres de la Guerra*, 1808 - 14), etching

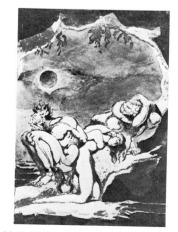

Ill. 22 W. Blake, *Visions of the Daughters of Albion* (frontispiece), 1793

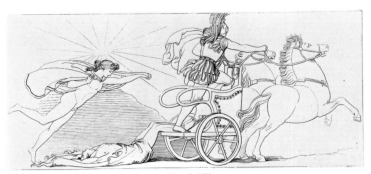

III. 23 Flaxman, *Hector being dragged by Achilles*

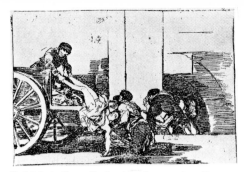

III. 24 F. de Goya, Cartload for the cemetery (from *Los Desastres de la Guerra*, 1808 - 14), etching

Flaxman's unconscious Andromache (*Iliad* 34) invites a comparison with the dead woman who provokes a necrophiliac 'Tantalus' to despair (*Caprichos*, 9). Is it coincidence or is there a common source? It could possibly be an antique bas relief which, as Schiff has demonstrated, influenced Fuseli (Schiff 372), or an engraving by Reiner Vinkeles of *Young Burying his Daughter* which appeared in the widely-circulated French translation of the *Night Thoughts* (1769). (See M. Löfström, 'The Star and the Night', in *Contributions to the History and Theory of Art*, Uppsala 1967, p. 127.)

In a certain sense Goya's print cycles can be seen as a kind of corrective to those of Flaxman, in which the 'poetry' of antique models is answered by the exalted 'prose' of the former.[11] Perhaps one should even see the ultimate objective of the Spaniard's cycles as a kind of consequence and demythification of Flaxman. In Goya's godless world the ancient heroes set no examples, and their bards are silent. This antithetical connection is seen most clearly if we compare their depictions of violent death. How does the conqueror treat his victim? Achilles in dragging Hector behind his chariots performs what is to us an ignoble ritual of vengeance but Flaxman, by creating a rhythmical interplay between the figures, disguises the horror of the occasion (ill. 23). As Goethe observed, other means were also used to diminish the horror: 'Hector's upper body appears to be enfolded by a rough hide, so that something visibly distances the outrage upon him; above, the floating figure of Phoebus tenderly covers him with a cloak.' This figure of Phoebus gives the impression that Achilles is about to carry off his victim to the heavens.

Goya, on the other hand, shows corpses shoved off a cart like slaughtered cattle (ill. 24). The wheel cut off by the side of the image has the cutting edge of an instrument of torture. Thus would man be treated more than one hundred years later in Nazi concentration camps.

III

The death of the gods begets the void in which fear and madness thrive.[12] This void appeared to rationalists as freedom for man to find himself and assert his creative power.

11 W.H., 'Poesie und Prosa – Rangfragen in der neueren Kunst', in *Bruchlinien, Aufsätze zur Kunst des 19. Jahrhunderts*, Munich 1979, pp. 180ff.
12 Walther Rehm, *Experimentum Medietatis*, Munich 1946.

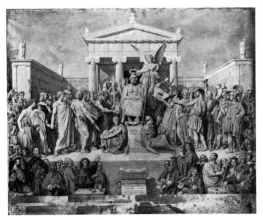

III. 25 J.A.D. Ingres, *Apotheosis of Homer*, drawing, 1865

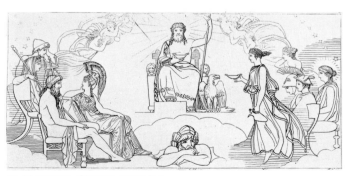

III. 26 Flaxman, *Olympus*, engraving

Ingres based the *Apotheosis of Homer* (ill. 25) on his own *Jupiter and Thetis* (no. 208) and this motif of the divine ruler (Gautier later applied it to Goethe the Olympian of Weimar[13]) in turn goes back to Flaxman's *Olympus* (ill. 26). The descent from the heavenly sphere is compensated for by the elevation of the 'great man' to divinity. Ingres places his Olympian scene before an Ionic temple and he populates it with great men from antiquity to the present day. Norman Schlenoff has counted 76 'Homerides'.[14]

In this complex but comprehensible composition, which Ingres was reworking until the end of his life, man, or to be more precise European man, is shown as essentially self-created: what he has become is due to his 'ingenium', and the spiritual ties which join all great men. In this company everyone is an heir to Prometheus, even if he does not appear. One hundred years after Goethe's rebellion against the tutelage of the gods there arises a gentle self-confidence which sees the past as a panorama of heroes. In this ancestry of modern humanity the ruler stands next to the architect, and the poet next to the general. Homer, in whose veneration all are joined, is the new pantocrator, the ruler of the world. In this light Ingres' composition can itself be seen as inherited from Christian teaching, but here it is the Homerides who are the saints of the new religion of humanity. Accordingly, Ingres' pictorial idea can be seen as a descendant of the iconographic schemes on the façades of Gothic cathedrals. What Ingres shows, however, has nothing to do with the imagery of the Old and New Testaments. Instead he adorns the walls around the temple with layers of friezes depicting events from the *Iliad* and *Odyssey*. The prototypes for this 'adventure strip' are Flaxman's engravings, and the artist himself is portrayed in this late version of the composition, in the right foreground behind Longinus. Thus Ingres was influenced and guided by Flaxman up to the end of his life, and in his old age even planned to paint a portrait of his mentor.[15]

This posthumous fame drew Flaxman out of the ranks of servants of the alliance of mythology and industry. Flaxman was, in effect, liberated by Ingres, who saw him as a Homeride and an example of the modern cult of the great men whose unique genius could outshine Olympus. Flaxman has therefore returned to the company of the keepers of the old wisdom and truth, for in Ingres' eyes his true place is not in the industrial marketplace as the author of endlessly reproduced designs for all sorts of commodities, but in a holy temple in which his art belongs to the company of the elect, and at the same time remains unique and his own.

13 'Lorsque nous pensons au grand Volfgang (*sic*), nous nous le représentons assis sur un trône d'ivoire et d'or, immobile et froid comme un marbre de Paros: Bettina d'Arnim, agenouillée à ses pieds, lui touchant d'une main les genoux et de l'autre la barbe, comme la Thétis suppliant Jupiter dans le beau dessin D'Ingres. – C'est ainsi que ce dieu nous apparaît dans la plénitude de sa force et de son génie . . .' (*L'Art moderne*, Paris 1956, p. 283).
14 Norman Schlenoff, *Ingres – ses sources littéraires*, Paris 1956, pp. 167ff.
15 Schlenoff, *op. cit.* p. 125.

III. 28 Flaxman, leaning on Homer's head: one of nine statues for the façade of the Royal Academy of Arts (Burlington House) by Henry Weeks, 1873 - 74

Chronology

1755

6 July John Flaxman born in York, the second son of John Flaxman Sr, a plaster-cast maker and sculptor.

1756

The family settles in London. Flaxman Sr continues his prosperous business of supplying casts for such well-known sculptors as Roubiliac and Scheemakers. Flaxman, being sickly, only attends school briefly. In his father's shop he learns to read, draw and model.

1767-68

A Mr Crutchley orders from the young Flaxman six drawings in black chalk after the antique. Flaxman exhibits at the 'Free Society of Artists' figures after the antique and portraits (many in wax).

1770

Flaxman exhibits at the Royal Academy two models for portraits and a wax figure of Neptune, for which he receives a silver medal. He enters the Royal Academy school to study as a sculptor, under the Presidency of Sir Joshua Reynolds.
80 Portrait of a gentleman; a model.
81 Portrait of a gentleman; a model in wax.
82 A figure of Neptune; a model in wax.

1771-73

Flaxman exhibits various works in Royal Academy exhibitions, but fails to win a gold medal, which would have enabled him to travel to Italy.

1771

70 Four portraits; models in wax.

1772

85 A Figure of History.
86 Ditto of a child in wax.
87 Bust of a gentleman; a model in terra-cotta.
King Street, Covent Garden.

1773

104 A figure of the Grecian comedy.
105 A Vestal in Basso-Relievo.

1775

Flaxman gets to know George Romney, who had just returned from Italy. Flaxman accepts an offer to work for the firm of Wedgwood and Bentley. He continues to exhibit regularly in the Royal Academy.
119 A portrait in wax.
420, Strand.

1777

122 A model in clay of Pompey, after his defeat at Pharsalia.
123 A ditto of Agrippina, after the death of Germanicus.
124 Portrait of a lady in wax.

1778

108 Hercules tearing his hair, after having put off the poisoned shirt given him by Dejanira; a model in terra-cotta.
109 A portrait in wax.

1779

91 Portrait in terra-cotta.

1780

A design by Flaxman for a tomb to the poet Chatterton is exhibited in the Royal Academy exhibition. He begins to design sculptural decorations for Wedgwood's Etruria Hall.
453 Sketch for a monument to Chatterton.
27, Wardour Street.

1781

272 Portrait in wax.
475 Acis and Galatea; a bas-relief.
476 Death of Julius Caesar; a bas-relief.

1782

John Flaxman marries Anne Denman.
515 Bust of Mercury.

1783

403 Model of a monument.

1784

Flaxman receives the commission for a tomb in Gloucester Cathedral of Mrs Sarah Morley who died in childbirth at sea.
508 Monument of a lady who died a short time before her child.
519 Bust of a gentleman.

1785-86

Flaxman executes a tomb for William Hayley's parents-in-law, the Rev. Thomas Ball and his wife Mary (Chichester Cathedral).

1785

486 An angel comforting a mourner; a monumental sketch.
639 Bust of a gentleman.

1786

579 An angel comforting a widow; a monumental bas-relief in marble.

1787

Flaxman and his wife go to Italy. They set off in the autumn and first visit Paris, then travel on to Rome. Flaxman executes a few commissions for Wedgwood in Italy, also overseeing some of the artists working there for him. He also procures plaster casts after the antique for George Romney.
655 Venus and Cupid.
7, Buckingham Street, Fitzroy Square.

1788

Flaxman copies the Borghese Vase for Richard Payne Knight.

Entries taken from the catalogue of the Royal Academy Exhibitors are in italics

1790

Lord Bristol, resident in Rome, orders from Flaxman the group *The Fury of Athemas.*

1792

Thomas Hope, then living in Rome, orders from Flaxman a restoration as *Hercules and Hebe* of the *Torso Belvedere* (a plaster model in University College, London). The artist receives from England a commission to design a tomb for William Collins (no. 139).

In the latter part of the year Flaxman is busy with outline drawings to the *Iliad* and *Odyssey*, which Mrs Hare-Naylor has ordered from him in Rome at 15 shillings per sheet. In addition he draws for Thomas Hope 109 sheets after Dante's *Divine Comedy* (nos. 98 - 108, 118 - 20).

1793

1 February the first edition of the *Odyssey* is published, followed on 1 June by the *Iliad*, both engraved in outline by Thomas Piroli.

In July Piroli engraves the Dante drawings but Thomas Hope forbids their publication. The widowed Countess Spencer, a cousin of Mrs Hare-Naylor, orders from Flaxman at a guinea a sheet illustrations to Aeschylus. The Aeschylus drawings are engraved by Piroli in August and September (nos. 109 - 17). Flaxman receives the commission for a monument to Lord Mansfield to be erected in Westminster Abbey (see no. 140).

1794

Flaxman returns with his wife to England. He continues his work on the Mansfield tomb.

1796

Flaxman exhibits in the Royal Academy a model of the Mansfield monument.

875 A Monument to the late Earl of Mansfield to be erected in Westminster Abbey.

1797

Election of Flaxman as Associate of the Royal Academy.

1106 A sketch in bas-relief from the New Testament.
1107 do. do. do.
1108 do. do. do.
1188 Sir William Jones writing from the Hindoo doctors or Pundits reading their sacred law.

1798

The tomb of General Paoli erected in Westminster Abbey.

1039 A bust of General Paoli.
1047 A Monumental basso-relievo.

1800

Exhibits the relief *Apollo and Marpessa* (no. 121) at the Royal Academy and receives a prize. He is elected a full member of the Royal Academy.

1004 Apollo and Marpessa.
1005 Sketch of a monument to the late General Thomas Dundas.
1054 An afflicted mother comforted by an angel; a monument at Lewisham church.
1056 Come, thou blessed; a marble bas-relief.
1098 A sketch of a monument for an eminent lawyer.

1801

961 Thy will be done; a monumental bas-relief in marble.
971 Sir William Jones compiling the Hindoo laws; a bas-relief in marble.
981 A monumental statue in marble.
1037 A sketch for a colossal statue of Britannia triumphant, proposed to be erected upon Greenwich Hill.

1802

In August Flaxman along with many other English artists goes to Paris which is now accessible to English visitors because of the Treaty of Amiens. In the Louvre he visits the collections looted by Napoleon.

946 A model of a monument to Capt. Montague, who fell in the cause of his country on the 1st of June, 1794, when the English, under the command of Earl Howe, obtained a compleat victory over the French fleet.
959 A bust of H.P. Hope, Esq.
1072 Domestic affliction; a marble bas-relief.

1803

Makes a tomb for Josiah Wedgwood, St Peter's Church, Stoke-on-Trent. He receives the commission for a monument to Sir Joshua Reynolds (finally erected in St Paul's Cathedral in 1813).

1805

Flaxman designs the Trafalgar Vase for the royal goldsmiths Rundell, Bridge & Rundell.

761 But deliver us from evil.
764 Angels strewing flowers on the tomb of a deceased poet; a basso-relievo in marble; part of a monument to the late I.H. Browne, Esq.
765 Mercury descending with Pandora.
766 Charity.
768 A basso-relievo in marble: "Blessed are they that mourn, for they shall be comforted."
770 Lead us not into temptation.

1807

The tomb for the Rajah of Tanjore (Calcutta) is erected.

1092 A small model for the statue of Sir J. Reynolds to be erected in St Paul's Cathedral.

1808

Starts work on a statue of Nelson (erected in 1818 in St Paul's Cathedral).

945 A marble basso-relievo.

1809

Designs two friezes for the rebuilt Covent Garden Theatre.

817 Resignation; a statue in marble.
823 "Deliver us from evil"; an alto-relievo.
834 "Thine is the kingdom"; an alto-relievo.

1810

Appointed Professor of Sculpture at the Royal Academy.

745 "Instruct the ignorant"; a basso-relievo.
822 A monument for India, to the late Josiah Webbe, Esq.: on the right of the tablet stand a Brahmin and a Mahommedan; on the left, two English gentlemen, his friends: one in the civil, the other in military department. The tyger and lotuses at bottom are emblematical of India.

1811

Begins his professional lectures on sculpture, which were not published until 1829.

925 Victory leaning on a trophy; a monument to Captains Walker and Becket for the Town of Leeds.

929 Maternal affection; a basso-relievo.

1812

896 A monument to the late Marquis Cornwallis, for the Prince of Wales's Island in India.

1813

911 A small model for a colossal statue of Gen. Sir John Moore to be erected in Glasgow.

937 A monumental basso-relievo in marble. "Deliver us from evil."

943 A resurrection; in marble.

1814

753 A pastoral Apollo.

779 Model for part of a monument in Chichester Cathedral.

803 The Good Samaritan.

805 A Canadian Indian, forming part of a monument to the late General Simcoe.

808 A British Volunteer, forming part of a monument to the late General Simcoe.

1815

900 The statue of a lady, authoress of "Psyche", a poem.

1816

930 A senatorial statue in marble.

967 A monument; basso-relievo.

1817

Publication of the illustrations to Hesiod, engraved by Blake.

1007 Maternal love.

1818

Delivers his design for the *Shield of Achilles* to Rundell, Bridge & Rundell (no. 190).

1063 A monument to Major-Gen. Sir B. Close, Bart.

1089 Charity; a model.

1819

1199 An alto-relievo in marble of Faith.

1236 An alto-relievo in marble of Charity.

1237 A monumental figure in marble.

1820

Flaxman's wife dies.

1063 Religious instruction; a basso-relievo in marble for St John's Church, Manchester.

1822

The marble groups *St Michael overcomes Satan* and a *Pastoral Apollo* made for Lord Egremont.

985 Satan overcome by St Michael; a groupe.

1024 A sleeping child; in marble.

1823

1088 Bust in marble of the late John Forbes, Esq.

1122 A basso-relievo in marble of the Saviour raising the daughter of Jairus. Luke, Chap. viii, ver. 54.

1824

1012 Psyche; a statue in marble.

1028 The Pastoral Apollo; a marble statue.

1826

9 December Flaxman dies: 15 December, according to his wish, he is buried not in St Paul's Cathedral but in St Pancras Cemetery, London.

1074 A small model of Michael Angelo.

1075 A small model of Raphael.

1827

1127 Statue in marble of the late John Philip Kemble. To be placed in Westminster Abbey.

David Bindman John Flaxman: Art and Commerce

For most visitors to the present exhibition the chief surprise will be the range of Flaxman's activity. While his sculpture is well known, in England at least, and his line engravings from classical authors have been extremely influential on the Continent, his activity as a designer for Wedgwood, and for the silversmiths Rundell, Bridge & Rundell, as well as his designs for medals, have been less often displayed. Indeed such was Flaxman's willingness to provide designs for different forms of manufacture that one might see him as an exemplary son of the Industrial Revolution, ever adaptable to new processes and means of reproduction. In reality, however, Flaxman was primarily moved by classical and Christian idealism, and his main ambition was to succeed as a sculptor in marble of monuments in an elevated style. There is no evidence that Flaxman was in any way moved by the possibilities for human happiness expressed by the scientifically minded circle of Josiah Wedgwood, or indeed that he took much interest in the exploitation of new materials or in the transmutation of his designs into decorations for chimney-pieces, vases or teapots. In these respects he was quite unlike the two other major artists who worked for Wedgwood: Wright of Derby and George Stubbs. Wright's paintings capture with astonishing sympathy the ideals of that very generation of enlightened amateur scientists who transformed themselves into the first manufacturers of the modern age (ill. 1), and Stubbs was passionately interested in working out the ways of painting on ceramic with Wedgwood's help (ill. 2).

It might seem odd that an artist as hostile to materialism as Flaxman was, should form a fruitful alliance with such enterprising manufacturers as Wedgwood and Rundell, Bridge & Rundell, but in fact the connections between Neoclassical idealism and the needs of manufacture are closer than they might appear. Wedgwood saw his pottery not only as a commercial enterprise but as the new Etruria, where the crafts of antiquity were revived. This ideal is expressed perfectly in Benjamin West's painting *Etruria* (Cleveland Museum of Art, ill. 3), which is a sketch for a painting of 'Genius calling forth the Fine Arts to adorn Manufactures and Commerce, and recording the names of eminent men in those pursuits'.[1] Here manufactures and commerce are seen as restoring the harmony between what we would call the fine and applied arts as it had existed in antiquity: a harmony which could produce such marvels as the Portland Vase (see no. 55a for a Wedgwood copy), shown held by a naked boy in the foreground of the painting.

Aside from the fact that Neoclassical taste was becoming fashionable in the 1770s and 80s, there were eminently practical reasons why Neoclassical designs should appeal to the manufacturer. For the sculptor, Neoclassical ideals implied a rejection of complex illusion and of elaborate contrasts of texture in favour of antique purity and nobility. Flaxman condemned Roubiliac (ill. 4) as follows:

He copied vulgar nature with zeal, and some of his figures seem alive: but their characters are mean, their expressions grimaces, and their forms frequently bad: his draperies are worked with great diligence and labour, from the most disagreeable examples in nature, the folds being either heavy or

III. 1 Joseph Wright of Derby, *Experiment with air pump*, Tate Gallery

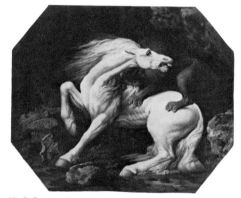

III. 2 George Stubbs, *Lion and Horse*, enamel on copper, Tate Gallery

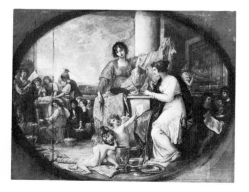

III. 3 Benjamin West, *Etruria*, 1791, Cleveland Museum of Art

III. 4 L.F. Roubiliac, detail from the Montagu tomb, Warkton Church, Northants, *c*. 1750

1 The painting, which is dated 1791, may be associated with decorations for Queen's Lodge, Windsor. (See H. Hawley, *Neo-Classicism: Style and Motif*, Cleveland Museum of Art, 1964, no. 77).

meagre, frequently without a determined general form, and hung on his figures with little meaning. He grouped two figures better together than most of his contemporaries, but his thoughts are conceits, and his compositions epigrams.[2]

Behind Flaxman's strictures there is a distaste for Baroque handling: the use of deep cutting to create dramatic folds, different coloured marbles, and the free touch which makes marble, in Sir Joshua Reynolds' words, 'sport and flutter in the air' in defiance of its supposed nature. Although the purity and antiquity of marble made it the prized material for Neoclassical sculptors, there is a tendency among Neoclassical artists, partly in reaction against the Baroque concern to please the eye, to disdain material as being of lesser importance than the 'idea'. In practice this meant that less of a premium was placed upon the artist's ability to endow the work with a life-giving touch, than upon his powers of mind in presenting a complete and self-contained intellectual construct. Marble might be the ideal material, but the material should not draw attention to itself. It is easy to see that such a notion could, under pressure, lead an artist to believe that his 'idea' was capable of surviving virtually any material transformation or setting, even on a teapot. Just as the *Apollo Belvedere* might convey its essence in a cast, a small bronze or even a line engraving, so an artist might believe that the power of his own work was not wholly diminished by being transferred to another material. In Flaxman's case one can see this process of transferability at work throughout his career, even when he was not working for manufacturers.

The *Apotheosis of Homer* design was, after all, transformed into a low relief mould from a line engraving after a painted design on a Greek vase (see no. 32). The motif used in a finished drawing of the *Acts of Mercy* may reappear in a relief tomb: the design for the plaster relief of *Mercury and Pandora* is used again as a line engraving for *Hesiod* (see nos. 155-57), and even the line engravings for Homer were intended, as Flaxman tells us, to be ideas for bas reliefs he hoped to execute on his return from Italy. Although Piroli's line engraving after the drawings for Homer, Aeschylus and Dante was notably insensitive and dry, Flaxman seems to have made no effort to impose a personal handling on them, nor to claim them as any less his own. In some cases the fluidity of the pen work and the suggestion of atmosphere in the drawings is completely lost (see ills. 5 and 5a). On the other hand, with line engraving the gain in accessibility was infinite, for the plates could be reprinted in large numbers, and the style was now simplified enough to allow for accurate tracing and copying.

Flaxman's relationship with Josiah Wedgwood began with the sculptor's father, John Flaxman, Sr, who was a cast maker, supplying casts for professional sculptors like Roubiliac and Scheemakers as well as for Wedgwood to copy. The young Flaxman first came to Wedgwood's attention not only as a promising young sculptor but as his father's son, who would naturally help with the family business of cast making. It is, therefore, particularly difficult to draw clear lines between what was supplied by father or son and what is an original design or an adaptation of the antique. While Wedgwood was no doubt impressed with Flaxman's growing reputation as a sculptor in London before his departure for Italy in 1787, he seems to have made little attempt to capitalize on it. In fact when he wrote to Sir William Eden in June 1787 about the two reliefs commemorating the commercial treaty with France (see nos. 51-2), which he had commissioned from Flaxman, he did not mention Flaxman's name to that potential client. There may of course have been some shrewdness in this, for Wedgwood was always worried about having to pay London prices for work he could get from his own modellers, and the technical processes were often so complicated that a design might have to be altered beyond recognition, or given to another modeller to do.

Flaxman was prepared to be accommodating towards Wedgwood, but, as he made clear, by 1785 this kind of work was not of central importance to him: 'I am concerned I could not send this bas relief sooner, upon which I have been chiefly obliged to work at Night and now and then have taken a day from some large Monuments I have in hand which are in great haste' (see ill. 6). His main concern in his early years was to raise money to go to Rome. As Sarah Symmons has demonstrated, money was a lifelong problem for Flaxman.[3] He had some aid in getting to Rome from his wife's family and from the Rev. and Mrs A. S. Mathew, and he also did supervisory work for Wedgwood, but as a relatively mature artist he knew that he could not make use of his time in Rome if he were forced into the usual paths of drudgery open to young artists.

While Flaxman's career as a sculptor was reasonably successful, he was aware that he could not aspire to the highest class of the art without extensive study among the great works of antiquity. Like Blake and others of his generation, he had responded with enthusiasm to Sir

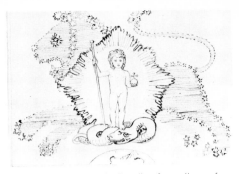

Ill. 5 Drawing for Dante's *Paradiso*, from album of drawings made for Thomas Hope, Houghton Library, Harvard College

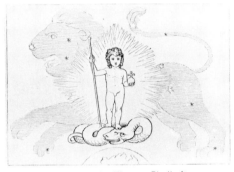

Ill. 5a Line engraving by Thomas Piroli after drawing in ill. 5

2 *Address on the Death of Thomas Banks*, Flaxman, 2nd ed., 1838, p. 289.
3 Symmons, 1975, p. 644.

Joshua Reynolds' call, in his *Discourse* to the Royal Academy, for English artists to excel in the Great Style, and Flaxman's respectful approach to the art of the past was in conformity with Reynolds' precepts. Flaxman may well have attended and would certainly have made careful note of Reynolds' *Discourse* to the Royal Academy on the subject of sculpture, delivered on 11 Dec. 1780. Reynolds argued that the art of sculpture was essentially more limited than painting: its range of subject-matter and style was circumscribed, and it was only suited for the highest class of art. The sculptor could not compete with the painter in what Reynolds called the 'ornamental' style, by which he meant the picturesque or imitative possibilities of painting. For Reynolds, as for other academic writers, the antique was pre-eminent and 'all endeavours will be vain that hope to pass beyond the best works which remain of ancient Sculpture.' Like Winckelmann, Reynolds saw in these antique remains the 'faultless form and perfect beauty' which could transcend the subject and survive fragmentation, but he also allowed that it was an equally lofty aim for the sculptor to convey sentiment through expression and gesture. This distinction between beauty and expression foreshadows the polarities in Flaxman's sculpture, between the ideal character of his forms and the humanity of his language of gesture, united by his special ability to infuse the conventions of Neoclassicism with warmth.

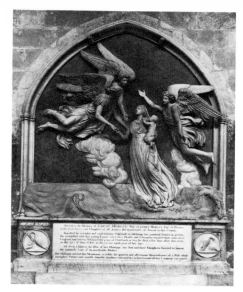

III. 6 Monument to Sarah Morley, *c.* 1785

The humanity of Flaxman's art can be associated with a powerful strain of Christian idealism which became stronger as he grew older, and in this he belongs more to the generation of Blake than of Reynolds. Like Blake, Flaxman had been drawn to the writings of Swedenborg, whose dedication to the life of the spirit proved attractive to those seeking an alternative to the supposed rationalism of established religion. Flaxman derived from Swedenborg a conception of heaven as a traditional paradise, governed by angels who watched over man and ensured an easy passage for his soul to eternal life. In this heaven the human affections were given an eternal form, and Devils of discord were cast out. Blake, on the other hand, in a spirit of irony, argued in *The Marriage of Heaven and Hell* that the Devils had a case and that active revolutionary energy was preferable to the Passive Good of the Angels: 'Good is the passive that obeys Reason Evil is the active springing from Energy.'[4] In a way, Flaxman was the archetype of the Swedenborgian 'Angel' in Blake's sarcastic definition: pious, conformist and essentially rational. In the long run the difference in character was reflected in their careers: one moving steadily towards worldly fame and high office, the other towards poverty and neglect, but they did remain friends of sorts. Flaxman continued to send Blake engraving commissions, but Blake rightly suspected a growing distaste on Flaxman's part for his 'Visions' and a feeling of condescension on the part of the Professor of Sculpture at the Royal Academy. Nevertheless, except at certain times, Blake remained a great admirer of the sculptor and recognized the essential spirituality of his work: 'When Michael Angelo or Raphael or Mr Flaxman does any of his fine things he does them in the spirit.'[5]

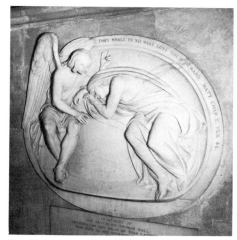

III. 7 Monument to Dean Ball, *c.* 1785 - 6, Chichester Cathedral

Flaxman's generosity towards Blake precipitated him into the tragicomic relationship with the poet William Hayley, who employed Blake as an amanuensis from 1800 to 1803.[6] Hayley's insensitivity towards Blake's originality, as well as his own mediocrity as a poet have given him a poor reputation, but his role in Flaxman's career was more positive. Hayley was personally responsible for many of the commissions for Flaxman's major monuments, and these include many of the finest and most sympathetic in feeling. His great generosity towards artists was mixed with a suffocating desire to control their work and his friendship was undoubtedly a heavy burden to bear. It could be argued, on the other hand, that his concern for the human affections and his belief in simplicity of feeling were of great benefit to Flaxman. Certainly some of his ideas about sculpture were close to those of Flaxman, and Hayley's inscription for the early tomb of his parents-in-law, Dean Ball and his wife of Chichester (see ill. 7), sets the tone perfectly for Flaxman's later monuments: 'This monument was erected according to his desire, and testamentary appointment, not to commemorate ostentatiously the virtues of the deceased, but to remain a faithful evidence of their affectionate union.'[7] Some of the monuments in which Hayley had a hand, like that to his school friend George Steevens (no. 117), are notably genial in sentiment, as if they had picked up some of the relaxed atmosphere of Hayley's social gatherings. Flaxman clearly made a special effort for Hayley and he took immense pains in designing the monument to William Collins (no. 132). As Morchard Bishop has pointed out, Hayley was above all a man of sensibility, in the late eighteenth-century meaning of that term, who cultivated his feelings at leisure, and who sought to draw out the feelings and talents of others. Flaxman was, of course, never as completely in thrall to Hayley as was the painter George Romney, who may, like Blake, have not entirely benefitted from the friendship.

The importance of Flaxman's seven years in Rome for his career cannot be overestimated: he went as a moderately successful professional sculptor and came back in 1794 with an international reputation which far transcended the normal boundaries of artistic fame. He was

4 G.L. Keynes, *Blake: The Complete Writings*, 1957, pp. 148 - 58.
5 Reported by Henry Crabb Robinson. See G.E. Bentley, Jr., *Blake Records*, 1969, p. 311.
6 See Bishop, 1951, for an excellent account of Hayley's personality.
7 See Symmons, 1975 *op. cit.*

universally agreed to be the first among English sculptors, and his outline illustrations to Homer had made him a household name across Europe. Yet his sojourn in Rome had not been a triumphal progress. For nearly three years virtually no commissions of substance came his way, and he was able to work diligently from the works of art available to him in Rome without advancing his career at all. He was forced to rely on meagre subventions from England, and by April 1790 he was preparing to return when the situation changed dramatically. He was commissioned by the extraordinary Earl of Bristol, who was living in Rome, to make a monumental Laocoön-sized group in marble of *The Fury of Athemas* (ill. 8), a work which gave him the opportunity he sought to vie with the ancients on their own ground, although the financial consequences were to prove disastrous. This was quickly followed by commissions from the wealthy Thomas Hope for a marble group of *Cephalus and Aurora* (ill. 9) and for a reconstruction of the *Belvedere Torso* (ill. 10). This attention from wealthy collectors made him a celebrity in the English colony in Rome, and led to further commissions, of a more modest nature, for outline drawings from the classics. By the end of 1792 he was quite overwhelmed by work, all of which enormously increased his reputation, and he was not able to leave Rome until four years after the original commission from Lord Bristol.

Although Flaxman had employed assistants in Rome, he was essentially working on single commissions from wealthy individuals. When he returned to England, only on rare occasions could he find patrons for works of a non-commemorative kind. He was obliged to become a specialist in church monuments, and even then he could scarcely make a living and pay his Roman debts by undertaking only commissions on the scale of the Mansfield and Nelson monuments (ill. 11), which might contribute to the 'elevation of national character in noble and useful arts'. Even after his election as Professor of Sculpture at the Royal Academy in 1810 he seems to have regarded no type of commission as being beneath him, and only through the survival of his account books are we able to attribute to him a number of memorial tombs with very little ornamentation, such as the tiny Maydwell tomb (ill. 12). Flaxman, we know, regarded these humble commissions as a distraction from great works: on the other hand, as a man of gentle temperament he did not fight against his fate. According to his accounts he employed six men as assistants on his return from Italy, not including the local masons, inscription cutters, etc., who would also be involved in the final product. Rather as an artist would have his design published by an engraver, so Flaxman, once he had produced the plaster model, would have had little physically to do with the final product. Certainly in his mature years he would have done very little marble cutting, and this is reflected in the varying quality of the final results.

There is, of course, nothing new in the sculptor employing assistants to make the final work from his design, but some aspects of Flaxman's methods do suggest that he was working in a new social climate. For one thing, Flaxman drew a distinction between his 'real' work and the 'potboilers' he made to bring in the money. In 1805 his wife wrote to William Hayley:

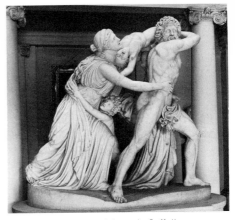

Ill. 8 *Fury of Athemas*, Ickworth, Suffolk

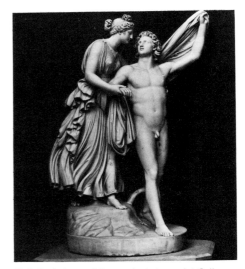

Ill. 9 *Cephalus and Aurora*, Lady Lever Art Gallery, Port Sunlight

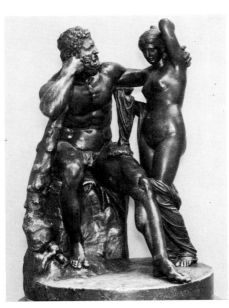

Ill. 10 *Hercules and Hebe*, University College, London

Ill. 11 Monument to Lord Nelson, St Paul's Cathedral

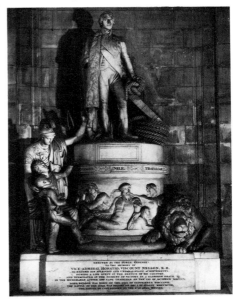

28

your good friend [i.e. Flaxman] is just in his zenith of confusion. it is ever so about this season – the great folks on leaving town come to see the state of their work, others to leave orders, others settling inscriptions and others their accounts, etc. I shall be most glad when he can boil his pot without such drudgery. I hate accounts & think with genius like his there should be none – I look forward (vain wish) when he may live in a cottage with plenty of ground for his working studies & where he may employ his talents as he best likes, not cramped by the obstinate will, or foolish whim of any one, but let the world see the *inward man.* [8]

While sculptors often brought in assistants to help with commissions they may have had in hand, Flaxman's potboiling was based upon repetition, admittedly with variations in each case, of a number of types of motif, and no doubt one reason he displayed the plasters so prominently in his studio was to show the range of possibilities to potential clients. The most popular type was a Greek stele with a single weeping female representing a mourning widow or 'Resignation'. The slab might be decorated either with acroteria or with different types of Gothic tracery, as if the sculptor kept a pattern book in the studio. Also popular was the wall slab with supporting figures of mourners, which again could be decorated in Gothic or classical styles (ill. 13), and in the case of the Walter Long monument in Salisbury Cathedral, there are preparatory drawings with classical and Gothic adornment as alternatives.

Flaxman was not the first to repeat designs for tombs, and to a degree it is inevitable that a busy monumental sculptor will tend to work from a limited number of ideas. On the other hand Flaxman was not cynical about it, nor can it be quite explained away by the demand of patrons for repetition of admired designs. In fact Flaxman seems to have followed the production methods of John Bacon the Elder, who perfected a more efficient kind of pointing machine, and who also had great success with small monuments which varied very little from each other.[9] Bacon, however, appears to have taken a more worldly view of the matter, and was reputed to have used the motif of 'The Pelican in its Piety' so often that when he was at a loss for an idea he would fall back on 'our old friend the Pellican'.[10]

In the end, the demand for such monuments came from the same 'middle orders' who bought domestic wares in the classical taste from the Wedgwood pottery, and their iconography commemorates not deeds of heroism or of public service but the virtues of family life. We can see from Flaxman's drawings how often he returned to themes of domestic affection and sought to transform his observation into a vocabulary of simple but affecting gestures, and how unaffected and moving his depiction of grief can be. These small monuments derive their quality not from exquisite handling but from the harmony between their simplicity of form and their unpretentious emotions, and the fact that one sees them in relative profusion in parish churches in England in no way diminishes their effect. Flaxman may have felt himself thwarted by the pressures of commerce and certainly he would have preferred to work on 'gallery' sculptures like *The Fury of Athemas* or *St Michael overcoming Satan* (ill. 14) for enlightened aristocratic patrons like the Earl of Bristol and Lord Egremont, or on great monuments in St Paul's, than produce what he regarded as potboilers. While his great monuments are not without virtues, in the long run he was no more adept with colossal marble groups than any of his contemporaries in England. The pressures of the Industrial Revolution, on the other hand, forced him back to a scale suitable to his talents, and the diversity of objects in the present exhibition is evidence of the adaptability of his gifts.

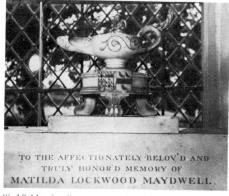

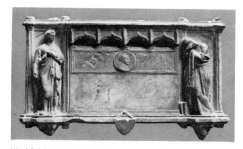

Ill. 12 Maydwell monument, Lambourne, Essex

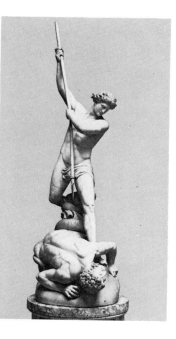

Ill. 13 Model for a wall monument, University College (destroyed)

Ill. 14 *St Michael overcoming Satan*, Petworth House, Sussex

8 Letter from Mrs Flaxman to William Hayley, Westfield College Library.
9 Whinney, 1964, p. 168.
10 Gunnis, 1953, p. 25.

Ludwig Schorn's visit to Flaxman

Of the recent death of the famous English sculptor, whose drawings won European fame and a claim to immortality sooner than his chisel, notice has already been given in these pages. The pain at his loss was general throughout his native land which lost in him not only one of the most revered, but unquestionably the most brilliant of its artists. The acquaintance of this man belongs to the most remarkable I have had. While as an artist he was for long worthy and dear to me, as a man he gained my respect and dedication to a greater degree. It may therefore be permissible for me here to speak of him in both connections and to lay this short account as a modest flower on his grave.

My wish to make Flaxman's personal acquaintance was favourably received by Professor von Schlegel in Bonn in that he gave me a letter of introduction to him. Yet I succeeded in the execution of my purpose in London only after I had got to know Flaxman the sculptor from his works. What had been known to me before in Germany of his achievements in sculpture did not attain the same standard as that incontestably won before the eyes of Europe as the draughtsman of outlines to Homer, Aeschylus and Dante. His works in marble, it was said, merely betrayed the sketcher and were not imbued with the elevated spirit that was anticipated in his designs. How greatly was I surprised when, on my first visit to St Paul's, I stood before the statue to Sir Joshua Reynolds, upon the pedestal of which Flaxman is described as the maker. The noble carriage of the figure had already caught my eye from afar: in the costume of his time and in the robe of a doctor of laws the famous painter stands upright on a high pedestal against a column, upon which is fixed a half-length portrait of Michelangelo. (. . .) From the face shine mildness, sagacity and modest worthiness: the body is that of a strong, rather tall and well built man, and the whole figure breathes life and, in spite of the restful posture, such an immediate movement that the work of the chisel seems modelled on nature. (. . .)

Further on, against one of the great pillars which separate the cathedral from the choir, I found the monument to Lord Nelson, likewise fashioned by Flaxman, a work of exceptional greatness and splendour and quite in keeping with the style that the English follow above all in the ordering of their funerary monuments, only that the artist has made as evident as possible the purity of his purpose shaped by antiquity, and the nobility of forms which he learnt from there. (. . .) Here the sea hero is sat on a high pedestal leaning on an anchor in the costume of his time, dressed in the fur he received from the Grand Commander. Somewhat lower down to his right Britannia, a tall figure similar to the war-like Minerva, is

leading two young mariners up to Nelson, their great exemplar. On the other side the British lion lies as a symbol and also as guardian of the monument. At the base on the plinth sit four figures representing the North Sea, the German Sea, the Nile and the Mediterranean, and on the cornice the words Copenhagen, Nile, Trafalgar are carved. (. . .) Westminster Abbey contains monuments and marble images of the great and deserving men from the earliest to recent periods of English history and all these works show the costumes of their times with perfect accuracy. (. . .) here one wanders through the corridors of English history and in front of the memories these stone and bronze images, these painted and gaily clothed masks awake one's thought of artifice and the desire for its enjoyment disappear.

In one of the largest sections in which stand more modern works, indeed of the greatest range, a work of Flaxman also has a place. It is the monument to Lord Mansfield, the first one to be placed between pillars, so enabling one to walk round it. At first sight its design is somewhat strange as the artist has chosen a cylindrical pedestal for the main figure and given it perhaps too much massiveness in comparison to the figure. On this high pedestal his Lordship is shown sitting as Lord Chief Justice and below him on a deep base are two allegorical figures, to the right Justice with balanced scales, to the left Science opening the book of law. (. . .) The execution is of a purity of taste that contrasts strikingly with the many mannered works nearby, and shows the point at which monumental sculpture in England has approached most closely to the designs of antiquity. (. . .)

In the exhibition of the Academy in Somerset House which had just opened, there were only two busts by Flaxman, Raphael's and Michelangelo's portraits, less than life size modelled in plaster. They were not of outstanding merit and seemed hastily worked, yet they did stand in a bad position where they could only be imperfectly seen, in the room which was in any event dark and very unsuitable for sculpture. (. . .) I was compensated, however, for this privation by a visit to the silversmiths Rundell and Bridge who kept a splendid shop not far from St Paul's on Ludgate Hill. Here I was shown the shield of Achilles, cast in silver and chased after a plaster model which Flaxman had executed to the King's commission. He had been engaged for ten years on this work but what he produced incontrovertibly puts into the shade anything modern art possesses of this type of low and ornamental relief. (. . .) The whole thing is permeated by a genuine spirit of antiquity: the execution of the figures may be somewhat superficial, but I would not venture to judge whether this stems from the hand of the master,

Ludwig Schorn published his reminiscences of his visit to the English sculptor (of which we reproduce extracts here) on 9, 12, and 16 April 1827. The Kunst-Blatt, *a supplement to Cotta's* Morgenblatt für die gebildeten Stände, *ensured a wide circulation for this report, which was able, for the first time, to bring to its German readers a lively introduction to Flaxman's personality and to the range of his creation.*

Schorn (born in Castell bei Schweinfurt in 1793 and died in Weimar in 1842) was encouraged in the study of art history by Sulpice Boisserée and Baron Haller von Hallerstein and became a pioneer of this subject through his lectures and essays. As editor and author of Kunst-Blatt *it was his job to report on the artistic life of the times and on new scholarly findings on works of the past.*

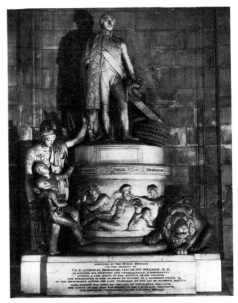

Flaxman, Monument to Lord Nelson

as I could not see the model, and the silver copy I was shown had been chased by the firm's workers. This shield has been cast four times in silver for the king, the Duke of York, the Duke of Northumberland and Lord Lonsdale. Gilded, the article costs 2000 pounds, ungilded 1900. In bronze it is to be had for 450 pounds. (...)

As Flaxman by this work came into contact with the workshop of Messrs Rundell and Bridge who supplied many costly and tastefully executed deluxe vessels, and all sorts of show pieces in fine metals, he did them the favour of making them small models for silver chess pieces which were ready for moulding. These delicate little figurines, some one and a half inches high, show kings, queens, bishops, knights and pawns in medieval costume, all in superlative taste and handled with extreme wit. It was somewhat moving for me to see that the spirit which had nourished and dealt with the greatest poems of the ancient and modern worlds, did not scorn these toys and gladly brought the magic slate pencil of his art to the embellishment of an insignificant object.

After so many varied works of his hand had come to my attention I could no longer hold back my visit to Flaxman. Mr William Young Ottley, the well-known author of an excellent work about old copper engravings and woodcuts, and owner of a superb collection of old Italian paintings, miniatures and *nielli*, accompanied me one morning to his friend Flaxman who lived not far from him in the upper end of town in Buckingham St, Fitzroy Square. We entered a small, simple house, but nice and well kept like all English dwellings, and were shown into the 'drawing room' on the ground floor which was decorated with some witty oil sketches of Fuseli and Stothard. In a few minutes a very small elderly lady appeared, Flaxman's sister, and apologised for having to receive us as her brother had just gone out. (...)

But the desire to get to know Flaxman in person was only heightened by this visit and I made use of my first free morning that next week to knock again on Flaxman's door. After a short wait in the drawing room I saw my wish fulfilled. A very small, thin and exceedingly hunched man in a grey summer coat came in: he had few grey hairs, his face was pale and ill and his features anything but regular. But a singular peace and mildness lay in them and out of his large and finely arched eyes shone vigorously a lively spirit and a sharply critical intelligence. In few men have I seen coupled this seriousness with so much good nature, in none this sweetness of conduct with such an unprepossessing exterior. He met me with friendly regret at my earlier abortive visit and expressed his pleasure that Herr von Schlegel had kept such a kind memory of him. I had to come up with him immediately to the living room where his two sisters were just having breakfast, two elderly ladies who saw to the business of the long-dead wife. When I told him how long I had wished to meet the author of the outlines which I had loved since my early youth and which were so prized in Germany, he replied 'These designs are perhaps more highly regarded then they deserve: they have even been imitated, but the artists would have done better to follow nature.' I mentioned the

outlines of Retzsch to Goethe's *Faust* which enjoyed particular favour among his fellow countrymen. 'Yes I know them too', he said 'but I much prefer Cornelius' drawings to those of Retzsch: they are imagined with a grander purpose and a deeper spirit.' He learnt for the first time through me that Cornelius was to be found in München and I then had to tell him much of the art and the Academy there. 'As professor of the London Academy', he said, 'I have also given lectures on art history but I do not dare, like Fuseli, Opie and Reynolds, to appear before the public with them. In the history of ancient art', he continued, 'I might propose a few things that have been incorrectly understood by Winckelmann...'. (...)

'I see', I added, 'that you still love ancient art as you did when you made your designs for Homer and Aeschylus: I had thought of the poetry of the Greek world as the main field for your artistic activity and was therefore more surprised to see with what intimacy you conceived the Christian subjects and how much you are occupied with them.'

With a seriousness that seemed to come from inner emotion he said 'It was the purpose of my lectures to the Academy to show that art in Christianity can rise higher than in paganism, since Christian ideas are more sublime than pagan ones, and the best that the art of Greece and Rome has produced is, to my mind, also contained in Christian ideas, for example the battle of the giants which the Apocalypse splendidly depicts. The sublimity of Greek art springs only from the memory of the idea of the single god and of the fall of man, which had remained from older times in the pagan world and which was only again made clear by Christ: truth, grace and the physical beauty of nature can be applied equally well to Christian subjects as to pagan ones, and I maintain that there are more suitable artistic subjects to be found in the Old and New Testaments than in pagan mythology.' (...)

Here we were interrupted and I then asked him to take me again to his workshop, a request he willingly granted. By the model of the Marquis of Hastings there stood this time a new one in clay, still damp: he took off the covering drapes while remarking that he was working here on a statue of Hope. It was a beautiful female figure, leaning on an anchor, full of feeling and expression. With a gentle movement of the body, the hands were entwined around each other and the gaze directed upwards: he had, however, captured this expression so tenderly and worthily that any sentimentality was completely avoided. This figure, three-quarters life-size, belonged to a monument to a young man who had died in Greece. I also looked once again at the two small reliefs of Innocence and Justice and said: what pleases me particularly is that he is as natural and simple in expression, as in arrangement and draperies: one sees here how the gifted mind may find enough beauties and motives in nature and, once arrived at the realization of beauty, have no need to imitate the ancients. Hereupon he said in a particularly melodious voice and with a cheerful look, which seemed to project the innermost

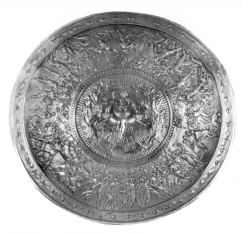

Flaxman, *Achilles' Shield*, 1818

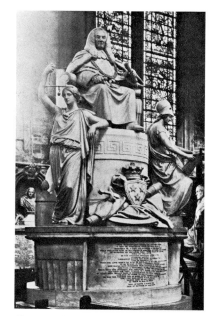

Flaxman, Monument to Lord Mansfield, 1794

31

depths of his soul, 'the works of God are always better than the works of man, and nature, even if imperfect in particulars, still remains forever unattainable. The artist unites in his works the most beautiful he has seen in it: yet it is not the beauty of nature that is the highest but that of the idea, and Plato rightly says that outer beauty depends on the beauty of the soul. Therefore all the beauty which we can portray is also individual, not merely because it appears only individually in nature itself, but because it also results from the character peculiar to the artist, and is, as it were, the blossoming of noble powers which are laid on him and which he must carefully preserve and develop.' Would that every young artist imprinted these golden words deeply on to his soul!

Among his casts I found a very fine and sharp one of the antique *Paris and Venus* bronze relief that I had come to know in the ninth volume of the Tischbein Homer. The bronze is owned by Mr Hawkins, who happened to be away from London, and I had sought in vain amongst the figures in the British Museum for a good cast. When Flaxman heard this, he made me a gift of his own as it was easy for him to obtain another from Mr Hawkins and I keep this delicate copy of one of the most graceful works of Antiquity as a treasured souvenir of the artist who became so dear to me in a few short hours. We took our leave of each other with warmth and his words had made such a deep impression on me that I made use of my first quiet moment to note down the most essential of them, so that I can vouch for the correctness of the above words. (. . .)

Extracts from C.R. Cockerell's diaries

C.R. Cockerell, the architect (1788-1863), had been a great admirer of Flaxman from his early days (in 1815 he had written to his father from Rome: 'Canova is no poet, he has no severe & elevated idea of his art at least in comparison with Flaxman'), and in the early 1820s when he was employed by Alexander Baring on the alterations to Grange Park, he came into frequent contact with the ageing sculptor who was working on a substantial relief for a mantelpiece. He recorded his conversations with and about Flaxman in his diaries, which are now on deposit in the British Architectural Library at the Royal Institute of British Architects, and the following extracts are taken directly from the manuscript, which contains very many more references to the sculptor. For further information on Cockerell and his relationship with Flaxman, see D. Watkin, The Life and Work of C.R. Cockerell, 1974.

29 January 1824:

I asked Flaxman why he had not illustrated sacred history – he said because he had not been employed – he had done the Graces, as feed the Hungry, cloath the naked etc. which were in 7 or 8 in. figures in sepia. I did not think greatly of them – Mrs Naylor had employed him on Homer, Mr Hope on Dante – these are the works by which he will live, & here is a striking example of the efficacy of patronage. It is a great happiness to an artist to be called into action by someone who he knows appreciates his peculiar forte – clearly the fruit of Flaxman's life as an artist are those works.

27 November 1824:

Mr Hare Naylor proposed to Flaxman to design the subject of Homer for which he paid him *1 guinea* each. There are also 40 in each (Iliad and Odyssey) [:] the plates of the Iliad were sold after by H. Naylor to Longman for twice as much as the engravings (original drawings) had cost him in Italy. Mr H. Naylor made at least 100£ by the books in Italy before his sale of the plates of the Iliad – those of the Odyssey were lost in the voyage. Flaxman had received 600£ for the composition of Athamas in [17]90 but the marble, time & expences had cost so much more to Flaxman that this work 'had beggared him' (his own phrase), he was glad being thus named to

accept the proposition to execute designs from Homer from Mrs Naylor. Flaxman composed the Dante at Mr Hope's invitation.

3 March 1825:

Called on . . . Flaxman, found he had done little to Baring's work – very feeble & slow. his lamp is expiring-little fruit can be expected from so old a stock however golden in his former productions-his religious learned & contemplative mind is too little of this world to feel powerfully the attractions of art & this will still diminish as he draws higher to the object of his thought.

28 September 1825:

I took the liberty of asking him how he had possessed himself so completely of the ancient writers [-] he replied that he had read them in the original as well as he could. I said it took much time [-] he confessed it did [:] he quoted from Plato and Socrates in a way that revealed a great desire to know them, defended them from the vain accusations renewed against them by the Edinburgh review.

11 November 1825:

Mr Smith of [the] British Museum told many anecdotes of Flaxman of great interest. That he was a cripple & used crutches as a child, was discovered by a clergyman teaching himself latin as a little boy, learnt Greek in Italy – has peculiar religious opinions – supposes our occupations in another world to be analogous with those we have best employed ourselves upon in this.

19 December 1826:

Lingard told me Lord Howe's monument had given offence to the navy by neglect of costume as giving pantaloons & above all by placing the ribbon over the wrong shoulder which is an unpardonable historical error – this arose from Flaxman's living too little in the world . . . there should be a facility and readiness to admit criticism, else by becoming too abstract we cease to do things for the world.

Explanatory notes

Measurements are in millimetres, height before width. The measurements given for drawings are of the size of the whole sheet, and in the case of three-dimensional objects normally the height only is given.

Virtually all of Flaxman's drawings have a pencil underdrawing, so this can be assumed where it is not stated in the catalogue entry.

The bibliographical references make no claim to completeness, and are normally the most recent discussions of the object in question.

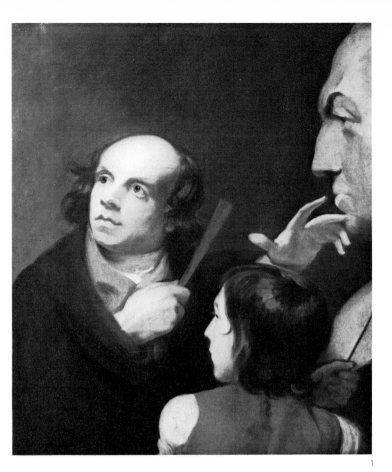

1

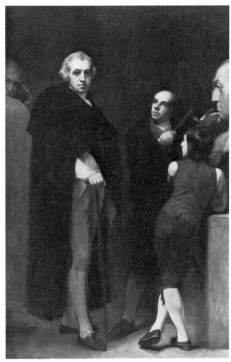

Ill. 15 George Romney, *Flaxman modelling the bust of William Hayley*, Yale Center for British Art, New Haven, Conn.

36

George Romney

1 Flaxman modelling the bust of William Hayley 1795

oil on canvas: 737 x 622
National Portrait Gallery, London
lit: Bishop, 1951, pp. 191 ff.: Romney, 1830,
p. 238

A version of, or possibly a study for, a portion of the large group in the Yale Center for British Art, which includes also a full-length portrait of William Hayley and a self-portrait of George Romney looking quizzically at the spectator (ill. 15). The youth in the foreground is Thomas Alphonso Hayley, Hayley's illegitimate son who worked as an assistant to Flaxman from 1795 until his death in 1800 at the age of nineteen. Both Romney and Hayley played an important part in Flaxman's career. Romney was one of the first men of talent to recognize Flaxman's ability, and Hayley, a prolific poet and a dabbler in artistic and literary matters, was instrumental in obtaining several major commissions for monuments for Flaxman among his large and influential circle of friends. The scene is perhaps more symbolic than actual, showing Hayley presiding over the creative activity of a convivial and playful group. The bust of Hayley is not known on such a scale, if it were ever executed in reality, but there is a small version in plaster in the Sir John Soane Museum, London.

Flaxman's intended career as a sculptor was established as a small boy when he made models in his father's plaster shop, but most of the early finished drawings to have survived seem not to be connected with his known sculpture. Although some of the subjects are classical, and he is known to have done many that are now lost, a romantic medievalism is more apparent, particularly in the fine series of drawings from the Fitzwilliam Museum (nos. 9-13). The young Flaxman was particularly drawn to medieval chivalry and romance as it was known through the publication of such works as Percy's *Reliques*. This taste was not only in conformity with his own strong Christian leanings, but also reflects the influence of his circle in the early 1780s, which extended through Romney to the poet William Hayley, and which included among his contemporaries William Blake, whose early *Poetical Sketches* (1783) was published by Flaxman's patrons the Rev. and Mrs Mathew (ills. 16, 17).

Although Mrs Mathew is reputed to have encouraged Flaxman's classical bent, in fact

III. 17 J. Flaxman, *Mrs Mathew*, British Museum

III. 16 J. Flaxman, *Rev. A.S. Mathew*, Christopher Powney Esq.

the 'Gothick' in all its forms was much discussed in her circle, and she commissioned medieval ornamental designs from Flaxman. It is more surprising, in the light of his later detachment, that Flaxman should have made so many self-portraits, or chosen subjects in which the anguish of the creative artist is hinted at, in a way characteristic of such painters of the time as Mortimer and Barry. Apart from the self-portrait drawings (nos. 2, 3), Flaxman is unmistakeably represented in the *Death of Julius Caesar*, and whether or not he can be identified with Chatterton in the drawing of *Chatterton receiving a bowl of poison from Despair*, as Sarah Symmons has suggested, there can be no doubt about his concern with the fate of Genius in an indifferent society.

Some of these early drawings reveal a poetic and atmospheric quality, and a range of handling which he was never to regain after experiencing the severity of the antique in Rome. In the self-portrait drawings Flaxman used a linear and stippled technique which suggests a close experience of the engravings and perhaps the drawings of John Hamilton Mortimer: in the *Chatterton* drawing there is something of the energetic fluency of Fuseli,

and the *Procession of Saints* is marked by a lyrical use of wash which seems to be entirely personal. A firm outline is already predominant in these early drawings, and the *Massacre of the Britons at Stonehenge* was clearly influenced by Greek vase paintings which he would have known from the publication of Sir William Hamilton's collection, perhaps while working on designs for Wedgwood. Unusually for a sculptor, many of these drawings are not conceived in three-dimensional terms, but exhibit the same lack of internal modelling as Blake's drawings of the same period.

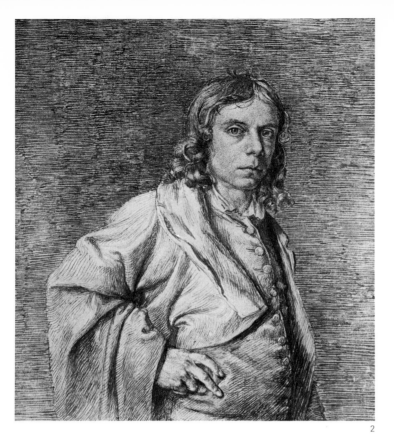

2 Self-Portrait 1778-79

inscribed: 'John Flaxman Jr. by himself'
pen and wash: 240 x 270
Earls High School, Hales Owen
lit: Irwin, 1966, p. 154 and pl. 153, London
1972: *Age of Neo-Classicism*, no. 562

A highly finished self-portrait drawing, closely
allied to no. 3 and probably of much the same
date. Both drawings are also closely related to
a dated terracotta relief of 1778 in the Victoria
and Albert Museum (no. 4a), and to the
plaster self-portrait in the British Museum
(no. 4b). The use of line and the stippling
technique suggest the influence of the painter
John Hamilton Mortimer.

3

3 Self-Portrait at the age of 24 1779

signed in pencil beneath mount: 'John
Flaxman, 1779'
pen, with some flesh tinting: 181 x 185
University College, London, no. 616

This exquisite self-portrait belongs in time
with the Hales Owen drawing (no. 2). As the
pen is held in the left hand, it was probably
drawn in front of a mirror. The sculpture on
the tripod behind is a model of the *Apollo
Belvedere*, no doubt from his father's cast
shop.

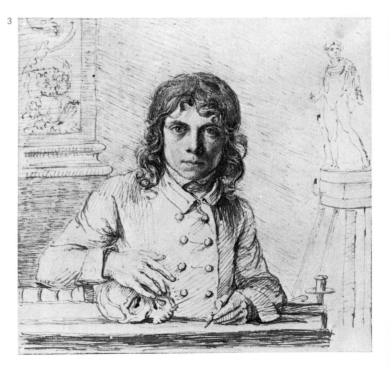

4a Self-Portrait 1778-79

inscribed (from the left hand side):
'ALUMNUS EX ACADEMIA REGALE. ANNO
AETATIS XXIV (beneath) A.D.MDCCLXXVIII +
HANC SUI IPSIUS EFFIGIAM FECIT IOANNES
FLAXMAN IUNIOR ARTIFEX STATUARIUM ET
COELATOR'
terracotta relief
Victoria and Albert Museum
lit: Constable, 1927, 23

Although Constable describes this work as
being wax it is in fact in terracotta, and may be
identified with the 'Portrait in terracotta'
exhibited at the Royal Academy in 1779.
There is a small discrepancy between Flax-
man's age and the date on the work, for if he
were born in 1755 he could not have been 24
in 1778. The close connection between this
relief and two other self-portrait drawings
(nos. 2, 3) make the latter year slightly more
likely. The amusingly pretentious Latin in-
scription is unique in Flaxman's work, and
gives it the air of an exhibition piece. The
word 'cœlator' is probably meant to be
'cælator' which can mean an artisan in bas
relief.

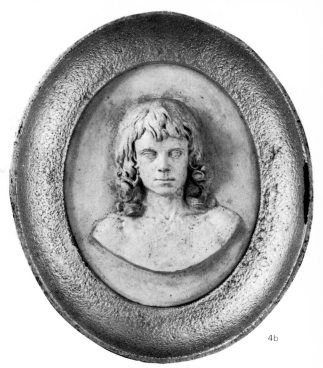

4a

4b

4b Self-Portrait *c.* 1779

plaster relief: 128 x 102 x 34
Trustees of the British Museum

This self-portrait seems closer in spirit to the
more self-absorbed mood of the University
College drawing (no. 3) than to the Hales
Owen drawing.

5 Portrait of John Flaxman, Sr (1726-95)
1794-95?

black chalk: 324 x 225
Museum of Fine Arts, Boston, Mass.
lit: Whinney, 1964, p. 183: Gunnis, 1953,
pp. 146-47

John Flaxman, Sr played an important role in
his son's career. He was a modeller and cast
maker, and he had been employed by many
notable sculptors in London, including Rou-
biliac and Scheemakers. The young Flaxman
was able to meet in his father's shop many
artists who would be important for his future
career, including George Romney, and it was
through his father's work for Wedgwood as a
supplier of casts that Flaxman began his
momentous association with Josiah Wedg-
wood. This drawing is extraordinarily free
and accomplished, and the subject's signs of
age suggest that it was made after Flaxman's
return from Italy in 1794.

5

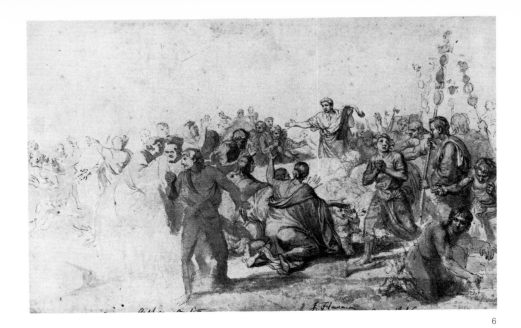

6

6 The Death of Julius Caesar *c.* 1768

inscribed: 'Anthonys Oration J. Flaxman
death of Jul: Caesar'
pen and wash: 223 x 341
Christopher Powney Esq.
lit: Exhib. cat. 1976, no. 40

There is every likelihood that this drawing is
connected with a lost relief plaque of the
Death of Julius Caesar, exhibited at the Royal
Society of Arts in 1768 (no. 147). It is, there-
fore, Flaxman's earliest known drawing
which can be dated with any confidence. The
complex spatial composition predates the
more simplified and frieze-like arrangements
of his later works, and suggests that he was at
this point looking more towards the example
of painters like Mortimer and Angelica
Kauffmann than towards sculptors. Indeed
it is difficult to see how such an intricate
grouping of figures in space could ever have
been accommodated to a sculptural relief.
The youthful figure in the foreground, ap-
parently recording the scene, seems to be a
self-portrait.

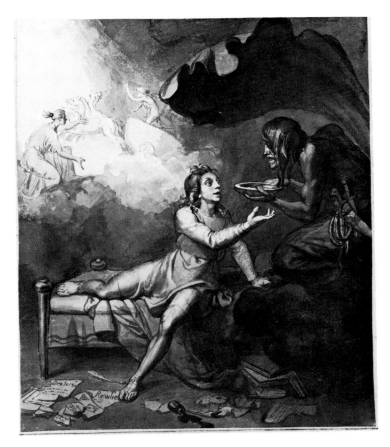

Ill. 18 Final drawing for *Chatterton*, British
Museum

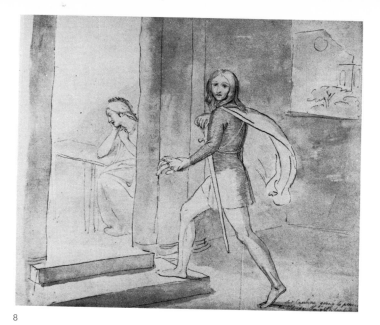

8

8 Sir Cauline's Return *c.* 1780
from Percy's *Reliques*, 'Sir Cauline'

inscribed: 'Sir Cauline going to present the
Eldridge Knight's hand to fair Christabelle'
pen and wash: 250 x 279
Christopher Powney Esq.
lit: Exhib. cat. 1976, no. 34

Thomas Percy's *Reliques of Ancient English
Poetry* (1765) was an important collection of
medieval and traditional ballads, which
made an immediate contribution to the re-
discovery of the Middle Ages and chivalry in
England. Flaxman was quite enthralled by
the book, and he gave his fiancée a copy in
1780, remarking in a letter to her of the same
year of 'the heroic virtue, the constant love,
and every noble quality which exalts the
human soul, which is expressed in a way so
simply [it] cannot fail of pleasing you.'
George Romney also made a drawing from
Percy's *Reliques*, apparently in the late 1770s,
of *Gil Morrice* (see Patricia Jaffé, *Drawings
by George Romney*, Fitzwilliam Museum,
1977, no. 30).

The tale of *Sir Cauline* tells of the love
between a king's daughter and a brave knight,
Sir Cauline, who defeats the giant Eldridge
Knight in order to win her hand. The themes
of love and of the chivalrous conflict between
good and evil recur in Flaxman's own poem
The Knight of the Blazing Cross (no. 147).
Flaxman also wrote ballads in the manner of
Percy in a manuscript now in the Fitzwilliam
Museum, Cambridge.

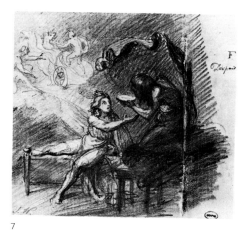

7

**7 Study for Chatterton receiving a bowl of
Poison from Despair** *c.* 1775-80

chalk: 188 x 312
Trustees of the British Museum
lit: Williams, 1960, pp. 246-50: Symmons,
1975, pp. 644-50

This is a study for the celebrated drawing
which is the high point of Flaxman's youthful
Romantic style, expressing a concern for the
young poet Thomas Chatterton, whose suicide
at the age of seventeen electrified his own
and subsequent generations. This drawing
shows the direct influence of Henry Fuseli. It
is usually assumed to be connected with a
design for a monument to Chatterton exhi-
bited by Flaxman at the Royal Academy in
1780, but according to *A Candid Review of the
Exhibition of the Royal Academy, 1780,
written by an artist* (copy in the London
Library), in the exhibited work 'Chatterton is
seen dying in the arms of one Muse, while
another stands weeping by.'

41

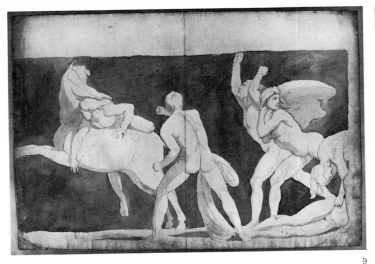

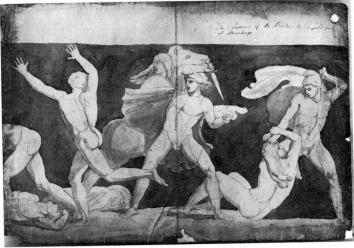

9

9 The Massacre of the Britons at Stonehenge
1783
from Chatterton, *Battle of Hastyngs* (II)

inscribed: 'The Massacre of the Britons by
Hengist's party at Stonehenge J. Flaxman
del. 1783'
pen and wash on two separate sheets:
489 x 692 and 485 x 690
The Syndics of the Fitzwilliam Museum,
Cambridge
lit: Irwin, 1966, p. 88

This drawing, the halves of which are here
shown together, is remarkable for the com-
bination of a classical frieze-like composition
and *pathosformulae* with a subject from early
British history. The uniform inking of the
background suggests also the influence of
Greek vase-painting. Chatterton wrote two
versions of 'Battle of Hastyngs', both of
which were first published in 1777. The
second version is more consciously 'antique'
in language and Flaxman's inscription on
this drawing suggests that this was his source.
Chatterton claimed that the second version
was the more authentic text, being taken from
the poem 'by Turgotus, translated by Roulie
for W. Canynge Esq.' Lines 539-40 contain
an account of Hengist's slaughter of the
British elders: having characterised Stone-
henge as 'A wond'rous pile of rugged moun-
taynes' the poet then describes the massacre:
'Twas here that Hengyst did the Brytons slee,/
As they were mette in council for to bee.'
Flaxman's three known drawings of Chatter-
ton themes and his monumental design of
1780 for a Chatterton tomb indicate the
strength of his interest in the popular
Chatterton cult which reached its climax in
the early 1780s.

10 A Procession of Early British Saints
c. 1783
from Chatterton, *Battle of Hastyngs* (II)

pen and wash: 482 x 690
The Syndics of the Fitzwilliam Museum,
Cambridge
lit: Symmons, 1975, p. 646

This drawing illustrates lines 421-24 of
Chatterton's poem, describing the appearance
of Queen Kenewalchae of the West Saxons,
whose virtue and beauty are compared with
the strength and picturesque qualities of

ancient Christian settlements. 'Magestic as
the grove of okes that stoode/Before the
abbie buylt by Oswald kynge;/Majestic as
Hybernies holie woode,/Where sainctes and
soules departed masses synge;' In his illustra-
tion Flaxman has tried to incorporate these
references, thought to be precise allusions to
Lindisfarne and to the ancient abbeys found-
ed in Cumbria, and he has created another
constricted, archaic line of figures, but set
here in a wild landscape.

s.s.

10

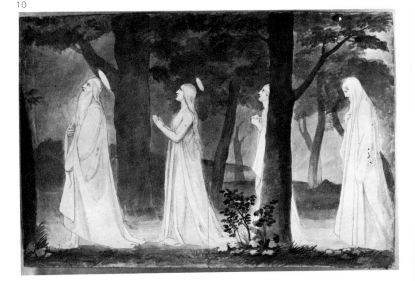

s.s.

11 A Medieval Scene *c.* 1783

pen and wash: 486 x 690
The Syndics of the Fitzwilliam Museum,
Cambridge

The source of the scene is unknown, but it
could come from Percy's *Reliques* or from
medieval history. It is close in feeling to some
of Blake's watercolours of medieval subjects
of *c.* 1780-85, for example *Edward III and the
Black Prince* in the Harold Macmillan collec-
tion (ill. 19). The theme of the drawing seems
to be concerned with the conflict between
military might, represented by the warrior,
and wisdom, represented by the bearded
figure.

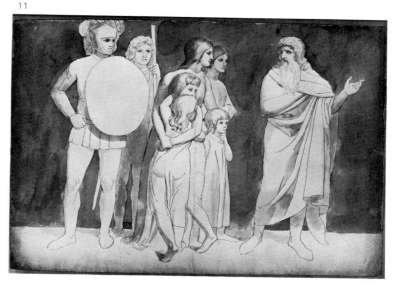

11

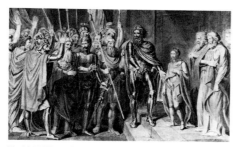

Ill. 19 William Blake, *Edward III and the Black
Prince*, Harold Macmillan collection

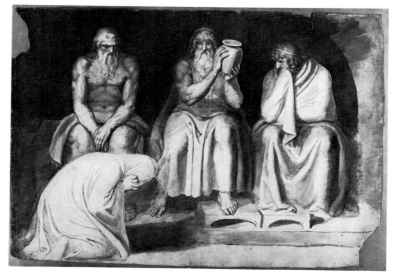

12

12 A Soul appearing before the Judges in
Hades *c.* 1783

pen and wash: 482 x 694
The Syndics of the Fitzwilliam Museum,
Cambridge

This drawing belongs in the same album as
the previous group of large drawings but is
of a classical subject. The precise subject
cannot be identified.

13 The Ascension of a Soul (?) *c.* 1783

pen and wash: 482 x 685
The Syndics of the Fitzwilliam Museum,
Cambridge
lit: Blunt, 1959, p. 42 and pl. 32c: Exhib. cat.
Blake, 1978, p. 32 and fig. 3

This mysterious drawing has attracted some
attention because of its imaginative quality
and its apparent foreshadowing of Blake's
celebrated colour print of the *Good and Evil
Angels*. Certainly the ethereal quality of the
figures evokes the world of Blake, who was a
close friend at the time, but the imagery is
also close to such early tombs as the Sarah
Morley monument in Gloucester Cathedral
(ill. 6), or the monument to Ann Russell (d.
1780) at Lydd, Kent. It could be an idea for a
relief monument, for it does seem to show on
the left the ascension of a mother and child.
On the other hand, it might illustrate the
Swedenborgian theme of the passage of the
body into the soul after death, retaining its
earthly form. In this case it could be connected
with a group of early drawings in which
Christ is the central figure, but the icono-
graphy is not traditional. There are examples
in the Huntington Library (Flaxman cat. no.
27), the Fogg Museum and the Yale Center for
British Art. About 1784 Flaxman joined The
Theosophical Society, the main purpose of
which was to propagate the writings of
Emmanuel Swedenborg.

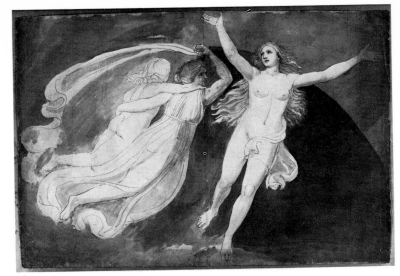

13

14 Jeremiah dictating to Baruch in Prison
c. 1785
Jeremiah 36, 4

inscribed: 'Baruch writing from the mouth of
Jeremiah in Prison'
pen and wash: 240 x 346
York City Art Gallery
lit: Bindman, 1977, p. 232, n. 64

Perhaps the closest to Blake of all Flaxman's
drawings, for the theme of the prophet who
proclaims his belief in the vanity of the world
even in chains was central to Blake from his
earliest days (see ill. 20). Here Baruch is
writing Jeremiah's prophecy of the destruc-
tion of Jerusalem.

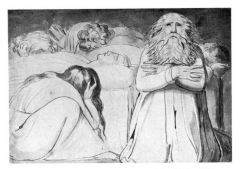

Ill. 20 William Blake, *The Death of Ezekiel's Wife*,
Fogg Museum of Art, Cambridge, Mass.

14

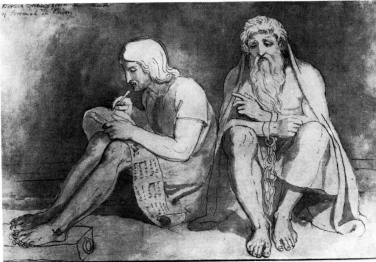

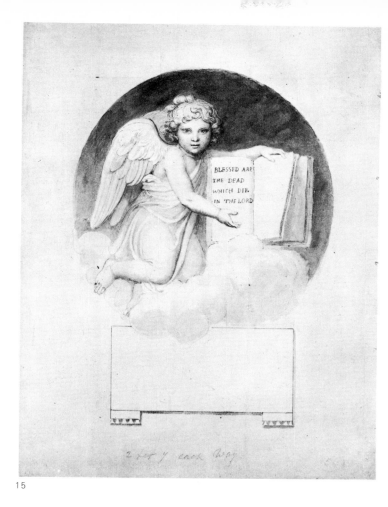

15

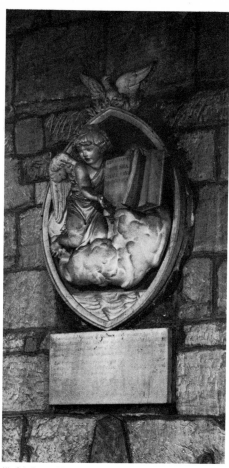

III. 21 *Bourchier Monument*, Newent, Glos.

**15 Study for a monument to John Stuart
Wortley** *c.* 1782 or *c.* 1797

inscribed: 'Blessed are the Dead which die in
the Lord' and (in pencil) '2 feet 7 each way'
pen and wash: 276 x 209
Trustees of the British Museum

The design and inscription correspond to the
monument to Agatha Halsey (d. 1782) in
Great Gaddesden, but the words 'Wortley

Esq.', written on the back of the drawing,
make it clear that this design was used again
(with a different inscription on the book) at a
later period for the monument to John
Stuart Wortley (d. 1797), Wortley, Yorks.
This was one of Flaxman's most popular
monument designs, and although it dates
initially from the early 1780s he did not
hesitate to use it many times, on one occasion
after 1800 (see ill. 21).

16 Design for a chimney-piece

inscribed: 'Sky light Room'
pen and wash: 362 x 438
Victoria and Albert Museum

A number of chimney-piece designs by Flax-
man are recorded, especially from his early
years when he was working for Wedgwood at
Etruria Hall. He also made more than one for
William Hayley, and an especially fine
example is still *in situ* in what was Hayley's
library at Eartham House near Chichester. It
was made at some time between 1784 and
Flaxman's departure for Italy in 1787 (see
Bishop, pp. 78-9), and this design probably
dates from the same period.

16

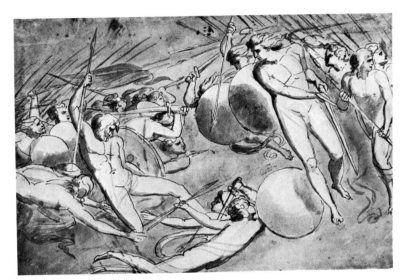

17

William Blake

17 Warring Angels *c.* 1780-85
from Milton, *Paradise Lost*, Book VI

pen and wash on pencil: 242 x 330
Bolton Museum & Art Gallery
lit: Blake, Tate Gallery, 1978, no. 12:
Frances Carey, 'Blake's *Warring Angels*',
Blake: an Illustrated Quarterly, Vol. II, 1977,
pp. 120-23

This example demonstrates the common style
of drawing in Flaxman's circle, of which
Blake and Romney were the most notable
practitioners. In the 1780s, they frequently
used pen and wash in a strongly linear manner,
treating the human form schematically with
an emphasis upon dramatic movement. See
also Romney's drawing of *Psyche being
rowed across the Styx* (no. 203). Blake's
handling, though vigorous and imaginative,
is notably less accomplished than that of
Flaxman.

William Blake

18 Copy from vase in Sir William
Hamilton's collection late 1770s?

pen: 274 x 425
Trustees of the British Museum
lit: Bindman, 1977, p. 17 and pl. 6

This drawing, and a companion in the same
collection, are taken from plates in P.F.H.
d'Hancarville, *Collection of Etruscan, Greek
and Roman Antiquities from the Cabinet of the
Honorable William Hamilton*, 1766-67, vol.
II, pl. 57. They can probably be dated either
during Blake's apprenticeship (1772-79) or
during his time as a student at the Royal
Academy. In any case they show that the
outline style was of interest in Flaxman's
circle before he went to Italy.

18

Bruce Tattersall **Flaxman and Wedgwood**

That John Flaxman was the finest English Neoclassical sculptor cannot be denied: that he showed great promise at the age of sixteen was at least recognized by one influential figure – Josiah Wedgwood (ill. 22). In a letter to his friend and business partner Thomas Bentley in February 1771, Wedgwood observes that he had just met a Mr Freeman who considers 'young Flaxman is a coxcomb but does not think him a bit the worse for it, *or less likely to be a great Artist.'* [1]

Wedgwood and Bentley's connection with Flaxman began through his father, one of the number of plaster-cast makers in London. Bentley made regular calls for models and casts, which were usually copies or squeezes from classical, French or Italian sources. Thus by the mid-1770s Wedgwood was beginning to demand something more original: 'I wrote to you in my last concerning Busts, I suppose those at the Academy are less hackneyed and better in General than the plaister [*sic*] shops can furnish us with: besides it will sound better to say this is from the Academy, taken from an original in the Gallery of etc. etc. than to say we had it from Flaxman [senior].' [2]

At this time Wedgwood and Bentley were establishing their new factory of Etruria, opened in 1769, which was to produce ornamental wares in what Sir William Hamilton termed 'a truer antique taste' [3], and which would in the next two decades advance the status of ceramics to that approaching a fine art. The impact of the work of Robert Adam saw the beginning in England of what we would now call interior design, in which all elements of a room create an artistic unity. It was to this new taste that Wedgwood addressed himself. However, in order to cater to it, he needed to find designers who would produce more sophisticated work than the naive modellers of the Potteries. Bentley, the metropolitan partner, was invaluable in this, commissioning work from several artists as well as exploiting the plaster shops.

At the beginning, Flaxman's relationship with Wedgwood and Bentley was merely that enjoyed by a number of artists and it is in this undemanding context that works such as the *Muses* should be seen. However, he was entrusted as early as 1775 with portrait medallions of Joseph Banks and Dr Solander, so

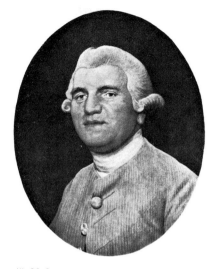

Ill. 22 George Stubbs, *Josiah Wedgwood*, Wedgwood Museum, Barlaston, Staffs.

some appreciation of his flowering talents was apparent, although probably the most telling reason for the commission was, as Wedgwood observed to Bentley, that he was 'more moderate' [4] in price than his main rival, Joachim Smith. About 1775 Flaxman was also producing wax portraits for direct sale to clients, which encouraged Wedgwood to obtain plaster casts of these more cheaply than the original waxes.

Two of the designs produced in 1778 mark a watershed in the relationship: the *Dancing Hours* and the *Apotheosis of Homer* were made on a large scale for incorporation into classical interiors and were both extremely popular. The fulsome praise of such a reputable connoisseur as Sir William Hamilton for the *Apotheosis* must have demonstrated to Wedgwood that he had found in the 'great coxcomb' an artist of exceptional ability.

The 1780s was the period of most commissions for Wedgwood, and culminated in Flaxman's visit to Italy, which Wedgwood partly assisted in order that Flaxman could preside over other artists producing works for Etruria. In addition, Wedgwood entrusted Flaxman with a number of private commissions for the extensions to his home, Etruria Hall, primarily in the Saloon, built in 1780-

81. These included designs for mouldings to be executed by local craftsmen and a design for a painted ceiling which seems to have had a mythological subject, probably painted in reds and blacks in the manner of Greek red figure vases. [5] There were 'four heads of Divinities' in the corners and an allegorical subject in the centre. [6] Full-size sketches were sent to Etruria to try them out *in situ* and the final version was painted by a 'Mr Blake' later in 1784. [7] A marble chimney-piece was also provided at a cost of £129.5.0. [8] Although Etruria Hall is still in existence, the interior was destroyed early in the twentieth century, so no exact reconstruction is possible. This is a grave loss as this interior would have presented Flaxman's first attempt at a complete interior scheme.

As early as 1771, Wedgwood was aware of Flaxman's wish to visit Rome, [9] and it is in no small measure due to his regular commissions during the 1780s that Flaxman was able to make the journey in 1787. [10] In the same year Wedgwood sent to Rome another sculptor, Henry Webber, whose task, as set

1 Wedgwood to Bentley, Etruria, 7 September 1771, Wedgwood Archive, Leith Hill Place Accumulation, uncatalogued.

2 Wedgwood to Bentley, Etruria, 16 February 1771, Leith Hill Place Accumulation, uncatalogued.

3 Hamilton to Wedgwood and Bentley, Naples, 22 January 1779, E32.5365: letter in receipt of a gift of a plaque of the *Apotheosis of Homer*. Hamilton was a patron and promoter of Flaxman: he owned the full-face self-portrait in terracotta, in the Victoria and Albert Museum. As late as 1786 he was still praising Flaxman's work to Wedgwood: 'I must do him [Flaxman] the justice to say I never saw a bas-relief executed in the true simple antique style half as well as that he did of the Apotheosis of Homer.' (John Ryland Library, Manchester, English Mss 1110).

4 Wedgwood to Bentley, Etruria, 8 July 1775, E25. 18608.

5 Perhaps the general effect was similar to that of the Etruscan Room of Osterley by Adam over a decade before.

6 Flaxman to Wedgwood, London, 5 February 1784, L2.30188, and Wedgwood's reply (draft), 20 Feb 1784, L2.30189.

7 Wedgwood's private account book.

8 Wedgwood's Commonplace Book no. 1, p. 183.

9 See note 1 above.

10 The contents list of his luggage survives, including 'some Classical Books none either Religious or Political': L1.26273.

out in a formal legal contract, was to 'undertake a Tour or Journey into Italy for the purpose of making Models Drawings and other Improvements in the Arts of Modelling and Designing for the Benefit and Advantage of the said Josiah Wedgwood'.[11] Since Wedgwood was to have an employee working full time for him in Rome there was no need for any formal agreement with Flaxman. There was, however, an informal one that Flaxman should supervise several artists working for Wedgwood, especially John Devaere. In fact, apart from a *Birth of Bacchus*, which by January 1790 was nearly finished,[12] there is no evidence of Flaxman carrying out any designs for Wedgwood in Rome. When he informed Wedgwood of this design, he was preparing to return in July 1790, bringing it with him. He did not return until four years later and the relief seems never to have been produced by Wedgwood, nor has the design survived.[13]

The reason for the drift away from Wedgwood's patronage is not hard to find. In January 1790 Flaxman wrote to Wedgwood: 'one considerable work which I have finished and an other I am engaged in have engrossed my time and thoughts.'[14] These works must have been the *Fury of Athemas* and the *Cephalus and Aurora*. They were new commissions, and with them new and more profound means of larger-scale expression were being proffered by the Earl of Bristol and by Thomas Hope, so it is not surprising that, despite his pious intention of returning to 'My Friends and Country'[15] he remained at 'the fountainhead of taste and the fine arts'[16] for a further four years. On his return, Wedgwood, in ill health, had less than a year to live, and after the potter's death his sons seem to have severed any connection, other than commissioning his tomb,[17] from a man their father considered a *Great Artist*.

In conclusion, what did the connection with Wedgwood mean for Flaxman? Initially, it gave him a degree of financial stability which helped his career through the 1770s and 1780s. It introduced him to primary source material, especially the illustrations of the Greek vases in the Hamilton Collection – the source of no less than four of his major designs for Wedgwood. Such a stimulus must have led Flaxman to observe the linear nature of the design and the significant use of empty space in the patterns on Greek red figure vases – a different order of reality from the geometric, perspectival universe of most artists from the quattrocento onwards. This inspiration fulfilled itself in his book illustrations for Homer (1793), Dante and Aeschylus (1795). Furthermore, his innate tendency towards a linear style, with no trace of modelling, was further encouraged by the restrictions necessary to produce wax designs for reproduction in Jasper, where to simplify mass production, modelling was subordinated to outline. Flaxman adopted a planar approach to such designs, modelling down through the wax in steps until he reached the slate. Often only a very thin membrane of wax constituted the plane nearest the slate, which gave rise to Wedgwood's censure that his modelling was 'too flat'.[18] This is particularly evident in his profile portraits where the bridge of the nose is so thin that the blue ground can be seen through it. This need to keep his style simple seems to have held back Flaxman's artistic development in his works for Wedgwood: once a successful formula was found, it was applied with little thought of change. The standard established in the portrait of Dr Solander of 1775 was a very high one but it was scarcely varied in his portraiture of the eighties. The *Mercury uniting the hands of Britain and France* is a noble design, yet its companion, *Peace preventing Mars from opening the Gates of the Temple of Janus*, is as clumsy as its title. The chessmen are miniature masterpieces in which his skill in modelling in the round can be seen to great advantage, for almost all of his other works for Wedgwood were in bas relief. This experience, however, in designing figures against a flat background would be of great use in his mature tomb designs where figures often appear in relief against a stele, as in the tomb of Dr Warton in Winchester cathedral, where the pedagogue's profile is like a life-size Wedgwood medallion, and the pupils are sensitively grouped in relief. Similarly his experience in modelling the figure in action from behind in *Blind Man's Buff*, his most delightful design for Wedgwood, was used to advantage in works such as the monument to Agnes Cromwell.

The discipline of working for Wedgwood therefore bore fruit in Flaxman's mature works, in their technical skill, classical imagery and style. When in 1809 Flaxman produced four reliefs of the *Ancient and Modern Drama*, he used in the former some of his figures of thirty years before, in the form of the Hours and the Muses. We must therefore conclude that behind the conventional modesty of a letter he wrote to Wedgwood there is more than a germ of truth and sincerity: 'I surely cannot do better than employ my small abilities in the service of so worthy a Friend.'[19]

It has been the intention in this to show, in the most comprehensive way, the scope of the work Flaxman did for Wedgwood. These exhibits do not, however, comprise a *catalogue raisonée* of his work for Wedgwood although it is as near complete as the generosity of lenders has made possible. (Of the portraits only those of Count and Countess Meerman and of J.C. Smith have been omitted.) All the selected exhibits have either documentary, stylistic or strong circumstantial evidence for their attribution to Flaxman. In the past many items have been attributed to Flaxman, particularly during the late nineteenth-century period of uncritical adulation, which flatter neither his abilities nor Wedgwood's taste. These will not be found here. Another problem of attribution is that, particularly with portraiture, the style of Charles Peart and of John Devaere is very close to Flaxman's. For these reasons a number of portrait medallions previously attributed to Flaxman have been rejected. Two especially, those of Sir William Herschel and J.P. Kemble, have been dismissed on these grounds and because of the lack of any other evidence to attach them to Flaxman. In several cases eighteenth-century copies of Flaxman's designs for Wedgwood do not

11 L.155. This is evidence that Wedgwood did not expect Flaxman to execute much work for him while in Rome.

12 Flaxman to Wedgwood, Rome, 20 January 1790, L2.30197.

13 A previous relief of this subject had been adapted by William Hackwood and another was produced by Henry Webber. Thus Flaxman's version may have been superfluous.

14 Flaxman to Wedgwood, Rome, 20 January 1790, L2.30197.

15 *ibid.*

16 Wedgwood's reply (copy) to 14 above, Etruria, 11 February 1790, E26.19008. The letter implies some disappointment with Flaxman: 'I well know that the

exist or are unavailable. In such cases modern replicas have been substituted.

Two published works are essential for this period of Flaxman's career. W.G. Constable's pioneer work of 1927 listed a comprehensive number of works which could be ascribed to Flaxman, although often identifying the subject without specifying the actual end results of Wedgwood manufacture. The situation is complicated by a number of versions of the same subjects existing in Wedgwood by different artists (see, e.g. the *Muses, Mercury*). Reilly and Savage, *Wedgwood – The Portrait Medallions* (1973), is essential reading for Flaxman attributions although their terms of reference for attributing work to Flaxman are less rigorous than have been applied here. Most of the manuscript material covering this period of Flaxman's career is in the Wedgwood Archive, on deposit at Keele University, Staffordshire. References to this archive are given simply in the form of an initial letter E or L followed by two sets of numbers (e.g. E25.18682). The location of any other documentary material is given in full in the catalogue.

A note on Wedgwood and Jasper

Jasper is a fine white stoneware, approaching porcelain, which can be tinted a number of colours using various metallic oxides which colour the body in firing. Wedgwood finally perfected it in 1774-75 after thousands of recorded experiments. The most popular colour is and was blue, varying from a slate blue to a deep violet blue. There was also a green, lilac, buff and black. The method of reproducing Flaxman's designs was as follows:

1 Flaxman, in London, would send Wedgwood a copy of the proposed design.
2 Wedgwood would return it with his comments and notes on any proposed alterations.
3 Flaxman would then send Wedgwood a wax model of the design. At this stage Flaxman's involvement would cease. Once Wedgwood obtained the wax it became his property and he could do as he wished with it. He had a number of specialist modellers at Etruria who could adapt the wax for reproduction, frequently simplifying or breaking up the design into component parts. Thus Flaxman or any other outside artist was totally divorced from the production process. There is, in fact, only one reference, in a letter of 1775, to Flaxman ever visiting Etruria.
4 A plaster cast would be taken from the wax to minimize the danger of loss or damage.
5 From this a biscuit (lightly fired earthenware) relief was cast. This would reduce the size of the work by about one-seventh.

Wedgwood took frequent pains to remind Flaxman that he must make his reliefs larger by this proportion than the final reliefs should be. He emphasized that there was no problem if the model was too large, since progressive firings of reliefs could be used to reduce the size, but that nothing could be done if the relief was too small.
6 From this biscuit relief, working moulds in plaster of Paris would be taken. These were sectional, having only parts of the design on each, so that they could be distributed over panels or vases of a chosen size. Thus Flaxman's designs often appear with additional figures from other designs or put in an order contrary to his original intentions.
7 Unfired Jasper clay would be pressed into these plaster casts, from which, once nearly dry, they would be extracted and placed with a little liquid clay upon the desired surface. One stoneware firing would be given and the item would be finished. This process used division of labour, with different craftsmen making and applying reliefs.
8 Smaller versions of the designs could be made by taking an earthenware cast from the mould, firing it (with a reduction of one-seventh), taking another earthenware mould from this and firing that (with a further reduction), from which mould another cast could be taken. The process could be repeated until the desired size was reached whereby a small relief could be obtained without loss of detail.

purpose of your going to Rome was to study and not to keep up a correspondence with your friends in England.'
17 Receipt dated 3 September 'for a Monument to the late Josiah Wedgwood Esq.', L1.214.
18 Wedgwood to Bentley, Etruria, July 1776, E25.18682. 'I am aware of the necessity a modeller will plead for making some of the parts so flat, in order to keep those parts back & to give a proper relief to the whole. But you will soon see, by turning to our blue and white Jaspers, that we cannot admit of such delicate parts, & must be content with such objects in our Figures as can be produced without them.'
19 Flaxman to Wedgwood, London, 8 July 1782, L.2.30187.

19a Pair of Ewers, 'Sacred to Bacchus' and 'Sacred to Neptune' 1775
modern replica

black basalt: max h. 388
The Trustees of the Wedgwood Museum, Barlaston, Staffs.

One of the designs provided by John Flaxman Sr, invoiced to Wedgwood on 25 March 1775: 'A pair of vases one with a Satyr & the other with a Triton Handle £3.3' (L1.204).

These designs, provided in the form of plaster copies which are still preserved at the Wedgwood Museum, are typical of the heterogeneous wares with which Flaxman Sr provided Wedgwood from his plaster shop. Their source is not classical but eighteenth-century French, probably by Clodion (1738-1814), although the originals have not survived.

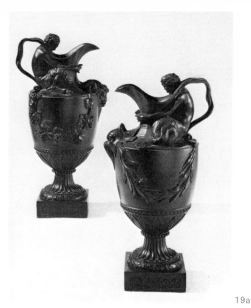

19a

21b

19b Water ewer impressed K and wine ewer impressed wedgwood c. 1790

solid blue Jasper, white relief: h. 384
Felix Joseph Collection, Castle Museum, Nottingham

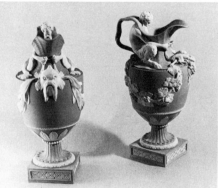

19b

21 Sir Joseph and Lady Banks

a designed c. 1775: white Jasper, lilac dip: oval, 87 x 71
b a pair modelled c. 1779: Sir Joseph (a modern replica) in solid blue and white Jasper: oval, 108 x 85: Lady Banks in white Jasper, lilac dip: oval, 86 x 69
lit: Reilly and Savage, 1973, pp. 55-7
The Trustees of the Wedgwood Museum, Barlaston, Staffs.

Version a is that referred to by Wedgwood in a letter to Bentley of July 1775 (E25.18617): 'I wish you would see Mr Flaxman before you leave London & if you could prevail upon him to finish Mr Banks and Dr Solander they would be an acquisition to us.'

Versions b are a pair, probably modelled in 1779, the year of their marriage. It seems likely that Flaxman's bill of 21 August 1779 (L1.206). 'The portrait of Mr Banks modelled in clay £2.2', refers to this model, which Wedgwood considered to be 'a good head and a strong likeness, but the original does not appear to have sat in a very pleasant mood'. Perhaps because of these comments this version was not used as a pair with Lady Banks. Instead version a was used, giving the false impression that young Mr Banks had married a lady many years his senior.

Sir Joseph Banks (1743-1820) distinguished himself as the leading dilletante scientist of the age, interesting himself in all aspects of natural philosophy from botany to the composition of porcelain. He became President of the Royal Society in 1778. Lady Banks (1758-1828) married Sir Joseph in 1779.

20 Self-Portrait, aged fourteen 1779
modern replica

blue Jasper, white relief: 78 x 62
City Museum and Art Gallery, Birmingham
lit: Constable, 1927, p. 113; Reilly and Savage, 1973, p. 138

This portrait is identified on the plaster mould at the Wedgwood factory and is presumably the one referred to in a letter from Wedgwood to Bentley of 20 March 1779 (E26.18886): 'I shall be glad to see Mr. Flaxman's head at Etruria and will do all the justice to it in my power.'

20

21a

21b

22

23 The Four Seasons 1775

a blue Jasper, white relief: 108 x 83
The Trustees of the Wedgwood Museum,
Barlaston, Staffs.
b a pair of flower vases *c.* 1785
impressed: Wedgwood
solid white Jasper with white reliefs of the
'Seasons' by Flaxman below arcades of
stylized palms, traces of gilding: square, h.
165
Felix Joseph Collection, Castle Museum,
Nottingham

Bought originally from Flaxman Sr 11 April
1775: 'Four Basso Relievos of the Seasons
£2.2'. These are adaptations of individual
figures from the Marlborough Gem (see no.
25a).

22 Dr Daniel Charles Solander 1775

pale blue Jasper, dipped darker blue, white
relief: oval, 88 x 71
The Trustees of the Wedgwood Museum,
Barlaston, Staffs.
lit: Reilly and Savage, 1973, p. 130

Modelled by Flaxman in 1775 (see under Sir
Joseph Banks, no. 21)
Solander (1736-82) was a Swedish natural-
ist who became librarian and companion to
Banks, and a friend of Thomas Bentley.

23

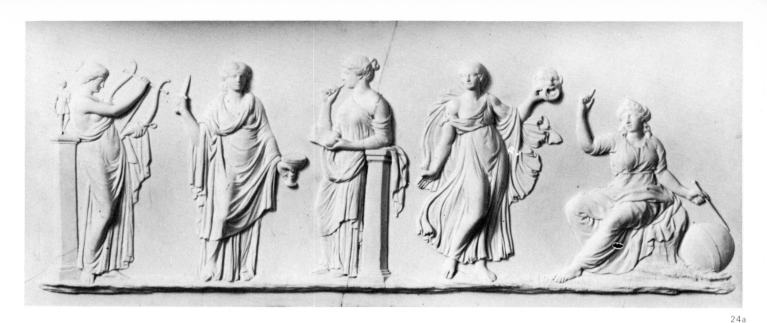

24 The Muses and Apollo 1777

a *Five Muses*
white bisque: 158 x 384
b *Euterpe*
white bisque: oval, 164 x 124
The Trustees of the Wedgwood Museum,
Barlaston, Staffs.

Wedgwood owned a series of Muse figures by
Edmé Bouchardon from 1770, but it was not
until 1777 that he began to contemplate using
them. They were quickly rejected as being
'poor copies' and 'left handed', implying that
they had been reversed from the original.
Plasters of Melpomene, Thalia, Terpischore,
Euterpe and Apollo were all bought from
Flaxman Sr in 1775 and are likely to be the
earliest ceramic works (modelled from engrav-
ings of classical gems, it is true) which may be
attributed to the younger Flaxman. In the letter
quoted above (27 October 1777, E25.18788),
Wedgwood requests Bentley to commission
from Flaxman the remaining Muses, indi-
cating that they already had Apollo, Mel-
pomene, Thalia and Terpsichore. However
only two days later, Wedgwood, having in-
spected his stock of 'all our Bas relief
Goddesses and Ladies', requested Bentley to
rescind the order. The remaining Muses were
made up of figures from the *Dancing Hours*
(Clio and Thalia) and from the *Muses
Sarcophagus* (Polymnia). Erato is probably
an adaptation of the 'tenth Muse', Sappho,
part of the original 1775 order. Urania is a
version of Erato in reverse and Euterpe is
from the original order. The large panel shows
Terpsichore, Melpomene, Calliope (probably
a Flaxman design), Thalia and Urania.

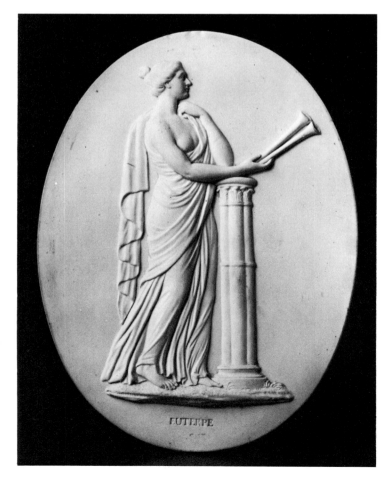

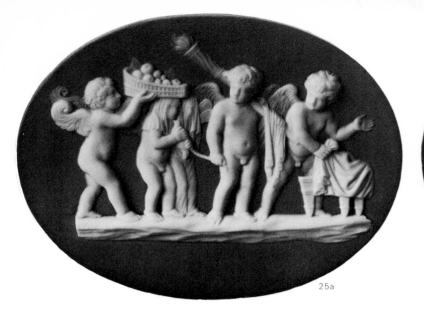

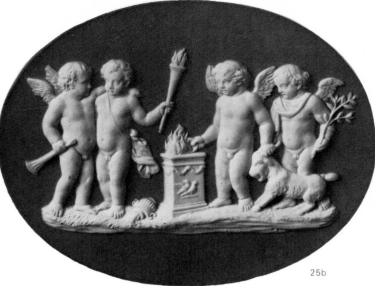

25a

25b

25a Marriage of Cupid and Psyche 'The Marlborough Gem' 1778

blue Jasper, white relief: oval, 75 x 59
The Trustees of the Wedgwood Museum,
Barlaston, Staffs.
lit: Kelly, 1965, pp. 57, 61, 68

A number of versions of this famous subject
were made by Wedgwood, one being a cast
from the gem itself. A larger version may have
been adapted from one in Coadestone and a
third, of intermediate size, from Picart, *Pierres
Antiques Gravées* (1724). Mr Tebo, a modeller
then at Etruria, attempted with little success
to model a relief from the latter source. In
1778 Flaxman modelled a companion (see
below), taking the opportunity to remodel the
original, making it stylistically compatible.
He did further work upon it in 1782, when he
records working on 'Psyche for a flower pot'.

25b Companion to Marriage of Cupid and Psyche

blue Jasper, white relief: oval, 81 x 66
The Trustees of the Wedgwood Museum,
Barleston, Staffs.
lit: Kelly, p. 64

This was modelled in 1778 and called *Cupids
with Goat* in the small version, and *A Sacri-
fice to Hymen* in the larger. The source is an
engraving by Bartolozzi after Cipriani.

26 Earl of Chatham 1778

light blue Jasper, dark blue dip: oval, 101 x 83
The Trustees of the Wedgwood Museum,
Barlaston, Staffs.
lit: Reilly and Savage, 1973, p. 99

Modelled by Flaxman in 1778: 'Mr Flaxman
called to tell me he was modelling a bas relief
of Ld Chatham, in order to sell copies in wax
and I told him we should be glad of a cast *and
he knew what use we should make of it*. I do
not know what he means to charge other
people but we, you know, are to pay a price
below *casts* and *models*' (Wedgwood to
Bentley 1 January 1778, E.25.18840).

William Pitt, first Earl of Chatham (1708-
78), was an eminent English statesman and
premier during the Seven Years' War.

26

27 The Dancing Hours 1778

a rum kettle, black basalt: h. 235
The Trustees of the Wedgwood Museum, Barlaston, Staffs.
lit: Kelly, pp. 62-4
b salt cellar, solid blue Jasper, white reliefs: h. 56, d. 83
The Trustees of the Wedgwood Museum, Barlaston, Staffs.

The first mention of this design by name is in a letter which dates from early in 1778 (E.25. 18847), from Wedgwood to his partner Thomas Bentley: 'The tablets of dancing hours are intended as frises to the marriage of Cupid etc.' There is no direct mention of Flaxman as being the artist responsible, although the fact that it is mentioned along with two known Flaxman works, the *Apotheosis of Homer* (see no. 32) and the *Marriage of Cupid and Psyche*, strengthens the traditional attribution. (Kelly, p. 64, cites a payment from Wedgwood to Flaxman for a number of designs, including the *Dancing Hours*.)

The source is a chimney-piece of white marble against a blue lapis ground, formerly in the Palazzo Borghese in Rome. In the eighteenth century it was installed in Moor Park, Hertfordshire, the seat of Sir Laurance Dundas, who is mentioned in the letter quoted above. It is now in the Lady Lever Gallery, Port Sunlight.

The *Dancing Hours* depicted the classical *Horae*, personifications of the hours of the day, and was one of the most popular Wedgwood designs. Originally intended as a frieze for mantelpieces, it was reduced in size and put to many other decorative uses. Later in the century they fell foul of censorship and were more heavily draped to conceal rather than reveal their charms. It is in this form that they are still produced today.

28 Captain James Cook

a *c.* 1779, pale blue Jasper dip: oval, 85 x 67
b 1784, modern replica, blue and white Jasper: oval, 108 x 83
The Trustees of the Wedgwood Museum, Barlaston, Staffs.
lit: Reilly and Savage, 1973, p. 111

The first version, full face, which is attributed to Flaxman, is derived from an engraving of the portrait by William Hodges in *Cook's Voyages*, published in 1777. It appears in Wedgwood and Bentley's catalogue of 1779.

The second version, profile, was modelled by Flaxman in 1784, probably after the Royal Society model by Lewis Pingo: 'A model in wax of Capt Cook £2.2' (E2.1339). Reilly and Savage illustrate a wax of this subject which they attribute to Flaxman.

Cook (1728-79) was the most celebrated navigator and explorer of the eighteenth century. Sir Joseph Banks and Dr Solander (see nos. 21 and 22) accompanied him on his first voyage.

28a

27a

27b

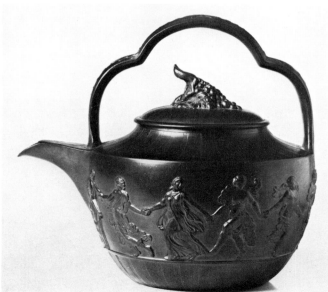

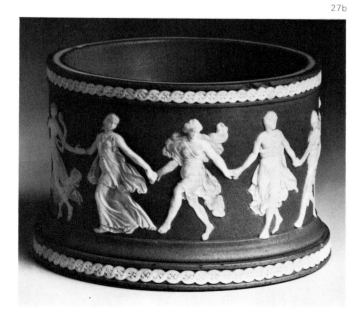

29 Sir Ashton Lever *c.* 1781

biscuit medallion with black dip : oval, 102 x 78
The Trustees of the Wedgwood Museum,
Barlaston, Staffs.
lit : Reilly and Savage, 1973, p. 215

Listed in oven book for December 1781.
Attributed on stylistic grounds to Flaxman,
it does not appear in the 1779 catalogue but is
in that of 1787.

Lever (1729-88) was a collector of curiosities and antiquities, and a friend of both
Banks and Solander. His portrait may be
seen as a companion to theirs.

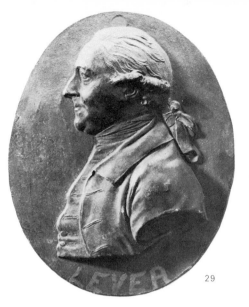

29

30 Blind Man's Buff 1782

a wax on slate : 375 x 102
The Trustees of the Wedgwood Museum,
Barlaston, Staffs.
b vase, white Jasper, green dip : h. 190
Victoria and Albert Museum

Modelled by Flaxman in 1782 as a response to
Wedgwood's request for 'some groups of
children, proper for bas relief to decorate the
sides of Tea pots' (Wedgwood to Flaxman
L2.1335).

Four drawings were initially sent to Wedgwood : *Blind Man's Buff, A Game of Marbles*
and two of the *Triumph of Cupid*. It appears
that only the *Blind Man's Buff* was continued
with. It is probably to be identified with the
'bas relief of boys in wax £11.0.6' in a bill of
28 March 1784 (E2.1339).

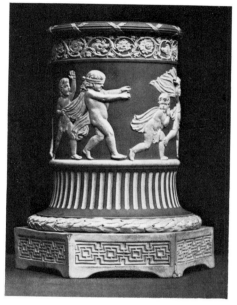

30b

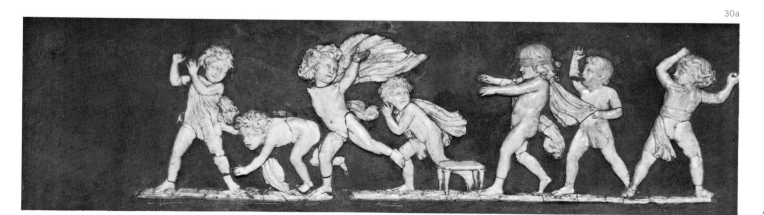

30a

55

31 Mercury after 1789

black basalt: h. 474
The Trustees of the Wedgwood Museum,
Barlaston, Staffs.
lit: Kelly, 1973, p. 53

Traditionally attributed to Flaxman on sty-
listic grounds. Flaxman exhibited a bust of
Mercury at the Royal Academy in 1781 and
offered a cast of it to Wedgwood in 1782: 'You
did me the honor to praise my bust of Mercury
the cast of which I hope you will honor with a
place in your study' (John Rylands Library,
Manchester, English Ms 1110).

Wedgwood also ordered a 'Mercury' from
the plaster makers Hoskins and Grant in 1779,
which fact has led to some debate over the
attribution, but this appears to have been a
whole figure rather than a bust and most
likely was a cast of Pigalle's *Mercury Fasten-
ing his Sandal* of 1744. Flaxman's bust has
similarities with the head of this famous
statue, which appears to be a likely source.
However, there is a change of mood: Pigalle
depicts a concentrated, active Mercury en-
gaged in a necessary, everyday task. Flaxman's
Mercury is disembodied, the spirit of the god,
with a timeless expression, evidence that even
at this early date Flaxman had achieved a
sophisticated understanding of the Neo-
classical style.

The bust does not appear in any of the
Wedgwood eighteenth-century catalogues
and most versions are of a mid-nineteenth-
century date, implying that Wedgwood kept
the bust for his study, although later genera-
tions exploited it commercially, amputating
the wings from the helmet, and calling the
result 'Paris'.

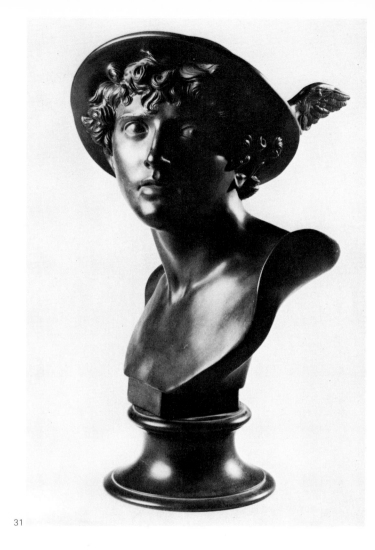

31

32 Apotheosis of Homer 1778

a *c.* 1778, solid blue Jasper, white reliefs:
d. 320
The Trustees of the Wedgwood Museum,
Barlaston, Staffs.
b 1786, vase, solid blue Jasper, white reliefs:
460 x 280 x 225
Given by Josiah Wedgwood to the British
Museum in that year
The Trustees of the British Museum
lit: Kelly, 1965, pp. 62-4: Scheidemantel,
1968: Exhib. cat. *The Age of Neo-Classicism*,
no. 1839

Flaxman is not mentioned as the designer
and modeller of this subject until July 1786,
in a letter from Sir William Hamilton to
Josiah Wedgwood: 'I never saw a bas relief
executed in the true simple antique style half
so well as he [Flaxman] did the Apotheosis of
Homer from one of my vases' (John Rylands
Library, Manchester, English Mss 1110).
Hamilton possessed a copy of the plaque
given to him by Wedgwood and Bentley in
1779 (letter from Bentley to Hamilton, 26
February 1779, Chellis Collection, Boston
Mass., and reply E32.5365).

The source for the design is the engraving
of a scene from a bell krater in the Hamilton
Collection, illustrated in D'Hancarville, *Col-
lection of Etruscan, Greek and Roman An-
tiquities from the Cabinet of the Hon. William
Hamilton*, Naples vol. III, p. 31. The subject
appears in the Wedgwood and Bentley
catalogue, 1779, class II no. 202.

Wedgwood considered the vase he present-
ed to the British Museum as 'the finest and

56

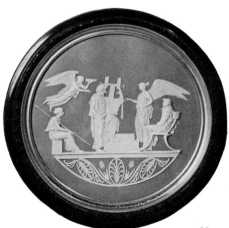

32a

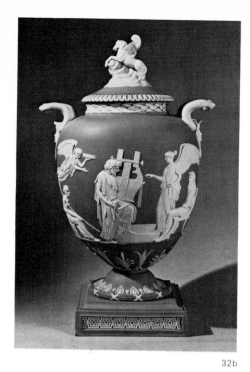

32b

most perfect I have ever made'. That perfection is certainly aided by the quality of Flaxman's design in which the transition from two-dimensional red figure to three-dimensional relief is particularly well executed. Although Flaxman adhered fairly closely to the original, it is notable that the seated female acolyte, floating in space on the original vase, is, in its rational eighteenth-century transformation, provided with a stool!

32c Plaque

Jasper: 365 x 193
The Trustees of the Wedgwood Museum, Barlaston, Staffs.

33 Collection of Etruscan, Greek and Roman Antiquities, from the Cabinet of the Hon. W. Hamilton

4 volumes, Naples, 1766-67
lit: Irwin, 1966, pp. 28-9 and 63: B. Fothergill, *Sir William Hamilton*, 1969, pp. 64-9

These sumptuous volumes were of immediate and incalculable importance to artists concerned with the revival of antiquity, and they were particularly influential upon Flaxman and Wedgwood, who had proofs of the plates

in his hands before publication. Many of Flaxman's designs for Wedgwood were directly based upon individual plates in the book (see no. 32), and it may be argued that the whole concept of the great Wedgwood vases derives from a study of this book. The book contains accurate representations of the Greek vases in Hamilton's first collection, which was eventually bought by the British Museum.

34a Account for the work executed between 1783 and 1787

The Trustees of the Wedgwood Museum, Barlaston, Staffs.

This bill, presented by Flaxman just before his journey to Rome, demonstrates the variety of work done for Wedgwood in that period from £23 for 'Hercules in the Garden of the Hesperidies' to 1s for 'A drawing of a crest, Cap of Liberty and a flame'.

34b Designs for a lampstand

pencil: 189 x 151
Private collection

Signed with the 'F' which denotes an early Flaxman drawing (see Williams 1960, 246-50), these may be studies for 'An Outline for a Lampstand' mentioned in the bill above. The lampstand was presumably meant for Etruria Hall.

34a

35

35 Sarah Siddons 1782

white Jasper, dark blue dip, white relief: oval, 118 x 90
The Trustees of the Wedgwood Museum, Barlaston, Staffs.
lit: Reilly and Savage, 1973, p. 306

Attributed by previous authors to Flaxman on stylistic grounds and because of the similarity of the pose to a queen from his chess set (see no. 45). This is confirmed by a letter from Wedgwood to Flaxman of 20 February 1784 (L2.30189): 'I can only add that you have my free consent, as it will so much oblige your friend Mr Burgess, to let him have the bust of Mrs Siddons: the mould will serve my purpose.'

In several cases Flaxman kept the original wax of a design, merely sending Wedgwood a plaster mould of it. In this case he charged £1.11.6 (12.1334), somewhat less than the going price for a wax, which was £2.2.

Sarah Siddons was an English actress engaged by Garrick in 1773 to perform at Drury Lane, where she first appeared, unsuccessfully, in 1775. She returned in 1782 after establishing her reputation in the provinces, becoming famous for her tragic roles which she performed at Covent Garden with her brother, John Philip Kemble, until her retirement in 1812.

57

36

38 Warren Hastings *c.* 1784
nineteenth-century version

blue Jasper, white dip: 133 x 103
Victoria and Albert Museum

Flaxman's account of 14 January 1785 reads
'A Portrait of Gov Hastings £3.3'.

Hastings (1732-1818) was Governor of
Bengal. The source of this work may be the
portrait bust by Nollekens: on the other hand,
it may have been executed by Flaxman *ad vivum*, when Hastings was on leave in England.

39

36 Hermann Boerhaave 1782

modern replica of medallion
solid blue Jasper, white relief: oval, 119 x 90
The Trustees of the Wedgwood Museum,
Barlaston, Staffs.
lit: Reilly and Savage, 1973, p. 66

One of the 'eminent Hollanders' (letter from
Flaxman to Wedgwood 8 July 1792, L2.
30187) modelled by Flaxman for Wedgwood
in 1782, this portrait medallion is an example
of the routine work which Flaxman frequently
did for reproduction in Jasper. The source is a
bronze medal by Pesez which could not be
used directly as a model for casting in plaster
for reproduction by Wedgwood.

Boerhaave (1668-1738) was a famous
Dutch physician and botanist. Reilly and
Savage illustrate a wax which purports to be
the original Flaxman model.

38

37

37 Dr William Buchan 1783

solid blue Jasper, white relief: 102 x 78
Trustees of the British Museum
lit: Reilly and Savage, 1973, p. 74

Modelled by Flaxman in 1783: 'A Portrait of
Dr Buchan £2.2' (E2.1339). Dr William
Buchan was a Scottish writer on medical
matters. In 1778 he moved to London where
he had a large successful practice.

39 Dr Samuel Johnson 1784

black Jasper, white relief: oval, 109 x 84
The Trustees of the Wedgwood Museum,
Barlaston, Staffs.
lit: Reilly and Savage, 1973, p. 199

Modelled in 1784, the invoice (E2.1339) shows
that Flaxman charged Wedgwood for 'a
print of the Dr for assistance in the model'.
Several prints are a possible source for this
(see Reilly and Savage, p. 199), although none
exactly corresponds. This is not surprising
for even in the most mundane work for
Wedgwood, Flaxman never made a literal
copy. Besides, the term he uses is 'assistance',
not 'imitating'.

Johnson (1709-84), the author and lexico-
grapher, was, with Wedgwood, a native of
Staffordshire.

40 Charles Jenkinson 1784

blue and white Jasper: oval, 109 x 83
The Trustees of the Wedgwood Museum,
Barlaston, Staffs.
lit: Reilly and Savage, 1973, p. 217

An invoice from Flaxman to Wedgwood is
dated 21 March 1784: 'A Portrait of C
Jenkinson Esqre. £2.2' (E2.1339).
Jenkinson, first Earl of Liverpool, (1727-
1808), was a prominent statesman who held a
number of important posts in the ministries
of the late eighteenth century.

40

42 The Manufacturers' Arms 1784

pen on laid paper: 265 x 207
The Trustees of the Wedgwood Museum,
Barlaston, Staffs.

Designed at Wedgwood's request for the
General Chamber of Manufacturers of Great
Britain. Three designs, of which this is one,
were submitted, each with Plenty and Neptune
as supporters with the arms surmounted by
Britannia. The mottoes and the marshalling
of the arms vary but all are indicative of the
virtues of productive industry. Flaxman
charged 5s for each design.

41

41 William Franklin *c.* 1784

white Jasper, green dip: 104 x 85
The Trustees of the British Museum
lit: Reilly and Savage, 1973, p. 149

Attributed to Flaxman, this first appears in
the oven book for November 1784, and is
included in the 1787 Wedgwood catalogue.
Franklin (1731-1813) was the son of
Benjamin Franklin and the last Royalist
Governor of New Jersey.

43 Coriolanus and Volumnia 1784
photograph only

bronze on wooden support: h. 277
Lady Lever Art Gallery, Port Sunlight
lit: Kelly, 1965, pl. 23

Flaxman's account is dated 12 December
1784 (E2.1339): 'A bas relief in wax of
Venturia and Volumnia entreating Coria-
lanus £9.9'. The source, as with so many of the
larger designs of classical subjects, is a scene
from one of Hamilton's red figure bases as
published in d'Hancarville. This bronze
version, which belonged to Flaxman himself,
appears to be a copy after the wax rather than
the model for it. In the 1787 Wedgwood
catalogue it was Class II, no. 258.

42

43

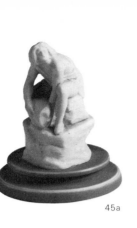
45a

45a

45a

45a

45c

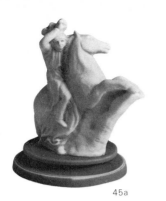

44

44 Gustavus III 1785

pale blue Jasper, white relief: oval, 87 x 68
The Trustees of the Wedgwood Museum,
Barlaston, Staffs.
lit: Reilly and Savage, 1973, p. 180

Flaxman's invoice is dated 23 November
1785: 'A Model of the King of Sweden £2.2'
(E2.1339). The source for the medallion is
Sergel's relief portrait of 1779 in the National
Museum, Stockholm.
 Gustavus (1746-92), King of Sweden,
attempted to establish himself as an enlight-
ened despot in a country unused to a strong
centralized monarchy. He was assassinated at
a masked ball.

45 Chessmen 1785

a selection from a set, blue, white and lilac
Jasper
b model of queen, wax: h. 109
c a fool, earthenware: h. 76
d drawing for chessmen, signed: 'I Flaxman

Invt et Delinit', pen and wash on lined paper:
173 x 518
The Trustees of the Wedgwood Museum,
Barlaston, Staffs.
lit: Constable, pp. 21-2; Kelly, p. 116;
Bevis Hillier, *Pottery and Porcelain 1700-
1914*, 1968: N. Stretton, 1956

The first evidence of a chess set designed by
Flaxman for Wedgwood is a bill for 'A figure
of a Fool for Chess £1-5s', dated 30 October
1783, implying that the subject had been
modelled in wax. Early in 1784 Flaxman
wrote to Wedgwood thanking him for 'the
liberal praise you bestow on my chessmen'.
In December of the next year Flaxman was
employed 'drawing bas relief vases chessmen
etc' for Wedgwood. This appears to have been
common practice for record keeping and for
showing to customers in the London show-
room. The first Jasper men were in production
in 1785, the year of the drawings (**d**).
 Within the Wedgwood milieu, although not
for Flaxman, the Gothic influence is, at first,
a surprise, although in fact many of the figures
are clever reworkings in medieval guise: the

45d

45b

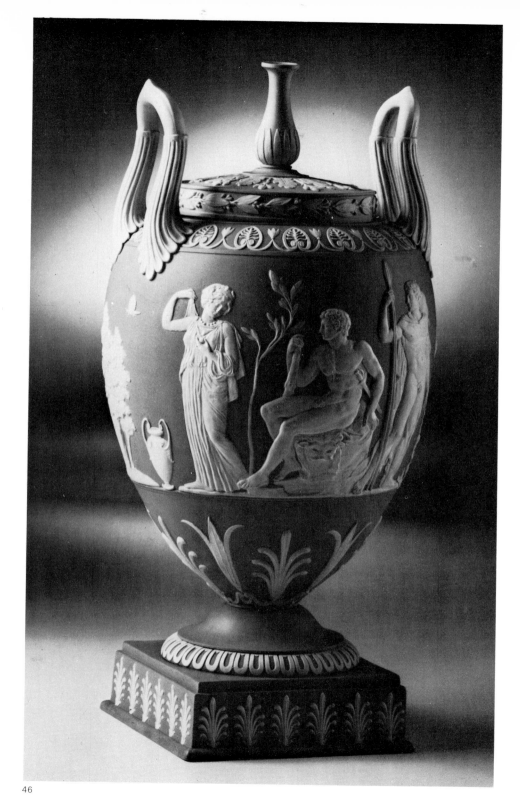

46

knight from the Parthenon frieze, the *Farnese Hercules*, the *Cavaspina*, the *Capitoline Faun*. The bishop has a genuine Gothic source from Wells Cathedral, whereas the kings and queens are traditionally said to represent the actors J.P. Kemble and Sarah Siddons in Shakespearian roles. This tradition is confirmed by the striking similarity between one of the queens (**a**) and Flaxman's portrait of Sarah Siddons (see no. 35).

The drawing of the set for which Wedgwood paid £6.6s is one of three unusually highly finished drawings by Flaxman for Wedgwood. Particularly noticeable is the use of deep shadows and modelling to give the impression of a *trompe l'oeil* set upon two shelves. The fool was for French sets, instead of a bishop.

46 Hercules in the Garden of the Hesperides
1785

vase, blue Jasper, white relief: 310
City Museum and Art Gallery, Stoke-on-Trent

This was modelled in two sections by Flaxman in 1785, for which he charged Wedgwood £23 on 10 August 1787.

The source is again d'Hancarville's *Collection of Etruscan, Greek and Roman Antiquities from the Cabinet of the Hon. William Hamilton* Vol. I, Naples 1766, p. 129, which for Wedgwood had a sentimental connection being the design chosen by Bentley for the six 'First Day' vases of 1769 which commemorated the opening of the new factory of Etruria. In these, the design was in red enamel on black basalt. Listed in the 1787 Wedgwood catalogue as Class II, no. 275.

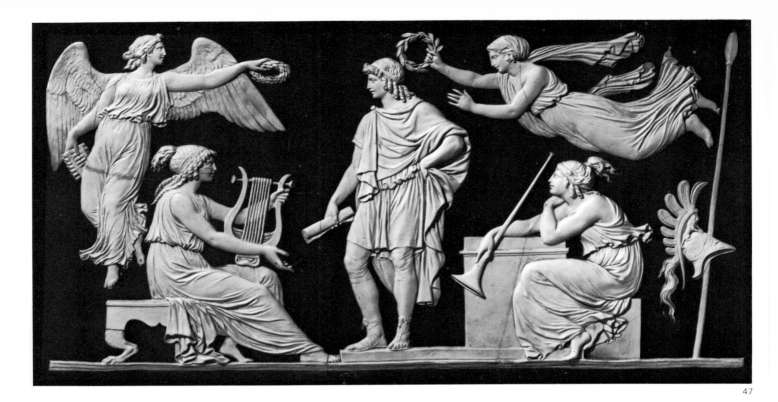

47 The Apotheosis of Virgil *c.* 1785
 nineteenth-century version

dark blue Jasper, white relief: 198 x 375
Victoria and Albert Museum
lit: *Age of Neo-Classicism*, no. 1841 (see p. 878
for earlier literature)

According to Constable this is the second
relief referred to as the 'Apotheosis of Homer
and Hesiod' in a letter from Wedgwood to
Flaxman of 13 December 1785. Oven-book
records show a number of firings in the
following year and it appears in the 1787
Wedgwood catalogue as a companion to
Homer, as Class II, no. 266. Like that design
it was also adapted as a relief on vases.

48 Tureen *c.* 1786

Queensware: h. 120
The Trustees of the Wedgwood Museum,
Barlaston, Staffs.

There are a number of references to Flaxman
designing shapes for Wedgwood. Indeed
two drawings for unexecuted designs are in
the Fitzwilliam Museum Cambridge (see ills.
23 and 24). However there is no direct evi-
dence to link any production shapes with
Flaxman. Thus the identity of the item in a
bill of 1786 for 'moulding a Turin (sic) 18s'.
cannot be established exactly. As the tureen
here shown is one of the most simple, classi-
cally derived shapes produced by Wedgwood
in Queensware, an attribution to Flaxman
may be tentatively proposed.

Ill. 23 Design for teapot, Fitzwilliam Museum,
Cambridge

48

Ill. 24 Design for bowl, Fitzwilliam Museum,
Cambridge

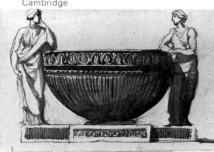

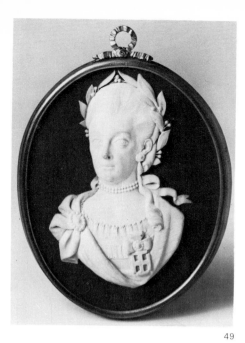

49

49 Maria I of Portugal 1787

white Jasper, black dip: oval, 100 x 78
The Trustees of the Wedgwood Museum,
Barlaston, Staffs.
lit: Reilly and Savage, 1975, pp. 228-29

Flaxman's invoice is dated 1 June 1787
(E2.1339): 'A model of the Queen of Portugal
£3.3'. The medallion was in production later
in the year, appearing also in the 1790 French
supplement to Wedgwood's catalogue.
 Maria I, Queen of Portugal (1734-1816),
was feeble minded and an incompetent ruler.
Her complete mental collapse in 1792 caused
her forcible abdication.

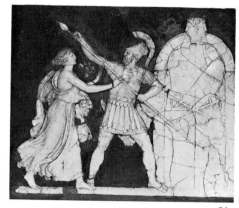

51a

50 William Pitt

white Jasper, pale blue dip: oval, 93
The Trustees of the Wedgwood Museum,
Barlaston, Staffs.
lit: Reilly and Savage, 1975, p. 276

The similarity to a bust by John Charles
Lochée (no. 58a), and a letter from him con-
cerning Pitt's sitting for him have led to
problems of attribution. However, the evi-
dence of the *European Magazine*, May/June
1812, which illustrates an engraving 'from a
bust by J. Flaxman Esq.' and the stylistic
similarities strengthen the Flaxman attribu-
tion.

50

51 Peace Preventing Mars Opening the Gates of Janus 1787

a wax on slate: 254 x 273
b earthenware biscuit: h. 220
The Trustees of the Wedgwood Museum,
Barlaston, Staffs.
lit: A. Finer and G. Savage, *The Selected
Letters of Josiah Wedgwood*, 1962: Kelly,
pp. 111-12

Commissioned by Wedgwood with *Mercury
Uniting Britain and France* (no. 52), to com-
memorate the Anglo-French Commercial
Treaty of 1786. Flaxman, in his account of
10 January 1787, charged Wedgwood £15.15
for the wax. In the 1788 Wedgwood French
catalogue it is Class II, no. 256 or 257.

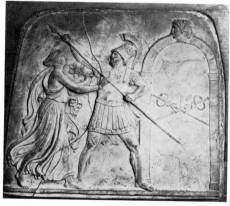

51b

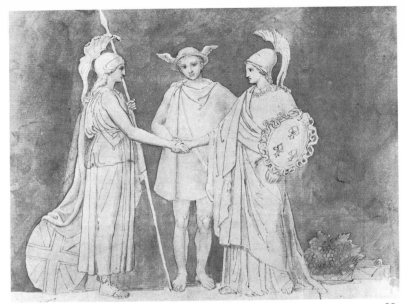

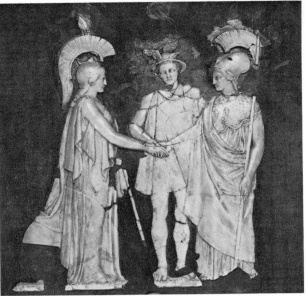

52a

52b

52 Mercury Uniting the Hands of Britain and France 1787

a pen and wash: 254 x 319
The Hon. Christopher Lennox-Boyd
b wax on slate: 254 x 267
The Trustees of the Wedgwood Museum, Barlaston, Staffs.
c mould: 250 x 270
The Trustees of the Wedgwood Museum, Barlaston, Staffs.
d earthenware biscuit: 260 x 270
The Trustees of the Wedgwood Museum, Barlaston, Staffs.
e solid blue Jasper, white relief: 250 x 250
Felix Joseph Collection, Castle Museum, Nottingham
lit: A. Finer and G. Savage, *The Selected Letters of Josiah Wedgwood*, 1962: Kelly, pp. 111-12

Commissioned by Wedgwood to celebrate the Anglo-French Commercial Treaty of 1786, this is one of the best documented of Flaxman's works for Wedgwood and is worth examining in detail to show how much Flaxman's final work was influenced by his client. Flaxman had first sent a sketch which originally included not only the three figures which became the final subject for the relief, but also a personification of Peace and the burning of the implements of war. Wedgwood suggested that the latter two subjects would be better as a separate group and that some alterations should be made to the Mercury group:

We must take care not to shew that these representations were invented by an Englishman: as they are meant to be conciliatory, they should be scrupulously impartial. The figures for instance, which represent the two nations, should be equally magnificent & important, in their dress, attitude, character and attributes: and Mercury should not perhaps seem more inclined to one than the other, but shew a full front face between them, and if you think there is no impropriety in it, I should wish France to have her helmet & shield as well as Britannia, & the Fleur de lis upon the latter.

The figures must be modelled 8 inches high.
[2 November 1786, L2.30193]

The wax model, altered in these respects, although France does not have a shield, was ready by 26 March 1787. Wedgwood was charged £13.13. The design appears in the 1788 Wedgwood French catalogue as Class II, no. 256 or 257.

53 Self-Portrait and Mrs Flaxman
c. 1787-94
nineteenth-century copies

white Jasper, green dip: circular, 155
The Trustees of the Wedgwood Museum, Barlaston, Staffs.
lit: *Constable*, 1927, p. 23: Reilly and Savage, 1975, p. 138: Wick, 1958, pp. 56-7

These are enlarged versions of the plasters in the Sir John Soane Museum which appear to have been taken from waxes executed during the Flaxmans' stay in Rome.

53

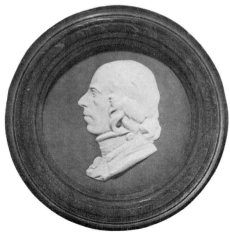

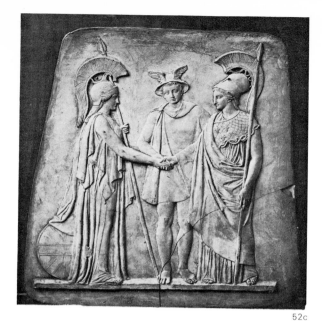

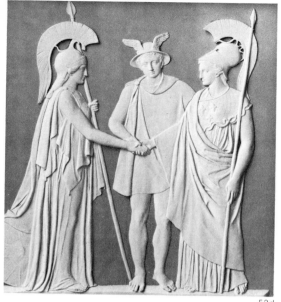

52c

52d

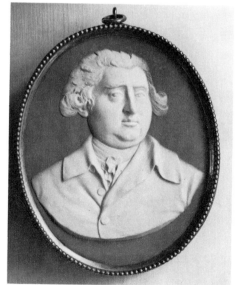

54

54 Charles James Fox *c.* 1790

dark blue Jasper, white relief: oval, 93 x 72
The Trustees of the Wedgwood Museum,
Barlaston, Staffs.
lit: Reilly and Savage, 1975, p. 144

Attributed to Flaxman on stylistic grounds,
and probably modelled after the portrait by
Sir Joshua Reynolds. Listed in the 1790
French supplement to Wedgwood's catalogue.

Fox (1749-1806) was a Whig libertarian
statesman and Pitt's main opponent.

Gaye Blake Roberts

A selection of works by Flaxman's contemporaries working for Wedgwood

During the eighteenth century Josiah Wedgwood was to employ a great many artists and modellers to provide the designs and reliefs for ornamental wares. The most notable amongst these was Flaxman, but it is important to an understanding of his work to give an idea of the designs of his contemporaries and associates, among whom were a number of artists worthy of attention in their own right.

Henry Webber 1754-1826

Born in July 1754 Henry Webber was the son of Abraham Webber, a Swiss sculptor who had settled in England. His early training included attendance at the Royal Academy where he won a silver medal in 1774 through his prior study as a pupil of John Bacon Senior. Henry Webber was employed by Josiah Wedgwood on the recommendation of Sir Joshua Reynolds and Sir William Chambers, (see letter from Wedgwood to Sir William Hamilton, 24 June 1786: E18976-26) initially for a period of seven years, as shown in a surviving contract dated 17 January 1785. This appointment gave him the title of head of the ornamental department at Etruria.

Josiah Wedgwood was to send Webber to Rome for 'the purpose of making models, drawings and other improvements in the art of modelling and designing for the benefit of the said Josiah Wedgwood'. The memorandum of agreement is dated 17 July 1787. Webber was to work for Wedgwood until 1795. He died in August 1826.

55a Wedgwood copy of the Portland Vase
 c. 1790

solid black Jasper, white relief: 254 x 188
The Trustees of the Wedgwood Museum,
Barlaston, Staffs.
lit: bib. in *Age of Neo-Classicism*, no. 1842

Modelled by Henry Webber in 1786-89, after the Roman glass original now in the British Museum. Wedgwood borrowed the vase from the third Duke of Portland after the sale of his mother's collection in 1786. Flaxman wrote to Wedgwood about the original when it was still in the hands of Sir William Hamilton, on 5 February 1784 (L2. 30188): 'I wish you may soon come to town to see Sir WM Hamilton's Vase it is the finest production of Art that [has] been brought to England and seems to be the very apex of perfection to which you are attempting to

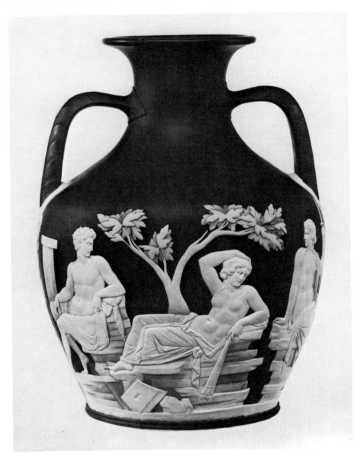

55a

55c Sydney Cove Medallion 1789

d. 60
The Trustees of the Wedgwood Museum,
Barlaston, Staffs.

The Sydney Cove medallion, originally designed by Henry Webber, was entitled 'Hope encouraging Art and Labour, under the influence of peace, to pursue the employments necessary to give security and happiness to an infant settlement'. This medallion was the result of clay being sent for experimentation to Josiah Wedgwood by Captain Phillips – a senior naval captain who had been commissioned by King George III to govern the penal colony newly established at Botany Bay. Josiah Wedgwood acquired the clay through the intervention of Sir Joseph Banks, who received the consignment in May 1789.

By November 1789 the first batch of medallions had been completed and inscribed with the words 'Made by Josiah Wedgwood of clay from Sydney Cove'.

The design, by Webber, was published as the title page to *The Voyage of Governor Phillips to Botany Bay* in 1789. In the first edition of July 1789 the design is accredited to Webber and the engraving is by Thomas Medland. However, in the second and all subsequent editions Webber's name is omitted.

The same design was utilised with some adaptations for a medallion to mark the French Revolution. This was mentioned in a letter from Josiah Wedgwood II to his father dated 29 July 1789: 'inclosed is a sketch of the medallion I mentioned to you last night...... the goddess of liberty with the cap of liberty in her left hand takes hold of France in her right. The figure of Hope in the Botany Bay medal would come in exceedingly well for the figure of liberty.' Examples of this form survive in blue and white Jasper dip.

bring your bisque and jasper. . . . [It is] in the same manner as a Cameo of the grandest and most perfect Greek Sculpture.'

This copy of the vase was bought in 1793 by Thomas Hope, the antiquarian designer and patron of Flaxman, for his London house in Duchess Street. It was subsequently at Deepdene whence it was acquired for the Wedgwood Museum. Although Flaxman praised the Portland Vase so highly it does not seem to have affected his artistic style in any significant way, neither in his work for Wedgwood, nor for any of his other patrons.

55b Candlestick

white biscuit: h. 320
The Trustees of the Wedgwood Museum,
Barlaston, Staffs.

This candlestick, which represents the seated figure of Minerva, is listed as number 263 in the Shapes Book of *c.* 1785-90. The form of the candlestick has very close parallels to a later, more ambitious, sculptured group representing Britannia on a plinth with applied portrait reliefs of four admirals, probably adapted to celebrate the British naval victories in the French Wars. Both these Wedgwood items perhaps owe their inspiration to the monument erected in Westminster Abbey to William Pitt, Earl of Chatham, who died on 11 May 1778.

55b

William Hackwood (d. 1839)

William Hackwood was hired in 1769 by Josiah Wedgwood who wrote to Bentley on 20 September describing him as 'an ingenious boy': 'he has modelled at nights in his way for three years past, has never had the least instruction, which circumstances considered he does things amazingly, and will be a valuable acquisition. I have hired him for five years'. In fact, Hackwood was to remain in the firm's employment until 1832 – a total of 63 years. The influence of Hackwood was quite marked on the modelling shop, and by 1776 Josiah Wedgwood was writing wishing, 'we had half a dozen more Hackwoods'. He was probably the most prolific of the modellers employed by Wedgwood and he was responsible for many of the heads in series such as the 'Illustrious Moderns'. He died in 1839.

56

56 Edward Bourne 1778

portrait medallion: with frame 167 x 142, without frame 125 x 95
The Trustees of the Wedgwood Museum, Barlaston, Staffs.

Edward Bourne, generally known as 'Old Bourne', was the bricklayer at Etruria, presumably building and maintaining the kilns and brick buildings in general. The portrait medallion was modelled in 1778 by Hackwood and was mentioned by Josiah Wedgwood in a letter dated 21 November 1778: 'Old Bourne's is the man himself with every wrinkle, crink and cranny in the whole visage.' Two of the surviving moulds for this item are inscribed 'Mr. Byrne Bricklayer, Wm. Hackwood 1779' and 'Mr. Bourne Bricklayer, by Hackwood 1779'.

57

John Bacon the Elder 1740-99

The portrait medallions of George III and Queen Charlotte are generally attributed to the work of John Bacon, who served his apprenticeship with Nicholas Crisp of Bow Churchyard, where he probably learnt the art of figure modelling. In 1769 Bacon was employed by Josiah Wedgwood, for whom he modelled various bas reliefs. George III and Queen Charlotte were great patrons of the arts and were to award Josiah Wedgwood the title of 'Potter to Her Majesty' in 1767.

57 Portraits of George III and Queen Charlotte 1778

light blue medallion with a white relief and contemporary ormolu mount: Queen Charlotte 88 x 59
George III 88 x 59
impressed mark 'Wedgwood and Bentley'
The Trustees of the Wedgwood Museum, Barlaston, Staffs.

John Charles Lochée

John Charles Lochée was employed by Josiah Wedgwood as early as 1774, two years prior to exhibiting at the Royal Academy for the first time. Evidence of the early association of Wedgwood and Lochée is provided by a letter from Josiah Wedgwood II to his father dated 24 March 1774: 'now you are in London it would be very kind if you would give Mr. Lochée a lecture on modelling and making [plaster] moulds – you know how he under-cuts – and his moulds are in general very bad, sometimes they appear to have had waxes taken out of them – and I believe always they are very full of pin holes.' Lochée was to complete several portrait heads for Wedgwood, including the Royal family and other nobles. By 1791 he was declared bankrupt and disappeared from the artistic world.

58a

58a William Pitt c. 1787

modelled by J.C. Lochée
impressed mark WEDGWOOD
white Jasper, green dip: oval, 93 x 72
The Trustees of the Wedgwood Museum,
Barlaston, Staffs.
lit: Reilly and Savage, 1975, p. 348

A note from Joseph Smith (Pitt's secretary) refers to Pitt being unable to sit for Lochée in November 1787 but willing to do so in the future (L.1 25).
　Pitt (1795-1806), the younger son of the Earl of Chatham, became Prime Minister before his twenty-fifth birthday, which post he still held during the designing of this medallion which was taken from life.

58b Marquis and Marchioness of Buckingham

blue Jasper with white relief: oval, 89 x 70
The Trustees of the Wedgwood Museum,
Barlaston, Staffs.

George Grenville, 1st Marquis of Buckingham (1753-1813), was the second son of George Grenville and was educated at Eton and Christ Church, Oxford. He married Mary Elizabeth, daughter and heiress of Robert Nugent, Viscount Clare, in 1775, and attained his title in 1784. The portrait medallion of the Marquis is mentioned in a manuscript letter from Charles Peart to Thomas Byerley on 26 March 1788. It seems probable that Lochée adapted the profile view from a plaster mask and a portrait supplied by Vincent Waldré, a protegé of Buckingham's, done about 1788.

George Stubbs 1724-1806

George Stubbs became a close associate of Josiah Wedgwood and undertook a wide range of works, from the painting of a large family portrait in 1780, to the execution of models for plaques such as the *Fall of Phaeton* (1785), and its companion *The Frightened Horse*. The association between Stubbs and Wedgwood grew through the assistance of Thomas Bentley, who encouraged Stubbs to work on cream coloured biscuit earthenware plaques.

59 The Frightened Horse

black basalt: c. 37 x 22
The Trustees of the Wedgwood Museum,
Barlaston, Staffs.

Stubbs was to visit Etruria during the Autumn of 1780 in order to complete work on the family pieces. The first mention of his presence in Staffordshire occurs on 7 August where it indicates that the factory were pressing 'some clay tablets for modelling upon'. Stubbs soon determined to model a bas relief of a lion and horse from his own design, and Josiah Wedgwood conceded that, 'He does very well so far, and with little practice will probably be as much master of his modelling tools, as he is of his pencils.' By August Stubbs was already working on the *Frightened Horse* plaque, as Wedgwood indicates in a letter to Thomas Bentley: 'He is now laying in the horse whilst I am writing a few letters this good Sunday morning', and by the 21st of the same month the work was completed with Wedgwood promising Bentley a copy 'very soon either in blue and white, or to save time in one colour'.

58b

58b

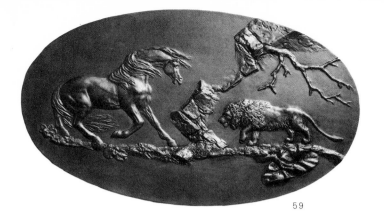

59

Joachim Smith active 1758-1803

Smith is chiefly remembered as a modeller. The first reference to his work occurs in 1758 when he received a premium of 10 guineas from the Society of Arts for a wax portrait. He was one of the men to provide models from which Wedgwood produced portrait medallions, although the process ran into some difficulties as emphasised in a letter he wrote Wedgwood on 8 February 1775: 'The many accidents I have had with several moulds as well as with some of the models has been attended with a considerable loss of time and deprived me of the possibility of sending you anything for some months past, but there is a difficulty that waits on everything in its infancy – which with a little indulgence I will be able to get the better of.'

Wax portraits by Joachim Smith were exhibited at the Society of Arts between 1760 and 1783 and portrait busts in the Royal Academy between 1781 and 1803.

60 Thomas Bentley (1730-80) 1773

white Jasper, black dip: oval, 127 x 83
The Trustees of the Wedgwood Museum, Barlaston, Staffs.

One of the most important medallions supplied by Smith in 1773 was a profile view of Thomas Bentley (1730-80), the Liverpool merchant and later partner of Josiah Wedgwood.

60

Lady Diana Beauclerk
1734-1808

Lady Diana Beauclerk was born Lady Spencer, the eldest daughter of Charles, 3rd Duke of Marlborough, and spent her childhood primarily at Blenheim Palace. At an early age she showed a definite artistic talent. In 1757 she married Lord Bolingbroke, but they divorced in 1768. Her second marriage was to Topham Beauclerk, the friend of Dr Johnson and member of the Literary Club formed by Sir Joshua Reynolds. Lady Beauclerk was a part of the literary and intellectual world of Gibbon, Hume, Garrick, Goldsmith, Burke and Charles James Fox.

Her designs for Wedgwood are usually chubby children and child bacchanals often reminiscent of the work of Giovanni Battista Cipriani. Lady Diana accomplished her most important work after the death of Topham Beauclerk in 1780.

The first record of Lady Diana's connections with Wedgwood occurs in a letter from Josiah Wedgwood to Charles James Fox dated 23 July 1785: 'Mr. Wedgwood presents his most respectful compliments to Mr. Fox, and a thousand thanks for the exquisite drawing he has received – and will be much obliged to Mr. Fox if he will be so good to signify to Lady Diana Beauclerk how much he esteems himself for this flattering mark of her Ladyship's notice. He has sent a few bas reliefs, which were modelled from some beautiful cut India paper which Lady Templetown provided him with, just to show the manner in which he will attempt to copy the drawing he is now honoured with.'

61 Bowl c. 1790

bas relief of three bacchanalian boys in blue Jasper with white relief, with a lapidary polished interior: d. 227 h. 120
The Trustees of the Wedgwood Museum, Barlaston, Staffs.

In the preface to Class II of Wedgwood's catalogue (1789) he says that the collection has been enlarged and enriched, 'with some charming groups, which Lady Diana Beauclerk and Lady Templetown, whose exquisite taste is universally acknowledged, have honoured me with the liberty of copying their designs.' One catalogue entry reads, '241 Group of three boys from designs by Lady Diana Beauclerk.'

61

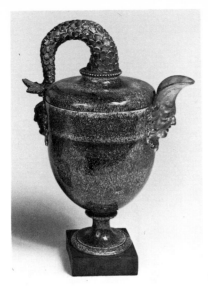

62

63

Anonymous designer

62 Vase *c.* 1770-80

no visible marks, Wedgwood
cream-coloured earthenware, with variegated
blue sponged surface upon square basalt
base: gilding on handle, spout and mask:
h. 276
Castle Museum, Nottingham

The source for these vases, called 'Stella's
Ewers', was *Livre de Vases aux Galeries du
Louvre*, by Jacques Stella. They were first
produced at Etruria in late 1770, which makes
their former attribution to Flaxman unlikely.

Camillo Pacetti

63 Achilles and Chiron *c.* 1787-90

pen and wash on lined paper: 76 x 208
The Trustees of the Wedgwood Museum,
Barlaston, Staffs.
lit: B. Tattersall, 'The Milton Milestone
Collection of Early Wedgwood', *Art at
Auction 1975-76*

A highly finished drawing of a design by
a member of the impromptu academy es-
tablished by Flaxman in Rome to produce
work by Wedgwood. The source for this
design, a classical marble disc in the Capitoline
Museum, Rome, shows the young hero
mounted upon a female centaur which has
been translated by the artist into Chiron,
Achilles' tutor who fed him on the hearts of
lions. The style of this drawing which is
probably not by Flaxman, is comparable in
finish to that of the chessmen of 1785 (see
no. 45d).

David Bindman **Italian drawings, 1784-94**

Drawings from life and figure studies, 1787-94 and later

Many of the following group of drawings are
thought to have been made during Flaxman's
seven-year stay in Rome from 1787 to 1794,
although there is evidence that he made such
drawings throughout his life. They are based on
direct observation and are notable for their
freshness and conscious simplicity. Some of them,
especially those where Roman costume is dis-
cernible, were certainly done in Rome, but others,
where the reduction of the forms has become
almost diagrammatic, may in fact be connected
with Flaxman's *Lectures* of 1810 onwards, which
contain remarks on the fall and flow of drapery.
Although the drawings reveal a delight in observa-
tion, they were probably not made for pure
pleasure. Some of them prefigure later, more
formal motifs, and it is likely that Flaxman
regarded them as a quarry for later designs. He
seems to be seeking to reduce each gesture and
grouping to the barest outline, perhaps partly

with the outline engravings in mind. The drawings
of monks and ecclesiastics in conversation may be
connected with the expressive use of cowls and
cloaks in the Dante engravings. The scenes of
charity and human compassion which Flaxman
observed in Rome became the raw material for
such series as *The Acts of Mercy*, published in
1831, and for relief monuments.

Flaxman's attitude to such drawings can be
gleaned from advice he gave to his sister in a
letter from Rome of 7 October 1790 saying she
should 'always choose some affecting Action or
sentiment for the subject of her composition, that
she will observe attentively the actions of people
engaged in conversation or employed in any way
that affects the passions or affections, to consider
their countenances, the Contour of their figures
and their draperies, and particularly so to habitu-
ate herself in making perfect sketches from
nature in a few Minutes'.

Ill. 25 *Mother embracing child*, University College, London

64a

64b

64 Two studies of a woman and child

pen: **a** 140 x 111, **b** 139 x 1$\dot{1}$2
University College, London, nos. 742 and 743

Two closely allied studies of movement, almost certainly of the Roman period.

Ill. 26 *Children playing.* Christopher Powney Esq.

65 Mother with child in swaddling clothes

pen: 140 x 105
Trustees of the British Museum

Although almost certainly drawn from life in Rome, the group has a certain rigidity, possibly derived from paintings by Mantegna.

65

71

66

66 A sleeping man

pen: 57 x 105
University College, London, no. 776

This is one of the most spontaneous of Flaxman's Roman life studies. Compare it with Humbert de Superville's drawing (no. 91).

67 A group of women and children in a doorway

pen: 172 x 133
University College, London, no. 899

Almost certainly of the Roman period.

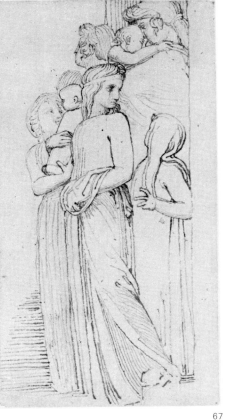

67

68

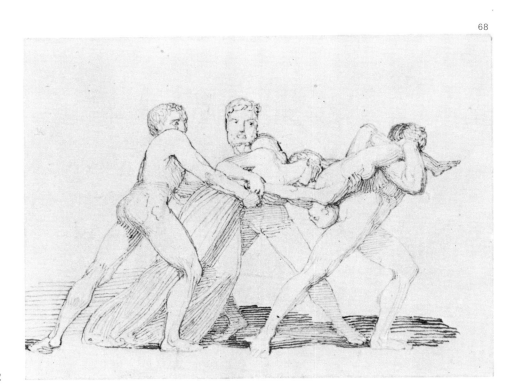

68 A group fighting over a child

pen: 112 x 148
University College, London, no. 802

Possibly based on an observed scene, but similar in feeling to the *Fury of Athemas* and some of the more violent scenes in the Aeschylus illustrations.

69

69 Cloaked and cowled figures

pen: 103 x 94
University College, London, no. 834

This study and the following, although certainly made from life in Rome, may be connected with the Dante series, for Dante and Virgil wear similar cloaks (see ill. 27).

Ill. 27 *Virgil and Beatrice meeting*, line engraving

70 Three cloaked figures

pen: 94 x 103
University College, London, no. 825

Certainly of the Roman period. See previous entry.

70

71 Two children with a seated woman

pen and wash: 81 x 84
University College, London, no. 777

A study from life, possibly executed in Rome.

71

72

73

72 A girl playing with a child

pen and wash: 160 x 107
University College, London, no. 836

This drawing could well have been made after Flaxman's return from Rome, and may be connected with such domestic scenes as *Maternal Love* in the Whitworth Art Gallery, Manchester (see no. 151).

73 Studies of groups

pen: 181 x 119
Trustees of the British Museum

Some appear to be studies from daily life, others are perhaps related to pictorial compositions. Probably from the Roman period.

74 Three cloaked figures

pen: 104 x 120
University College, London, no. 768

These studies may be connected with Flaxman's extended account in *Lecture VIII* of the principles guiding the fall of drapery, and therefore should be dated after 1810.

74

75 Two cloaked figures

pen: 126 x 166
University College, London, no. 867

Two studies of the fall of drapery, possibly for the *Lectures*.

75

76

76 Two draped female figures

pen and wash: 185 x 121
University College, London, no. 752

These studies may also be connected with Chapter VIII of Flaxman's *Lectures*.

77 Studies of a girl shaking out a cloth

pen: 122 x 191
University College, London, no. 861

Perhaps connected with Flaxman's discussion in the *Lectures* of the 'Effect of Wind on Drapery or Water' (see pl. 42 of the *Lectures*).

78 Studies of attitudes

inscribed: 'youthful gaiety Divided Attention attention Maternal care Concern'
pen and pencil: 234 x 380
Trustees of the British Museum

This drawing gives insight into the way in which Flaxman sought to convert his observations in Rome and elsewhere into monumental forms in which the accidental is eliminated. The drawing stands somewhere between the studies made in the Roman streets and such highly finished and monumental drawings of a moralizing kind as *Feed the Hungry* (no. 80).

79 Beggars receiving charity

pen and wash: 186 x 116
University College, London, no. 716

A drawing certainly made from a scene observed in Rome, but of a type which was later to provide source material for series like the *Acts of Mercy* (see no. 147), and also monuments like that to the Yarborough family, Campsall, Yorks (see ill. 28).

Ill. 28 *Yarborough Monument*, Campsall, Yorks.

80 Feed the Hungry after 1800

inscribed: 'Feed the Hungry'
pen and wash: 273 x 254
University College, London, no. 698
lit: *The Acts of Mercy*, engraved by F.C.
Lewis after Flaxman, 1831

One of the series of drawings for the eight
Acts of Mercy, of which several are represent-
ed in the exhibition. This monumental and
generalized image derives from life studies
made by Flaxman in Rome, such as the
Beggars receiving charity (no. 79), but was
probably drawn many years after he returned
to England in 1794.

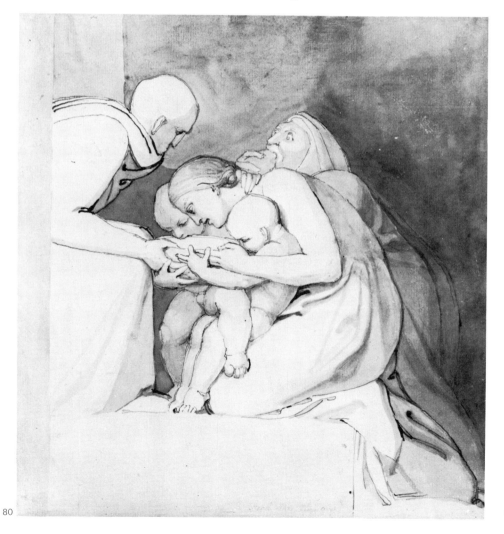

80

Studies in Rome, 1787-94

Flaxman studied with remarkable diligence in Rome and elsewhere in Italy, filling many sketchbooks with drawings and information about works of art of all kinds. He frequently annotated the drawings, and fragmentary drafts suggest that he was beginning to think of writing a history of sculpture, a project which reached a kind of fruition in the *Lectures* to the Royal Academy from 1810 onwards. This led him to look also at sculpture outside the normal canons of classical taste, but his response to both early Italian painting and sculpture was sincere and heartfelt. The two sketchbooks from the Victoria and Albert Museum are filled with drawings after such early masters as Duccio and Donatello, who would have appealed to him as the precursors of the High Renaissance, and as Christian artists aware of classical prototypes. Flaxman laid continuous emphasis upon classical sources, even of such medieval conceptions as Maitani's *Last Judgment* at Orvieto.

Flaxman's enthusiasm for medieval art can be seen in the light of the rediscovery at this time of Italian 'Primitives'. He became friendly with one of the principal pioneers, William Young Ottley, who made extensive copies of fourteenth- and fifteenth-century frescoes. They visited Orvieto together, in 1792, possibly also in the company of the Dutch artist Humbert de Superville, who was helping Ottley with the project of producing a series of engravings of early Italian painting.

This enthusiasm for such rediscoveries was not at the expense of classical works, and Flaxman made many studies, particularly of Roman and Greek relief sculpture in the great Roman collections. He confirmed also his great regard for Michelangelo as the inheritor of both antiquity and the Christian art of earlier epochs.

A small group of drawings at the end of this section shows the work of Flaxman's colleagues Ottley and Humbert de Superville.

81 Studies after William Blake June, 1792

inscribed: 'J. Flaxman from memory of three drawings of Blake, June 1792'
pen: 204 x 244
Private collection
lit: G.E. Bentley, *Blake Records*, 1969, p. 47; Bindman, 1977, p. 38

This drawing is the most direct evidence of Blake's influence on Flaxman, and it is revealing that Blake should have been in Flaxman's mind at the time he was beginning work on the Homer and Dante outlines and also on the *Fury of Athemas* for Lord Bristol. In fact none of the sketches corresponds to any known Blake drawings, which would almost certainly have been seen by Flaxman before he left England in 1787. The embracing group in the right-hand corner does bear some resemblance to a known Blake study of *c.* 1785 for *Joseph discovering himself* (Royal Collection), and it also foreshadows the grouping of the *Fury of Athemas*.

82a

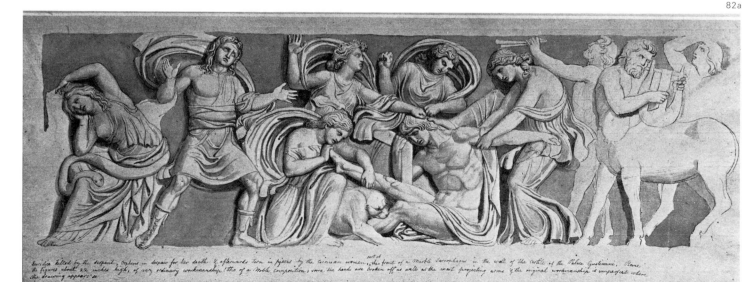

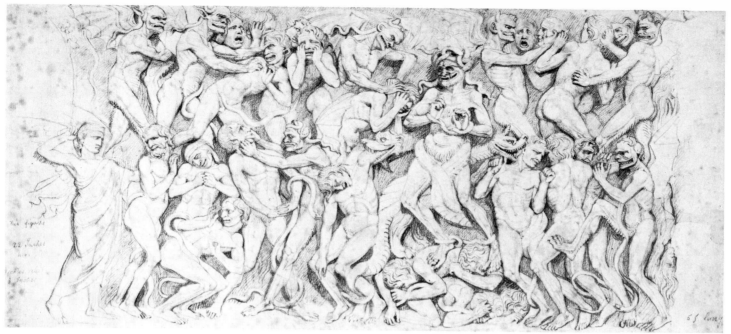

83

83 Study after Lorenzo Maitani's Last Judgment, Orvieto

pencil: 233 x 491
Trustees of the British Museum
lit: Irwin, 1966, pp. 72 and 89

Flaxman went to Orvieto in 1792, where he particularly admired the reliefs on the west front of the Duomo, which he attributed not to Maitani but to Nicola Pisano (Irwin, p. 89, n. 4). According to no. VI, p. 169 of the *Lectures*, 'Grecian composition may be traced in the biblical basso-relievos of Orvieto by Nicolas and John Pisani.'

82 Studies of antique reliefs in the Palazzo Giustiniani

pen and wash: **a** 248 x 652, **b** 246 x 437
a Whitworth Art Gallery, University of Manchester
b Trustees of the British Museum

These are careful and accurate studies of reliefs in the Palazzo Giustiniani in Rome. One (**a**) is copied from a Roman sarcophagus still *in situ*, not of *Orpheus and Euridice* as Flaxman suggests, but of the *Punishment of Pentheus* from the Bacchic cycle, of the late Antonine period, *c.* 170-80 (reproduced in

R. Turcan, *Les Sarcophages romains à représentations Dionysiaques*, 1966, pl. 32a). The other is a copy of the right-hand end of one of two friezes belonging to the so-called 'Altar of Ahenobarbus', which probably decorated a public building or enclosure in the centre of Rome. The frieze is in Asiatic marble, and was probably carved in north-west Asia Minor towards the end of the second century BC, being taken to Rome at a later date (see F. Coarelli 'L'Ara di Domizio Enobarbo', *Dialoghi di Archeologia* II 1968). I am indebted to Dr Malcolm Colledge for his help with the classical prototypes.

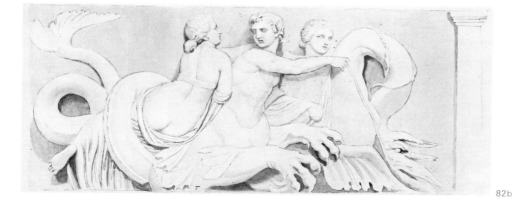

82b

79

84

85 Sketchbook used in Italy

71 pages mainly pencil, some pen and wash:
c. 152 x 362
Victoria and Albert Museum
lit: Whinney, 1956, pp. 269-82; Irwin, 1966,
p. 89

This sketchbook has been exhaustively ana-
lyzed in the above article by Whinney, and
the prototypes of each drawing are listed in an
appendix (pp. 280-81). It is notable for con-
taining many studies of thirteenth-, four-
teenth- and fifteenth-century works of art, in
the history of whose revival Flaxman has a
notable place. Among the artists Flaxman
copies here are: Cavallini, Donatello, Ghiber-
ti, Traini, Brunelleschi, Tino da Camaino,
Duccio and Uccello.

84 Study after an early Italian painting

pen and wash: 116 x 116
University College, London, no. 793

This drawing appears to be copied from a
fifteenth-century painting or fresco, but the
original has not yet been identified. It is not
wholly dissimilar in composition from the
portion of Luca Signorelli's *Last Judgment*
fresco copied by Ottley (no. 89), and it might
be simply a rough drawing of it made from
memory.

85

80

85

85

85

85

VIVIT VIVIT VIVIT DVO·FRATRES·FABREI·TIG

C·CAVIVS·C·L·DARDANVS C·CAVIVS·SPV·F·RVFVS CAVIA·C·E·L·ASIA C·GAVIVS·C·L·SALVIVS

Cloyster of S. John de Lateran

85

86

86

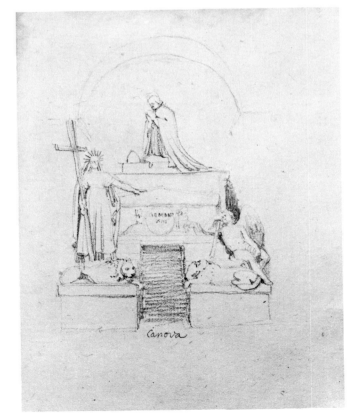

86

86

87

86 Sketchbook used in Italy

170 pages, mainly pencil, some pen and wash:
approx. 267 x 210
Victoria and Albert Museum
lit: Whinney, 1956, pp. 281-82; Irwin, 1966,
p. 89; Whinney, p. 272, no. 16

This large sketchbook was variously used for
a treatise on the human figure in Greek art,
for studies of the model and for studies of
monuments in Rome, made in connection
with the *Mansfield Monument*, which was
designed before Flaxman left Italy in 1794.
After a scheme for a relief tomb was rejected
(see no. 133), Flaxman turned to the Papal
tombs in St Peter's for a new scheme (some-
what oddly, as the monument was to be free-
standing), and he made, in this sketchbook,
studies of Canova's Clement XIII tomb and
Bernini's Alexander VII, an unexpected
choice for a sculptor so unsympathetic to the
Baroque. According to Whinney, the Papal
drawings must date from 1792 or after be-
cause Canova's tomb was only erected in that
year, but the Tuscan drawings might be
earlier. There are also several fine studies of
sculpture, including Michelangelo, Giovanni
da Bologna and Cellini.

87 Prophetic figure, after Michelangelo

pen, grey ink and wash: 140 x 114
Courtauld Institute of Art, University of
London

This Michelangelesque drawing appears to
be a conflation of figures of the Prophets and
Ancestors of Christ on the Sistine Chapel
ceiling. It shows that Flaxman was susceptible
in Rome to the influence of the Sublime, and
reveals his occasional affinity to Fuseli and
Blake, especially the latter's frontispiece to
Europe (see ill. 29).

Ill. 29 William Blake, frontispiece to *Europe* 83

88 Statuette of Apollo ?

Early Imperial Roman copy of fifth-century BC original, or early Imperial original, with head, left hand, right arm, legs below knees and base restored; ancient part in Pentelic marble, restorations in Carrara marble:
515 x 176 x 145
The Syndics of the Fitzwilliam Museum, Cambridge
lit: L. Budde and R. Nicholls, *A Catalogue of Greek and Roman Sculpture in the Fitzwilliam Museum*, 1964, no. 39

This work belonged to J. Disney, who had been given it by a friend who had bought it from Flaxman in 1796. Such drastic restoration of sculpture, executed in 1793 by Flaxman and Antonio d'Este, was a common way for sculptors to support their studies in Rome in the late eighteenth century. Flaxman was, however, particularly interested in the theoretical questions raised by antique fragments, and in 1792 he was commissioned by Thomas Hope to make a conjectural restoration of the *Torso Belvedere* as a group of *Hercules and Hebe*. Only the plaster was made, and it now belongs to University College, London (see ill. 10 and Watkin, pp. 30-1).

William Young Ottley

89 Study after Signorelli 1793

inscribed: 'WY O delt.ab Orig. 1793'
pen and wash: 560 x 395
Trustees of the British Museum

lit: G. Previtali, 'Alle origini del primitivismo romantico', *Paragone*, 13, 1962, no. 149, pp. 32-51

This drawing was used for pl. 52 of Ottley's volume *A Series of Plates engraved after the Paintings and Sculptures of the Most Eminent Masters of the Early Florentine School*, published only in 1826 and dedicated to Flaxman. Humbert de Superville also made drawings for the project, and Flaxman would have known them both in Rome at the time. In the book the design is captioned: 'The Wicked destroyed at the end of the world by Fire from Heaven', and it is copied from a portion of the *Last Judgment* fresco by Signorelli in the Duomo at Orvieto. According to Previtali, Ottley was interested in Signorelli because Vasari had noted that Michelangelo had made a particular study of his art.

88

89

90

William Young Ottley
90 Twelve Stories of the Life of Christ 1796

engraved by Thomas Piroli
book of 12 engravings with aquatint: approx.
page size 397 x 271
Trustees of the British Museum

These rare aquatints by Ottley, engraved by
Flaxman's engraver Piroli, show the strong
influence of his studies of early Italian art,
and make an interesting parallel with Flax-
man's Dante engravings.

P.D.G. Humbert de Superville
91 Reclining Figure *c.* 1798

pen over black chalk: 81 x 158
Rijksprentenkabinet, Leiden

Probably shows an acquaintance with Flax-
man's Roman drawings from nature. See,
for example, no. 66.

91

92

P.D.G. Humbert de Superville
92 Flying female figure 1790s

Pen over black chalk: 84 x 110
Rijksprentenkabinet, Leiden

Close to Flaxman's outline style, particularly
in the Dante designs.

93

P.D.G. Humbert de Superville
93 Three male figures 1798–99?

pen over black chalk: 103 x 130
Rijksprentenkabinet, Leiden
lit: Delft, Stedelijk Museum 'Het
Prinsenhof', *Humbert de Superville*, 1975,
no. 37

Possibly made on Humbert's visit to Civita-
vecchia in 1798-99, this drawing has analogies
in its spontaneity and simplicity to Flaxman's
drawings of the Roman period, which Hum-
bert might well have known.

85

On 12 September 1792 Flaxman wrote to George Romney from Rome giving a brief account of his activities: 'My employments at present are finishing Ld Bristols Great Group in Marble [*The Fury of Athemas*] making a model for a Restoration of the Torso Belvidere & in the Evenings making a Series of drawings from Homer & Dante which are engraving.' The line engravings from Homer and Dante, along with those from Aeschylus, were Flaxman's most celebrated works in his own day, but he evidently regarded them as secondary to the more serious business of making monumental sculpture, and even showed some signs of embarrassment at their fame.

The project for engraving Flaxman's designs came from the enthusiasm of English patrons in Rome. Mrs Hare-Naylor, the daughter of the Bishop of St Asaph, who commissioned the Homer illustrations, and a Mr Udney both owned sets of drawings for the *Iliad* and the *Odyssey*. The drawings in the exhibition from the Royal Academy belonged to the family of Mrs Hare-Naylor but Mr Udney's set can no longer be identified. The Aeschylus drawings were also worked on at the same time as the Homer for the Countess Dowager Spencer, but they were not published until 1795 after Flaxman's return to London. The circumstances surrounding the illustrations to Dante are slightly bizarre because both drawings and engravings were commissioned by Thomas Hope, who refused to release them to the public. Mrs Flaxman wrote to William Hayley on 22 July 1793: 'the set of drawings from his [Flaxman's] Divina Comedia is now compleat (both as to numbers, grace and beauty) as are the Copper Plates engraved from them but I am sorry to inform you that Mr. Hope does not mean to make them public, as he wishes to give them away himself to the chosen few, whom he may think from their taste and virtue are entitled to them.' The original bound volume of drawings presented to Thomas Hope is now in the Houghton Library, Harvard College, and it is possible to see how much has been lost in Piroli's outlines (see ills. 5, 5a).

Flaxman's own view of the outlines was that they were not ends in themselves, but were compositions upon which sculpture could be based; he wrote to Hayley on 26 October 1793: 'my view does not terminate in giving a few outlines to the world: my intention is to shew how any story may be represented in a series of compositions on principles of the Antients, of which as soon as I return to England I intend to give specimens in Sculpture of different kinds, in groups of basrelieves, suited to all the purposes of Sacred and Civil Architecture.' The clarity, the simplicity and the reduction of naturalistic space which Flaxman's contemporaries so much admired were, then, partly a consequence of his attempt to see the designs in terms of marble cutting in low relief. Here he was thinking of Roman sarcophagi, which he regarded as prototypes for his classical designs: 'the ancient Sarcophagi . . . present a magnificent collection of compositions from the great poets of antiquity, Homer, Hesiod, Aeschylus, Euripides and Sophocles . . . The study of these will give the young artist the true principles of composition, with effect, and without confusion, to produce the chief interest of his subject by grand lines of figures, without the intrusion of useless, impertinent, or trivial objects.'

This ambition to revive the form of the Antique bas relief did not preclude a wide variety of influences, from such contemporaries as Gavin Hamilton and William Blake, through Donatello and early Italian art, to Greek vases in the collection of Sir William Hamilton, whom he met in Italy. Some of this variety has been indicated in the section on Flaxman's studies in Rome. One can inevitably find the direct use of early Italian prototypes in the Dante designs, but one can also see the impact of, for example, Donatello in the Homer designs. In the *Iliad* and *Odyssey* designs, as befits the heroic character of the events, Flaxman has emphasized the nobility and strong feelings of the protagonists, whereas in the Aeschylus designs he has sought to bring out the ritualistic and incantatory quality of the original plays by hieratic composition and repetition from one design to another. In the Dante designs he has drawn from early Italian Last Judgments and Apocalyptic subjects a sense of inner torment and spiritual isolation appropriate to the sense of the original text.

The use of earlier art is also guided by the idea of fitting the style to the period in which the texts were written, by, as Robert Rosenblum has argued, adopting a deliberately primitive style. George Romney remarked in 1793 that 'They are outlines without shadow, but in the style of antient art. They are simple, grand, and pure . . . They look as if they had been made in the age, when Homer wrote.' Flaxman, in the *Lectures* (pp. 262-63), says of the art of the Homeric or 'the heroic age':

At the beginning the endeavour was limited to the single figure, naked and in few and simple attitudes. It is nevertheless likely, before this age passed away, the artists became more bold, and adorned their earthen vases with subjects of three or four figures, such as frequently occurred in their habits of life, a conversation, a battle or a procession, the designs of these compositions appear like profiles of their statues, and unconnected with each other.

Drawings for the **Iliad** *and the* **Odyssey**

The drawings in this section from the Royal Academy derive from the family of Mrs Hare-Naylor, who commissioned the first edition of the books engraved in Rome in 1793 by Piroli. Some of them are rejected or unfinished designs, and in certain cases it is possible to see the development of a particular composition. All of these drawings can be dated to the latter half of 1792.

The 1793 edition of the *Iliad* consisted of 34 plates, but 5 more, engraved by William Blake and James Parker, were added in the 1805 edition. The *Odyssey* was re-engraved by English engravers for the 1805 edition. Flaxman used Alexander Pope's translation of Homer, to which reference is made here.

94 The Iliad of Homer Engraved from the compositions of John Flaxman R.A. Sculptor

a Rome 1793, engraved by Thomas Piroli, first edition
Thorvaldsen Museum, Copenhagen

b London 1805, engraved by Thomas Piroli with additional plates by William Blake and James Parker.
39 plates, line engravings: 308 x 454 (cover)
Private collection
lit: Bentley, 1964, pp. 34-6

The first English edition, with 5 extra engravings by Blake and Parker.

95 'First Thoughts' for the Iliad late 1792

inscribed: 'Homer's Iliad First Thoughts'
pen: 267 x 195
Trustees of the British Museum

The upper design depicts *Venus protecting the body of Hector* (*Iliad*, Book XXIII, not engraved), the bottom design the *Funeral Pyre of Patroclus* (*Iliad*, pl. 35). The 'Mr. U' mentioned in the right-hand column of figures must be Mr Udney, who had ordered a set of the Homer drawings in 1792 (see Essick & La Belle, p. vi).

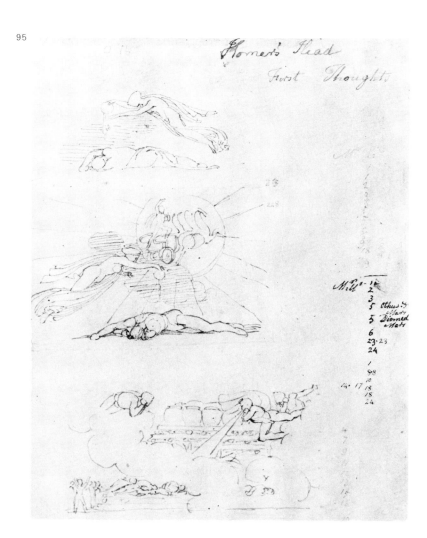

95

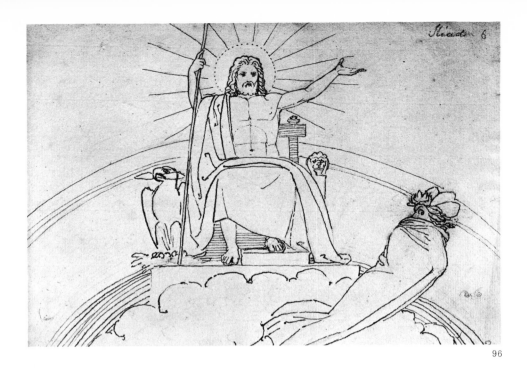

96

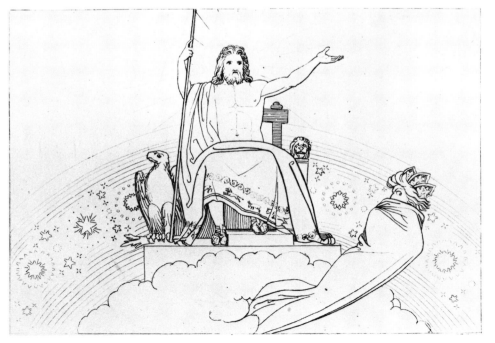

Ill. 30 *Jupiter sending an Evil Dream to Agamemnon*, line engraving

96 Jupiter sending an Evil Dream to Agamemnon
Iliad Book II, 9

inscribed: Iliad 6
pen: 171 x 241
Royal Academy of Arts, London
lit: *Iliad*, 1805, pl. 6: Essick & La Belle, 1977, p. xxi

Compositionally close to the final version (ill. 30), but without the elaborate depiction of the heavens in the engraving. Jupiter, in response to the request of Thetis, sends a deceitful dream to Agamemnon to persuade him to lead the Greeks against Troy.

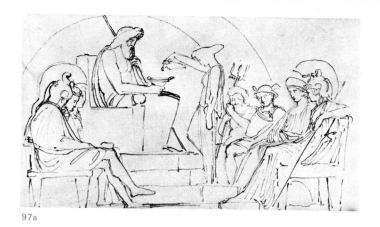

97a

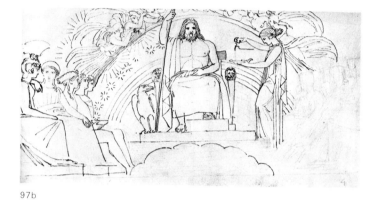

97b

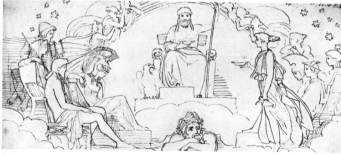

97c

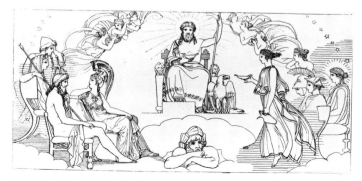

Ill. 31 *The Council of the Gods*, line engraving

97 The Council of the Gods
Iliad Book IV, 3-4

preparatory drawings on one mount
pen: **a** 235 x 292, **b** 232 x 330, **c** 171 x 368
Royal Academy of Arts, London
lit: *Iliad*, 1805, pl. 9: Essick & La Belle, 1977,
p. xxii

The Gods about to deliberate on the Trojan War, as 'Immortal Hebe, fresh with bloom divine, / The golden goblet crowns with purple wine'. In the first and second design Hebe is shown pouring the wine for Jupiter, but in the final drawing and in the engraving (ill. 31) Jupiter has received it and the discussion has begun. Between the first and second designs Flaxman has made a major compositional change by moving Jupiter to preside frontally on the central axis which has been strengthened by the figure of the Genius of Mount Olympus below. A shift has been made away from a naturalistic, stage-like design to a more hieratic composition.

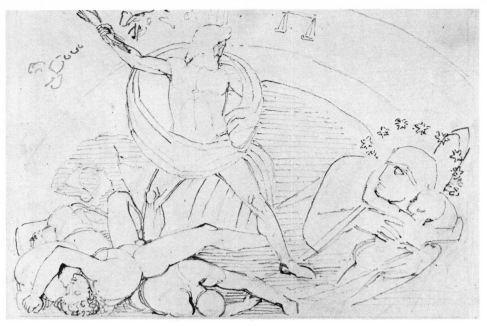

98a

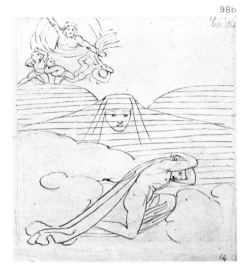

98b

98 Sleep escaping from the Wrath of Jupiter
Iliad Book XIV, 294

two alternative designs, pen: **a** 238 x 292,
b 238 x 270
Royal Academy of Arts, London
lit: *Iliad*, 1805, pl. 23: Essick & La Belle,
1977, p. xxiv

Design **a** was rejected in favour of a vertical
format and a different phase of the action (ill.
32). Juno applies to Sleep to close Jupiter's
eyes, but he recounts that when he had tried it
before, Jupiter would have destroyed him,
'But gentle night to whom I fled for aid/The
friend of earth and heaven her wings
display'd'.

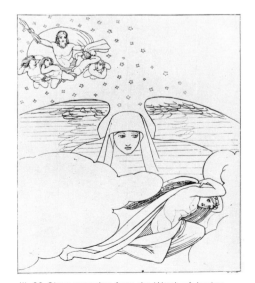

Ill. 32 *Sleep escaping from the Wrath of Jupiter,*
line engraving

99 Thetis bringing the Armour to Achilles
Iliad, Book XIX, 5

pen: 171 x 280
Royal Academy of Arts, London
lit: *Iliad,* 1805 pl. 31; Essick & La Belle,
1977, p. xxv

Thetis brings to Achilles, as he mourns over
Patroclus, armour made by Vulcan (ill. 33).
She carries the Shield of Achilles, the subject
of a long account in the previous book, and
which Flaxman was later to recreate from
Homer's description (see no. 187).

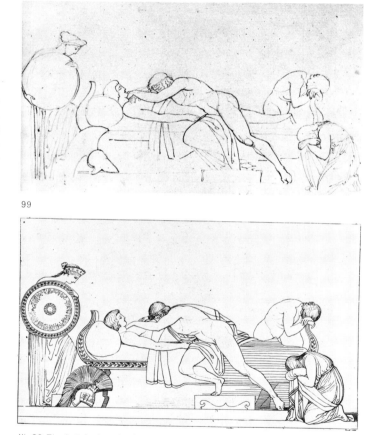

99

Ill. 33 *Thetis bringing the Armour to Achilles,* line
engraving

**100 The Odyssey of Homer Engraved from
the Compositions of John Flaxman R.A.
Sculptor** London, 1805

a Rome 1793
first edition
engraved by Thomas Piroli
Thorvaldsen Museum, Copenhagen

b
engraved by Parker and Neagle
34 plates, line engravings: 308 x 454 (cover)
Private collection
lit: Bentley, 1964, pp. 22-5

After the loss of Piroli's original plates, this
edition was re-engraved in London by Parker
and Neagle and issued in a uniform edition
with the *Iliad*.

101 Penelope surprised by the suitors
Odyssey Book II, 123

pen: 165 x 241
Royal Academy of Arts, London
lit: *Odyssey*, 1805, pl. 4; Essick & La Belle,
1977, p. xxvii

A rejected design, showing a quite different
composition from that finally engraved. There
is another design close to the present one in
the Whitworth Art Gallery, Manchester. The
scene of Penelope surprised is recounted by
one of the suitors, who encounters her de-
laying over Ulysses' shroud. The charming
domesticity of the rejected design gives way
to a more monumental and solemn concep-
tion in the final engraving (ill. 34).

101

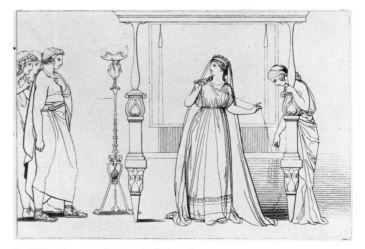

Ill. 34 *Penelope surprised by the Suitors*, line
engraving

102 Ulysses terrified by the Ghosts
Odyssey Book XI, 779

pen: 229 x 298
Royal Academy of Arts, London
lit: *Odyssey*, 1805, pl. 17; Essick & La Belle, 1977, p. xxx

The engraving (ill. 35) follows this design very closely, but the right-hand group of ghosts is only pencilled in. This scene, from Ulysses' narration, tells how he 'Curious to view the kings of ancient days', was put off by 'swarms of spectres'. The imagery suggests the lingering influence of Fuseli.

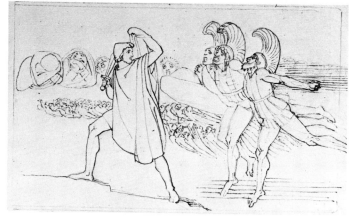

102

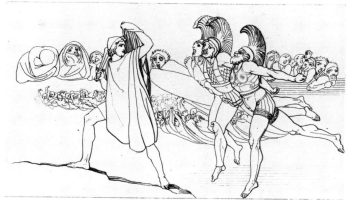

III. 35 *Ulysses terrified by the Ghosts*, line engraving

103 The Harpies going to seize the daughters of Pandarus
Odyssey Book XX, 92

pen: 165 x 292
Royal Academy of Arts, London
lit: *Odyssey*, 1805, pl. 29: Essick & La Belle, 1972, p. xxxii

An illustration of Penelope's wakeful prayer, in which she asks Diana to be snatched away to the Furies like the daughters of Pandarus. The figure in the background, eliminated in the engraving (ill. 36), is presumably 'Bright Cytherea', who left them unguarded 'to learn their lots in nuptial love'.

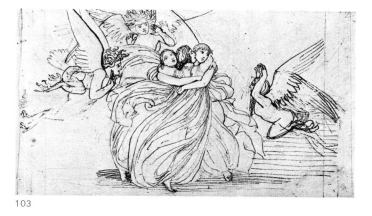

103

III. 36 *The Harpies going to seize the daughters of Pandarus*, line engraving

93

Drawings for the **Tragedies of Aeschylus**

These drawings were made about the same
time as the Homer illustrations, but they were
not published until 1795, after Flaxman had
returned to London. They are dedicated to
the Countess Dowager Spencer, a cousin of
Mrs Hare-Naylor. Flaxman used R. Potter's
translation of Aeschylus, to which reference
is made here.

**104 Compositions from the Tragedies of
Aeschylus designed by John Flaxman
engraved by Thomas Piroli** 1795

Engraved by T. Piroli 'from the original
drawings in the possession of the Countess
Dowager Spencer'
inscribed (on title page) in Flaxman's hand:
'To William Hayley Esquire in testimony of
Affection from the Author'
line engravings: 295 x 462 (cover)
Courtauld Institute of Art, University of
London
lit: Bentley, 1964, p. 39

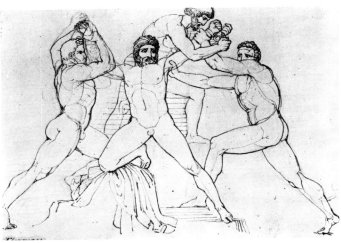

105

105 The binding of Prometheus
Prometheus Chain'd

pen: 237 x 333
Trustees of the British Museum
lit: *Aeschylus*, 1795, pl. 2

Prometheus bound to the rock by Vulcan,
Force and Strength. According to the *Lec-
tures*, p. 170: 'Vulcan, Force and Strength:
Mercury, Ocean, and the Nymphs are but
contingents to the adamantine spirit of Pro-
metheus, whom the threats of Jupiter could
not move, nor convulsions of the universe
terrify: the interest is in him, to which the
ministering violence, admonition, consola-
tion or tenderness of the inferior characters
give subordinate relation' (ill. 37).

Ill. 37 *The Binding of Prometheus*, line engraving

106

106 Prometheus and the Nymphs of the Ocean
Prometheus Chain'd

pen: 235 x 286
Royal Academy of Arts, London
lit: *Aeschylus*, 1795, pl. 3

Prometheus visited by the Nymphs of the Ocean (ill. 38).

107 Mars invoked by the Theban Women
Seven Chiefs against Thebes

pen: 232 x 333
Royal Academy of Arts, London
lit: *Aeschylus*, 1795, pl. 12

As the Seven Chiefs prepare to attack Thebes the Theban virgins invoke Mars. The setting is the Acropolis of Thebes, depicted here with primitive severity (ill. 39).

Ill. 38 *Prometheus and the Nymphs of the Ocean,* line engraving

107

Ill. 39 *Mars invoked by the Theban Women,* line engraving

108

III. 40 *The Lament over the Death of Polynices,* line engraving

108 The Lament over the Death of Polynices
Seven Chiefs against Thebes

pen: 235 x 400
Royal Academy of Arts, London
lit: *Aeschylus*, 1795, pl. 14

Antigone insists upon burying her brother Polynices after his death at the hands of his brother Eteocles, despite the dishonour he brought upon Thebes (ill. 40).

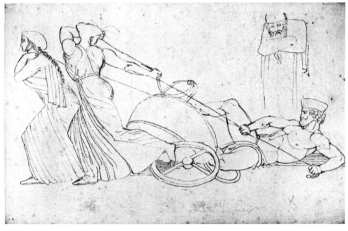

109

109 The Dream of Atossa
The Persians

pen: 232 x 333
Royal Academy of Arts, London
lit: *Aeschylus,* 1795, pl. 29

Atossa, the mother of Xerxes, the Persian king and invader of Greece, dreams of the future defeat of her son, who is pulled along by two maidens in Persian and Greek costume, until the Greek maiden breaks the harness causing Xerxes to fall. Darius, his aged father, laments his fall. In the engraving the figure of Xerxes is transformed into a more Grecian type than in the drawing (ill. 41).

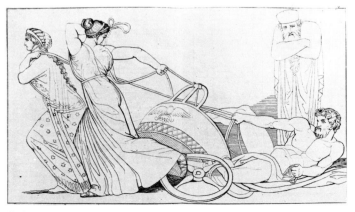
III. 41 *The Dream of Atossa,* line engraving

110

110 The Procession of the Trojan Women
Choephori

pen: 219 x 298
Royal Academy of Arts, London
lit: *Aeschylus*, 1975, pl. 19: Rosenblum, 1956,
p. 161

Elektra leading a Chorus of Trojan virgins
to the tomb of Agamemnon. Rosenblum re-
gards the engraved design (ill. 42) as one of
the high points of Flaxman's 'primitive' style,
and sees it as an influence, in its ritualistic
severity, on Blake's *Procession to Calvary*
(Tate Gallery).

Ill. 42 *The Procession of the Trojan Women*, line
engraving

97

Flaxman was working on the drawings for Dante at about the same time as those for Homer and Aeschylus, but they were engraved privately for Thomas Hope, and were not published in England until 1807. Most of the studies for Dante are still in their original volumes in the Rosenwald Collection and in the Fitzwilliam Museum (no. 112). The volume of finished drawings owned by Hope is now in the Houghton Library, Harvard College. In the absence at that time of a full English translation of Dante, Flaxman would have read it in Italian.

111 Compositions from the Hell, Purgatory, and Paradise of Dante Alighieri, By John Flaxman, Sculptor

Engraved by Thomas Piroli, from the Drawings in Possession of Thomas Hope Esq., 1793
110 plates engraved by Piroli: 292 × 455
see ills. 43, 44

a first edition, 1793
inscribed: 'C. Wolff, Roma, 1794'
Herzog August Bibliothek, Wolfenbüttel

The first edition, because it was privately printed and distributed by Thomas Hope himself, is extremely rare. This copy has many of the captions in manuscript.

b First London edition, 1807
Courtauld Institute of Art, University of London

112 Sketchbook with designs for Dante's Divine Comedy 1792-93

58 leaves: *c.* 138 × 195
The Syndics of the Fitzwilliam Museum, Cambridge

This sketchbook contains working drawings, on the whole of a summary nature, for the *Inferno, Purgatorio* and *Paradiso.* In most cases the studies differ significantly from the final designs, and they appear to represent an early stage of development, perhaps between the album in the Rosenwald Collection and the final drawings made for Thomas Hope in the Houghton Library, Harvard College.

Ill. 43 *Entering the Dark Wood, Inferno,* canto 1, line engraving

Ill. 44 *The Beatific Vision, Paradiso,* canto 33, line engraving

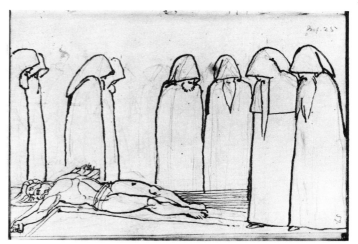

112

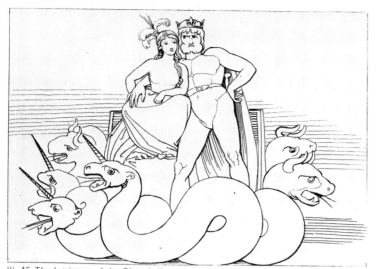

Ill. 45 *The Intrigues of the Church*, line engraving

113a

113b

113 The Intrigues of the Church
 Purgatorio, canto 32

a pen: 178 x 229
b pen: 238 x 286
inscribed: 'J. Flaxman 1792/from the Author'
Christopher Powney Esq.
lit: Flaxman, 1976, no. 17: *Dante*, 1793,
Purgatorio pl. 37

An illustration to *Purgatorio*, canto 32,
altered considerably in the final design. In the
earlier version **a**, the Giant and the Harlot are
shown as 'ever and anon they mingled kisses',
but in the final engraving (ill. 45) the couple,
representative of corrupt church and rapa-
cious tyranny, embrace more chastely. For
Blake's version of the scene, see *Blake*
(Hamburg, 1975, no. 216).

Before the turn of the century Flaxman was still largely dependent on a small number of friends and admirers for commissions for large sculptures. Until he set off for Rome in 1787 much of his time was occupied in work for Wedgwood, but nevertheless he exhibited at the Royal Academy models of classical subjects in clay and terracotta, portraits in wax and terracotta together with models for monuments in an endeavour to attract notice as an independent sculptor. The admiration and friendship of Romney supplied the first piece of good fortune, for it was he who in 1783 introduced Flaxman to that enthusiastic encourager of genius, the poet William Hayley. Almost at once Flaxman was commissioned by Hayley to execute a monument to Hayley's father-in-law Dean Ball, erected in Chichester Cathedral (ill. 7). With this beautiful composition, which he entitled *An angel comforting a mourner*, Flaxman initiated a series of monuments whose piety of sentiment and classical form were his most important contribution to the Romantic Neoclassicism of late eighteenth- and early nineteenth-century English art. Sculptural decorations for Hayley's new library at Eartham and busts of Hayley and Romney quickly followed. It was through Hayley that Flaxman received while in Rome the commission for the Collins monument (see no. 132), with the designs for which he took an immense amount of trouble. The monument was executed after his return to London and Hayley's son Thomas, by this time apprenticed to Flaxman, sat for the figure of Collins. This led in turn to the monument to Mary Blackshaw (no. 115), a variation on the theme of the Ball monument, and a bust of Mrs Blackshaw. Many other commissions later came to Flaxman through the good offices of Hayley, and, by the time Hayley's 'Essay on Sculpture', a poem designed to promote Flaxman's professional career, was published in 1800, the sculptor's account book records a satisfying amount of work in progress.

In the last two decades of the eighteenth century, for the first time patrons appeared willing to commission, and in some cases even to pay for, monumental figure sculpture conceived as an independent work of art and intended to adorn a gallery. Among the patrons whom he first met in Rome were such enthusiastic collectors as Lord Bristol and Thomas Hope who admired the work of the 'purest of the latter-day Greeks'. From these pillars of Neoclassical taste Flaxman benefitted considerably, for in 1790 Lord Bristol commissioned the heroic group of the *Fury of Athemas* (ill. 8) now at Ickworth, Suffolk. At the time Flaxman was greatly excited: 'who would have employed me in England to make a group 7 feet high of a Man, a woman, an infant and a larger child?' And Lord Bristol was mightily pleased with the result: 'The Laocoon is the finest thing in the Pope's Museum', he is reported to have said, 'but there is a work superior to that . . . Flaxman's Athemas, Flaxman is the greatest artist that ever lived and I am possessed of the finest work ever done in sculpture.' Thomas Hope was an equally warm admirer, commissioning among many other sculptures, the attempted restoration of the *Torso Belvedere* which Flaxman turned into *Hercules and Hebe* (ill. 10). Hope, Sir William Hamilton, the Hare-Naylors and Lady Spencer were all generous in their patronage of the sculptor, both in Italy and after Flaxman's return to England in 1794.

The most significant work that he undertook on his return was the monument to Lord Mansfield in Westminster Abbey (see no. 133). He had received this commission before he went to Italy, where it was placed under Sir William Hamilton's care, and he had selected the marble for it in Carrara on his way home. The success of the composition with its novel design as a free-standing monument was, given the competition from Banks, Bacon and Nollekens, of singular importance to Flaxman's reputation.

Although Flaxman was to gain his share of public monuments to the national heroes of the day, such as Howe and Nelson (ill. 11), these large works are among his least successful, and we cannot but be thankful that his projected scheme for a Naval Pillar, a statue of Britannia two hundred feet high, placed on the top of Greenwich Hill, was not adopted (no. 139). It is in the expression of more intimate piety and of poetry that his genius as a sculptor excels. And works of this kind were largely to occupy him throughout the remainder of his career – the exceptions are a few portrait statues, decorative friezes and the execution of a commission from Lord Egremont for a *Pastoral Apollo* and a large group of *St Michael overcoming Satan*, an attempt to marry Neoclassicism to the inspiration of Giovanni da Bologna.

By the last decades of the eighteenth century the revival of active piety that allied itself to the vogue for sentimental simplicity and austere elegance, banished much of the allegorical funerary imagery of the Baroque and Rococo. In its place we find small and often impersonal monuments, tending to use only a few standard designs which could be readily adapted to most requirements, and which could be more or less expensive according to the marble used. In Flaxman's case the simplest was a tablet surmounted by an urn which, together with the design of a tablet, usually upright and pedimented, flanked by figures of Christian virtues in high relief, altered to soldiers or other allegories as occasion demanded, were amongst the cheapest and most frequent. Next came the monuments in the shape of a pedimented stele with one or more draped figures in low relief mourning beside a pedestal surmounted by an urn, and those which showed a draped female figure seated on a step holding a book and contemplating either the book or the heavens. It is characteristic of the essential historicism of late eighteenth- and early nineteenth-century taste that Flaxman worked not only in the Greek style, but also in the Gothic, which was already acquiring that renewed vitality as the proper language of Christian art. Yet Flaxman's Gothic always retains something of the prettiness of eighteenth-century medievalism. The figure sculpture of these monuments with their obvious sincerity of feeling, the grace and charm of their design and their crisp architectural details, redeem such works from monotony and insipidity.

Like all artists blessed with a large practice, when presented with an interesting commission Flaxman produced a more imaginative design, and in these compositions, employing either the rare faculty of invention which is his special gift as a sculptor, or the more traditional devices of allusion to the attributes and achievements of the person commemorated, Flaxman achieved works of art at once original and sincere. So the monuments

to Collins, to Mary Blackshaw and to Agnes Cromwell (no. 116), the later part of the Baring monument illustrating the *Lord's Prayer* in Micheldever Church, a monument in the round to Lady Fitzharris who is shown seated reading to two small boys at Christchurch Priory, Lady Shuckburgh-Evelyn on her death bed at Shuckburgh, Warwickshire, and the monumental statue of Mrs Tighe (no. 126) are examples of the workings of his poetic inspiration. So are the monuments to Sir William Jones (compiling his *Digest of Hindu and Mohammedan Law*) in University College Oxford, to Abraham Balme, the teacher, at Bradford Cathedral, to the Yarborough family dispensing charity at Campsal, Yorkshire, to the Reverend John Clowes, an ardent Swedenborgian, preaching, and to the celebrated Dr Warton, headmaster of Winchester, in wig and gown instructing a group of pupils in the Classics, at Winchester Cathedral (see no. 136).

Flaxman was well aware of the merits and significance of such compositions, for these and others like them on which he bent his real talents were the ones that he selected to exhibit as models at the Royal Academy. In his faculty of poetical invention Flaxman is again a child of his time and place, for in late eighteenth- and early nineteenth-century England poetry and the fine arts of painting and sculpture were seen as closely linked expressions of a single artistic inspiration. Characteristic of Flaxman's art is the charming ease with which he blends realism of portraiture and dress with classicism of pose, drapery and architectural motifs. One of the secrets of his success is the unity imposed by his relief style, which is always classical in its use of two-plane composition and of spatial interval.

Often but not invariably starting from a drawing, it was Flaxman's practice to make small models of his monuments in clay. As a rule these sketch-models of the design were for the whole monument, including the inscription tablet. The sketch was then cast in plaster and from it a large-scale model of the figures only was made in clay. The figures were modelled first nude and then clothed to ensure accurate proportions, graceful drapery lines and the correct sentiment; the model was cast in plaster and any final detail worked up. Because of the difficulty of working with large quantities of clay it was Flaxman's custom to make many of his figure models only half-size, particularly those of life-size statues. This practice had the severe disadvantage of multiplying any defect when enlarging the composition in marble, and of making wrong proportions almost impossible to rectify. The coarse and heavy execution of most of his historical compositions has been attributed to this error, of which he was evidently sensible, for he made a life-size model for his last large group, *St Michael overcoming Satan* (University College, London, on loan to the Victoria and Albert Museum).

Greatly admired for his sensitive work with the modelling tool, Flaxman was less adept with the chisel and he worked very little on the final marbles; he adopted, in fact, the pernicious practice of handing over the entire execution of the marble to workmen in his studio. The sometimes flat and dull execution that resulted robs more than a few of his marbles of the merit of a fully realized execution. Consequently we must judge Flaxman's technical gifts as a sculptor from his models, though the marbles naturally show his inventive gifts as a designer. Flaxman realized that his models were the fullest expression of his powers, for he kept them in their hundreds round the walls of his studio.

There is a certain irony in the fact that Flaxman, one of the three great sculptors of Neoclassicism, should survive not so much as a carver of the hard and eternal planes of white marble, that archetypal medium of Neoclassical art, but as a modeller of works in clay which survive for us in casts of plaster.

114 Apollo and Marpessa *c.* 1790-94

marble: 241 x 540 x 63
Royal Academy of Arts, London
lit: Irwin, 1966, pp. 64 and 109

Begun in 1790, this bas relief was probably finished before Flaxman left Rome in 1794. As with many of the sculptures he made in Italy this relief does not appear to have been commissioned. Like other marbles executed in Rome it is more highly wrought than his later works, a reflection both of the qualities of Italian masons and of Flaxman's striving to gain a reputation. He exhibited it at the Royal Academy in 1800 (1004) and presented it to the Academy as his diploma piece on his election as Academician later in the same year.

The subject, a rare one, is to be found on vases; it illustrates a story from the *Iliad* in which Apollo carried off Marpessa from Idas. Zeus intervened in the ensuing flight between the two lovers and left the decision with Marpessa, who chose Idas from fear lest Apollo should desert her if she grew old.

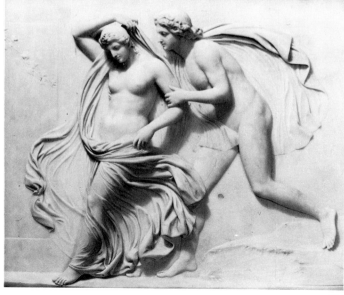

114

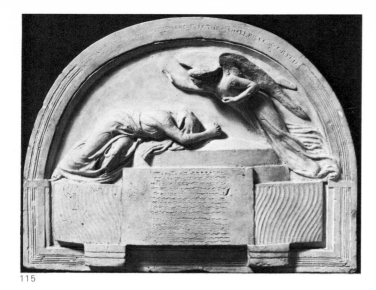

115

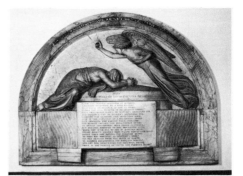

Ill. 46 Mary Blackshaw monument, St Mary's, Lewisham

115 Blessed are They That Mourn for They Shall be Comforted 1798-99
monument to Mary Blackshaw

plaster sketch-model: 400 x 502
University College, London
lit: Croft-Murray, 1939-40, p. 62;
Whinney and Gunnis, 1967, no. 96

Mary Blackshaw (1771-97), eldest daughter of William Lushington M.P. for London 1795-1802, banker, and Paulina his wife: wife of George Blackshaw of Portland Place. The monument in St Mary's Church, Lewisham (ill. 46), was commissioned by Mrs Lushington after seeing Flaxman's monument to Collins in Chichester Cathedral and reading the verses by Hayley thereon. In writing to Hayley on 20 July 1798, entreating him on Mrs Lushington's behalf to write an epitaph for 'her beloved angel', he described his patron as 'a very amiable mother, really bowed down by sorrow almost to her grave' at the loss of 'her eldest daughter, her nearest, dearest and most intimate friend'. Flaxman portrays the sorrow of the bereaved mother who lies on the tomb of her daughter, while an angel above her points up to the text inscribed on the frame of the lunette that encloses the composition: BLESSED ARE THEY THAT MOURN FOR THEY SHALL BE COMFORTED. Below the tomb the central panel is reserved for the verses Hayley wrote as a tribute to the heartfelt affliction of Mrs Lushington:

Blame not, ye calm observers of distress,
A mother sorrowing to a fond excess! . . .

A large model for the figures only is in the Flaxman Gallery at University College, London.

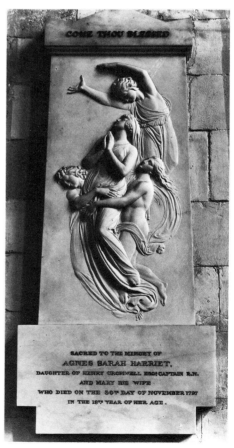

Ill. 47 Agnes Cromwell monument, Chichester Cathedral

116a Come thou blessed 1798-1800
monument to Agnes Cromwell

plaster sketch-model: 337 x 171
University College, London
lit: Croft-Murray, 1939-40, p. 61:
Whinney and Gunnis, 1967, no. 97

Rough sketch-model of the whole monument in Chichester Cathedral (ill. 47), showing the positions of the figures, and their degree of relief. The only surviving example of a rough sketch. Probably executed after no. 116b in order to show the proportions of the bas relief when transferred to the monument. The marble monument was exhibited at the Royal Academy in 1800 (1056).

Agnes Cromwell (d. 1797, aged 18) daughter of Captain Henry Cromwell, R.N.

116a

116b

116b Come thou blessed *c.* 1797-98

plaster sketch-model: 520 x 260
University College, London
lit: W. Hayley, *Memoirs*, II, 1823, pp. 397-98; Whinney and Gunnis no. 98

Sketch-model for the figures of a bas relief showing a young female figure borne upwards to Heaven by two angels while a third floats above.

Flaxman exhibited a bas relief of this composition before receiving a commission for a monument from it. For several years after his return from Rome he was still striving to establish himself as a sculptor in London; most of the figured monuments he made during those years were commissioned through friends, and he was anxious to extend his public practice beyond inscribed tablets. It is not therefore surprising to learn that he made more preparatory sketches for this composition than was subsequently to be his practice. A sketch-model for the figures is in the Sir John Soane Museum, another (destroyed) was formerly at University College, London.

Flaxman wrote to Thomas Hayley on 20 July 1798: 'I think you were pleased with my composition, which is to be introduced in Miss Cromwell's monument for Chichester. It is from a bas-relief which I exhibited. When you are stronger, I beg you to look out a fine light in the Cathedral for this small piece of sculpture, which is one of my chief favourites.' This model was probably executed in connection with the exhibited bas relief. A large model belonging to University College, London shows slight alterations in the position of the arms of the supporting angels and in the flow of hair into drapery that were incorporated into the monument to Miss Cromwell.

117

117 Monument to George Steevens after 1800
St Matthias, Poplar

marble relief with inscribed tablet: 1730 x 1080
Diocese of London
lit: Rev. Daniel Lysons, *The Environs of London*, 2nd edition, 1811, vol. 2, part 2, County of Middlesex, pp. 699-700; Smith, *Nollekens and his Times*, 1828, vol. I, p. 70; N. Pevsner, *London, except the Cities of London and Westminster*, Buildings of England series, 1952, p. 316

This celebrated monument was one of Flaxman's best-known monuments in his own day, and it has retained its reputation, in Pevsner's words, as 'an unaffected composition of great ease'. It is also notable in being of a famous and controversial literary figure of the period.

George Steevens (1736-1800) had a great reputation as a Shakespeare scholar, in particular for his efforts to establish a correct text through the systematic study and annotation of early sources. His knowledge was based upon his own great collection of Elizabethan literature, and he was also known as the foremost collector and connoisseur of Hogarth's engravings of his time. He was by no means as retiring as these pursuits would suggest, and his own personality overshadowed his achievements for many of his contemporaries. Dr Johnson, of whose circle Steevens was a notable member, remarked that he made 'sport of people by vexing their vanity', which is a gentle way of saying that he was a merciless mocker of his friends and his enemies and a ferocious controversialist. He knew no moderation in his opinions of fellow scholars, and his commentaries are enlivened by contempt for his predecessors, some of whom hit back in equally strong terms. He clearly relished a life of combat, but in the end he found himself increasingly isolated, and retired to his house in Hampstead as an 'outlaw' where his conduct became ever more strange. J.T. Smith in *Nollekens and his Times* recounts that on the day of his death he came into his servants' kitchen and 'snatched at their pudding, which he ate most voraciously, at the same time defying the grinning monster in the most terrific language'.

Steevens was also capable of acts of spontaneous kindness and charity, but the extremes of his personality are hardly captured by Hayley's epitaph:

How oft has pleasure in the social hour
Smil'd at his wit's exhilirating power.
And truth attested with delight intense
The serious charms of his colloquial sense.

Hayley had been a friend from early years, and they had both attended the same school in Kingston-on-Thames, although at different times. His conception of Steevens, which he no doubt imparted to Flaxman, was influenced by the scholar's private personality, and the final monument is unsurpassed in Flaxman's oeuvre in its quiet humour and geniality. Hayley wrote the epitaph beneath the monument, but his precise role in its erection has not yet emerged. It is safe to see the monument, however, as one of the most characteristic and sympathetic products of the collaboration between sculptor and poet. The pose may also have been influenced by Hayley's knowledge of Steevens' personal vanity, for Smith recounts that 'Steevens, who had remarkably handsome legs, which he generally covered with white cotton stockings, would frequently pique himself upon having walked from his house at Hampstead, half over London, and back, without receiving a speck of dirt upon them.'

The Church of St Matthias, Poplar was originally built by the East India Company, of which Steevens' father had been a wealthy director. D.B.

118

118 Henry Philip Hope *c.* 1801-03

marble: h. 542
Copenhagen, Thorvaldsen Museum
lit: Croft-Murray, p. 80: Watkin, 1968,
p. 118, fig. 16

Henry Philip Hope (1774-1839), youngest
brother of the celebrated virtuoso Thomas
Hope, was an influential early patron of
Flaxman. He commissioned the bust for the
centre of the chimney-piece of the dining-
room of the house in Duchess Street, London,
which he was remodelling in accordance with
the theories he published in *Household
Furniture*, 1807 (ill. 48). At Thomas Hope's
request the bust was posed frontally, accord-
ing to Greek practice, and is an early example
of strict Neoclassic aesthetic, pioneered by
Hope. Inscribed Φιλιππος, (meaning horse-
lover), the second of Henry Philip's names,
the bust was flanked on the chimney-piece by a
large pair of antique horses' heads. As a
young man Henry Philip Hope travelled in
Europe and Asia. He later settled in London
and amassed a collection of diamonds valued
at £150,000, as well as a large collection of
Dutch and Flemish pictures which he gave
to his brother. He bought Chart Park,
adjoining his brother's estate at Deepdene,
and presented it to his mother. Munificent
in his charities, Hope died unmarried and left
large fortunes to his three nephews.

Flaxman charged 80 guineas for the bust in
1803. In the previous year he had exhibited
at the Royal Academy (959) a bust of H.P.
Hope, perhaps the plaster from which the
present marble was carved. After Thomas
Hope's son sold Duchess Street the bust was
taken to Deepdene where it was in the sale
of the property in 1917 (Humbert & Flint,
1917, lot 1130).

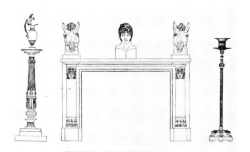

Ill. 48 Chimney-piece of Thomas Hope's dining
room, from *Household Furniture*, 1807

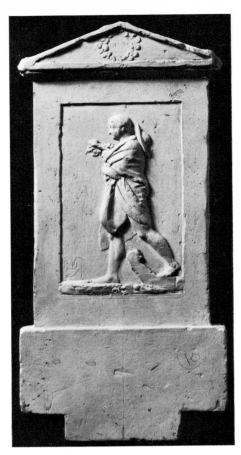

119

Ill. 49 John Sibthorp monument, Bath Abbey

119 Dr John Sibthorp 1802

plaster sketch-model: 425 x 200
University College, London
lit: Croft-Murray, 1939-40, p. 64:
Whinney and Gunnis, 1967, no. 51; Penny,
1977, pp. 26-8

That Flaxman received the commission for
the monument, erected in Bath Abbey (ill.
49), was undoubtedly due to one of Sib-
thorp's executors, John Hawkins, who had
known and patronised Flaxman during his
period in Rome. The originality of this Greek-
revival monument, in the form of stele, must
lie with those who commissioned it: Sib-
thorp is shown as an ancient Grecian
traveller wearing a *chlamys* with a *petasus*
slung on his back. But in the absence of any
document about the commission we can only
surmise that Sibthorp is here stepping from
Charon's boat onto a shore with a distant
temple, and that the bunch of flowers he
carries is emblematic of the wish, provided

for in his will, that the work he began should
be continued and published after his death.
In the pediment is a garland of *Sibthorpia
europaea*, the Cornish Moneywort, a creeper
named after Sibthorp's father; faintly in-
scribed within the garland (on the plaster
model only) is the name SIBTHORP. Three
palmetic acroteria are now missing from the
pediment.

John Sibthorp M.D., R.S.S. (1758-96),
botanist. A founder member of the Linnaean
Society, Sibthorp succeeded his father Hum-
phrey as Sherardian Professor of Botany at
Oxford University. An intrepid traveller, he
visited Greece, Cyprus and the Levant in
search not only of the flora, but also the
survival of ancient knowledge and nomen-
clature, and all matters of antiquarian in-
terest. Sibthorp died on his third journey,
two years after the publication of his *Flora
Oxoniensis*. His *Flora Graecae Prodromus* (2
vols., 1806-13) and his *Flora Graecae Sib-
thorpiana* (10 vols., 1806-40) were edited and
published posthumously.

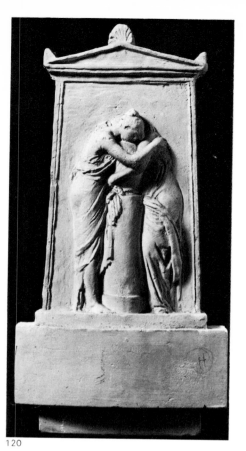

120

120 Two Sisters in Affliction 1804
Monument to John and Susannah
Phillimore

plaster sketch-model: 413 x 234
University College, London
lit: Croft-Murray, 1939-40, p. 83: Whinney
and Gunnis, 1967, no. 71

John Phillimore (d. 1795) of New Broad
Street, London, and Susannah Phillimore (d.
1762), his wife. A typical example of a type of
monument designed in the shape of a tapering
stele surmounted by a pediment with acroteria,
containing one or more figures mourning
over an urn; below an inscription tablet.

A large model for the figures is in the
Flaxman Gallery at University College, London.
The marble, formerly at St Stephen's
Church, Coleman Street, London was
destroyed.

121 Angels Strewing Flowers on the Tomb
of a Deceased Poet 1804-05
Monument to Isaac Hawkins Browne

plaster sketch-model: 254 x 381
University College, London
lit: Croft-Murray, p. 81; Whinney and
Gunnis, 1967, no. 106: Penny, 1977, p. 103

The model was formerly surmounted by a
medallion containing a portrait head of
Browne (now missing), a design which was
carried out in marble, the medallion being
encircled by a wreath of bay. Several preparatory
drawings for this monument exist,
and a full-size model was made for the figures
of the angels (formerly University College,
London, destroyed). Flaxman gave the composition
its title when it was exhibited at the
Royal Academy in 1805 (764).

Isaac Hawkins Browne the elder (1705-60),
poet and wit; author of the Latin poem *De
Animi Immortalitate* 1754; M.P. for Wenlock;
friend of Dr Johnson and father of Isaac
Hawkins Browne the younger, essayist, who
commissioned the monument in Trinity
College Chapel, Cambridge (ill. 50).

Ill. 50 Isaac Hawkins Browne monument, Trinity
College, Cambridge

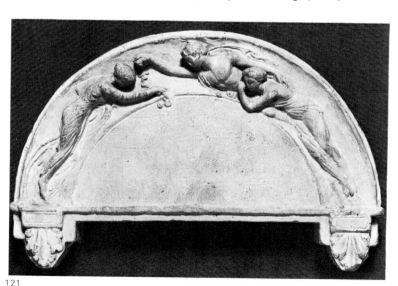

121

122 Mercury descending with Pandora
 c. 1804-05

plaster: 720 × 800
Ny Carlsberg Glypthotek, Copenhagen

Pandora brought to Earth, an illustration to
Hesiod, *Works and Days*:

> He bade Heaven's messenger convey thro' air
> To Epimetheus hands.

The days of innocence and the idyllic subject-
matter of Hesiod delighted Flaxman who
published line illustrations to *Works and
Days* and to the *Theogony* in 1817 using the
composition for plate 6. *Mercury descending
with Pandora* was one of his favourite works
and he exhibited it at the Royal Academy in
1805 (765). A plaster sketch-model is at
University College, London.

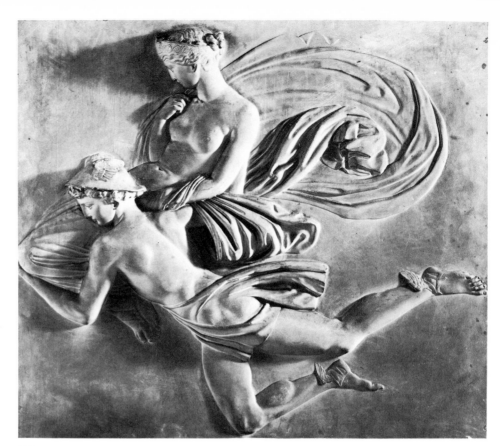

122

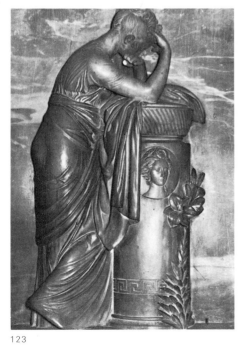

123

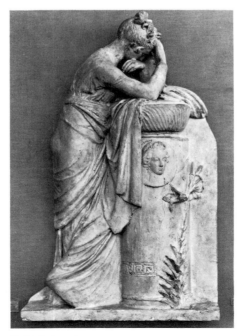

Ill. 51 Barbara Lowther monument, Richmond,
Surrey

123 Draped Female Mourning over an Urn
 1805-07
 Monument to the Hon. Barbara
 Lowther

plaster model (irregular; background
missing): 1162 × 660
University College, London
lit: Croft-Murray, 1939-40, p. 86;
Whinney and Gunnis, no. 107

Large-scale model for the figure with fully
worked details ready for transferring to
marble. The medallion portrait-head on the
pedestal supporting the urn is of Barbara
Lowther.
 The Hon. Barbara Lowther (d. 1805),
daughter of Robert Lowther, sister of the 1st
Earl of Lonsdale and of Katherine, Duchess
of Bolton, who erected the monument in the
church of St Mary Magdalene, Richmond
(ill. 51).

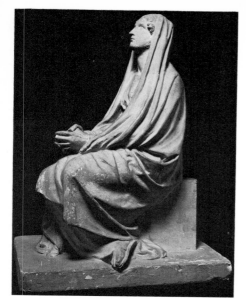

124

124 Resignation 1806-09
Part of the monument to the Baring
family

plaster model: 622 x 450
University College, London
lit: Croft-Murray, 1939-40, p. 93;
Whinney and Gunnis, 1967, no. 113

Model in the round for the figure of Resigna-
tion (R.A. 1809, 817) which forms the central
and first part of the monument to the Baring
family, erected in Micheldever Church in
1809 (ill. 52). Commissioned by Sir Francis
Baring, 1st Baronet (1740-1810), merchant
and banker, founder of Baring Brothers, and
Director and Chairman of the East India
Company, as a monument to his wife
Harriet (d. 1804).

Writing to Flaxman about the commission,
Sir Francis told him in July 1806: 'The design
you preferred has been approved', and again,
in 1809, after the monument was erected:
'The monument is universally admired as
well as the church they are worthy of each
other.' The monument shows the figure seated
on a plinth decorated with quatrefoil tracery
in front of the inscription tablet and beneath
a shallow gothic arch framing the inscription
THY WILL BE DONE. At the top of the centre is a
shield bearing the coat-of-arms surmounted
by a helm, to either side the bust of an angel.
A sketch-model for this composition is in
University College, London (Whinney and
Gunnis, no. 89) and a drawing for the figure of
Resignation is in the British Museum.

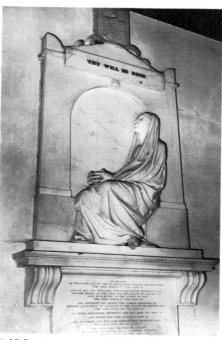

Ill. 53 Bromley monument, Baginton, Warwickshire

Ill. 52 Baring monument, sketch for setting,
Fitzwilliam Museum, Cambridge

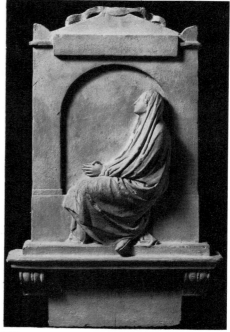

125

125 Thy Will be Done 1811-13
Monument to the Bromley family

plaster sketch-model: 508 x 330
University College, London
lit: Whinney and Gunnis, 1967, no. 75

The first of many adaptations of the figure of
Resignation from the Baring monument.
The figure is set against an arch on a pedi-
mented stele: the monument in Baginton
Church, Warwickshire, is inscribed THY WILL
BE DONE; the coat-of-arms is centred above
the ribbon which is inscribed with the family
motto (ill. 53). A drawing for this model is
at University College, London.

Erected by Mrs Lucy Price, the only sur-
viving daughter of William Bromley (d. 1769)
and his wife Bridget Davenport (d. 1778).

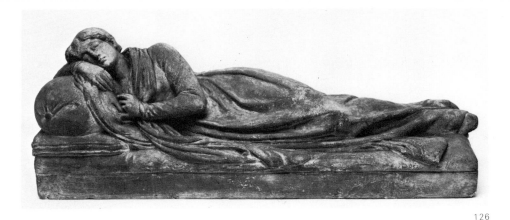

We went to the tomb, 'the grave of a poetess', where there is a monument by Flaxman: it consists of a recumbent female figure; with much of the repose, the mysterious sweetness of happy death, which is to me so affecting in monumental sculpture. There is however, a very small *Titania* – looking sort of figure with wings, sitting at the head of the sleeper, and intended to represent Psyche, which I thought interfered woefully with the single-ness of effect which the tomb would have produced: unfortunately too the monument is carved in a very rough stone, which allows no delicacy of touch.

This visit inspired Mrs Hemans' lyric:

I stood where the lips of song lay low,
Where the dust had gathered on beauty's brow,
Where stillness hung on the heart of love,
And a marble weeper kept watch above.

126 Statue of a lady, authoress of 'Psyche' a poem 1814-15
Monument to Mary Tighe

plaster sketch-model: 295 x 810
University College, London
lit: Whinney and Gunnis, 1967, no. 84:
H.F. Chorley, *Memorials of Mrs Hemans*, II, 1837, p. 193

Mary Tighe (1772-1810), poet, daughter of the Rev. William Blachford of Rosanna, Co. Wicklow, married her cousin, Henry Tighe of Woodstock, Co. Kilkenny. Mrs Tighe's poem *Psyche, or the Legend of Love* (1795), written in Spenserian stanza, was widely admired: six later editions included her other poems. Her verse is melodious and pleasingly direct and delicate. Dying of consumption contracted some five years earlier, Mary Tighe was buried in the Tighe Mausoleum at Inistioge, where Flaxman's monumental statue commemorates both her beauty and her authorship of *Psyche* (ill. 54).

The marble, which was exhibited at the R.A. in 1815 (900), includes a small figure of Psyche kneeling behind the head which is absent from both the sketch-model belonging to the Hon. Desmond Guinness and the present subsequent model, where there are, however, two holes and cut-marks in the plaster for fitting the figure. A small model of a figure of Psyche in the Soane Museum, perhaps made in 1824 for Samuel Rogers, which shows only minor differences in the length of wings and hairstyle, is closely connected with that made for Mrs Tighe's tomb.

Describing her visit to the Tighes at Woodstock in 1831 the poetess Mrs Hemans wrote:

127 Thy Will Be Done 1815-16
Monument to the Reverend Thomas Brand

plaster sketch-model: 317 x 241
University College, London
lit: Whinney and Gunnis, 1967, no. 115

The monument at Wath erected by Brand's former pupil, the 5th Earl of Ailesbury (ill. 55), is in the form of a rectangular sarcophagus with a low pedimental lid, inscribed THY WILL BE DONE. The mourning figure, clad in a *chlamys*, is seated with bowed head before an urn on a pedestal. In the marble the urn is garlanded with laurel and the knob of the lid is in the form of a pine cone. This simple Greek-revival design reflects Lord Ailesbury's interest in Neoclassical art and commemorates his travels with his tutor and preceptor.

A large-scale model for the figure was formerly in University College, London (destroyed).

The Reverend Thomas Brand M.A. (1750-1814) was tutor to Lord Bruce, eldest son of the 4th Earl of Ailesbury and his wife Susannah, daughter of Henry Hoare of Stourhead. Brand accompanied Lord Bruce on his Grand Tour from 1788-94, and in Florence in 1793 performed the ceremony of his marriage to Henrietta daughter of the 1st Lord Berwick. Brand was subsequently Rector of Wath, Yorkshire for fifteen years.

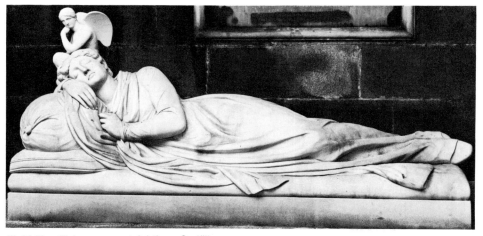

III. 54 Mary Tighe monument, Inistioge, Co. Kilkenny

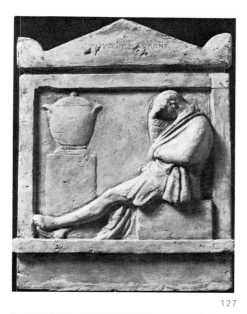

127

128

128

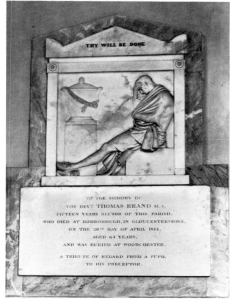

Ill. 55 Thomas Brand monument, Wath, Yorks.

128 Statuettes of Raphael and Michelangelo
c. 1825

plaster models: 680
Trustees of the British Museum

Executed for Sir Thomas Lawrence, models for statuettes of Raphael and Michelangelo were exhibited at the Royal Academy in 1826 (1074, 1075).

The figure of Michelangelo is adapted from one in the *Last Judgment* in the Sistine Chapel · in his right hand is a pair of calipers. A drawing for the figure of Raphael is at University College, London. A pair of models is at the Soane Museum and at the Royal Academy and another was formerly at University College, London (destroyed). It is not clear which pair was actually owned by Lawrence, but the British Museum versions have, perhaps, the best claim.

129 Head of an angel

plaster model: 140
University College, London

Model of a support or bracket for an unidentified monument in the gothic taste. A companion head is also in the collection of University College, London.

129

111

A small selection from the many hundreds of surviving tomb designs has been made to illustrate some of the types of monument made by Flaxman, and the problems entailed in the creation of a monument. It is difficult in most cases to know whether decisions were made by the sculptor or by the patron, but Flaxman was in general prepared to submit different designs to the patron and to accept any changes suggested. In the case of the Collins monument, the sculptor offered a wide range of possibilities and sizes, and in others he willingly offered repetitions of popular designs. Thus the figure of Resignation for the Baring monument was frequently re-used, usually with a small variation. Flaxman also offered decorative elements on memorial tablets in classical or Gothic types. The problem of costume was also one which could allow for differences of opinion between artist and patron, and in the case of the Warton monument there are two drawings showing the schoolmaster and boys in togas, but in the monument itself they are all in contemporary costume, while Warton wears a full wig.

130 Portrait of Burge, Flaxman's marble-polisher

inscribed: 'Burge'
pencil: 108 x 89
Museum of Fine Arts, Boston
lit: Smith, 1828, Vol. I, p. 451

According to J.T. Smith, Flaxman 'never kept a servant in livery, though sometimes his polisher of marble, John Burge, stood behind his chair, at the Royal Academy dinners, in his Sunday clothes.' According to Flaxman's accounts books, after he returned from Italy he had normally six assistants in his employ.

131 Portrait of Sarti, plaster-cast maker

inscribed: 'Portrait of Sarti'
pencil: 158 x 89
Museum of Fine Arts, Boston

Sarti was a plaster-cast maker who lived in Greek Street. This drawing suggests that he also acted as a model for Flaxman.

130

131

The story of the William Collins monument in Chichester Cathedral can be told in unusual detail, and we can trace the whole work from the initial proposals to the finished work in a series of drawings and an explanatory letter. Flaxman was invited from England to design the monument while he was in Italy, and he therefore submitted a number of different schemes.

William Collins (1721-59) was a major poet who was born and died in the city of Chichester. His reputation grew after his death, and in 1789 an appeal for a memorial was made by the Rev. Mr Walker, and joined by William Hayley. Hayley was instrumental in procuring the commission for his friend Flaxman, who had already been responsible for the monument to Thomas Ball and his wife, Hayley's parents-in-law, in the cathedral.

In the first 'Thought' for the monument, Flaxman proposed a characteristic mixture of Christian and classical sentiment: Collins' meditation upon the Bible was to be balanced by a frieze illustrating his famous poem 'The Passions', an ode to the goddess of Music in her pristine state in ancient Greece. According to a letter from the sculptor to Hayley, the motif of Collins reading the Bible is a reference to the poet's end: 'I have attended to your own words, "that the poet was found reading the Bible in his last illness", which situation I like much better than the action of pointing. . . . I think I have succeeded, it has pleased all who have seen it in Rome.' Flaxman's initial proposal was that the frieze should illustrate the passage of the ode where Revenge, impatient with the song of Hope, seizes the trumpet: 'And with a with'ring Look,/The War-denouncing Trumpet took,/And blew a Blast so loud and dread,/Were ne'er Prophetic Sounds so full of Woe' (see a). This apparently inappropriate sentiment may have contained a reference to Collins' madness or to the sense of loss at his death, but Flaxman also offered as a design for the frieze the previous passage in the poem, before Hope's 'soft responsive voice' was interrupted by Revenge. Flaxman included several designs in his letter to Hayley of 4 July 1792 (see d), offering the monument in different sizes with prices attached, some with or without either the frieze or the relief of Collins. In the event, the committee chose the cheapest of that type, on the model of c at £98 (see right hand-corner of b); as a result, none of the suggestions for the frieze was carried out, and the only reference to Collins' authorship of 'The Passions' which remains in the finished marble is a scroll under his chair. Flaxman worked on the final marble mainly in 1795, and it was erected that year in the cathedral, with an epitaph by Hayley and the poet John Sargent.

Transcript of portions of the letter from Flaxman to Hayley, containing schemes 1, 2 and 3. Rome 4 July 1792 (d):

Music & Painting decorating the altar of pity – in high relief – extreme dimensions of the square 4 feet
Price from 60 to 65£

132d (verso)

Rome, 4 July 1792

Dear Sir,
I thus trouble you with your own thoughts for the Honored Bard I am solicitous that my work may not degrade his memory & I disclaim profit on the present occasion, my first desire is to act with such caution respecting you, that you may not incur any additional expence in carriage or custom house-duty, for which reason I have confined the price of those designs which I think likely that the subscribers will choose, between 60 & 70 & the overplus I leave for the extra expences, among which I reckon the cutting the inscription, which it would be impossible for me to have done here by an Italian without the hazard of some enormous blunder which might ruin the work, to get the inscription cut I advise the following method: let some friend of yours in London enquire of Mr. Bacon or Mr. Banks where Mr. Chapple lives who cuts inscriptions for all the best sculptors in and about London he or his son will come down to Chichester, do that business and set up the monument at a rea[son]able expence, they are men of [the] worthiest character and of great ability in their way: in the designs I have sent I have done my best and I may say I have given them thrice the consideration which I ever gave to a similar work: it will occur to you and the other Gentlemen of the Committee, that any of these designs would derive great advantage from being executed on a more extensive scale, but you may rest assured of my utmost endeavours for the price fixed. . . . pray wh[en the] committee have determined on the sketch be so kind to cut it off and send it in yours, in return I will send a more finished drawing with price and dimensions marked for the committee to keep as an earnest of what the marble is to be.
No. 1 [written under drawing]
And Hope enchanted smil'd and wav'd her golden hair
Revenge, Anger, Fear Despair are retiring on one side on
the other Joy and Mirth led on by Love, heads of Exercise
Sport are amongst the trees
No. 2 would be the design for the Monument in which the bas-reliefs No. 1 or No. 4 might be introduced.
No. 2 (pediment with inscription underneath) with the bas-relief No. 1 might be executed with the figures about 2 feet/high, low relief, the length of the whole about 5 feet and the whole height about/4 feet 6 inches for about £70 – but the bas-relief being the principal object/of the Monument would not be sufficiently large and distinct to produce/a good effect, on the contrary the figures in No. 6 forming only a/kind of framework to the inscription could not fail I think of/exciting the spectator's attention to observe and decypher the former whilst he read the latter.

132a

132b

132

a Study for whole monument

inscribed: 'Thought for a Monument for Colins the Poet. J. Flaxman.'
pen and wash: 264 x 190
Whitworth Art Gallery, University of Manchester

The relief is barely sketched in but clearly shows Revenge blowing the trumpet.

b Schemes A, B and C for the monument with different prices

pen and wash: 364 x 234
Trustees of the British Museum
lit: Constable, 1927, pp. 41-5: *Age of Neo-Classicism*, 1972, nos. 566-67

A scale is given at the side. D represents scheme A seen from the side.

c Schemes E and F for the monument

pen and wash: 234 x 361
Trustees of the British Museum

Here Flaxman is proposing that the relief of *The Passions* should form the principal motif of the monument, without the figure of Collins.

132c

d Letter from Flaxman to Hayley, containing schemes 1, 2 and (on the verso) 3; Rome, 4 July 1792

pen and wash: 390 x 267
Trustees of the British Museum

Here Flaxman proposes an alternative pediment shape for *The Passions* for which the design of Hope standing in the centre was more appropriate. The line illustrated here is '& Hope enchanted smiled & wav'd her golden hair'.

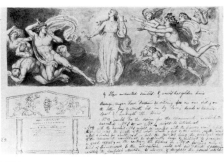
132d

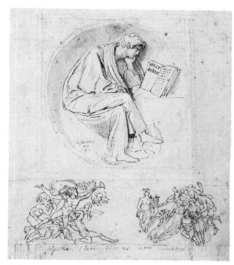

132e

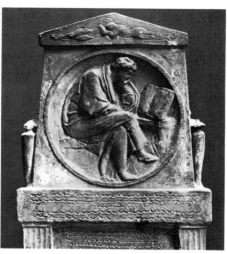

132f

132g

e A study for the monument

inscribed: 'figures I foot. figures more dispersed'
pen and wash: 165 x 143
Trustees of the British Museum

A narrower frieze is here proposed. The manuscript of 'Passions an Ode' has now appeared beneath the figure of Collins.

f Sketch-model for the monument
photograph only

plaster, destroyed in Second World War
formerly University College, London

The beautiful motif of an angel embracing the soul has now appeared at the top.

g The final monument in Chichester Cathedral
photograph only

marble

The verses by Hayley and Sargent refer to Collins' madness in his final years, when he haunted Chichester Cathedral in despair, finding solace at the end only in the Bible.

h Engraving showing an early installation of the monument

from H and B Winkles, *architectural and picturesque illustrations of the cathedral churches of England and Wales*, 1836-42: 145 x 102
David Fuller Esq.

This engraving after H.K. Brown shows the installation before it was moved to an adjacent wall, where it now rests.

132h

115

133 The Mansfield monument, Westminster Abbey

lit: Whinney, pp. 189-90 and 273, notes 31-3

a The first scheme, as a relief monument

pen and wash: 194 x 158
Hamburg, Kunsthalle

Professor David Irwin has kindly identified this drawing as being of the first scheme for the Mansfield monument, commissioned originally by Mansfield's nephew but submitted to Sir William Hamilton for approval. On 30 July 1793 Flaxman wrote to Hamilton describing a design of Mansfield seated high above Justice and Wisdom, the latter wearing Minerva's helmet 'to mark his Lordship's attic wit', with swords of Justice and Mercy bound together by a civic crown above the group. Professor Irwin has also pointed out that this suggests that Flaxman had at this stage a wall monument in mind, although it subsequently was executed as a free-standing monument, after Flaxman's return from Italy.

b The Mansfield Monument in its setting

pen and wash: 225 x 175
University College, London

This design is one of three in the same collection intended to show the placement of the monument in Westminster Abbey, so it must date from after Flaxman's return to England in 1794 (ill. 56). The conception has now become free-standing, although in most respects it follows the general form of the Papal tomb, with Lord Mansfield enthroned and Justice and Minerva flanking him, but with the addition of the figure of a condemned youth behind him. We can connect this not altogether happy solution with some drawings of Papal tombs in St Peter's in an Italian sketchbook (see no. 86). The monument was set up in 1801, but was moved to a less conspicuous position in the abbey in 1933.

134 Study for a monument *c.* 1813

pen and wash: 268 x 178
Trustees of the British Museum

An example of the way in which Flaxman repeated the figure of a mourning female in several monuments (see ills. 57, 57a), but provided different settings in various Gothic and classical modes. The figure in the Bromley monument (no. 125) can be identified from a preliminary drawing as Resignation, but the Bible here may identify this figure as Religion, an appropriate allegory if the design is, as has been suggested, for the tomb of the Rev. William Saltren (d. 1811) in Holme Pierrepont Church, Nottingham. The figure for that monument, however, faces in the opposite direction.

III. 56 Lord Mansfield monument, Westminster Abbey

133a

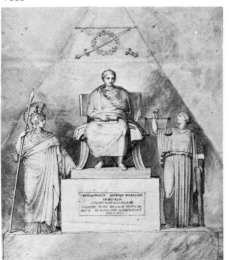

133b

134

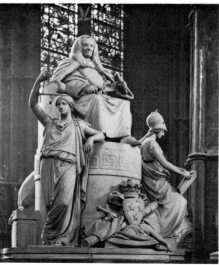

134

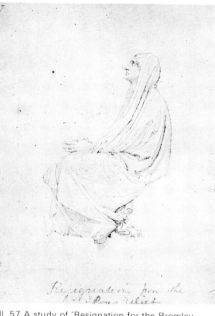

Ill. 57 A study of 'Resignation for the Bromley
Monument' (no. 125), British Museum

Ill. 57a Study possibly for the Mrs Wortley
Mackenzie monument, Wortley Church,
Yorks.

135 Study for a proposed monument to John Howard *c.* 1800

inscribed on a separate piece of paper:
'To Howard'
pen and wash: 132 x 186
Hamburg, Kunsthalle

John Howard, the great prison reformer and author of *The Principal Lazarettos in Europe*, 1789, was particularly admired by William Hayley and his circle, and his visits to the horrific prisons and lazar-houses of Europe were the subject of several drawings by George Romney (see Patricia Jaffé, *Drawings by George Romney*, Fitzwilliam Museum, 1977, nos. 94-100). Howard died in 1790, the occasion of a long panegyric by Hayley, but the commission for the monument in St Paul's went to another sculptor, John Bacon, who had already begun work on it in 1791 (Whinney, p. 270, n. 15). In fact the form of this drawing suggests a bas relief at the base of a statue rather than a relief tomb, and we know that Hayley was involved in such a scheme in 1800. Howard was to hold in his hand a lamp which should shed 'a splendid and perpetual light' (Bishop, 1951, p. 104).

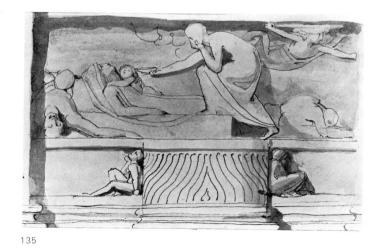

135

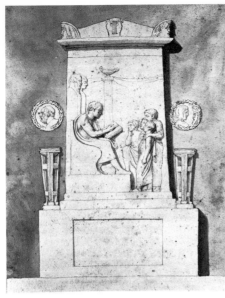

136

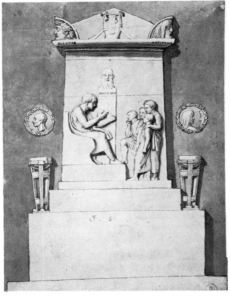

Ill. 58a Design for the tomb of Dr Joseph Warton, British Museum

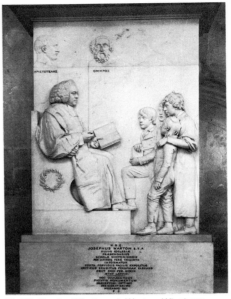

Ill. 58b Tomb of Dr Joseph Warton, Winchester Cathedral

136 Design for the tomb of Dr Joseph Warton 1804
Winchester Cathedral

pen and wash: 302 x 222
Victoria and Albert Museum
lit: Whinney, 1964, p. 193; Bishop, 1951, p. 86; Penny, 1977, pp. 153-55

This is one of two finished designs for the Warton monument, the other being in the British Museum (ill. 58a). Both the drawings show Dr Warton, who was the headmaster of Winchester School, *all'antica*, but in the final monument (ill. 58b) he is shown in con-temporary costume, although classical allu-sions remain. The final monument has a grace and naturalness which put it in the first rank of Flaxman's monuments, belying the unfortunate career of the subject, whose scholars rebelled on three occasions. Accord-ing to Morchard Bishop, the monument 'represents him paternally instructing sundry angelic boys who, being composed of marble, are incapable of mutiny'. Warton was a friend of William Hayley, who was no doubt responsible for the commission, although Penny suggests it may have come through the Hare-Naylors, Flaxman's Roman patrons, whose sons served as models for the boys.

137 Design for a tomb in a classical style

pen and wash: 156 x 186
Hamburg, Kunsthalle

This design has been connected with a pro-ject for a tomb of John Howard, but this is unlikely as the deceased appears to be female. It might be an alternative design for the tomb of Mary Blackshaw (see no. 115).

137

139 A Letter to the Committee for Raising the Naval Pillar 1799

a pamphlet with 3 engravings by Blake after Flaxman: 250 x 195
Trustees of the British Museum

b Flaxman's drawing for 'Britannia by Divine Providence triumphant'
pen: 191 x 152
inscribed: 'Colossal statue 230 feet high proposed to be erected on Greenwich'
Victoria and Albert Museum
lit: *Blake Books*, no. 458: Whinney, 1964, p. 190

The scheme was intended to commemorate the British naval victory in the Battle of the Nile, and springs from the same propagandist spirit as the massive tombs to naval heroes in St Paul's Cathedral. Flaxman's pamphlet states the case for such a colossal monument by citing precedents in the ancient world. Fortunately this monstrous scheme was not carried out, for it would have dominated Wren's great buildings at Greenwich and been visible across London. A much more agreeable suggestion for the same purpose can be seen in Flaxman's drawing of a Commemorative Arch (Princeton University Art Museum; illustrated in Rosenblum, pl. 188). There is a model of Britannia in the Soane Museum.

138 Study for a tomb in a Gothic style

pen and wash: 246 x 286
The Syndics of the Fitzwilliam Museum, Cambridge

This drawing appears to be a study for a proposed tomb, rather than a copy of an existing medieval one. The tomb, if it were intended as a serious project, is not known to have been completed.

138

139

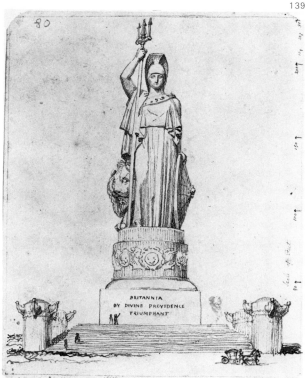

It is surprising that the success of the illustrations to Homer, Aeschylus and Dante did not lead to the publication of more such series. In fact apart from the above, only the designs for Hesiod and three plates for an edition of Milton were published in Flaxman's lifetime, and *The Acts of Mercy* and *The Lord's Prayer* only after his death. The *Pilgrim's Progress* drawings were never published, and we can only assume that Flaxman was reluctant to allow them to overshadow his reputation as a sculptor. He seems to have regarded some of them, such as *The Knight of the Blazing Cross*, as private works, and he may well have done other groups of drawings for friends. These series were also used as a source for tomb designs, especially *The Acts of Mercy* and *The Lord's Prayer*. In addition there are many drawings of Biblical subjects which cannot be associated with any known series, and he occasionally in later years made highly finished drawings on classical themes.

140

140 The Knight of the Blazing Cross 1796

manuscript volume of 26 pages, written and illustrated with pen drawings by Flaxman:
c. 248 x 183
The Syndics of the Fitzwilliam Museum, Cambridge
lit: Irwin, p. 160

This manuscript, which is entirely in Flaxman's hand, was intended as a birthday present to his wife and a commemoration of fifteen years of marriage. The idea behind the work is made clear in the dedication:

The Anniversary of Your Birth-Day calls on me to be grateful for Fifteen Happy Years passed in your Society: Accept the tribute of these Sketches which were produced at Your desire; under the allegory of a Knight Errant's Adventures are indicated the trials of Virtue, the Struggles and Conquest of Vice preparatory to a happier state of existence; after the Hero is exalted to the Spiritual World and blessed with a Celestial Union he is then armed with the power of the Elements for the exercise of his ministry in the dispensations of Providence, he becomes the Associate of Faith,

Hope and Charity, and his Universal Benevolence is employed in the Acts of Mercy.

The work is one of a series of birthday presents from Flaxman to his wife, which includes a volume of portraits of his friends, also in the Fitzwilliam Museum, and the watercolour illustrations to Gray's *Poems* by William Blake at the Yale Center for British Art. This context suggests that the work should not be taken too seriously, but it does provide insight into the spiritual direction of of Flaxman's mind. The book is strongly Swedenborgian in spirit in its emphasis both on good works and on the afterlife. The work ends with the knight carrying out some of the Acts of Mercy which were to be the subject of a series of drawings (see no. 147), and these are seen in the light of heavenly salvation: 'so shall thine own free spirit learn to spurn this prison house of flesh/And rise to Heavenly Bliss and Freedom'. It is perhaps also worth pointing out that the work was particularly admired by Swedenborgians: the Rev. J. Clowes, the well-known Swedenborgian churchman, tried to persuade Flaxman to publish it.

141

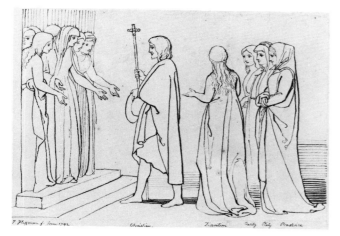

Ill. 59 Illustration to *Pilgrim's Progress*, Yale Center
for British Art, New Haven, Conn.

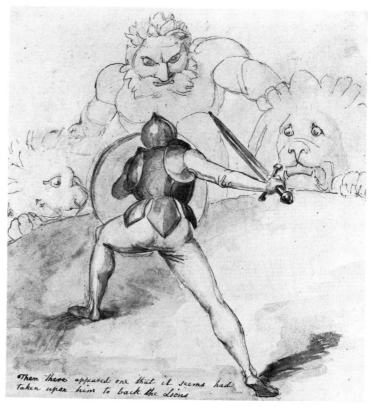

142

141 **Christian and the Giant Despair** 1792
from *Pilgrim's Progress*

inscribed: 'J. Flaxman f. June 1792 At this
they trembled greatly: & I think that
Christian fell into a Swoon: Pilgrim's
Progress'

Drawn in Rome in 1792, when Flaxman was
beginning work also on the Homer designs.
This drawing, and others in the same style,
similarly dated, at the Yale Center for British
Art (ill. 59) and in the British Museum, show
that Flaxman was working on a series on
Bunyan's *Pilgrim's Progress*, possibly with a
view to line engraving. It is probable that his
patrons in Rome responded more enthu-
siastically to classical than to Christian
subjects.

142 **Christian and the Lions** after 1800?
from *Pilgrim's Progress*

inscribed: 'Then there appeared one that it
seems had taken upon him to back the Lions'
pen and wash: 200 x 180
York City Art Gallery

This drawing belongs to a widely dispersed
group of studies and finished drawings for
Pilgrim's Progress which seem later than the
Roman versions. Here Flaxman has empha-
sized more the 'Knightly' character of
Christian, which comes closer to his concep-
tion of *The Knight of the Blazing Cross*. There
are also many small *Pilgrim's Progress*
drawings in the Huntington Library, Univer-
sity College, London and in the British
Museum which have extensive quotations
from Bunyan's text, suggesting that Flaxman
had contemplated making an illuminated
manuscript of the book.

121

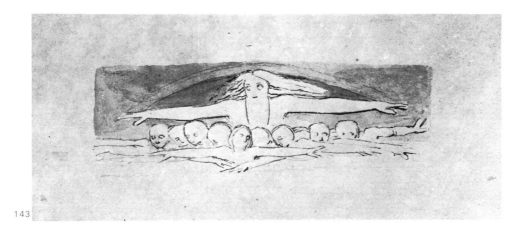

143

143 And God Made the Firmament

pen and wash: 81 x 177
The Syndics of the Fitzwilliam Museum,
Cambridge

A study for a more finished drawing in the
Huntington Library which is inscribed with
the passage beginning 'And God made the
firmament' (Genesis, I, 5). Robert Wark
notes the Blakean character of the design
(*Wark*, 1970, no. 28). This drawing does not
appear to belong to an identifiable series, but
it may be compared with a drawing of *The
Creation of the Heavens* in the Yale Center for
British Art (Flaxman, 1976, no. 24).

144 Three Marys at the Sepulchre

pen and wash: 103 x 159
University College, London, no. 679

This drawing can be connected with others
of the same format of scenes from the Life
of Christ (see ill. 60), but there is no evidence
of Flaxman's intentions for them. This draw-
ing is remarkable for its religious fervour and
for the expressive contrast between the
emptiness of the tomb and the prospect of
Resurrection.

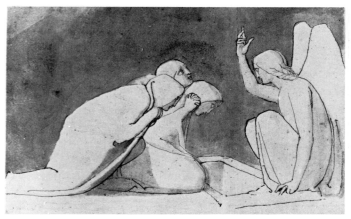

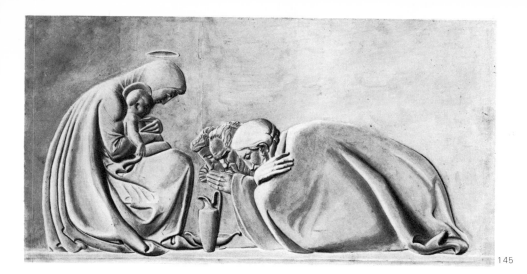

145

145 The Adoration of the Magi

pen and wash, in imitation of bas relief:
272 x 472
Trustees of the British Museum
lit: Denman sale cat., 1862, no. 300

This unique drawing is an imitation in pen
and wash of bas relief. Its purpose is unknown,
but it was certainly connected with a sculptural project. A plaster-relief model corresponding to this design was at University
College, London, but was destroyed in the
last war. This drawing was lot 300 in the
Denman sale of 10 April 1862: '*The Adoration
of the Magi. A finished drawing in imitation
of a bas relief*'.

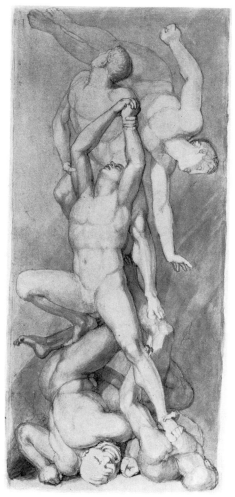

146 But Deliver us from Evil

inscribed: 'But Deliver us from Evil'
pen and wash: 445 x 197
Christopher Powney Esq.
lit: *The Lord's Prayer*, 1835

A finished drawing for the group of designs
for *The Lord's Prayer*, which were lithographed after Flaxman's death in 1835. Like
The Acts of Mercy they appear to have been
intended for publication, but this was not
achieved in Flaxman's lifetime. A similar
design was used for the Baring monument,
1806-13 (see Whinney and Gunnis, no. 5).

146

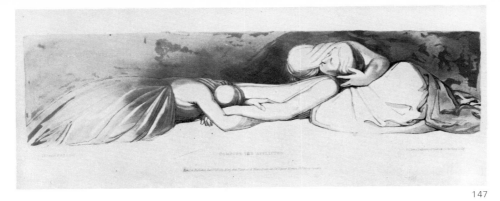

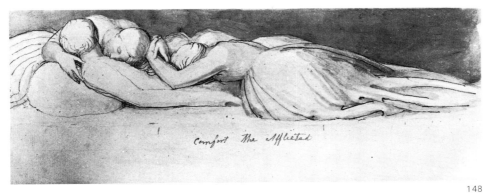

147

148

147 The Acts of Mercy 1831
engraved by F.C. Lewis after Flaxman

8 aquatints: 323 x 510
Christopher Powney Esq.

These fine aquatints were published after Flaxman's death by his heirs from drawings left by Flaxman, several of which are included here.

149 Clothe the Naked

pen and wash: 262 x 297
Trustees of the British Museum
lit: *The Acts of Mercy*, 1831

A drawing for *The Acts of Mercy* published after Flaxman's death in 1831.

148 Comfort the Afflicted 1810-25

inscribed: 'Comfort the Afflicted'
pen and wash: 197 x 315
Whitworth Art Gallery, University of Manchester
lit: *The Acts of Mercy*, eng. by F.C. Lewis after Flaxman, 1831

One of a series of studies for the eight *Acts of Mercy*, to which nos. 80, 149 and 150 also belong. The drawings for *The Acts of Mercy* are scattered in different collections and do not appear to be homogeneous in finish. They were gathered together and engraved by F.C. Lewis in a large volume published by Flaxman's heirs in 1831. In fact this design is described as *Go to the House of Mourning* in the published edition, and that is perhaps a more likely title.

149

124

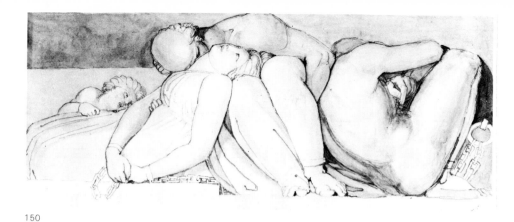

150

150 Deliver the Captive

inscribed: 'Deliver the Captive J. Flaxman d.'
pen and wash: 144 x 327
Trustees of the British Museum
lit: *The Acts of Mercy*, 1831

Another drawing for *The Acts of Mercy*.

151 Maternal Love

pencil, pen and ink with sepia wash:
239 x 207
Whitworth Art Gallery, University of
Manchester

This drawing, which is almost certainly a late work, can be related to a number of studies of the Tulk family, who were, like Flaxman, devoted followers of Swedenborg (see no.

152). A drawing of Mrs Charles Augustus Tulk and her two sons in the Fitzwilliam Museum is dated 1816 (see ill. 61), and there is another version of that drawing illustrated in the Heim catalogue, 1976 (no. 53). This drawing is evidently meant to be a more general depiction of the theme of domestic affection, but it is still based on observation. It is also influenced by Michelangelo's Madonnas, which Flaxman particularly admired (see *Lectures*, 1828, pl. 38).

III. 61 *Mrs Charles Tulk and her Sons*, Fitzwilliam Museum, Cambridge

151

152 Evil Spirits cast out

from Emmanuel Swedenborg's *Arcana Coelestia*, no. 1272

watercolour over pen and pencil: 226 x 184
Christopher Powney Esq.

This drawing is almost unique in Flaxman's oeuvre in being a watercolour: only one other on this scale is recorded, in the collection of the Hon. C. Lennox-Boyd. The identification with the passage in Swedenborg depends on a preliminary drawing, also in the Powney collection, inscribed with the number '1272', which belongs to a group of drawings illustrating the *Arcana Coelestia*.

The passage illustrated appears to come in fact in paragraph 1271, in which Swedenborg tells of deceitful spirits who 'supposed that they had all power to do what they pleased, and that they could take away life from everyone: but to expose the vanity of this imagination, they were thrust down again to their infernal abodes by a little child, at whose presence they began so to totter and tremble that they could not help expressing their anguish by cries'. Flaxman had been connected with forerunners of the New Jerusalem Church in the mid-1780s, and in later life he belonged to a group devoted to the ideas of Swedenborg but which did not wish to join

the Swedenborgians in a formal sense, and thus sever connection with the Church of England. In this he was closely associated with his friend Charles Tulk (1786-1849), who also knew Coleridge and Blake (see Raymond H. Deck, Jr., 'New Light on C.A. Tulk', *Studies in Romanticism*, Vol. 16, no. 2, 1977, p. 217). Flaxman had been an active member of the New Church under Joseph Proud between 1797 and 1799, but apparently gave up formal contact with it subsequently. He and Tulk were later members of 'The Society for Printing and Publishing the Writings of the Hon. Emmanuel Swedenborg', formed in 1810.

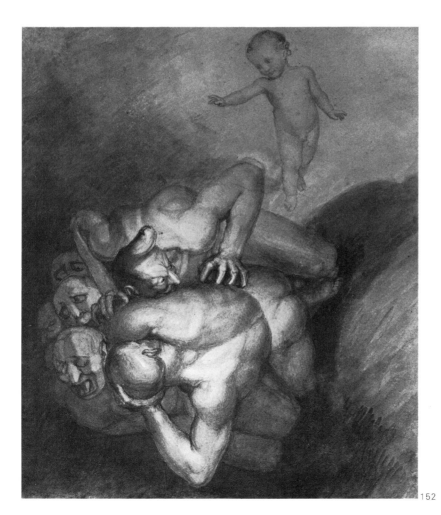

152

153 Illustration to Emmanuel Swedenborg's Arcana Coelestia

pen and wash: 103 x 192
Trustees of the British Museum

This drawing belongs to a group of illustrations to the *Arcana Coelestia*, of which there are examples in the British Museum and in the Powney collection (see Heim cat. nos. 35-8). Unfortunately the number of the paragraph has been cut off.

153

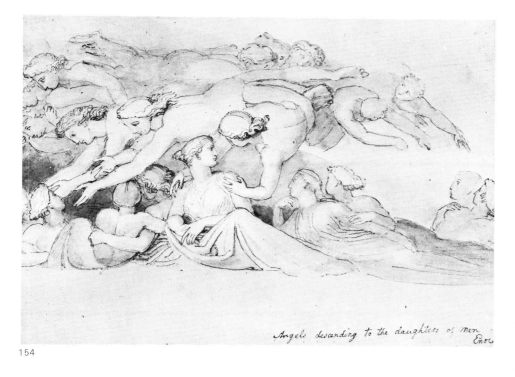

154

154 Angels descending to the daughters of Men

inscribed: 'Angels descending to the daughters of Men Enoch'
pen and wash: 166 x 230
University College, London, no. 667

This drawing is for the apocryphal *Book of Enoch*, which was rediscovered in an Ethiopian version in 1773 and was translated into English in 1821. Flaxman made many drawings from the book, and the shaky handling of some of them suggests a very late date. However, he would certainly have known of the book before 1821 because Hayley made a paraphrase of it in his notorious *Essay on Old Maids*, which has a long discussion of an 'Antidiluvian Old Maid'. The starting point for the *Book of Enoch* is the passage in Genesis, VI, 1-4, 'the sons of God came in unto the daughters of men', and it is in fact capable of a highly erotic interpretation, as in Blake's series of drawings for *Enoch*, in the Rosenwald Collection (see Allan R. Brown, 'Blake's Drawings for the *Book of Enoch*', *Burlington Magazine*, 1940, Vol. 77, pp. 80-5). There is a study for the present drawing in the Huntington Library (see Wark, 1970, no. 25).

155 Compositions from the Works Days and Theogony of Hesiod. Designed by John Flaxman R.A. P.S. Engraved by William Blake 1817

37 stippled line engravings: 270 x 420
Royal Academy of Arts, London
lit: Bentley, 1964, p. 53

156 Studies for Hesiod's Theogony

pen and pencil: 147 x 140
Trustees of the British Museum
lit: *Hesiod*, 1817, pls. 34 and 35

This sheet of studies shows Flaxman working on two adjacent compositions at the same time (see ills. 63a, 63b), no doubt in order to differentiate the two scenes of titanic struggle. Each is concerned with the mighty battle between Jupiter and the Titans of his devouring father Cronus.

These drawings were made for two plates in the edition of line engravings for Hesiod, published in 1817, from the translation by C.A. Elton. The engraving was done by William Blake, who was at that time undergoing a period of extreme neglect and poverty. According to Bentley (1964, p. 54), Flaxman was working on the Hesiod designs as early as 1807, and Blake had begun work on its engraving in 1814.

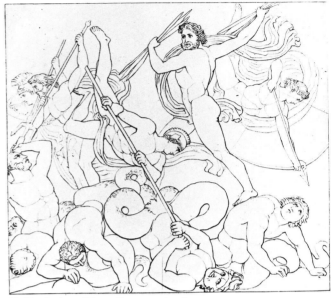

Ill. 63a *Gods and Titans*, line engraving (from French edition)

156

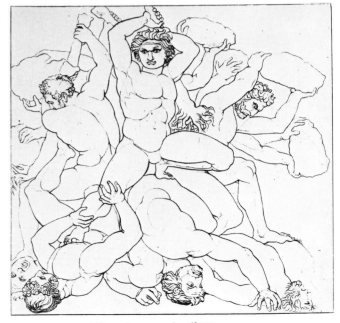

Ill. 63b *Giants and Titans*, line engraving (from French edition)

157 Gaea and the Youthful Zeus
Hesiod, *Theogony*

pen and wash: 162 x 126
Trustees of the British Museum

This drawing belongs with the same group as
Rhea consulting Uranus and Gaea and *Rhea
delivering the infant Zeus to Gaea* in the
Powney collection (Heim cat. nos. 21 and 22
see ill. 64). They are quite different in style
from the outline drawings made for the
engravings and they may be contrasted with
engraving no. 32, *The Infant Jupiter*, which is
in pure outline. They may be from a different
series altogether, or Flaxman might at one
stage have intended to have them reproduced
in aquatint. They are strikingly more atmos-
pheric than the final engravings.

157

158 The Latin and Italian Poems of Milton
1808
Three outline designs for William
Hayley

line engravings after Flaxman by A.
Raimbach: 295 x 226 (cover)
Private collection

Apart from the Hesiod illustrations these are
the only outline engravings from Flaxman
designs made after 1800.

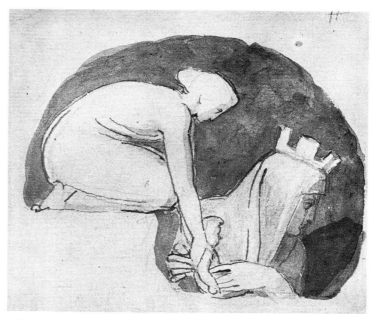

III. 64 *Rhea delivering the infant Zeus to Gaea.*
Christopher Powney Esq.

129

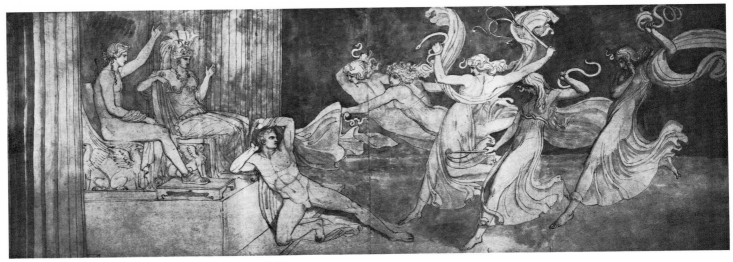

159

159 Orestes pursued by the Furies *c.* 1809

pen and wash: 597 x 1638
Victoria and Albert Museum

This interpretation of the scene from Aeschylus' *The Furies*, is quite different from that represented in the line engravings for Aeschylus, pl. 27. The large size of this drawing and the stage-like setting suggest that it might be connected with the two friezes of *The Ancient Drama* and *The Modern Drama* for Covent Garden in 1809. A different scene from the same episode in *The Furies* was used in the *Ancient Drama* panel (see Whinney and Gunnis 1967, nos. 111-12).

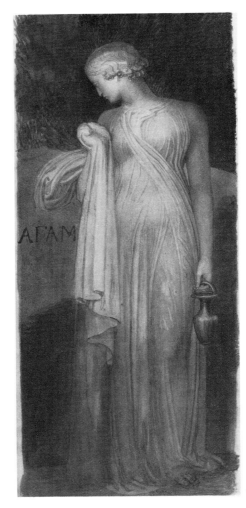

160

160 Elektra at the Tomb of Agamemnon
1820s?

pen and wash: 444 x 197
John Baskett Esq.

Elektra by the tomb of her father Agamemnon, offering a prayer that his murder might be avenged. Most probably derived from Aeschylus, *The Choephori*, but this scene is not illustrated in the line engravings to Aeschylus. The drawing is very much later than the line engravings and is more plastic and atmospheric in conception.

The choice of Flaxman by the Royal Academicians as their first Professor of Sculpture in 1810 is an indication of the artist's contemporary reputation as the leading sculptor in Britain. His appointment was to be the only official recognition of his achievement that he was to receive in his own country, since, unlike Westmacott and Chantrey, he was not to be knighted. His only other honour was to come from abroad, when he was elected to the Accademia di San Luca in Rome.

Flaxman performed his professorial duties scrupulously. He was always a kind and considerate man, and he treated the students studying in the Academy Schools with the 'affection of a parent', as Lawrence expressed it in his funerary oration. Flaxman spent much time not only in giving advice to the students, but also in preparing his lectures. Some of these were eventually published posthumously, in 1829, with a second edition in 1838. His sister-in-law, Maria Denman, executed the drawings which Flaxman had used to illustrate some of his points.

The published version of the lectures distorts Flaxman's main intention in delivering them, as he explained it to Ludwig Schorn (see pp. 30-2). Flaxman is reported to have said that the purpose of his lectures was to show that Christian themes were greater than pagan ones because they are more noble. He also apparently argued, in the course of conversation, that ancient Greek and Roman themes were contained within Christian ones, citing the battle of the giants as a prototype for the Apocalypse. Although these ideas are touched upon in the volume of *Lectures*, they are not fully developed; neither are they elaborated among the few unpublished sheets of lecture notes.

What has survived in his *Lectures* is nonetheless important, and they merit more serious consideration than they have so far received. The *Lectures* are the first attempt by a British sculptor to talk at length about his own art. Within the Academy itself his only precursor had been Reynolds, whose 1780 discourse was on sculpture. The nearest contemporary parallel to Flaxman's *Lectures* is to be found on the Continent, among the various books published by Falconet, whose *Réflexions sur la sculpture* had appeared in an English translation in 1777. Another equiva-

lent publication, but not by a practising sculptor, was Count Cicognara's *Storia della Scultura* (1813-18), which was being published at the same time as Flaxman was delivering his lectures. Like Flaxman, Cicognara discussed a wide range of works from antiquity to the trecento and the Renaissance, on to more modern examples. Flaxman tried to survey the whole of the past and present state of sculpture both in Britain and abroad. Since he was the first holder of the professorship at the Academy, he seems to have felt obliged to set sculpture within a broad historical framework.

The more personal, and therefore more interesting, of the lectures are those in which Flaxman expresses his own preferences. For these reasons the two best lectures are the first, which is devoted not to classical art, as perhaps one might expect in the context of the period, but to early English sculpture: and the last, which discusses the post-medieval period, mainly on the Continent.

Flaxman's discussion of the merits and defects of English sculpture had already formed the substance of his memorial address on Thomas Banks (1805), and of an article he published two years later. Flaxman's great concern at this time with the art of his country should be set against the background of the Napoleonic Wars. Britain, culturally cut off from the Continent and the habitual Grand Tour, turned with greater interest to its own art of the past. To the mid-century Gothic Revival was now added a patriotic passion, which led one diarist in Flaxman's audience in 1811 to record that Flaxman's 'John Bullism' was highly applauded by his listeners on several occasions.

When discussing early English sculpture, Flaxman's own tastes emerge quite strongly. Despite his interest in early and primitive civilizations, Flaxman was incapable of appreciating the vigorous qualities of Romanesque sculpture, and was not able to praise any works until he reached the middle of the thirteenth century. Flaxman becomes very enthusiastic in his lecture by the time he reaches the west façade of Wells Cathedral, admiring in particular the 'magnificent and varied', as well as potentially 'useful' subject-matter. Even with this façade, however, all was not to Flaxman's liking, because parts

were 'ill drawn' and the sculptures were 'rude and severe'. But he concludes his discussion of Wells with a series of phrases which are often found in his writings and which are characteristic of his descriptions of works he likes: 'In parts', he told his audience, 'there is a beautiful simplicity, an irresistible sentiment, and sometimes a grace, excelling more modern productions.'

In Westminster Abbey he singled out two of the most important late medieval tombs there, those of Edmund Crouchback, Earl of Lancaster and of Aymer de Valence, Earl of Pembroke, describing them in unusually ecstatic terms, citing their 'loftiness', 'delicacy of thought' and 'tender sentiment', which combine to 'carry the thought not only to other ages, but other states of existence'.

Phrases such as 'tender sentiment' and 'beautiful simplicity' are equally applicable to Flaxman's own art. It is clear throughout his writings, from the time he was in Italy onwards, that he admired in the art of the past characteristics which were meaningful to him as a creative artist. This is what one would expect of many painters and sculptors, and there are therefore numerous points in the *Lectures* which throw light back onto Flaxman's own art. When reading the first lecture, one is constantly aware that it was delivered by a leading supplier of tombs to churches throughout the country, and that Flaxman was stressing the transcendental qualities of monumental sculptures consistent with his Christian piety.

In the last published lecture, entitled 'Modern Sculpture', Flaxman's preferences determine the nature of the entire discourse. The most interesting part is the long section devoted to Michelangelo, whose name occurs throughout the lectures on more occasions than that of any other modern artist. Although whilst in Italy Flaxman had sketched several of Michelangelo's sculptures, in the lectures he concentrated on his frescoes, saying that he prefers them because the marbles lack the 'chaste simplicity of Grecian art'. But he makes an exception of the Medici Chapel *Madonna and Child*, stressing an aspect of Michelangelo's art that he found particularly sympathetic. This group, according to Flaxman, is 'endowed with a sentiment of maternal affection never found in Greek

131

sculpture, but frequently in the works of this artist, particularly in his paintings, and that of the most tender kind.' Elsewhere in his lectures, Flaxman had already discussed differences between the subject-matter of antique and modern art, highlighting the novelty of the themes of parental affection and domestic charities, themes which he related to Christian belief. He therefore admires Holy Families not only by Michelangelo, but also by Raphael and Correggio, a triumvirate of the High Renaissance whose art he saw as directly relevant to his own, including both his sculptures and his drawings.

In view of the importance of trecento and quattrocento art for his own work, Flaxman's comments on these centuries in his lectures are not as full as one might wish. One can gain far more about his views from his Italian-period journals and sketchbooks. He singles out Nicola and Giovanni Pisano's pulpits in Pisa, Pistoia and Siena as 'most magnificent', and Giovanni's statues of the Virgin and Child as 'elegant'. Amongst quattrocento sculptors Flaxman admires Donatello above all others (although whilst in Italy he seems to have spent more time making sketches after Ghiberti). In his last lecture Flaxman places Donatello's work 'beside the best productions of ancient Greece without discredit'.

After the lengthy discussion of Michelangelo, Flaxman turns to Giambologna, some of whose works he admires, including versions of the antique theme of a crouching Venus, *Woman bathing*. But once Flaxman reaches the seventeenth century, he sees the decline of modern sculpture fully established as a result of the influence of Bernini. Although willing to make exceptions of Bernini's youthful *Apollo and Daphne* and his portrait busts, he castigates Bernini's larger works because they are 'remarkable for presuming airs, affected grace and unmeaning flutter'.

Flaxman concludes his last lecture with practical advice on subject-matter, beginning with the 'severely beautiful personages and events' in Homer and Hesiod, continuing with the 'terrific and afflicting' scenes of the Greek tragedies, following these with the 'innocent simplicity' of the pastoral poets. To these sources Flaxman adds the Bible, which he says in spite of its frequent use in the past has been neglected in part, especially the Psalms and the Prophecies. He concludes his list with *Paradise Lost*, expressing the hope that the students in his audience would be resourceful in their use of past literature. Although his lectures were mainly historical in content, Flaxman never forgot his didactic

aim in addressing future artists. In the same lecture Flaxman refers to Edward Young's *Conjectures on Original Composition* (1759), that important essay in the early development of the Romantic stress on originality. He agreed with Young that the contemporary artist or writer had access to a far greater store of mental riches than that enjoyed by the ancients, and that such an advantage should be exploited.

The central core of Flaxman's lectures, as one might imagine, is devoted to a discussion of Greek and Roman sculpture. As he says at the end of his ninth lecture, a study of such works has the practical advantage of 'guarding against error and false systems', and that if artists wish to attain excellence, then 'we cannot proceed by a more certain course than that by which it has been attained before', thus echoing the convictions of earlier commentators. A great deal of what Flaxman has to say about classical art, however, is disappointing and unoriginal. He cites too many examples, and does not give himself enough time to discuss any works in detail. He also seems to have been overwhelmed by the bulk of existing antiquarian literature, mentioning in great number authors whose works would doubtless have been useful for student booklists, but which he does not discuss. Flaxman seems nonetheless to have born Reynolds' dictum in mind that 'he can never be a great artist who is grossly illiterate.'

Flaxman knew at first hand few sculptors from the sixth century BC or earlier, seeing them merely as a 'tasteless and barbarous' prelude to the age of Phidias. When sculpture reaches its 'maturity' in the fifth century, he becomes more enthusiastic, heaping praises on Phidias and on the work of his contemporaries. He saw the aim of classical sculptors as that of constant improvement in the imitation of nature. Flaxman measured other earlier art by this standard, with the result that the Lion Gate at Mycenae failed, just as Egyptian bas reliefs, Hindu sculptures, Mexican and South Sea Island art did. 'Science must attain a certain perfection', argues Flaxman, 'before the arts of design can be cultivated with success, and that before the human form can be well represented, some system of proportions must be collected from the measurement of man himself.' He also used Greek art as a means of assessing the merits of more modern artists. The example of Donatello has been cited above. The same measurement was used for Canova in the memorial address that Flaxman gave in 1822: 'It has been observed by some', he says, 'that in Canova's sculptures, we sometimes seek in vain for the severe chastity of Grecian art;

this may indeed not be destitute of some foundation in truth, but we must not look for complete perfection in the works of imperfect man.' Flaxman was prepared to make exceptions; he was never a rigid dogmatist.

Amongst the many writers and historians cited by Flaxman is the name of Winckelmann, the number of references to him being only outnumbered by that of Pliny. But Flaxman failed to use Winckelmann's historical approach properly, and did not distinguish as clearly as he had the stylistic characteristics of one century from the next, especially the fifth from fourth century BC. He even discussed some famous sculptors in the wrong chronological order. As he was trying to give an historical outline, one can only assume that he had not fully grasped the significance of archaeological writings from the 1760s onwards.

Some of Flaxman's lectures are on general topics, rather than on specific periods and styles. He gave, for example, a very practical lecture on 'Composition', and another on 'Drapery', at the beginning of which he explains very clearly why he thinks drapery studies are so important. The passage merits quotation at length:

Drapery, as a medium through which the human figure is intelligible, may be compared with speech, by which ideas and thought are perceived. Dignity is expressed by simplicity, grandeur, quantity: action by exertion and succession; grace by those gentle and harmonious undulations peculiar to all the efforts of this quality, and which are inspired by the most graceful and soothing dispositions of the soul. This consistency of the original image with its outward appearance, is proper and decorous, and cannot be violated without inflicting the shock of absurdity and folly: for as the noblest thought would be degraded by low and unbecoming speech, so would the person of a legislator or a prophet by the dress of a buffoon or a bacchanal!

Flaxman interpreted his role as Professor of Sculpture literally, never digressing to discuss the decorative arts, even when he might have had occasion to do so, for example in the context of medieval art. Perhaps he felt he had not enough time, or must keep within the Academy's restricted interest in the 'fine' arts to the exclusion of the others. Whatever the reason, it is disappointing that he nowhere in his lectures comments on historical and modern examples of ceramics and metalwork.

The fairest contemporary assessment of Flaxman's lectures is to be found in the diary of his friend, the architect C.R. Cockerell, who jotted down in 1823: 'Flaxman's lectures are literally but the exposition of beautiful

drawings', lacking that 'poetry or perception in his lectures which is so abundantly displayed in his works. So true is it that the critic and the poet are separate beings to be united.' As Flaxman had written himself, earlier in life and in another context, he was 'happier with the chisel than the pen'. But in spite of these limitations, his *Lectures* are an important document in the contexts both of contemporary taste and of Flaxman's own art.

David Bindman **Drawings connected with Flaxman's Lectures to the Royal Academy**

Flaxman made many drawings in connection with the *Lectures*, and they were reproduced lithographically in the 1829 and 1838 editions. A high proportion of the surviving drawings are in the possession of the Hamburg Kunsthalle, and a selection of them is shown here, with a sketchbook devoted partly to Indian art, possibly also made in connection with the *Lectures*.

161 Flaxman's Lectures on sculpture to the Royal Academy 1829

first edition, with lithographic plates after Flaxman's designs
Private collection

The *Lectures* were not published until after Flaxman's death, with lithographs by Maria Denman after Flaxman's drawings. A second edition was published in 1838 with additional material from manuscripts in the family.

162

162 Six drawings for plate 16 of Flaxman's Lectures

pen and wash: 228-275 x 169-190
Hamburg, Kunsthalle
lit: Flaxman, 1829, pl. 16

Each of the three separate figures was reproduced on pl. 16 of Flaxman's *Lectures*, published posthumously in 1829. They are there inscribed 'From small Bronzes of the Daedaleon School'. According to Flaxman's account of them (pp. 71-3), they are small bronzes in the British Museum of the greatest antiquity, which reflect 'a naked Hercules in wood' mentioned as being the work of Daedalus, the mythical creator of the labyrinth at Knossos.

From the style of extreme antiquity in these statues – the rude attempt at bold action, which was the peculiarity of Daedalus – the general adoption of this action in the early ages, – the traits of savage nature in the face and figure expressed with little knowledge, but strong feeling- by the narrow loins, turgid muscles of the breast, thighs, and calves of the legs – we shall find reason to believe that they are copied from the above-mentioned statue.

163 Minerva
for plate 17 of Flaxman's *Lectures*

pen and wash: 269 x 189
Hamburg, Kunsthalle
lit: Flaxman, 1829, pl. 17

Pl. 17 in the *Lectures* is inscribed 'Minerva of
Dipoenis & Seylles', for it represents the
Minerva, 'by Endaeus, the disciple of Daede-
lus . . . which Pausanias saw in the Acropolis
of Athens' (*Lectures*, p. 73).

164 The boss of Minerva's shield
for *Lectures*, plate 19

pen and wash: 270 x 164
Hamburg, Kunsthalle
lit: Flaxman, 1829, pl. 19

Apparently a study for the boss on the statue
of Minerva by Phidias, which is depicted on
pl. 19 of the *Lectures*, although the reproduc-
tion there is not completely clear. The work is
discussed on pp. 86-7 of the *Lectures*.

165 Drapery study
for *Lectures*, plate 43

pen and wash: 242 x 170
Hamburg, Kunsthalle
lit: Flaxman, 1829, pl. 43

On pl. 43 of the *Lectures* the design is
captioned '(Drapery) Accommodated to the
limbs'. Flaxman devoted the whole of Lecture
8 to drapery. He particularly commended the
drapery 'peculiar to the more elegant and

163

delicate female characters of Grecian
sculpture':

The more transparent of these draperies leave the
forms and outline of the person as perfectly
intelligible as if no covering were interposed
between the eye and the object, and the existence
of the veil is only understood by groups of small
folds collected in the hollows between body and
limbs, or playing in curves and undulations on
the bolder parts, adding the magic of diversity to
the charm of beauty.

166 A maenad
for *Lectures*, plate 45

pen and wash: 276 x 193
Hamburg, Kunsthalle
lit: Flaxman, 1829, pl. 45

The caption for this design reads 'One of the
Menades'. Apparently connected with the
discussion of the effect of movement upon
draperies in Lecture 8 (pp. 245 ff.), it is
probably copied from a Neo-Attic vase or
frieze.

167 The 'Hindu' Sketchbook *c.* 1792 and
after 1800

27 leaves, with drawings in pen, pencil and
watercolour: *c.* 192 x 134
The Syndics of the Fitzwilliam Museum,
Cambridge

This sketchbook was used initially in Rome,
but it is probable that the ten pages of Indian
subjects were made after Flaxman's return to
England. Most of the drawings derive either
from a costume book or from European
drawings or paintings of Indian scenes. Two
of the latter are inscribed 'from Mr. Devas',
who can be identified as Arthur William
Devis (1763-1822), a painter who had spent
some time in India as a draughtsman for the
East India Company. The most striking are
two elaborate and accurate copies of South
Indian company paintings of the late
eighteenth century. According to Mr R.W.
Skeleton the originals could well have derived

164

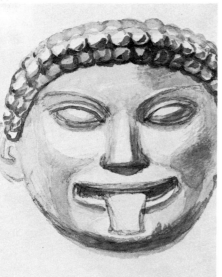

165

166

167

167

from Tanjore, and it may not be coincidental that Flaxman had been commissioned to make monuments for Sarfoji, the ruler of Tanjore (1799-1832), who was in the habit of giving albums of such paintings to visitors. Sarfoji had commissioned from Flaxman a monument to the missionary Christian Friedrich Schwartz (1726-98) in Tanjore (Whinney, 1964, p. 193). I am grateful to Mr Skelton for identifying the possible originals of the water-colour copies, and for suggesting the connection with Sarfoji.

Graham Pollard **Flaxman and designs for medals and coins**

John Flaxman's interest in medals commenced at a commendably early age. Colvin (p. 9) records that when aged five Flaxman asked his father to obtain a medal at the coronation of George III, and was disappointed in receiving a mere button ornamented with a horseman. Flaxman occupied himself with the occasional designing of medals and coins throughout his working life. Of his coin designs nothing has been identified relating to the two known commissions. In 1798 Flaxman wrote to Hayley, mentioning that he had submitted designs for new coinage with other Academicians (in an unpublished letter in the Fitzwilliam Museum, MS 62, 1949, f. 19). In 1823 his designing for Indian coinage is recorded by the exhibit of the wax modeller Peter Rouw at the Royal Academy (Pyke, p. 123).

What we do have is a group of seven drawings for medals, and, in addition, three medals with another form of documentation. Of the drawings, only one concerns a known medal.

Flaxman was sufficiently interested in the medal as a work of art to have formed, mainly in Italy, a distinguished collection of them. All that is known of the collection is the enthusiastic description given by J.T. Smith in his book on Nollekens (2nd ed., 1829, pp. 290-92). Flaxman gave casts of his favourite medals to the young sculptor Henning, and from this we know that Flaxman admired most the work of Pisanello and Matteo de 'Pasti.

Flaxman presented his medal designs to his clients both as wax models and as drawings. This method of presentation is recorded for the medals of the Earl St Vincent and for the Society of Arts. No wax model for a medal has survived.

Only one of the seven medal drawings by Flaxman can be related to a finished medal. It is the earliest of the dateable drawings, that of 1785 for the medal of the Lyceum Medicum of London.

The drawing for a Victory Medal may be ascribed to either 1802, on the Peace of Amiens, or to 1815, when Flaxman received a major commission from the Government for Waterloo medals. The rather tentative character of the drawing perhaps suggests the earlier date. The Waterloo commission was unanimously voted to Flaxman by his fellow Academicians. There were to be two medals, one of them on a grand scale (Hocking, pp. 208-09). Flaxman did complete drawings for the competition, for they are mentioned in a letter from Smirke to Farington (*Diary*, 15 August 1815). This important commission was eventually placed with Benedetto Pistrucci and Thomas Wyon junior.

The next dateable drawings form a group of three for a proposed medal to commemorate the fiftieth anniversary of the founding of the Royal Academy. The Academy *Council Minutes*, 2 February 1819, resolve that . . .

a Medal should be struck to commemorate the Fiftieth Anniversary of the Royal Academy, bearing the head of the King on one side, and the head of the Prince Regent on the other.
Resolved unanimously that Mr Flaxman be requested to prepare a model for such a medal, to be laid before the General Assembly.

The Council further resolved that the three medals intended for the Court and for the British Museum should be given special ornamental borders, as shown in one of the drawings.

There are three remaining drawings. That of the head of George III, with a trident as adjunct symbol, is presumably for a naval medal. No medal with the type appears in the standard work by Milford Haven. The drawing with a head of Hypnos cannot be related

135

to any known commission. Both subject-matter and presentation suggest that it is for a funeral monument rather than for a medal.

The third drawing appeared in the Flaxman exhibition at Heim, London, 1976 (no. 51). It is the design for the reverse of a medal commemorating the death of Nelson, ascribed to W. Wyon (Milford Haven, no. 507) but in fact by Thomas Webb of Birmingham (Forrer, vol. 6, pp. 401-02, illustrated).[1]

Documented Medals

Besides these drawings there are three medals documented as deriving from Flaxman's designs. The Earl St Vincent Medal of 1800 was engraved by C.H. Küchler at Matthew Boulton's Soho Mint, Birmingham, and is recorded in Flaxman's published account book (Croft-Murray, p. 70).

In 1806 Flaxman submitted wax models and drawings for a Society of Arts prize medal (Thomas, pp. 52-4; Wood, p. 317). The dies were cut by G.F. Pidgeon, also at Matthew Boulton's Soho Mint, Birmingham, with Flaxman supervising the progress of the dies. The medal has as obverse type heads of Minerva and Mercury, the drawings for which may be those recorded as lot 25 of the Flaxman sale at Christie's, 10 April 1862. The Society published an engraving of the medal as the frontispiece to volume 25 of its *Transactions*, 1807, and the design was also used for the Society's *Honorary Testimonial*, instituted in 1845 (Wood, facing p. 354).

The ascription to Flaxman of the designs for the Fothergill prize medal (1824) of the London Medical Society, is recorded in his unpublished account book (1809-26). The commission had been placed through the Court goldsmiths, Rundell, Bridge & Rundell. In 1823 the medallist William Wyon showed at the Royal Academy (no. 1044) an impression from a die for a medal of the Cymmrodorion Society as being after a design by Flaxman.

Flaxman was also consulted about the medal designs of other artists. Peter Rouw wrote to M.R. Boulton, on 17 December 1813, about the wax portrait-model to be used for a proposed memorial medal to Matthew Boulton, and to be engraved by G.F. Pidgeon (Pollard, pp. 316-18). Rouw's comment is a fitting judgment on Flaxman and the medal:

Perhaps Mr Flaxman would be the properest person to have the Model as I understand you have requested him to revise the Medal die and in my humble opinion you could not have fixed upon one whose judgment is more matured and whose extreme modesty and kindness will do away what in general is as very offensive, I mean the pointing out of faults . . .

1 The drawing is now in the Maritime Museum

169

169 Design for a victory medal 1802 or 1815

Minerva and Mars (military glory) shaking hands before an altar on which stands Victory crowning them both. SAPIENTIA VICTORIA VIRTUS
on altar, EUROPAE PAX
pen and ink, pencil: 109 x 104
University College, London, no. B.712
lit: Colvin, 1876, pl. IV.17

The design was made either to commemorate the Peace of Amiens, 1802, or as a result of the commission from fellow Academicians to design the government's medals after Waterloo. The male figure is named as VIRTUS, but has the attributes, the club and lion skin, of Hercules.

168 Designs for a prize medal of the Lyceum Medicum, London 1785
photograph only

obv: Jugate heads of Drs Fordyce and Hunter
rev: A snake casting its slough
ink and wash: 79 x 123
Victoria and Albert Museum
lit: *Catalogue, Ionides Collection*, 1904, no. 986

The design was made for a prize medal at five guineas of the Lyceum Medicum of London, founded by Fordyce and Hunter in 1785 (see E. Finch, 'The Influence of the Hunters on medical education', *Annals of the Royal College of Surgeons*, 20, 1957, p. 243). For the finished medal, see no. 175.

168

170

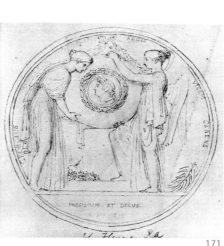

171

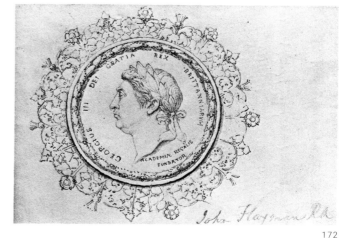

172

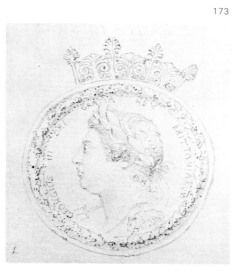

173

170 Design for the obverse of a Royal Academy anniversary medal 1819

Painting, Sculpture and Architecture kneeling before a seated figure of George III
GEORGIVS III DEI GRATIA BRITTANIARVM (*sic*) REX
in exergue ACADEMIAE REGALIS FVNDATOR A.D. 1768
watermark: J WHA
18
pencil and wash: 189 × 244
Royal Academy of Arts, London

Design for a medal on the fiftieth anniversary of the Royal Academy, proposed in 1819.

171 Design for the reverse of a Royal Academy anniversary medal 1819

Two female figures holding a medallion profile of George, Prince Regent GEORGIVS PRINCEPS [GRATIS] VICEM GERENS REGIS
in exergue PRAESIDIVM ET DECVS AD 1818
no watermark
pencil and wash: 188 × 240
Royal Academy of Arts, London

Design for a medal on the fiftieth anniversary of the Royal Academy, 1819. The R.A. Council Minutes, 2 February 1819, say that the reverse type should be a head of the Prince Regent. This and the preceding drawing are similar in style and technique.

172 Design for the obverse of a Royal Academy anniversary medal 1819

head left, laureate GEORGIVS III DEI GRATIA REX BRITTANIARVM (*sic*)
below bust ACADEMIAE REGALIS FVNDATOR
watermark FELL
18
on verso is written: 'Engraving the die 105 Gold for two medals 105 43 silver medals £2 each 86'
Royal Academy of Arts, London

The design shows the ornamental frame for the medal suggested by the Royal Academy Council meeting of 2 February 1819, as proper for two specimens of the medal in gold for the Prince Regent and for the King, and for one silver example for the British Museum.

173 Design for a naval medal of George III
photograph only

Head left, laureate, in field before bust, a trident, below bust a bear (?). GEORGIVS III DEI GRATIA REX BRITTANIARVM (*sic*), on the rim of the design, a crown.
pen and wash: 165 × 93
Victoria and Albert Museum
lit: *Catalogue, Ionides Collection*, 1904, p. 39, no. 985

The design appears not to have been used.

174

174 Design for a roundel, Hypnos

Head of Hypnos, right.
pen, grey ink, pencil and wash: d. 155
Trustees of the British Museum

The subject-matter is more appropriate to a
sculptured roundel for memorial sculpture
than to a medal, an impression confirmed by
the shadow below the lower edge of the design.

175 Prize medal of the Lyceum Medicum, London 1785

obv: Jugate busts of Hunter and Fordyce
GEORGIVS · FORDYCE · ET · JOANNES
HVNTER · PATRONI
below I · MILTON · F
rev: An erect serpent casting its slough
RENOVANDO VIGET
exergue LYCEVM · MEDICVM · I · M · F · TOWER ·
silver: 42
copper: 42
Trustees of the British Museum
lit: *Numismatic Chronicle*, 1891, pp. 92-3;
Brettauer no. 359
For the drawings for the medal, see no. 168.

176 The Earl St Vincent's medal 1800

obv: Bust left EARL ST VINCENT'S TESTIMONY
OF APPROBATION. 1800 C H K
rev: Standing figures of seaman and marine
LOYAL AND TRUE
in exergue, K
gold: 47
Trustees of the British Museum
silver and white metal: 46
The Syndics of the Fitzwilliam Museum
lit: Pollard, 1970, pp. 289-90, no. 19;
Milford Haven, 909, no. 456

The medal was awarded by the Earl St Vincent
to commemorate the loyalty of his flag-ship

175

176

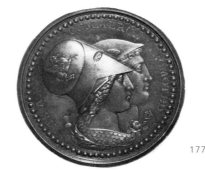

177

H.M.S. *Ville de Paris* at the time of the Nore
Mutiny, 1797.

The attribution of the design to Flaxman
is given by his account book, 13 December
1800 (Croft-Murray, p. 70). Flaxman provid-
ed both the designs and models. The uniface
specimen of the medal in white metal is a trial
piece by the engraver C.H. Küchler, of the
Soho Mint, Birmingham.

177 Society of Arts prize medal 1805-06

obv: Jugate heads of Minerva and Mercury,
right. ARTS AND COMMERCE PROMOTED
rev: laurel wreath, below SOCᵞ INSᴰ
LONDON 1753

silver: d. 44
Trustees of the British Museum
lit: Thomas, 1955, pp. 52-4; Wood, 1913,
p. 317

Flaxman was invited to design the medal by
the Society in 1805. He submitted both wax
models and drawings and supervised the
progress of the dies, which were cut by
G.F. Pidgeon at Matthew Boulton's Soho
Mint, Birmingham. The design was engraved
from a drawing by Flaxman's sister-in-law,
Maria Denman, and used as frontispiece to
volume 25 of the Society's *Transactions*. The
medal was the Society's principal award.

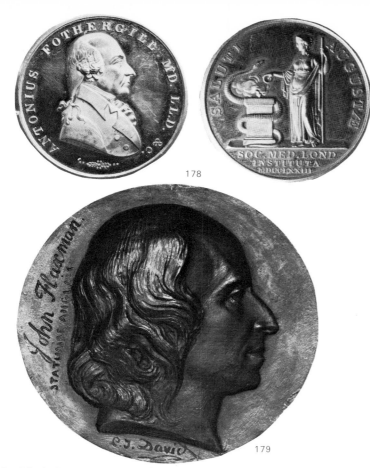

178

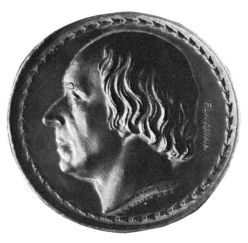

179

A.J. Stothard

180 John Flaxman

obv: Bust left, hair short on neck, inscribed in field FLAXMAN on truncation, A.J.STOTHARD F. below, E.H.BAILEY RA D
rev: Female figure standing against a short column, holding a label inscribed TO GREAT MEN: on plinth, PUBD BY S PARKER LONDON in field; below, MDCCCXXVI T STOTHARD RA D A J STOTHARD F
bronze: d. 62
Trustees of the British Museum
lit: *Numismatic Chronicle*, 1891, p. 92

The effigy was designed by E.H. Baily, and it differs in the treatment of the hair from the sculptor's bust of Flaxman of 1823. The name Baily is misspelt on the medal. The reverse was designed by the painter Thomas Stothard, father of the medallist. The Royal Academy exhibition of 1827 (no. 1003) showed 'an impression from a die' for the medal which is one of a small series of medals of famous men by Stothard begun in 1826.

180

178 London Medical Society prize medal
1824

obv: Bust of Anthony Fothergill, right. ANTONIVS FOTHERGILL . MD . LL.D. &C. on truncation, J. VINING.FT ornament below
rev: Hygeia standing, making libation at a flaming altar, around which her snake is entwined. SALUTI AUGUSTAE
in exergue SOC. MED. LOND INSTITUTA MDCCLXXIII
in field, W. WILSON.F
white metal: d. 45
Trustees of the British Museum
lit: Brettauer, 1937, no. 362

Flaxman's authorship of the design of the medal is given by his unpublished account book, 1809-26, at Columbia University Library (PS no. 0258, p. 77) where Rundell, Bridge & Rundell were charged £2.12.6 on 10 January 1824 for a sketch for the medal.
The artist signing the obverse is otherwise unknown, and was probably a journeyman-engraver employed by the medallist who signed the reverse, W. Wilson. In the Royal Academy exhibition of 1828 (no. 1100) Wilson

showed 'Obv. impression from a prize medal given by the Medical Society of London'.

David d'Angers

179 Cast bronze medallion portrait of Flaxman by David d'Angers

Head to right, in field, John Flaxman STATUAIRE ANGLAIS P.J.DAVID
bronze, uniface: d. 210
Galerie David et Musées d'Angers
lit: Chesneau, 1934, no. 558; Schazmann, 1973, pp. 30-1

The medallion is one of a suite of some five hundred portraits of distinguished European contemporaries by David. It is conventionally dated to David's second visit to London in 1828, although Schazmann proposes the first visit, 1816. Although the work appears to be undocumented, David did arrive in London in 1816 with an introduction to Flaxman from Canova, so that despite the brevity of the visit Flaxman's profile could have been taken then, even if used later for the medallion. David's second visit to London was in 1828, two years after Flaxman's death.

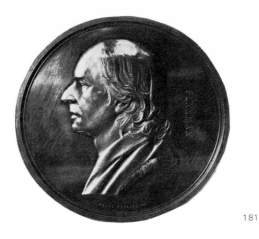
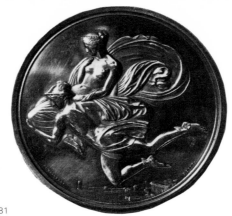

181

Henry Weigall

181 John Flaxman

obv. Bust left, behind head FLAXMAN below,
HENRY WEIGALL SC.
rev: Flaxman's relief of Mercury bringing
Prosperpina from Hades. H. WEIGALL FECIT
edge: ART-UNION OF LONDON 1854
silver, in orginal box (another in copper):
d. 56
The Syndics of the Fitzwilliam Museum,
Cambridge
lit: G.K. Beaulah, 'The medals of the Art

Union of London', *British Numismatic
Journal*, 36 (1967), p. 132, no. 6

The commission for the medal was first given
to W. Wilson, who showed a model for it at
the Royal Academy in 1846 (no. 1372). The
work was so delayed that the commission was
passed to William Wyon who died in 1851
with the work still unfinished. Henry Weigall
showed proofs of the medal at the Royal
Academy in 1854 (no. 1273) in which year it
was distributed by the Art Union as a prize.
The effigy is taken from Baily's bust.

Shirley Bury Flaxman as a designer of silverwork

Flaxman was greatly venerated as a designer
of silver even during his lifetime, while his
posthumous fame inspired the Victorians to
feats of emulation. The British section of the
1851 exhibition was scattered with pieces to
which the artist's name was, however tenu-
ously, attached. But despite his celebrity,
there are many gaps in our knowledge about
Flaxman's career in the silversmithing and
metalworking trades. His best-known work
is associated with the great London firm of
Rundell, Bridge & Rundell, the Royal Gold-
smiths to George III and George IV, but it is
worth noting that he was connected, directly
or indirectly, with other firms. As early as
1783 he designed a medallion and a figure for
a silver tureen commissioned by Wedgwood
(see John Wakelin and Wiliam Tayler,
Gentleman's Ledger, 1777-87, fo. I; Garrard

Ledgers, V & A),[1] and in 1797, Garrard's of
Panton Street supplied a client with 'a
Flaxman Coffee pot',[2] which was presumably
engraved with a composition taken from one
of Flaxman's illustrations of the *Iliad*. In 1800
Flaxman executed a commission transmitted
to him by the firm of Makepeace of Serle
Street, Lincoln's Inn Fields, designing a
medal to commemorate Lord St Vincent's
approbation of his officers' and men's con-
duct on board the *Ville de Paris*; the medal
was actually struck by Conrad Heinrich
Küchler.[3] When an exhibition of local manu-
factures was held in Birmingham in 1849,
constituting a practice run for the Great
Exhibition two years later, it was claimed
that Flaxman had once also designed for
Messenger & Sons.[4] As Messenger's con-
tributed some of their characteristic bronze

lighting fittings and other items to the exhibi-
tion, it can be assumed that they supplied the
information.

In 1804 Rundell's became the Royal
Goldsmiths, having formerly been possessors
of a royal warrant, in common with Garrard's
and several other London firms patronized by
George III and members of his family. Now,
rather better than *primus inter pares*, and
graced with the active interest of the Prince of
Wales and his brother the Duke of York,
Rundell's were anxious to justify their new
status by recruiting the best designers to work

1 We are indebted to Mrs Elaine Barr for this informa-
 tion.
2 John Wakelin and Robert Garrard, Day Book vol.
 XXI, 1797-99, entry dated 3 April 1797.
3 Croft-Murray, 1939-40, p. 70.
4 *Journal of Design*, III, 1850, p. 11.

for them. The painter and sculptor William Theed (1754-1817) was the firm's chief modeller: though he was also a partner in the concern, he emerges from the pages of his friend Joseph Farington's diary as a harassed, slightly querulous figure, doubtless because he was under continual pressure to produce new models and re-deploy others in different combinations. Flaxman was persuaded to design for the firm on or before 1805: reputedly his first effort for Rundell's was the Trafalgar Vase, for which, unfortunately, no drawings survive. The commission to make an edition of these vases was only part of an enormous amount of business received from John Julius Angerstein, the Russian-born philanthropist and underwriter at Lloyd's who was, according to George Fox, one of Rundell's shopmen, 'a particular Friend' to the Royal Goldsmiths. [5]

One of Flaxman's account books, containing a record of his transactions with Rundell's from 1817 and 1825, [6] reveals a great deal more about his association with the firm than the bald statement of designs sold and payments received would appear to indicate. His notes show that he was paid sums ranging from five guineas in 1819 for a group of unidentified 'Sketches of Candelabra, Cups & a Border' to five or, at most, seven guineas for a single drawing. In the latter category are two drawings made for the National Cup in 1819, for which he received fifteen guineas. That these sums fell within the normal scale of payment is shown by George Foggo's statement to the Select Committee on Arts and Manufactures in 1835. Foggo, who declared that he himself had 'repeatedly designed for bronze and silver', claimed that for fear of having their patterns pirated, few silversmiths would expend more than £5 on a design, though he cited one instance in which he had received 8 guineas for a piece of plate costing £800. [7]

Flaxman's returns on his designs were even smaller than might at first appear, for like most artists he found it necessary to explore a theme with a number of sketches before arriving at the final version and he was, of course, only paid for the one or two drawings which showed different viewpoints of the finished design. Occasionally the sketches exist in sufficient numbers to demonstrate the way in which he played with an idea. Particularly revealing are his drawings of the theme of Mercury descending to the nymphs with the infant Bacchus, which was first used in one of a pair of candelabra acquired by the Prince Regent in 1811. Among them is a sketch which shows that at one stage he thought of the group in terms of a support

for a dessert stand (ill. 65a); another sheet of studies, which probably represent his earliest ideas on the subject, proves that he began, as he ended, with a candelabrum in mind (ill. 65b). Alas, the figure group in the central drawing, running from the candle branches, forms a spiralling composition of great verve and fluidity which is lacking in his completed design.

There was one outstanding exception to the normal scale of payments noted in Flaxman's accounts. Apart from £200 received in 1817 'on account of the Shield (sic) of Achilles', his magnificent reworking of a traditional tribute to military success, £525 was paid to him for the model of the shield a year later. It is clear, therefore, that this is the

Ill. 65a Drawing for *Mercury* candelabrum as dessert stand, Victorian and Albert Museum

Ill. 65b Studies for *Mercury* caldelabrum, Victoria and Albert Museum

only specimen of plate produced between 1817 and 1825 which was actually modelled by Flaxman himself. As there is no record in the account book of further fees for chasing either the silvergilt or bronze versions made from his model, we can also conclude that he was content to leave this task to other hands: in this case to those of William Pitts.

Flaxman may have started by modelling his pieces, but most of the models made from his designs were executed either by Theed or, later, by Flaxman's pupil E.H. Baily (1788-1867) who came to him from Bristol in 1807 and left to join Rundell's as a modeller and designer in 1815, two years before Theed's death. Theed was almost certainly responsible for modelling the Mercury candelabrum and

its pair. Farington records that he visited Theed at the Dean Street workshops of the firm a few months after the candelabra had been acquired by the Prince of Wales and was shown 'several of His models: Candelabrums for the Prince of Wales & other works . . .'. [8] On the evidence of J.T. Smith, Baily modelled a cup designed by Flaxman for presentation to the actor John Philip Kemble on his leaving the stage in 1817. [9] The fact that Flaxman had no responsibility for the designs once he had parted with them does much to explain why his figure groups were not always used in the context he had intended. In order to make the two candelabra for the Prince suitably regal, for instance, Flaxman's base with three seated lionesses was abandoned for a much larger one embellished with three piping fauns and additional candle branches. His lack of involvement with the finished article probably also accounts for his lack of interest in functional components such as candle branches, which are rarely detailed in his designs.

5 George Fox; Ms. history of Rundell, Bridge & Rundell; presented to the Baker Library, Harvard University, by his great-granddaughter, Mrs Lydia Burgess Brownson. Photocopy in the library of the Victoria and Albert Museum, p. 56.
6 Columbia University Account Book.
7 Select Committee on Arts and Manufactures. *Report*, 1836. *Minutes of Evidence* (Sess. 1835), p. 46, paras 683-86.
8 *Farington*, 1922-28, vol. VII, p. 24.
9 Smith, 1828, vol. II, p. 448.

The drawings sold by Flaxman to Rundell's were naturally copied and traced in the firm's workshop for record purposes. Some of these, together with copies of designs by Thomas Stothard and others, mounted in a folio album lettered *Designs for Plate by John Flaxman etc.* (in the Print Room of the Victoria and Albert Museum), are discussed and illustrated in an article by Charles Oman.[10] Unfortunately, none of the drawings is dated, though dates can be attached to two of Flaxman's designs which are cited in his account book. But the account book unfortunately does nothing to solve one of the most contentious problems relating to Flaxman's designs for silver, for it contains no reference at all to an important group of pieces with marine themes made by Rundell's in the

Ill. 66a Studies for a centrepiece of Venus. Victoria and Albert Museum

1820s for the Royal Collections. These were popularly associated with Flaxman in Victorian times, and there seem to be grounds for this belief in the form of extant drawings which are discussed under catalogue no. 189. Two of the sketches cited, for a centrepiece with Venus borne aloft by tritons who are in turn supported by sea horses (ill. 66a), are executed on a sheet of paper watermarked 1807, on the back of which are figure studies, two of them for the Baring monument at Micheldever, Hampshire, which was installed in 1809. Even allowing for the possibility that Flaxman sketched the centrepiece on

paper which had been lying about in his studio for several years, it is reasonable to suggests that he made use of the paper before 1817, the year in which the entries in the account book start, in which case we can perhaps assign the whole group of related designs to the years 1809-16. The lapse of time before the designs were actually executed is of no significance: Flaxman began work on the Achilles Shield in 1810 (perhaps even earlier) and the first version was only made by Rundell's in 1821-22.

It only remains to mention briefly the Royal Goldsmiths and their associates. The firm, based in Ludgate Hill in the City of London, went under the title of Rundell and Bridge from 1788 until 1805, the partners being Philip Rundell (1743-1827) and John Bridge (1755-1834), who were known to their employees as Vinegar and Oil. Rundell was a slavedriver and miser, who amassed a fortune of £1½ million, while Bridge was a natural courtier. The firm was styled Rundell, Bridge & Rundell after Rundell's nephew became a partner, and it remained so until about 1830, when the name was changed to Rundell, Bridge & Company. The concern went into dissolution in 1842. As the two senior partners were jewellers by training, they were compelled to farm out their early commissions for plate to practising silversmiths. In 1802 they set up their first workshop in Greenwich, installing Digby Scott and Benjamin Smith as managers. This workshop appears to have closed down on Smith's departure from Greenwich in 1813-14. Meanwhile, in 1807, the firm acquired workshops and other premises in Dean Street, Soho. The workshops were managed by Paul Storr, who became a director of the firm. But Storr, too, departed, in 1819, and first Rundell, then Bridge, registered nominal maker's marks at Goldsmiths' Hall. None of the subsequent partners ever registered a mark.

10 Charles Oman, 'A Problem of Artistic Responsibility: the Firm of Rundell, Bridge & Rundell', *Apollo*, vol. LXXXIII, 1966, pp. 174-82.

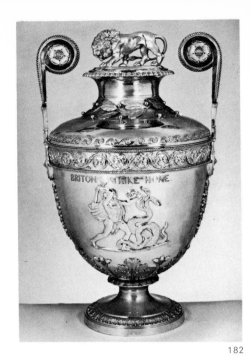

182

182 The Trafalgar Vase

London hallmark for 1805-06: maker's mark of Digby Scott and Benjamin Smith inscribed: 'Rundell, Bridge et Rundell, Aurifices Regis et Principis Walliae, Londini Fecerunt.'
silver: h. 483
Victoria and Albert Museum (Bond Gift): 803-1890
lit: Lieut.-Col. A.N. St Quintin, *The Patriotic Fund at Lloyds*, 1923, p. 50; Warren Dawson, *The Nelson Collection at Lloyds*, 1932, p. 11; Charles Oman, *English Silversmiths' Work, Civil and Domestic: an Introduction*, London (HMSO), 1965

On one side of the body is a cast and applied figure of Britannia holding up a figure of Victory, and the inscription, 'Britannia Triumphant': on the other, Hercules slaying the Hydra, and the legend, 'Britons strike Home'. The British lion prowls on the cover. These were standard emblems in the current patriotic repertory. Flaxman used a standing Britannia and a lion *couchant* in his huge monument to Admiral Lord Nelson (1758-1805) in the south transept of St Paul's Cathedral, 1807-18.

Some sixty-six vases of this design were commissioned from Rundell's by J.J. Angerstein of the Lloyd's Patriotic Fund for presentation to both naval and military officers. The former predominated, many of the recipients having served under Nelson at the Battle of

Trafalgar on 21 October 1805. The fund was founded on 20 July 1803, when a meeting was held of merchants, underwriters and other subscribers to Lloyds, at which it was resolved 'That to animate the efforts of our defenders by sea and land, it is expedient to raise by the patriotism of the Community at large a suitable fund for their comfort and relief. . . . and for the granting of pecuniary rewards or honourable badges of distinction, for successful exertions of valour or merit.' George Fox of Rundell's said that the cost of the testimonial vases varied from one hundred to five hundred guineas each (see n. 5 of introductory text).

This specimen appears never to have been presented, as there is no trace of an erased inscription to any recipient. Four vases, including one presented to Nelson's brother, are in the collections of the National Maritime Museum, Greenwich; another is in the possession of the London Stock Exchange. Lloyd's themselves own two. A puzzling reference to a Flaxman relief of *Mercury and Pandora*, intended for a Trafalgar vase, exhibited at the Royal Academy in 1805, cannot be elucidated (Constable, p. 68). The exhibition catalogue cites the title of the piece but makes no reference to its use on a vase.

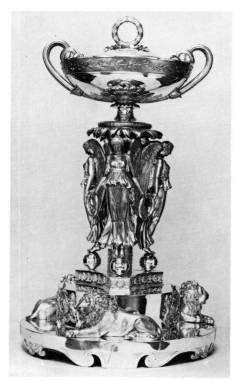

183

183 Centrepiece

celebrating the landing at Figuera, Portugal, by the British Army in 1808

London hallmark for 1810-11; maker's mark of Paul Storr. The base stamped: 'Rundell Bridge et Rundell Aurifices Regis et Principis Walliae Londini Fecerunt'. On the plinth, the applied Royal arms as borne by George III, and the arms of Wellesley within the collar of the Garter. An inscribed plaque, surrounded by flags and surmounted by laurel branches, records the presentation of the piece to their Commander, Lieut.-General the Rt Honble Sir Arthur Wellesley, by the General Officers who landed in Portugal in 1808, in 'testimony of the high Respect & Esteem they feel for him as a MAN, & the unbounded Confidence they place in him as an OFFICER'.
silver, parcel-gilt: h. 837
Wellington Museum, Apsley House, W.M. 799-1948
lit: N.M. Penzer, *Paul Storr, 1771-1844*, London, 1944, pl. XXXIV, p. 146; Oman, 1965, pl. 197

A drawing by Flaxman (see no. 191) combines elements of this centrepiece and of another, also in the Wellington Museum, which is surmounted by a winged figure of Victory (W.M. 798-1948). Both pieces are concerned with the start of the Peninsular campaigns of Sir Arthur Wellesley (1769-1852), later to become the 1st Duke of Wellington. The motifs, winged Victories, British lions, palms, laurel leaves, oak leaves and acorns, reflect the patriotic theme of pride and confidence in Wellesley as a military leader. In the typescript transcription of the diaries of Joseph Farington (British Museum, Department of Prints and Drawings, p. 6505) is an entry dated 9 May 1814 which records the artist's visit to Rundell's premises: 'There saw a beautiful silver vase executed after a design made by Flaxman, a present from several Officers to Lord Wellington in testimony of the high Respect they bore him while serving him in Portugal' (reference supplied by Mr Michael Snodin). Was Farington referring to

this centrepiece, or to that surmounted by a winged Victory? The only clue lies in the wording of the inscription, which Farington clearly read and in part remembered. The inscription on the other piece speaks of 'admiration', 'confidence' and 'attachment', but that on this specimen includes the phrase 'high Respect', which exactly corresponds with the words used by Farington. It is not surprising that Wellington had not yet taken possession of his testimonials. The Peninsular campaigns had only recently ended in victory, and in April 1814 he accepted the offer of a Dukedom and the Paris embassy, the latter in the following terms: 'Although I have been so long from England . . . I feel no objection to another absence in the public service . . .' (Elizabeth Longford, *Wellington: the Years of the Sword*, 1969, chapter 17).

184 The Theocritus Cup

London hallmarks for 1811-12, 1812-13; maker's mark of Paul Storr. Both cup and base stamped with the Latin signature of Rundell, Bridge & Rundell. The foot of the cup engraved with the arms of the Town of Liverpool, the stand with the arms of Thomas Earle (1754-1822), of Spekelands, co. Lancaster, Mayor of Liverpool in 1787. The cup also bears an inscription recording the presentation of the piece 'by the Mayor, Aldermen, Bailiffs of the Common Council of the Borough and Corporation of Liverpool to Thomas Earle, Esq., Alderman in testimony of the sense they entertain of the zeal, judgement & unremitting attention in the progress of the act for the improvement of the Port & Town of Liverpool, AD 1811'.
silvergilt, the cup on a detachable base: h. 370 overall
Merseyside County Museums, Liverpool
lit: John Culme, *Nineteenth-century Silver*, London, 1977, p. 19

Despite Flaxman's omission of handles in his early study for this cup (no. 193), he probably always intended to incorporate them into the design, for, as Dr Penzer has shown (*op. cit.*,

p. 158), the piece is closely based on the description of the cup in the First Idyll of Theocritus. The following quotation was taken by Penzer from A.S.F. Gow's translation (*Theocritus*, I, Cambridge, 1950, pp. 7, 8):

And I will give thee a deep cup, washed over with sweet wax, two-handled, and newly fashioned, still fragrant from the knife. Along the lips above trail ivy.... And within is wrought a woman, such a thing as the gods might fashion, bedecked with cloak and circlet. And by her two men with long fair locks contend from either side in alternate speech.... By these is carved an old fisherman.... And a little way from the sea-worn old man there is a vineyard with a fair load of reddening clusters, guarded by a little boy who sits upon its dry-stone wall....

Translated into silver, rather than wood, Flaxman's design uses the krater form instead of the kylix indicated in the Idyll. The twisted vine-stem handles are his own invention, inspired by Roman rather than Greek models. The composition of the group of the lady and her suitors, apparently based on the 'Orpheus' relief in the Villa Albani at Rome (drawn by Flaxman in his Italian sketchbook, fo. 41) occupies one side of the cup; the scenes of the fisherman and the boy are combined on the other side.

Other versions of the Theocritus cup include one of 1811-12 in an American collection (cited in Wark, *Huntington Catalogue*, 1970, p. 79) and another, hallmarked for 1812-13, in the Royal Collections (Penzer, pl. XL). Neither of these has a stand, and it is unlikely that the stand shown here was designed by Flaxman. It has a curiously old-fashioned appearance, and the fluted supports headed by rams' masks and terminating in hoof feet are in fact reminiscent of the work of Storr's master, Andrew Fogelberg, in the late 1770s (see Robert Rowe, *Adam Silver*, London, 1965, pl. 75A). It can only be suggested that the stand languished for years in Storr's workshop, unmarked, only to be produced when the Liverpool order was received, or that it was assembled from Storr's book of existing patterns to satisfy the Mayoral demand for a suitably impressive piece.

Another cup, cited by E.A. Jones, engraved with the Prince of Wales' badge and the arms of Winchester College, appears to have belonged to William Stanley Goddard, headmaster of the college from 1793 to 1810. This cup was later acquired by Mr Frederick G. Morgan (*op. cit.*, p. xlix).

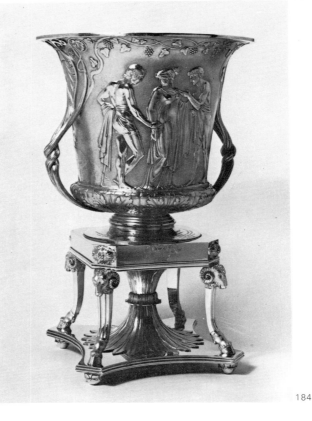

184

185a Seven-Light Candelabrum

(the stem representing the serpent Laden, guardian of the Golden Apples of the Hesperides, being fed by the the three daughters of Erebus and Night: Aegela, Erytheia and Hesperethusa)

The stem and base, including a cartouche with a medallion of Neptune: London hallmark for 1821-22: maker's mark of Philip Rundell. The branches hallmarked for 1830-31: maker's mark of John Bridge. Two cartouches on the base with the arms of the Worshipful Company of Goldsmiths bear the London hallmark for 1880, when the Company acquired the piece. The nozzles and drip pans are engraved with the crest of an Earl.
silvergilt: h. 1105
The Worshipful Company of Goldsmiths, London
lit: J.B. Carrington and G.R. Hughes, *The Plate of the Worshipful Company of Goldsmiths*, 1926, p. 102: Europalia 73 exhibition: 'L'Orfevrerie de la Cité de Londres', Bruxelles, 1973, no. 129, p. 124.

The column, with a figure group modelled from Flaxman's design, was first used in one

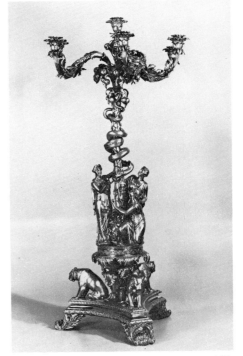

185a

of the two candelabra acquired by the Prince Regent in June 1811. The tripod base, with three seated lionesses surrounding a column encased in fronds of acanthus foliage, conforms to Flaxman's original design (see no. 192). Flaxman's concern with the design probably ended with the apple tree at the junction with the candle branches, which are decorated with vines and acanthus leaves and which support three birds.

185b Twelve-Light Candelabrum
(the stem representing Mercury presenting the Infant Bacchus to the Nymphs of Nysa)
photograph only

London hallmark for 1809-10; maker's mark of Paul Storr. The base stamped with the Latin signature of Rundell, Bridge & Rundell.
Photograph by Gracious Permission of Her Majesty the Queen (copyright reserved)
silvergilt: h. 1030

Designs for this piece survive in some numbers (see ills. 65a, b and no. 192). As is explained on p. 141, the figure group, cast from a model made from Flaxman's design,

was first used in one of the pair of twelve-light candelabra which were acquired by the Prince Regent in June 1811 at a total cost of £4003.15s. The subject of the second candelabrum is discussed above.

186 The Galvanic Goblet

London hallmark for 1814-15; maker's mark of Paul Storr.
silvergilt: h. 125
Lent by Gracious Permission of Her Majesty the Queen
lit: Catalogue of an Exhibition of Royal Plate from Buckingham Palace and Windsor Castle, published for the Victoria and Albert Museum by Her Majesty's Stationery Office, 1954, no. 93; N. M. Penzer, 'Galvanic Goblet: Paul Storr', *Connoisseur*, vol. CXXXIII, 1954, p. 188; Shirley Bury, *Victorian Electroplate*, London 1971, p. 7.

The bowl of the goblet is decorated with a bas-relief frieze emblematic of the Hours, after a design for Wedgwood by Flaxman, who is unlikely otherwise to have concerned himself with the piece. It was described by Rundell's in their inventory of the Royal Plate, made for William IV in 1832, as 'A very

small Galvanic Goblet, with basso relievo of the Hours around the body. From Flaxman' (p. 46). The adjective was derived from the surname of the Italian scientist Luigi Galvani, celebrated in the late eighteenth century for inducing muscular contractions in frogs by the application of electricity. For this reason it appears possible that Rundell's made otherwise unrecorded experiments in electro-gilding during the second decade of the century. Another Italian scientist, Luigi Vincenzo Pignatelli, is known to have gilded two silver medals by means of electricity as early as 1805. But though the process was the subject of intensive experimentation in Europe in the first three decades of the century, it was not brought to a state which allowed of commercial production until the late 1830s.

Other versions of the Galvanic Goblet are known to have been made for the Royal Collection (one for George IV's brother, the Duke of York). A similar piece, hallmarked for 1818, is in the collections of the City Museum and Art Gallery, Birmingham.

187 The Shield of Achilles

London hallmark for 1821-22; maker's mark of Philip Rundell of Rundell, Bridge & Rundell. On the back, the cipher of George IV within the Garter. Inscribed: 'Executed and Published by Rundell, Bridge and Rundell, Goldsmiths and Jewellers to his Majesty. London, MDCCCXXI'
silvergilt: d. 955
Lent by Gracious Permission of Her Majesty the Queen
lit: J. T. Smith, II, 1828, p. 446; E.A. Jones, *The Gold and Silver of Windsor Castle*, Letchworth, 1911, pl. LIV; Catalogue of an Exhibition of Royal Plate, London (HMSO), 1954, no. 104; Michael Clayton, *The Collector's Dictionary of the Silver and Gold of Great Britain and North America*, London/New York etc. 1971, p. 11.

Described in the inventory of the Royal Plate prepared by Rundell's for William IV in 1832 (p. 25), as 'this masterpiece of modern art', the shield was designed and modelled by Flaxman from the description in the eighteenth book of the *Iliad* of the shield made in encrusted iron for Achilles by the god Hephaestus. In the centre, the chariot of the Sun, surrounded by the constellations. The scenes in the border are (1) the marriage procession and banquet; (2) the quarrel and judicial appeal; (3) the siege and ambuscade; (4) the harvest field; (5) the vintage; (6) shepherds defending their flocks and (7) the Cretan dance. The rim is embossed with the

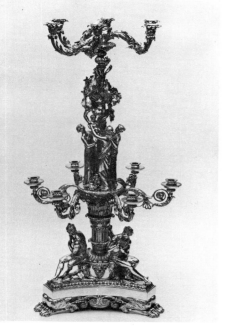

185b

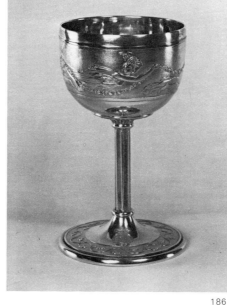

186

mighty Stream of Ocean. According to the anonymous *Memoirs of the late Philip Rundell, Esq.*, which appeared shortly after Rundell's death in 1827, this avaricious and uncultured gentleman had 'surprised all those persons who were acquainted with him' by listening patiently night after night to Flaxman reading aloud from the *Iliad* (perhaps from Alexander Pope's well-known translation) and discussing the treatment of the themes. These unexpected scenes presumably occurred between 1810 and 1817 (see no. 194a, b). Flaxman modelled the piece, cast it in plaster and then sharpened the cast by carving (*Nollekens and his Times*, II, p. 446). The author of the *Memoirs* held that the shield was originally designed in tribute to the Duke of Wellington, the cost of the design and manufacture being partly defrayed by 'the munificence of several spirited individuals, by each of whom a cast was ordered', the Duke of York, the second son of George III, 'being the first supporter of the performance in question, as well as his present Majesty, George the Fourth' (*op. cit.*,

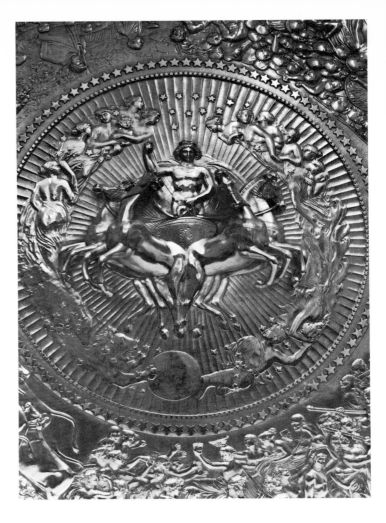

187

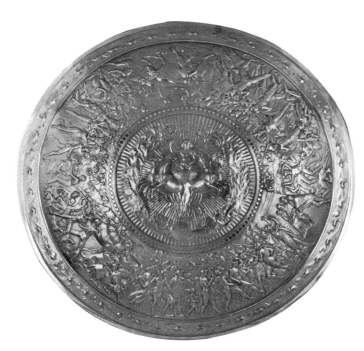

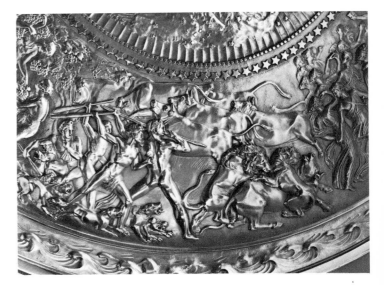

pp. 21-3). While Flaxman was recompensed generously for his design and model, the work of chasing the casts in silver and bronze was probably undertaken, as was normally the case, by other artists. The historical painter and designer George Foggo, in his evidence to the Select Committee of Arts and Manufactures in 1835 (*Minutes of Evidence*, sess. 1835, p. 47, para 693), declared that at

least one of the bronze versions was chased by William Pitts, 'a very celebrated artist', who was trained both as a sculptor and silver chaser. William Pitts and his father, also William, often worked for Rundell's, and it is therefore possible that the younger Pitts had a hand in the silver versions as well.

A.W. von Schlegel wrote after his visit to England in 1823 that 'Flaxman was bent on my seeing his shield of Achilles and with that view accompanied me into the city, to the king's jeweller and silversmith, where there was on view a copy of the work executed in silver-gilt after his model' (E.A. Jones, *op. cit.*, p. xlviii). The number of casts made, once computed at four silvergilt and four bronze, appears to have been larger. E.A. Jones stated that the silvergilt version of 1821-22 formerly in the possession of the Duke of Cambridge was acquired at the sale of his effects in 1904 by his sister, the Dowager Grand Duchess of Mecklenberg-Strelitz (*op. cit.*, p. xlviii).

Another bronze version, together with a plaster cast, were sold in 1911 by Mrs J.E. Bridge at The Manor House, Piddletrenthide. Mrs Bridge was the widow of the son of John Gawler Bridge, a junior partner in the Royal Goldsmiths. (Catalogue . . . of the Highly Interesting and Valuable Collection of Works of Arts [etc.] formed by J. Bridge & J. Gawler Bridge . . . Waring & Gillow Ltd., 20-22 September 1911, lots 300, 300a). Still another cast was owned by Sir Thomas Lawrence (Christie, 6 July 1830, lot 68). An electrotyped reproduction, shown by Hunt and Roskell in the Fine Arts Court of the Great Exhibition of 1851 was favourably noticed (*Reports by the Juries*, single-volume edition, 1851, pp. 736, 740).

188

188 The National Cup

London hallmark for 1824-25: maker's mark of John Bridge of Rundell, Bridge & Company.
Lent by Gracious Permission of Her Majesty the Queen
silvergilt, set with diamonds and coloured stones: h. with cover: 49
lit: E.A. Jones, 1911, pl. LXXXVII; Catalogue of an Exhibition of Royal Plate from Buckingham Palace and Windsor Castle, Victoria and Albert Museum, 1954, no. 129; S. Bury, A. Wedgwood and M. Snodin, 'The Antiquarian Plate of George IV: a Gloss on E.A. Jones', *Burlington Magazine*, June 1979 (*ill.*)

Flaxman's design of 1819, existing now only in a copy of one of his two drawings (see no. 195), was plainly made with the Royal Collections in mind, though the cup was not executed for some years afterwards. It was acquired by George IV on 21 June 1825, together with a glass shade, stand and case, for £870. The decoration is emblematic of the United Kingdoms of England, Scotland and Ireland (Wales, as a principality, was not included). The patron saints, St George, St Andrew and St Patrick, stand beneath Gothic canopies; in between are applied a gem-set rose, a thistle and St Andrew's cross, and a shamrock, below is an Imperial Crown. The cover is surmounted by a cast group of St George and the Dragon, the model for which was re-used by Rundell's on the cover of a silvergilt cup of 1825-26 which was sold to the King on 12 December 1826. The form of the bowl is probably derived from bell-shaped cups of the late fifteenth century, the sides of the body straightened to accommodate the niches. Rundell's were presumably responsible for introducing stones into the design, as they do not appear in the drawing. The stones, of assorted cuts and sizes, were probably taken from unwanted jewellery belonging to the King.

Another version of the cup, one of two more traced by Dr David Irwin, bears the hallmark for 1826-27 and is studded all over with cabochons (Private collection; see D. Irwin, *English Neoclassical Art*, pp. 93, 113; *ill.*).

189 Tureen and Cover

London hallmark for 1826-27; maker's mark of John Bridge
from a set of four; silvergilt; h. 445
Lent by Gracious Permission of Her Majesty the Queen
lit: E.A. Jones, 1911, pl. LXXXI; London, 1954, Royal Plate from Buckingham Palace and Windsor Castle, 1954, no. 109; S. Bury, 1966, p. 152

In the inventory of the Royal Plate prepared for William IV by Rundell's in 1832 (p. 1) four tureens, of which this is one, appear in the list of pieces constituting the Grand Service, a collection of plate started by George IV as Prince of Wales in about 1804 and added to for the rest of his life. The attribution of the design to Flaxman rests partly on a sheet containing two sketches for a centrepiece with Venus, tritons and sea horses, dating from about 1807-09 (ill. 66a), and partly on his drawing for a salver with Venus, Neptune and Amphitrite, tritons and sea horses (ill. 66b). Two stands for ewers made from the second design, hallmarked for 1822-23 and bearing the maker's mark of John Bridge, are in the Royal Collections (Jones, *op. cit.*, pl. LXV); they are supported on three feet composed of tortoises and shells, reminiscent of those on which the tureens rest.

Rundell's made two versions of the tureens, the earliest without a cover; one of these, hallmarked for 1823, is in the Art Institute of Chicago. The uncovered design was later adapted by Hunt & Roskell for the Royal Hunt Cup awarded at the Ascot Races in 1848. A woodcut of the race prize was published in the *Illustrated London News* in the same year, and Flaxman acknowledged as the author of the design (vol. 12, 1848, pp. 375-76). Hunt & Roskell's chief modeller was E.H. Baily, Flaxman's pupil and a former employee of Rundell's.

Ill. 66b Design for a salver with Venus, Neptune and Amphitrite, British Museum

189

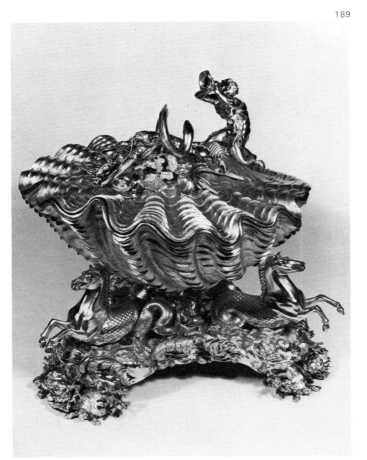

190

190 Study for a candelabrum *c.* 1805-15

pen and wash: 395 x 225
Victoria and Albert Museum

Surmounted by a figure of a mounted Hussar.
On the base, above a seated captive or
mourners, are figures of War and Peace.

This drawing, which has been dated by the
Hussar's uniform, was perhaps made at the
same date as no. 192, which uses a very
similar canopy of acanthus leaves. No silver
made to this design has been recorded.

191 Study and light sketch for a centrepiece
 presented to Sir Arthur Wellesley
 c. 1810

pencil, pen and ink: 305 x 182
Victoria and Albert Museum

The study differs in detail from the completed
centrepiece, (no. 183), notably in having a

figure of Victory as a finial. A similar figure
was, however, used on a centrepiece of
closely related design made for presentation
to Sir Arthur Wellesley in 1811-12 (Welling-
ton Museum, WM 798-1948).

192 Full-sized drawing for the lower part of
 the candelabrum representing Mercury
 presenting the infant Bacchus to the
 Nymphs *c.* 1809

pen and wash: 597 x 360
Trustees of the British Museum
lit: Wark, 1970, no. 60, pp. 78-9

This is the most finished design, presumably
once completed on another sheet, from a
group of drawings which show the candela-
brum from several angles and at various
stages of development (Victoria and Albert;
University College, London; Huntington
Library, California). The earliest recorded
example of the *Mercury* candelabrum was
made for the Prince Regent in 1809-10, (see
no. 185b), at a cost of £1,985, as a pair with the

191

Garden of the Hesperides candelabrum made
a year later (see no. 185a). Only the upper
parts of the Royal pieces follow Flaxman's
designs; the bases show piping fauns seated
around a foliated column. Rundell's adapta-
tion of Flaxman's design is hinted at in the
bill presented to the Regent: '2 rich candela-
bras to fit occasionally on tripod stands,
composed from designs made by Flaxman...'
(E.A. Jones, *The Gold and Silver of Windsor
Castle*, 1911, p. 116). The bifurcated candle
branches are unlikely to have been designed
by Flaxman, who appears rarely to have
concerned himself with functional elements of
this kind. A candelabrum following the
present design almost exactly was made by
Rundell's in 1816-17, with candle branches
of 1819-20 (Christie's sale, 31 March 1976,
lot 130, pl. 31). The twisting and freely
descending figure of Mercury which was in
Flaxman's mind when designing the piece,
although later obscured by foliage (see ills.
65a, 65b) is close to the flying figures of his
relief compositions.

192

149

193 Study for the Theocritus Cup *c.* 1811
(showing the side bearing the scene of suitors)

pen and ink and wash: 277 x 238
Victoria and Albert Museum
lit: Wark, 1970, no. 59, pp. 77-9

The high flat handles and bulging upper outline of the body represent an earlier scheme than the twisted vine-stem handles of the executed cup (see no. 184), which also lacks the wine-cooler liner. Separate studies of the suitors group, which is apparently based on the 'Orpheus' relief in the Villa Albani, are in the Victoria and Albert and the Huntington Library. A study for the figures on the reverse of the cup is in the British Museum, where there is also an etching of the whole cup, perhaps made for Rundell, Bridge & Rundell.

193

194b

194a Study for the Shield of Achilles
in frieze form, showing all the scenes except that of the shepherds defending their flocks, paper watermark 1809

pen and ink and wash with pencil border on several sheets pasted together: 200 x 1745
Christopher Powney Esq.

This drawing represents the earlier unexecuted versions of these scenes, each one having been carried out on a separate sheet of paper. It is a noticeably more awkward and less compact composition than the executed design.

194b Study for the Shield of Achilles
displayed as part of a trophy

pen and ink and wash: 173 x 200
Trustees of the British Museum
lit: Wark, 1970, no. 59

At least ten drawings survive for the Shield of Achilles (British Museum, Victoria and Albert, Huntington Library and one formerly in the Powney collection, see also no. 187), several of them for an unexecuted scheme. Payments for designs had begun by October 1810 (letter in the Fitzwilliam Museum) and were perhaps concluded in January 1817 with a payment from Rundell, Bridge & Rundell of the large sum £200. A year later they paid £525 for the model (Columbia University Account Book, p. 80). This drawing is the simplest of three in the British Museum in which the shield forms the centre of an increasingly elaborate display emblematic of peace and national victory.

195

195 Study for the National Cup *c.* 1819
after John Flaxman

inscribed twice in pencil and ink in a later
hand: 'cup designed for George IV. St
George. St Andrew. & St Patrick. By J.
Flaxman'
pencil and wash: 363 x 196
Victoria and Albert Museum
lit: Physick, 1969, pp. 170-71

In November 1819 Flaxman was paid £15.15s
by Rundell, Bridge & Rundell for '2 drawings
of a gothic cup & St George, Andrew and
Patrick' (Columbia University Account Book,
p. 80), but this drawing is evidently a copy of
one of Flaxman's originals.

196

196 Studies for silver
a race-cup, tureen, coffee pots, and a
salver border decorated with marine
motifs

inscribed: 'No. 2'
pen and wash: 176 x 245
Trustees of the British Museum

Flaxman appears to have produced very few
designs for everyday silver. The vessels in
these studies are notably simpler and purer in
form than much silver of the period.

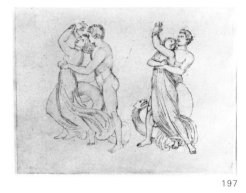

197

**197 Peleus struggling with Thetis, who is
transforming herself into a serpent**
c. 1824

two studies on one sheet
pen and wash: 162 x 203
York City Art Gallery

In January 1824 Flaxman was paid by
Rundell, Bridge & Rundell for a series of
drawings for seven figure groups illustrating
classical myths, including two drawings for
Thetis and Peleus, for which he received £6
(Columbia University Account Book, p. 77).
Drawings exist for all the pieces (British
Museum, Victoria and Albert, Huntington
Library, Metropolitan Museum of Art),
which seem to have been intended for silver
candelabra, but no surviving silver is recorded. 151

John Flaxman's outline illustrations to Dante, Homer and Aeschylus, commissioned and executed in Rome in the early 1790s, aroused immediate interest and enthusiasm among collectors. They became popular even before their publication was completed. Mrs Flaxman recorded in a letter, written in July 1793, [1] that during the spring of that year English tourists had bought individual, unbound plates of the *Iliad*. By the end of 1794 the outlines were sought by many more foreign visitors to Rome; long after the first appearance of the outlines artists and collectors throughout Europe continued to admire them.

The first illustrations to be engraved were those to Homer's *Odyssey*. The Italian engraver, Thomas Piroli, finished this set between February and April 1793; [2] the *Iliad* designs and the outlines to Dante's *Divine Comedy* appeared in July of the same year and the Aeschylus drawings between August and September. Piroli received 107 *soldi* from Flaxman for engraving the Aeschylus, [3] the only set which the English artist owned himself. Flaxman had sold the copyrights of the Homer and Dante illustrations with the drawings, something he later bitterly regretted. When Mr Hare-Naylor, whose wife had commissioned the Homer illustrations, sold them to the publisher Longman in 1805 he made a clear profit of more than £100.[4] But Flaxman's most demanding patron was the wealthy banker, Thomas Hope, who had commissioned the Dante illustrations. Hope forbade publication entirely and the outlines to the *Divine Comedy* did not appear officially in England until 1807, after Hope too had sold the copyright to Longman. Consequently, although the outlines gave Flaxman an international reputation, he derived little financial benefit from them.

The publishing history of these illustrations is beset with muddles and mysteries. For example, two sets, the outlines to Dante and to Homer's *Odyssey*, became known throughout Europe long before they were officially put into circulation. Flaxman himself took the plates and drawings of the Dante to Thomas Hope in 1794 and was allowed only a few presentation copies for friends in return. The plates for the *Iliad* and the *Odyssey* were shipped to England from Leghorn. The

Minerva, which carried the *Odyssey*, was attacked by the French *en route* and her cargo was confiscated. The *Odyssey* was apparently thrown into the sea [5] and no English edition appeared until Longman published one in 1805. However, David's pupil Antoine-Jean Gros, the history painter, made a series of detailed copies from Flaxman's *Odyssey* illustrations in a notebook which he kept in Italy in the 1790s; [6] and Philipp Otto Runge, studying in Copenhagen in 1800, received a copy of Flaxman's *Odyssey*, sent by his brother in Germany. [7] A French edition was published in 1803. Similar obscurity surrounds the first publication of the Dante illustrations. Despite Thomas Hope's ban on the first edition, Goya, working in Madrid in 1795, made at least one detailed copy after several plates from Flaxman's *Paradiso* illustrations (no. 236): in 1799 A.W. von Schlegel published his commentary on Flaxman's Dante illustrations (no. 248), having worked from a first Roman edition of 1793. The clue to such bibliographical enigmas undoubtedly lies in the second set of plates which Thomas Piroli insisted on keeping in Rome as part of his remuneration. Each set of illustrations which Flaxman made for a patron was, as a consequence, probably in circulation long before the copyrights changed hands. Piroli may have printed precisely as many editions of the outlines as he thought would sell and, since outline engraving is extremely cheap to reproduce, he must have been more than satisfied with the results. The one exception to this piracy was the set of illustrations to Aeschylus which Flaxman had kept. It is unlikely that Piroli would have brought out unofficial editions of the Aeschylus, since he had a great respect for Flaxman. Both artists evidently felt resentful over the high-handed behaviour of the patrons. Flaxman allowed

1 Fitzwilliam Museum, Flaxman Letter-box no. 3, ff. 1-2.
2 Bentley, 1964, p. 288.
3 British Museum Add. Ms. 39784, f. 35.
4 R.I.B.A. Drawings collection ms., C.R. Cockerell, *Diaries*, 27 November 1824.
5 British Museum, Add. Ms. 39781, ff. 23-4.
6 Musée du Louvre, Cabinet des Dessins, R.F. 29955.
7 P.O. Runge, *Hinterlassene Schriften*, Göttingen (1965), Vol. II, p. 56.

Piroli to engrave and publish a Roman edition of the Hesiod illustrations, after their publication in 1817, despite the fact that critics and friends of the artist often accused Piroli of spoiling the sculptor's delicate drawings with his flat, uniform, rather heavy line engravings. And Piroli's first edition of the Dante illustrations appeared in Rome in 1802, five years before Thomas Hope sold his copyright. It is fairly certain that there was also a French edition of the Dante in the same year, coinciding with the first German edition of the outlines, the Aeschylus, published in Hamburg.[8]

In England, a first edition of the *Odyssey* was regarded as a collector's item. As early as 1803 William Hayley wrote to Lady Hesketh, congratulating her on having preserved the copy belonging to William Cowper.[9] The 1805 edition of the Homer illustrations was larger, and Flaxman added 11 new designs to the *Iliad* and *Odyssey*, some of which were engraved by William Blake. The new edition was also given a great deal of publicity. Admirers abroad began to look forward to the appearance of Flaxman's Hesiod illustrations, which he had already started to design in Rome. In 1814 Flaxman had still not completed them and he wrote to William Hayley: '. . . French artists and German scholars intrude their speculations "whether the Hesiod will be a second part of the Homer". . . .'[10] In 1816 Flaxman negotiated a contract with Longman for the Hesiod but the set was commercially less successful than the earlier outlines. Between 1817, when the Hesiod first appeared, and 1838, 12 years after Flaxman's death, Longman sold 182 copies out of a first edition of 200. Only 5 new, official editions of Hesiod were printed: this compares unfavourably with the 9 new editions of the Aeschylus, 16 of the Dante, 19 of the *Iliad* and 15 of the *Odyssey*.[11]

Flaxman himself never fully understood the reasons for the critical acclaim of his outline illustrations. In 1811, Henry Crabb-Robinson showed him part of Schlegel's *Athenaeum* article (no. 248) and Flaxman only said: 'he wished the Germans had something better to exercise their critical talent upon'.[12] More anxious over reactions to his sculpture, Flaxman explained to William Hayley in 1793 that he considered the outline illustrations as no more than blueprints for future bas reliefs: 'My view does not terminate in giving a few outlines to the world', he wrote. 'My intention is to shew how any story may be represented in a series of compositions on principles of the Antients, of which, as soon as I return to England I intend to give specimens in Sculpture of different kinds, in groups of basreliefs, suited to all the purposes of Sacred and Civil architecture.'[13] Despite this aim, Flaxman himself never used the outlines as architectural decoration. In the early 1800s the Carabelli brothers made a decorative relief out of the Homer illustrations for the rotunda of Ickworth House in Suffolk, the building erected by the Earl of Bristol which also houses Flaxman's *The Fury of Athemas*. A few years later François Rude also used some of Flaxman's *Iliad* designs when making a decorative relief for a Château in Belgium (see no. 231). Ingres, too, copied the plates of the *Iliad* and the *Odyssey* onto the frieze of the temple in the background of *Homère Déifié* (nos. 225, 226) and considered putting Flaxman's portrait into the painting *The Apotheosis of Homer* (see ill. 67). However, the most bizarre unrealized decorative project for the outlines was formulated by the English painter G.F. Watts. Giving evidence before a commission enquiring into the position of the Royal Academy in relation to the fine arts in 1863, he suggested that Flaxman's outlines should be painted on the walls of public schools '. . . that the young men of Eton would grow up under the influence of works of beauty of the highest excellence.'[14]

This notion of the outline illustrations having a salutary effect upon the spectator was widespread. For example, when the first edition of Flaxman's *Complete Works* was published in France in 1833 by Reveil, the conservative periodical *L'Artiste* became positively lyrical about Flaxman's beneficial influence as a regenerative, artistic force. This opinion was extended even to the artist's personal character. 'L'homme le plus pauvre, le plus humble, le plus modeste, vivant en dehors du monde dans la plus profonde retraite'[15] was how the reviewer saw Flaxman's way of life. And it was the outlines which contributed particularly to this conviction, although Reveil had also included engravings after Flaxman's most famous funerary monuments in his volume. The

8 Bentley, 1964, p. 374.
9 British Museum, Add. Ms. 30803, B.f. 110v.
10 Fitzwilliam Museum, Flaxman Letter-box no. 4, f. 31.
11 Bentley, 1964, pp. 377-78.
12 London, Dr William's Library, typescript, Henry Crabb-Robinson, *Diaries*, Vol. I, 17 January 1811.
13 Fitzwilliam Museum, Flaxman Letter-box no. 4. ff. 1-2.
14 G.F. Watts, *Works*, London, 1912, Vol. III, p. 109.
15 Anonymous reviewer, 'Oeuvre Complet de John Flaxman', *L'Artiste*, 21e livraison, Tome V, pp. 259-60.

illustrations to Homer and Dante were singled out as the supreme examples of Flaxman's talent, praised as possessing '. . . une grande pureté, une grande finesse, un très-grand soin'.[16]

And, for many artists of the nineteenth century, these were the qualities they sought in their own work. Austere, flat and restrained, Flaxman's outlines also possessed a primitive vitality which was attractive to painters and sculptors who themselves drew inspiration from primitive art. Flaxman, having studied antique vase decorations, early Renaissance masters, Egyptian designs, Gothic sculpture and Indian miniatures, offered a unique synthesis of different styles through his graphic work. Unorthodox, eclectic and apparently revolutionary, at least as a designer, Flaxman appealed especially to art students: to the group in David's studio known as *Les Primitifs*, to the young painters who formed the *École Lyonnais* and to students in Northern Europe. When Philipp Otto Runge wrote that he could now neglect his Etruscan vase designs because he had Flaxman instead, he may have been expressing a widely-held opinion. The cult of the primitive, simple image, and the interest in new, restricted perspectival forms was something that painters could find in Flaxman's graphic work, rather than in authentic primitive art.

In Germany the innovations of Flaxman's outlines were not only prized, but also criticized. When Flaxman's sister Mary went to Weimar as a governess in 1805 she met Goethe, who '. . . was extremely kind to me *for my name's sake* and spoke in the highest terms of my brother'.[17] Goethe had mixed feelings about Flaxman's work. He owned several sets of the outlines, a copy of the *Iliad*, the *Odyssey* and the illustrations to Dante's *Inferno*.[18] He was far less impressed by their qualities than A.W. von Schlegel whose panegyric to Flaxman appeared in the *Athenaeum* in 1799 (no. 248). In the *Propyläen* of the previous year Goethe had announced the first of a series of art competitions promoted by the Weimarishe Kunstfreunde. The subject-matter offered was to be a scene from Homer, but Goethe cautioned the competitors against using Flaxman's Homeric outlines as models for their own designs because, Goethe said, he felt that Flaxman's style was full of technical errors.[19] Such censure was at odds with the reactions of critics and painters in France and Germany who were generally favourable towards the extent of Flaxman's influence. Even David, while examining the first French edition of the outlines, was to say: 'Cet ouvrage fera faire des tableaux.'[20] However, Baudelaire, reviewing the work of some of Ingres's pupils at the Salon of 1846, was to remark rather gloomily about one painting: '. . . une espèce de Flaxman, dont l'aspect est si laid, qu'il ôte l'envie d'examiner le dessin.'[21] Perhaps Baudelaire was thinking of the numerous nineteenth-century Neoclassical artists, such as Lehmann, Amaury-Duval and Scheffer (see no. 214), who regularly produced Flaxmanesque paintings and sold them for high prices.

Despite the rather monotonous appearance, throughout the nineteenth century, of painted copies after the outlines, the most significant and valuable indications of Flaxman's influence came from artists' private experiments, inspired by the English artist's graphic techniques. Often these experiments were strikingly similar. William Blake and Francisco Goya, for example, copied the cloaks which Flaxman had designed for figures illustrating the *Inferno*. Both artists seem to have been attracted by Flaxman's anonymous and repetitive shapes: David, Ingres and Runge designed battle scenes which were all probably based on the same two plates from Flaxman's *Iliad*. Géricault (see ills. 68 and 69), Seurat and Girodet-Trioson all made adaptations after the same plate from the *Odyssey*; and the embrace of Paolo and Francesca from the *Inferno*, depicted by Flaxman as a simple, colourless series of lines, offered numerous pictorial possibilities to painters of medieval love scenes (see ills. 71 and 72).

Copying formed a major part of the artist's learning process in the nineteenth century. Many of the artists who appear in this section of the exhibition copied the work of other masters, greater than Flaxman. But, in turning for inspiration to Flaxman's outlines, these distinguished copyists give us a rare glimpse of the kind of formal problems which preoccupied them. We can compare the actual mechanics of totally different styles. Some of the drawings shown here are private studio sketches; smudgy, rather battered works, they might not normally have been

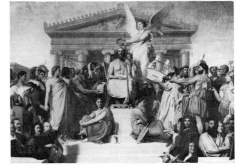

Ill. 67 Ingres, *Apotheosis of Homer*, Louvre

Ill. 68 Géricault, *The Raft of the Medusa*, Louvre

Ill. 69 Géricault, page from Zoubaloff sketchbook, p. 24, Louvre

16 *ibid.*
17 British Museum, Add. Ms. 39782, f. 9v.
18 C. Schuchardt (ed.) *Goethes Kunstsammlungen*, Jena (1848), Vol. I items 43-4.
19 J.W. von Goethe, Nachricht an Künstler und Preisaufgabe,' *Propyläen*, Ersten Bandes, Erstes Stück, Tübingen, 1798, p. 165.
20 Symmons, 1973, p. 592.
21 Charles Baudelaire, 'Salon de 1846', *Curiosités Esthétiques*, Paris (1962), p. 155.

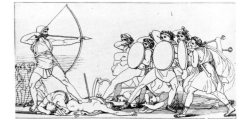

Ill. 70 Flaxman, *Odysseus killing the Suitors*, line engraving

included in a public exhibition. But what they show us is the way in which artists actually worked, how one man would experiment with formal possibilities which another rejected. Ingres's roughed-out study for *Homère Déifié* (no. 226), Goya's way of changing Flaxman's figures of Dante and Virgil into cloaked Spaniards (no. 232) and Runge's tentative exploration of Flaxman's strange, linear world (no. 249) all demonstrate the skeletal techniques used to acquire new ideas. And such drawings display a basically similar purpose: that of treating modern subject-matter with a new, graphic simplicity. Géricault's heroic, muscular nudes in his picture *The Raft of the Medusa* (ill. 68), and the dead and dying of Goya's *Los Desastres de la Guerra* (nos. 233-35) are images produced within the first twenty years of the nineteenth century. Although quite different in appearance, these works rely upon drawing the spectator's attention through a contraction of compositional methods. Similar pictorial reductions appear in the paintings of Ingres and David. All these innovations derive from studies made in sketchbooks or on bits of paper, studies which so often include the spare, flat, frieze-like figures of the Flaxman illustrations. For many nineteenth-century masterpieces, Flaxman's outlines became a never-failing compendium of new ideas and images.

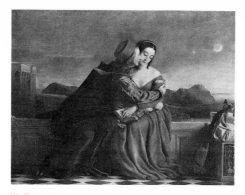

Ill. 71 W. Dyce, *Paolo and Francesca*, oil painting, Edinburgh, National Gallery of Scotland

Ill. 72 Fleury Richard, *Blanche Bazu*, Musée Magnin, Dijon

(a) *Cloaked Figures*

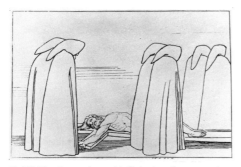

Ill. 73 *The Hypocrites with Caiaphas,* line engraving

William Blake

198 The Hypocrites with Caiaphas 1824-27

inscribed: 'HELL Canto 23'
pencil and watercolour: 373 x 527
The Trustees of the Tate Gallery
lit: Catalogue, 1971, no. 64

Here Blake expands the hooded, anonymous shapes of Flaxman's *Hypocrites* (ill. 73) into a longer, seemingly endless, repetitive sequence of almost abstract forms. Blake, having engraved Flaxman's Hesiod illustrations and several plates for the 1805 edition of the Homer, evidently knew Flaxman's designs extremely well; on occasions, in fact, he accused the sculptor of copying his work. Flaxman did admire and copy Blake's images, especially in the 1780s, after both artists had left the Royal Academy. However, when

198

Blake was commissioned by John Linnell to make a series of watercolour illustrations to Dante's *Divine Comedy*, he probably borrowed numerous motifs from Flaxman's set of Dante illustrations. Like Goya, however, who also copied this same plate by Flaxman, Blake transforms Flaxman's original work into something quite new and personal.

199

Francisco de Goya

199 Three pairs of hooded monks *c.* 1795

indian ink wash on paper: 176 x 262
Madrid, Biblioteca Nacional
lit: Ángel de Barcia, *Catálogo de la Collección de Dibujas Originales de la Biblioteca Nacional*, Madrid (1906), no. 1275, p. 206: Rosenblum, p. 177: Symmons, 1971, p. 511: Gassier, 1975, no. 341, p. 514

These monks are copied exactly by Goya from 6 figures in Flaxman's illustration to Dante's *Inferno*, canto 23, *The Hypocrites* (ill. 73). Another figure, taken from canto 26, can be seen faintly through a washed-in erasure. Here Goya shows little interest in the original subject-matter and omits the crucified figure of Caiaphas, who appears in Flaxman's plate. Goya seems to have been attracted by the anonymous, repetitive shapes of the monks and he obliterates their features with dark areas of wash. This drawing prefigures many more such hooded and menacing shapes which Goya was to draw throughout

his career, particularly in his series of etchings, *Los Caprichos*, *Los Desastres de la Guerra* and the *Proverbios*.

Francisco de Goya

200 Drawing for 'Pobrecitas!' 1797-98
(*Capricho* no. 22)

red chalk on paper: 195 x 144
Madrid, Museo del Prado
lit: Gassier, 1975, no. 83, p. 120

Los Caprichos, a series of prints made in etching and aquatint, was completed and published by Goya in 1798, having been designed during the previous three years. The plates portray figures set in a steep foreground space against a generally blank or amorphous background with little recession. This drawing is preparatory for the plate in which two poor prostitutes are shown to be followed and threatened by two gendarmes. Pierre Gassier suggests that Goya's copy after Flaxman's three pairs of monks could have provided the Spanish artist with the formal

200

201

basis of his own design, and he was to use similar compositional formulae again, specifically in *Los Desastres de la Guerra*.

Francisco de Goya

201 Drawing for 'Chiton!' 1797-98
(*Capricho* no. 28)

red chalk on paper: 203 x 143
Madrid, Museo del Prado
lit: Gassier, 1975, no. 87, p. 124

Another of Goya's *Caprichos* which shows how he adapts anonymous, hooded shapes to fit a contemporary, comic scene. Here he is still experimenting with the pattern of hooded figures, learnt originally from Flaxman's Dante illustrations.

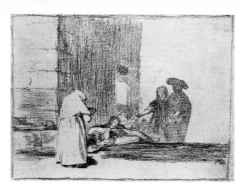

202

Francisco de Goya

202 Drawing for Caridad de una Muger
c. 1812-15
(*Desastre* no. 49)

red chalk on paper: 168 x 212
Madrid, Museo del Prado
lit: Gassier, 1975, p. 260

Another drawing of cloaked and silhouetted figures, this work uses these images to depict a scene of famine in Madrid. By this time Goya's sketches of flat silhouettes against a blank background are entirely personal. Nevertheless, the hooded figure in the foreground of this drawing, juxtaposed with the long, sprawling figure of the dying man, could well derive from Goya's earlier analysis of Flaxman's Dante plate, *Caiaphas and the Hypocrites* (ill. 73).

(b) *The Infernal Boatman*

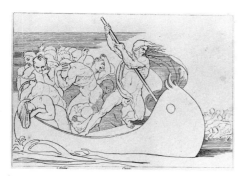

Ill. 74 *Barque of Charon*, line engraving

George Romney

203 Psyche being rowed across the Styx
1776-78

pen with brown ink over traces of pencil on paper: 313 x 481
The Syndics of the Fitzwilliam Museum, Cambridge
lit: Anne Crookshank, 'The Drawings of George Romney', *The Burlington Magazine*, XCIX, no. 647 (February 1957), p. 43

In this drawing Romney creates a contrast between the flowing beard and muscular body of the boatman, Charon, and the figures of the desperate, doomed souls on the left. This drawing seems to prefigure Flaxman's portrayal of the Infernal Boatman who ferries the souls of the dead across the main river of the Underworld: for Dante's *Inferno*, canto 3, Flaxman designed a similar boatman. Greatly influenced by Romney's drawing

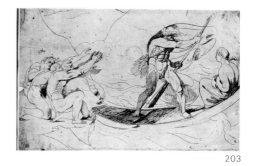

203

style, Flaxman wrote an enthusiastic tribute to the painter for William Hayley's biography of Romney which appeared in 1809. The painter had always encouraged Flaxman's artistic ambitions and was particularly interested in the sculptor's drawings, even at the beginning of the younger man's career. Flaxman himself said years later: 'I always remember Mr Romney's notice of my boyish years and productions with gratitude.'

157

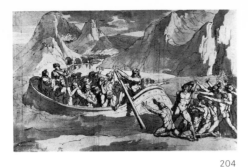

man eliminates a great deal of the horror and pathos expressed by Dante in the original poem, and a drawing such as this corresponds more closely to the text by giving the scene a sense of space and background.

Bartolomeo Pinelli

205 Barque de Dante 1808

signed and dated: 'Pinelli: invento e fece Anno 1808 Roma'
pen, brown ink and grey wash on paper: 430 x 580
Copenhagen, Thorvaldsen Museum
lit: Jacques Vilain, 'Dessins néo-classiques', *La Revue du Louvre*, 2, 1976, XXXVIe année, p. 74

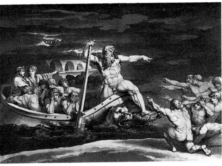

205

Anne-Louis Girodet

204 Barque de Dante

pen and wash: 500 x 750
Pontoise, Musée de Pontoise
(Tavet-Delacourt)
lit: Jacques Vilain, 'Dessins néo-classiques', *La Revue du Louvre*, 2, 1976, XXXVIe année, p. 74

Until recently this drawing was attributed to Bartolomeo Pinelli, another artist who was influenced by Flaxman's outlines. The Thorvaldsen Museum in Copenhagen possesses a drawing by Pinelli very similar to this one by Girodet, and the theme seems to have fascinated early nineteenth-century artists, just as so many other subjects from Dante's *Inferno* were to become popular. Flaxman's use of line in his own depiction of the Infernal Boat-

Joseph Anton Koch

206 La Barque de Dante *c.* 1803

pen over pencil on paper: 304 x 385
Innsbruck, Museum Ferdinandeum

Koch's portrayal of the scene from Dante's *Inferno*, canto 3, is more detailed and dramatic than Flaxman's. The German artist made several versions of the subject and this design probably derives as much from Michelangelo's *Last Judgment* in the Sistine Chapel as from Flaxman's outline version in the Dante illustrations. Nevertheless, the running figures in the background and some of Charon's doomed and desperate passengers are straight quotations from several Flaxman illustrations to the *Inferno*.

(c) *Jupiter and Thetis*

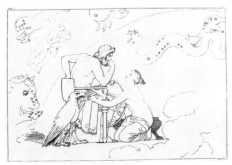

Ill. 75 *Jupiter and Thetis*, line engraving

George Romney

207 Jupiter and Thetis *c.* 1779

pen and ink over pencil: 205 x 238
The Syndics of the Fitzwilliam Museum, Cambridge

This drawing is a remarkable pictorial anticipation of the *Jupiter and Thetis* designed by Flaxman for the new London edition of the *Iliad* illustrations of 1805. It may well be the first in a long line of pictorial experiments with the juxtaposition of these two figures, experiments which include those by Ingres and Gustave Moreau (see nos. 208 and 209).

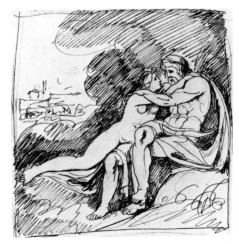

207

Jean Auguste Dominique Ingres

208 Jupiter and Thetis 1810

pencil on tracing paper: 325 x 242
Montauban, Musée Ingres

In 1811 Ingres exhibited a large painting of *Jupiter and Thetis* (Aix-en-Provence, Musée Granet) at the Salon in Paris. This preliminary drawing combines figures from two of Flaxman's *Iliad* illustrations: Jupiter, copied from *The Gods in Council*, is set next to Thetis, from Flaxman's own design of *Jupiter and Thetis* (ill. 75). This last plate was added by Flaxman to the 1805 edition of the Homer illustrations, published in London by Longman and engraved by William Blake. Ingres' library in Montauban contains two first editions of Flaxman's *Iliad* and *Odyssey*

illustrations but, in 1810, while preparing this important painting, Ingres must have obtained one of the later English editions of the *Iliad*. Perhaps the French artist was interested in how Flaxman had depicted this moving Homeric scene, but Ingres's final painting is one of the strangest Neoclassical works produced in the nineteenth century. This drawing gives us little idea of how the French artist was ultimately to portray Thetis: as a long, sinuous figure, reaching up to touch Jupiter's beard. Ingres made numerous preliminary sketches for these two figures. He evidently regarded the relationship between them to be of supreme importance, and they ultimately appear as an almost abstract pattern of colour and form.

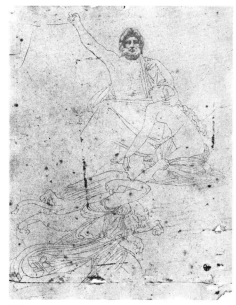

208

209

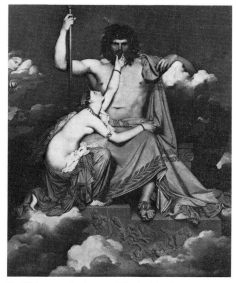

Ill. 76 Ingres, *Jupiter and Thetis*, Musée Gravet, Aix en Provence

Gustave Moreau

209 Jupiter and Semele 1891-95

watercolour on paper: 265 x 210
Paris, Musée Gustave Moreau
lit: Julius Kaplan, 'Gustave Moreau's Jupiter and Semele', *Art Quarterly*, no. 33, 1970, p. 403

On 26 June 1891 Gustave Moreau wrote on his copy of the 1836 *Oeuvres de Flaxman*, engraved by Reveil: 'Cet ouvrage m'a été donné il y a cinquante cinq ans par mon père, Louis Moreau Architecte.' During the

evolution of his painting *Jupiter and Semele*, completed in 1895, Moreau may have referred frequently to Flaxman's outlines. This preliminary study for the painting demonstrates Moreau's dependence not only on Flaxman's depiction of Jupiter but also on Ingres's *Jupiter and Thetis*: Julius Kaplan has additionally proved that many of the figures Moreau painted around the central motif of Jupiter and Semele in the finished work are quotations from some of Flaxman's Dante illustrations.

159

III. 77 *The Lovers Surprised*, line engraving

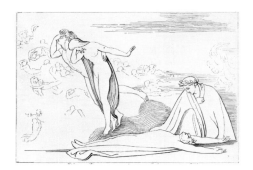

III. 78 *The Lovers Punished*, line engraving

(ill. 71). Like Flaxman, Delacroix portrays Francesca as wearing a complicated head-dress, but his picture is closer in feeling to the versions by Koch and Ingres who also make use of a curtained recess, concealing the figure of Gianciotto Malatesta. Delacroix also emphasizes the medieval surroundings, and details such as furniture and costume became increasingly important in later nineteenth-century treatments of this moving story.

William Blake

210 The Circle of the Lustful: Francesca da Rimini 1824-27

inscribed: 'The Whirlwind of Lovers from Dante's Inferno Canto V'
unfinished engraving: 280 x 350
Trustees of the British Museum
lit: Bentley, *Blake Books*, no. 448, plate in reverse

Blake's portrayal of Paolo and Francesca from Dante's *Inferno* is probably the most powerful and original interpretation of the subject in the nineteenth century. Here, the figures, caught up in the infernal whirlwind, create an abstract, dynamic pattern which owes nothing to the earlier illustration by Flaxman. But Blake has also added, almost as a pictorial quotation, a small roundel above Virgil's head, enclosing the image of the lovers' disastrous embrace which led to their deaths and damnation. Blake thus telescopes past and present events into one picture, unlike Flaxman who designed two consecutive pictures.

Eugène Delacroix

211 Paolo and Francesca 1824-25

signed on right: Eug. Delacroix
watercolour on paper: 280 x 210
Dr Peter Nathan, Zurich
lit: M. Sérullaz, *Mémorial de l'Exposition Eugène Delacroix*, Paris (1963), no. 60, p. 40

This young, bashful Paolo and Francesca shares the apparent immaturity of Flaxman's figures (ill. 77), a trait which also appears in the versions of this subject by Koch (nos. 215 a, b), Ingres (no. 212) and William Dyce

Jean Auguste Dominique Ingres

212 Paolo and Francesca

signed: Ingres
pencil on paper: 136 x 176
Montauban, Musée Ingres

This sketch shows a figure of Francesca which bears a strong resemblance to Flaxman's portrayal. Ingres has elaborated the drapery, however, which he was to do in the version at the Musée Condé, Chantilly. Altogether, he painted six versions of this subject.

210

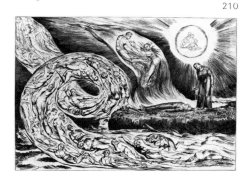

· 211

212

213

Jean Auguste Dominique Ingres

213 Paolo and Francesca in the Whirlwind

pencil on paper: 107 x 176
Montauban, Musée Ingres

Sketch for a larger composition of the same theme.

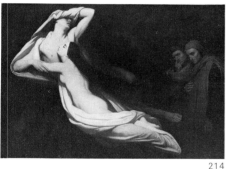

214

Ary Scheffer

214 Paolo and Francesca in the Whirlwind
1854

signed and dated 1854
oil on canvas: 582 x 805
Hamburg, Kunsthalle
lit: Antoine Etex, *Ary Scheffer, Étude sur sa Vie et Ses Ouvrages*
Paris (1859), p. 20: Symmons, 1973, p. 595, n. 23

Scheffer produced several versions of this popular subject, of which the earliest (Paris, Musée du Louvre) is dated 1835. The artist was recorded as saying: 'If I *have* unconsciously borrowed from *anyone* in the design of the "Francesca" it must have been from something I had seen among Flaxman's drawings.' In fact, this image of Paolo and Francesca does not derive exactly from Flaxman's plate of the same subject. The two floating figures are more likely to have been

inspired by some of the plates from the *Purgatorio* and *Paradiso* illustrations, where Flaxman drew several floating figures to represent the souls of the dead.

Joseph Anton Koch

215a Paolo and Francesca

pen over pencil: 280 x 350
Private collection
lit: Lutterotti 1940, p. 261, no. 396

215b Paolo and Francesca

watercolour: 260 x 335
Copenhagen, Thorvaldsen Museum
lit: L. Müller, *Déscription des Tableaux et Dessins au Musée Thorvaldsen*, Copenhagen (1849), no. 203, p. 121

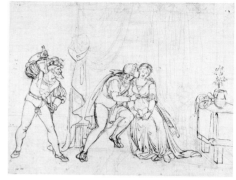

215a

Fascinated by the Paolo and Francesca episode from Dante's *Inferno*, canto 5, Koch returned to it on several occasions concentrating mainly, as here, on the surprising of the lovers by Gianciotto Malatesta. Although Koch's painting of this scene, executed in 1807, is now apparently lost, there are several drawings and prints of Koch's work, which might well have influenced Ingres in his own depiction (see no. 212). Flaxman's austere design (ill. 77) may have inspired both Ingres and Koch to transform the subject into a medieval costume piece, but while Ingres encloses his figures inside a hermetic, box-like space, Koch places the embracing pair in an interior with an open background and pillared window, not unlike the medieval-styled Paolo and Francesca by William Dyce (ill. 71).

215b

Joseph Anton Koch

216 Paolo and Francesca in the Whirlwind
1823
(after A.J. Carstens)

inscribed: A.J. Carstens inv. 1797 J. Koch exc. 1823
watercolour: 765 x 105
Copenhagen, Thorvaldsen Museum
lit: L. Müller, *Déscription des Tableaux et Dessins au Musée-Thorvaldsen*, Copenhagen 1849, no. 201, p. 120

In 1819 Flaxman received a copy of Asmus Jakob Carstens' engravings after illustrations to Dante, sent to him from Germany by Henry Crabb-Robinson. Flaxman was enthusiastic

216

about the work, calling Carstens 'The modern designer from Dante whose imagination is vivid and his conceptions poetical'. Carstens seems to have been the only contemporary German artist whose outlines Flaxman admired. The sculptor made some scathing comments about Moritz Retzsch's outlines to Goethe's *Faust* because he felt that Retzsch had failed to 'understand the nature of an outline'. Koch's many works illustrating Dante were probably unknown to Flaxman but his reaction to this copy after Carstens by Koch might have been more favourable than Koch's professed coolness towards Flaxman's own work. Koch seems to have learnt a lot from both Carstens and Flaxman, especially in his own Dante illustrations. This portrayal of canto 5 from the *Inferno* is closer to the original text than are the illustrations by Flaxman and Blake (see no. 210, ill. 78). Carstens has depicted in detail the other doomed lovers, forced like Paolo and Fran-

217

cesca to fly forever in the infernal whirlwind: they include Dido, Cleopatra, Paris and Helen. In the distance, the First Circle, Limbo, can be seen with the Unbaptised and Virtuous Pagans, a reference to canto 4.

Dante Gabriel Rossetti

217 Paolo and Francesca da Rimini
1855

watercolour: 250 x 450
inscribed along foot of left compartment: 'Quanti dolci pensier Quanto disio'; along foot of right compartment: 'Menò costoro al doloroso passo – O lasso!'
The Trustees of the Tate Gallery
lit: W.M. Rossetti: *Ruskin, Rossetti, Pre-Raphaelitism* (1899), p. 467: V. Surtees, *The Paintings and Drawings of Dante Gabriel Rossetti, A Catalogue Raisonné* (1971), no. 75

In November 1849 Rossetti composed a triptych of these three scenes, arranged in a different order. He made many more studies of the subject, particularly the scene of the lovers' embrace, the image which had especially attracted Koch and Ingres (see nos. 215 a, b: 212, 213).

(e) *Warriors Fighting*

Ill. 79 *The Fight for the Body of Patroclus*, line engraving

Ill. 81 *Achilles contending with the Rivers*, line engraving

162

Jacques Louis David

218 Study for the composition of The Sabines 1796-98
exhibited Hamburg only

black chalk, pen, grey wash, heightened with white (on 3 pieces of paper pasted together): 476 x 636
Paris, Cabinet des Dessins, Musée du Louvre
lit: R. Cantinelli, *David* (1930), p. 58: Rosenblum, 'A New Source for David's Sabines', *The Burlington Magazine*, vol. CIV, (1962), p. 161

In 1794, while in prison in the Luxembourg, David petitioned the Committee of Public Safety to allow him models, without which he was unable to work. In October of the same year the painter's pupil, Delafontaine, was allowed to visit him, bearing various materials, including prints, to serve as source material for David's own work. It is possible that an early copy of Flaxman's *Iliad* was among the engravings which Delafontaine gave David, at this time, since the painter designed the composition of *Les Sabines* before his release, a painting which bears a strong resemblance

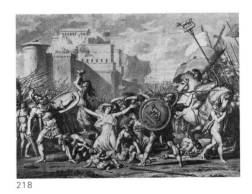

218

to Flaxman's battle scene, *The Fight for the Body of Patroclus*. The finished painting is particularly close to Flaxman's outline and it represents David's greatest effort to come to terms with Greek art: 'Je veux faire du grec pur.' This penultimate drawing was probably made several years after the painter had left prison and it anticipates the finished work very closely, although Romulus, on the right, and Tatius, who faces him, were both depicted finally as nude figures.

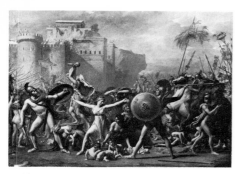

Ill. 80 J.L. David, *Les Sabines*, Louvre

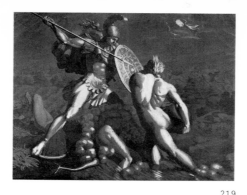

219

221

Philipp Otto Runge

219 Achilles and Scamander 1801

brown wash with white heightening on
brown paper: 527 x 663
Hamburg, Kunsthalle
lit: Berefelt, 1961, *passim*; Traeger, p. 205

Runge's drawings of a scene from Homer's
Iliad, Book 21, *Achilles Fighting with the
Rivers*, was intended to be the artist's entry
for the annual drawing competition held in
Weimar. Runge's pictorial interpretation of
this subject depends on the basic pattern
evolved by Flaxman in the *Iliad* illustrations,
plate 33. Flaxman's plate was praised by
Goethe in 1799: 'Achill in und mit den
Flüssen kampfend, sehr schön gedacht und
komponiert. Die Flüsse walzen gleichsam die
Leichname auf den Wellen hin, es entsteht ein
Raum, in dem Achill kämpft.' This interplay
between the patterns of figures and waves also
attracted Runge and he made numerous
versions of the scene. In this drawing the
figures seem sculptural: white is placed by the
artist on the contours of their limbs. The
distant figure of Pallas Athena, floating in the
sky, probably derives from Runge's earlier
copy after Flaxman's *Odyssey* illustration,
plate 1.

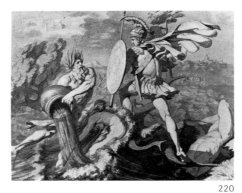

220

Carl Wilhelm Gangloff

221 Fight over the Body of Patroclus
c. 1809

pen over pencil on paper: 188 x 315
Stuttgart, Staatsgalerie
lit: Ulrike Gauss, *Die Zeichnungen und
Aquarelle des 19. Jahrhunderts in der
graphischen Sammlung der Staatsgalerie
Stuttgart* (1976), p. 59

Gangloff (1790-1814), whose style was pro-
foundly affected by his study of Flaxman's
outlines, made numerous sketches of Homeric
subjects, preparatory for a series of Homeric
lithographs which were published in London
in 1817. In this version of Flaxman's famous
plate 26 from the *Iliad* illustrations, Gangloff
has reversed Flaxman's composition, adding
a mounted warrior and a fallen bull.

222

Jean Auguste Dominique Ingres

222 Drawing for Romulus Defeating Acreon
1811-12

pencil on paper: 342 x 520
Montauban, Musée Ingres

Bearing a strong pictorial resemblance to
two great battle paintings by Ingres's teacher,
David, *The Sabines* and *Leonidas at Thermo-
pylae* (Musée du Louvre), *Romulus Defeating
Acreon*, painted by Ingres in 1812, inherits the
pictorial convention which David had
explored in Flaxman's *Iliad* illustration, *The
Fight for the Body of Patroclus*. This outline
sketch for the final work emphasizes the
similarity between the stooping figure in the
Phrygian cap and the Trojan warrior in
Flaxman's plate who bends down on the left
of Patroclus' corpse. Ingres painted *Romulus*
for the Salon de l'Impératrice in the pontifical
palace of Monte Cavallo on the Quirinal in
Rome, a room dedicated to representations
of heroic, antique combat. Ingres's painting
was paired with another by David's Spanish
pupil, José de Madrazo, which depicted the
actual subject of *The Fight for the Body of
Patroclus*, and which was also based upon
Flaxman's seminal design.

Philipp Otto Runge

220 Achilles and Scamander 1801

wash, chalk and white heightening on
blue-grey paper: 453 x 570
Hamburg, Kunsthalle
lit: Traeger, 201

Another drawing of Achilles with an addi-
tional quotation of a sprawling body, possibly
from some of Flaxman's Aeschylus illustra-
tions.

163

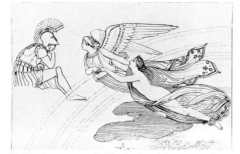

III. 82 *Venus wounded in the hand,* line engraving

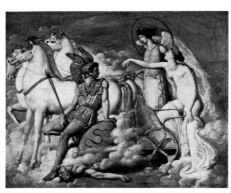

223

Bénigne Gagneraux

223 Dix-huit estampes au trait 1792
composées et gravées à Rome par
Gagneraux, Paris
not exhibited

lit: Henri Baudot, *Éloge Historique de
Bénigne Gagneraux*, Dijon (1889), pp.
xi-xiii: Rosenblum, 1967, p. 180

The 18 copperplate etchings of this publica-
tion comprise the first original designs to be
etched and published in pure outline. Gagner-
aux, having been trained by François Devosge
at the famous École de Dessin in Dijon, was
a brilliant draughtsman and designer, a
distinction he shared with Prud'hon and
François Rude, his fellow-pupils at Devosge's
Academy. These line engravings, however,
are not works of art in their own right but
copies after the most famous paintings
produced by Bénigne himself and by his
brother Claude. Bénigne spent most of his
life in Rome, working for eminent patrons
such as the Kings of Naples and Sweden and
the Grand Duke of Tuscany, who made
Bénigne a professor at the Accademia delle
Belle Arti in Florence in 1794. In the same
year Flaxman visited the Duke in Florence
and presented him with a rare early copy of
the Dante illustrations, in return for two
large silver medals. Flaxman must have
known of Bénigne's outline engravings and it
is possible that they had some influence on
the English sculptor's own designs since one
of the Aeschylus plates, *Pelasge protecting
Danaïdes,* appears to derive from one of
Gagneraux's plates which depicts a man
tormented by the Furies.

Jean Auguste Dominique Ingres

224 Venus Wounded by Diomedes 1805
exhibited Hamburg only

signed: Ingres
oil on canvas: 270 x 330
Basel, Kunstmuseum
lit: Jon Whiteley, *Ingres*, London (1977),
p. 20: Rosenblum, *Ingres* 1967, pp. 17-18

This subject from the *Iliad* was treated by
many Neoclassical artists including David
and Gagneraux. Ingres made several sketches,
probably as preparation for a larger and
uncompleted project. This version may derive
specifically from Flaxman's outline illustra-
tion of the same subject, especially in the
flaccid, undulating figure of Venus, although
the horses are Ingres's own contribution and
derive from an antique relief.

224

Jean Auguste Dominique Ingres

225 Apotheosis of Homer
exhibited Hamburg only

a sketch for the painting of 1827
pen: 118 x 150

b left, under signature: Ingres inc. et Pinxit
preliminary sketch for painting of 1827
black chalk, pen, wash: 210 x 305

c finished version of *c.* 1865
signed: 'J.A.D. Ingres inv. Pinxit Delineavit.'
'Flaxman' is written on the bottom, right
corner, between the names of 'Mme. Dacier'
and 'Barthélemy'.
black chalk, pen, ink and wash on paper:
210 x 310
Paris, Cabinet des Dessins, Musée du Louvre
lit: N. Schlenoff, *Ingres*, *Ses Sources
Littéraires*, Paris (1956), p. 167

Ingres owned 6 works by Flaxman when he
died in 1867: illustrations to *The Lord's Prayer*
(1835); an Italian, 1802 edition of the Dante
illustrations; an 1836 *Oeuvres de Flaxman* by
Reveil; an undated edition of the Aeschylus
illustrations and first editions of Flaxman's
Iliad and *Odyssey.* The French painter is
known to have admired Flaxman's work and
this drawing constitutes Ingres's greatest trib-
ute. On the frieze of the temple behind Homer
are Flaxman's illustrations to Homer, and a
portrait of the sculptor himself is put in the
bottom right corner, together with Louis
XIV, Madame Dacier and the Abbé
Barthélemy. This subject is an extension of an
important commissioned work which Ingres
produced for the Salle Clarac in the Louvre in
1827. He selected numerous artistic person-
alities from the past and portrayed them
paying homage to the blind Greek poet. This
later drawing was probably made for the
engraver, but Ingres enlarged the group of the
elect around Homer and included several
contemporary figures who had been omitted
from the first version (Musée du Louvre).
Originally, Ingres had intended to include the
three representatives of modern painting,
architecture and sculpture: David, Ledoux
and Flaxman. A drawing in the Musée
Ingres, Montauban, dated 1826 by Daniel
Ternois shows that all three masters were to

225a

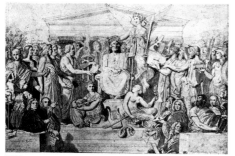

225b

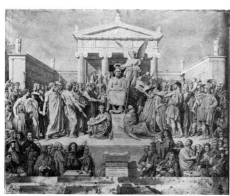

225c

Jean Auguste Dominique Ingres

226 Apotheosis of Homer *c.* 1865
preliminary sketch

pen and pencil on paper: 140 x 420
Montauban, Musée Ingres

This rough sketch for the drawing in the Louvre shows the frieze of the background temple with copies of Flaxman's outlines. The *Odyssey* is on the left, the *Iliad* on the right. The order and identity of the plates Ingres has copied here show that the French artist was working from the new edition of 1805 printed in London by Longman, for which Flaxman designed the extra plates.

226

Jean Auguste Dominique Ingres

227 Woman and Two Children

inscribed by Ingres: De Flaxman chez Mr. Percier
pen on paper, some pencil underdrawing: 122 x 71
Montauban, Musée Ingres

This subject, a standing woman with two children, often appears in Flaxman's works, notably in his Italian drawings, and later, between 1816 and 1819, when the sculptor was working on a figure of Charity for the monument to Countess Spencer. This copy by Ingres, with its inscription, may come from such a Charity group, although its date is uncertain. The reference to Charles Percier, however, is particularly significant. Flaxman met Percier, the Napoleonic designer and architect, while both artists were studying in Rome. Percier admired Flaxman's work and a close friendship sprang up between the two men. When Flaxman went to Paris in 1802 he was a frequent visitor to Percier's studio in the Louvre and he could well have met Ingres there. Flaxman was known to admire Ingres's painting of *The Ambassadors of Agamemnon* (Paris, École des Beaux-Arts) which won the Prix de Rome in 1801, and Ingres's own admiration for Flaxman may well date from this period. Ingres's copy of the woman and children does not correspond exactly to any of Flaxman's drawings depicting this theme, although the motif of an infant leaning out of the woman's arms to embrace another child appears in one or two of Flaxman's Roman drawings. The figure of the woman recalls the main figure in *Clothe the Naked*, one of Flaxman's *Eight Acts of Mercy* (see no. 147) and Ingres was to use a similar woman and child in some of his drawings for the painting of 1834, *Saint Symphorien* (Autun, Cathédrale Saint-Lazare).

227

appear in the final painting. Since Flaxman and David had died by this time it is possible that Ingres wanted to pay them tribute, but he finally rejected this idea. The inclusion of Flaxman's outlines in this drawing, together with the sculptor's portrait, is very significant. The outlines are the only works of art to appear and they are copied exactly. Although Ingres never painted this later version of Homer's *Apotheosis*, it represents a private testament of artistic faith, on which he had worked for several years.

165

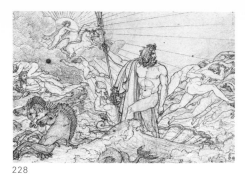

228

Anne-Louis Girodet

228 Neptune ordonne aux vents de se retirer

black chalk: 263 x 420
Paris, Cabinet des Dessins, Musée du Louvre

Girodet-Trioson's style of outline drawing owed much to Flaxman. The French artist was fascinated by the outline illustrations and many copies of different editions were sold among his effects after his death. The influence of Flaxman's imagery is noticeable both in Girodet's illustrations to Virgil and to an earlier set he made for a new edition of Racine.

This drawing was made for one of the illustrations to Book I of Virgil's *Aeneid* and has been compared with William Blake, Fuseli and Beardsley as well as with Flaxman.

Anne-Louis Girodet

229 Illustrations to Virgil's Aeneid
not exhibited
published 1827

based on drawings by Girodet-Trioson and engraved in lithograph by the artist's pupils Munich, Zentralinstitut für Kunstgeschichte

Like those of Flaxman, Girodet's delicate drawings suffered somewhat from the effects of engraving, and here his pupils have tried to emphasize and even to exaggerate the similarity between these outlines and those of Flaxman. The original drawings which Girodet made for this series of illustrations are remarkable for the dynamic, animated quality of the lines, essentially different from Flaxman's more static style. However, Girodet's enthusiasm for the English sculptor's drawings lasted all his life and was witnessed by the poet Alfred de Vigny. In recalling certain episodes from his childhood, de Vigny vividly remembered listening to his father reading Homer aloud while Girodet: '. . . faisait passer sous la lumière les traits merveilleux de Flaxmann (*sic*).'

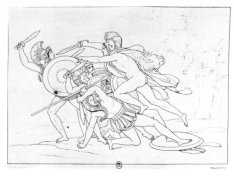

229

230

Anne-Louis Girodet

230 Illustrations to Sappho published 1829

engravings after drawings by Girodet, engraved and published by Chatillon Hamburg, Kunsthalle Library

This series of outline illustrations is somewhat similar to those for Girodet's *Aeneid*, also engraved and published by the painter's pupils, two years before the *Sappho*. In these designs Girodet's fine, dynamic line is essentially quite different from Flaxman's simpler and more austere outlines, but plate 1 of these illustrations contains an obvious quotation of a Flaxman Jupiter. Plate 10, which portrays the death of Sappho, is also Flaxmanesque in the use of repetitive patterns over the surface of the plate which suggest distance but which, simultaneously, seem to lift the whole design onto a two-dimensional plane. A preliminary drawing for the figure of Sappho appears in a work entitled *Venus et Amor* in the Musée d'Orléans.

François Rude

231 Achilles Mourning the Abduction of Briseis 1820-23

inscribed by Rude's wife: 'Dessiné pour la loterie de l'église Saint-Jean Sophie Rude' pen on paper: 215 x 370
Dijon, Musée des Beaux-Arts
Homer's *Iliad* in Neoclassical art', *Art Bulletin*, XLVI, (March 1964), p. 27: Symmons, 1973, pp. 591-99

Rude constructed this scene when preparing a bas relief depicting the life of Achilles for the Château de Tervueren which stood just outside Brussels. Although the Château is now destroyed, the plaster models for Rude's relief and a few drawings are still preserved in Dijon at the Musée des Beaux-Arts and the Musée Rude (ill. 83). Rude may have begun

231

Ill. 84 *Achilles and Briseis*, line engraving

Ill. 83 F. Rude, *Achilles and Briseis*, plaster, Musée Rude, Dijon

this particular design by making a tracing of Flaxman's plate of this subject, since one or two more drawings show the composition in reverse. Although the French sculptor followed Flaxman's composition fairly closely, he also creates a more complex scene in which Patroclus comforts Achilles, the hero's weapons litter the ground and the drapery worn by the girl and Agamemnon's messengers falls in elaborate pleats and folds. Rude obviously admired Flaxman's delicate fine lines, but his own transcription makes the contours of the figures seem harder, perhaps because he uses a more consistently thick outline, without the variations in width peculiar to Flaxman's drawing style (ill. 84).

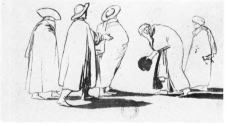
232

Francisco de Goya

232 Five Men with Cloaks and Hats

indian ink and wash on paper: 162 x 259
Madrid, Biblioteca Nacional
lit: Symmons, 1971, p. 511: Gassier, 1975, pp. 340, 513

Here Goya combines figures from three of Flaxman's plates from the *Inferno* illustrations, 1 (see ill. 43), 2 and 16. Again, the figures have been adapted into Spanish peasants, and the style of all these figure drawings anticipates that of Goya's two sketchbooks, the Madrid and Sanlucar, in which the artist sketched ideas he was later to use in *Los Caprichos*.

Francisco de Goya

233a Por Que? 1812-20
(No.32 from *Los Desastres de la Guerra*)

etching and aquatint: 155 x 205
lit: Symmons 1971, p. 512

This design of the garotted man may originate in Flaxman's illustration to the *Inferno*, canto 22, *The Lake of Pitch*. The demon on the left of Flaxman's design, hauling the doomed Ciampolo out of the lake by his hair, corresponds to the soldier in the plate by Goya who pushes down the shoulders of the victim with his foot. The twig of the stunted tree, a recurring image in these plates, is placed by Goya in precisely the same position as the hooked prong of the demon's pitchfork in Flaxman's design. Flaxman's own portrayal of this scene derived from a sketch he made in Rome from a thirteenth-century wall painting of the Last Judgment.

John Flaxman

233b Copy of a thirteenth-century Last Judgment 1790-92
photograph only
Notebook no. 832/8 fol. 59 recto

inscribed: OPERA MALA FECIT OPERA BONA FECIT
black chalk: 165 x 235
The Syndics of the Fitzwilliam Museum, Cambridge
lit: Symmons: 1975, p. 648

Flaxman made this copy after a wall painting in the Portico of St Lawrence Without the Walls in Rome. It depicts the weighing of a guilty soul, and the pattern of the composition formed the model for Flaxman's striking illustration to Dante's *Inferno*, plate 24, *The Lake of Pitch*, a plate which was itself to inspire Goya.

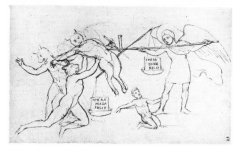
233b

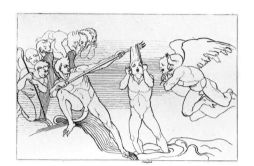
Ill. 85 *The Lake of Pitch*, line engraving

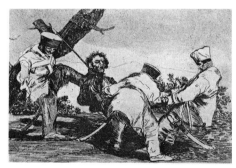
233a

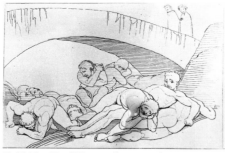

III. 86 *The Pit of Disease*, line engraving

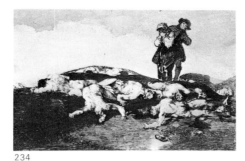

234

236

Francisco de Goya

234 Enterrar y Callar *c.* 1810-12
(no. 18 from *Los Desastres de la Guerra*)

etching and aquatint: 160 x 235
lit: Symmons, 1971, p. 512

Goya's *Los Desastres de la Guerra*, designed and etched between *c.* 1810 and *c.* 1820, were not published until 1863, thirty-five years after the artist died. This series of plates, designed with great simplicity, portrays terrifying scenes from the Spanish Peninsular War (1808-12). Figures are set, as if in a sculptured relief, against blank backgrounds or sparse landscapes; there is little movement and the effect of such images is extraordinarily powerful. This particular scene is based on Flaxman's illustration to Dante's *Inferno*, canto 29, *The Pit of Disease*. Goya takes no more than the basic pattern of the Englishman's plate: two figures standing to the right of the composition, beside a central, elliptical arch with scattered nude bodies beneath. The position of the prone, struggling body with clenched hands on the left of Flaxman's outline, also corresponds to the corpse in the left foreground of Goya's print.

235

Francisco de Goya

235 Drawing for Enterrar y Callar
c. 1810-12
Desastre no. 18

red chalk on paper: 185 x 236
Madrid, Museo del Prado
lit: Gassier, 1975, no. 177, pp. 222-23

Dated by Pierre Gassier as one of the earliest designs for *Los Desastres de la Guerra*, this drawing anticipates almost exactly the rolling clouds of smoke in the etching. If this work is among the first *Desastres* then its derivation from Flaxman's illustration to *The Pit of Disease* suggests that Goya may have begun his terrifying portrayals of scenes from the Spanish Peninsular War with a new study of Flaxman's Dante illustrations.

Francisco de Goya

236 Three figure groups and a mother and child in bed 1795

inscribed by Goya: En en(er)o 1795
inscribed by Valentin Carderera: Salen en las abras de Flaxman
indian ink and wash on paper: 195 x 266
Madrid, Museo del Prado
lit: Xavier de Salas, 'Sur Cinq Dessins du Musée du Prado', *Gazette des Beaux-Arts*, LXXV, 1970, pp. 29-42: Symmons 1971, p. 511; Gassier (1975), no. 345, p. 518

The figures in this drawing are taken from six of Flaxman's illustrations to the *Inferno*, plates 1 (see ill. 43), 3, 7, 15, 17, 26. The date of Goya's inscription means that the artist must have obtained a first edition of the Dante before its official publication in Rome in 1802. Goya transforms Flaxman's sparse, cloaked figures into Spaniards, something he was to do in almost all his copies after Flaxman. There are five known exact copies by Goya after Flaxman's *Divine Comedy* designs and they may all date from this period. They remained in the artist's collection until his death, when this and the copies in the Biblioteca Nacional in Madrid passed into the collection of one of Goya's first biographers, Valentin Carderera.

Flaxman, Thorvaldsen and some Danish artists

Flaxman's influence on Danish art lies more with the engravings after his drawings than with his sculptures. Neoclassical ideas had come to Denmark rather early through two French artists, J.F.J. Saly, the sculptor, and N.H. Jardin, the architect, who were both in Denmark in the 1750s. Shortly afterwards more such ideas were brought back to Denmark from Rome by two Danish artists, the sculptor Johannes Wiedewelt and the painter Peder Als, both friends of Winckelmann. In the 1770s in Rome N.A. Abildgaard was friendly with the Swedish sculptor Johan Tobias Sergel and the Swiss born painter Henry Fuseli, and the proto-romantic Neoclassicism of these three artists had a great effect on Abildgaard's pupils at the Royal Academy in Copenhagen, where he was made professor in 1778. There he influenced Carstens and taught Caspar David Friedrich, Philipp Otto Runge and Bertel Thorvaldsen, as well as many less well known Danish artists.

Although there is an interesting parallel between Abildgaard's allegorical drawings of the death of Catherine II of Russia and one of Flaxman's Dante illustrations,[1] the two drawings are contemporary and Abildgaard was not influenced by the English artist. But engravings after Flaxman were not unknown in Denmark. Runge received some of them from his brother Daniel during his stay in Copenhagen and copied both them and Tischbein's illustrations to *Hamilton's Vases* (no. 246).[2]

Thorvaldsen arrived in Rome 1797, sadly lacking in classical education. He gave the archaeologist Georg Zoega, who was to help him most in understanding the classical past, the impression of being 'höchst unwissend in allem, was ausserhalb der Kunst liegt', and 'ohne die geringste Kenntnis von Geschichte und Mythologie'.[3] Through Zoega, Thorvaldsen met Carstens and was probably thereby introduced to Flaxman's Homer illustrations. Zoega had visited Flaxman's studio in Rome and had written accounts of his *Athemas* group and of Piroli's engravings after his drawings.[4] Flaxman's name must also have cropped up when Thorvaldsen rented his first studio in Via Babuino, which Flaxman had occupied during his stay in Rome.

Carstens and Flaxman represented, along with Canova, Thorvaldsen's ideals during his first years in Rome. Examples of Canova's influence are legion, but he copied the other two artists as well : Carstens in large drawings, now in the Thorvaldsen Museum, Flaxman in tracings directly from the engravings which he owned bound in volumes.[5] Shortly after his death, Carstens' illustrations to the *Argonauts* were engraved in outline by Joseph Anton Koch.[6] Because of their greater plasticity, these were considered to be opposed to Flaxman's linear style, but both Thorvaldsen and Koch took what they could use from these artists and created a style of their own, combining Carstens' plastic modelling of the figures with Flaxman's undulating lines. When the two friends made drawings with motifs from Dante, Flaxman's influence shows itself again, but now more in terms of iconography (no. 255).[7]

In the first decade of the nineteenth century Thorvaldsen worked with motifs from Homer, perhaps inspired by the popularity of Flaxman's *Iliad* and *Odyssey* illustrations. His style of drawing is quite different from Flaxman's, or rather from Piroli's rendering of it in the engravings. His figures are more plastic, often not defined by clear outlines but rather growing out of a tangle of lines. In a few reliefs he comes closer to Flaxman : as the medium of bas relief requires, the figures are clearly defined, and are placed parallel to the surface.[8]

In 1803, shortly after finishing *Jason*, Thorvaldsen modelled the relief of *Briseis led away from Achilles by Agamemnon's heralds* (ill. 87), which derived its composition from both Canova's relief of 1790 and from

Piroli's engraving after Flaxman's drawing of the same subject.[9] Thorvaldsen's Achilles is, however, more violent in his reaction, inspired directly by Roman sculpture, especially the *Dioscuri* at Monte Cavallo.

In 1804 Thorvaldsen began work on a series of Homeric drawings, the motifs of which he continued to translate into reliefs almost to the end of his life. The drawing of *Hector with Paris and Helen*[10] is far from Flaxman's rendering of the same motif, but the relief of

1 Gunnar Berefelt, 'Abildgaards manierism', *Konsthistorisk Tidskrift*, vol. XXX, 1-2, Stockholm 1961, p. 26.

2 Gunnar Berefelt, *Philipp Otto Runge zwischen Aufbruch und Opposition 1777-1802*, Uppsala 1961, p. 121.

3 In a letter from Zoega to Fr. Münter, printed in Friedrich Gottlieb Welcker : *Zoega's Leben*, II, Stuttgart und Tübingen 1819, p. 186.

4 Letters from Zoega, printed under the title 'Konstsager fra Rom' in the monthly *Minerva*. Athemas is mentioned in a letter dated 12 February 1794, and the engravings to Homer in a letter dated 17 April 1793, both in *Minerva*, March 1799.

5 In Thorvaldsen's library, The Thorvaldsen Museum: The *Iliad* and *Odyssey* in the Piroli edition, Rome 1793: the same in French editions, s.a.: a volume of supplementary engravings of both the *Iliad* and the *Odyssey*: The *Tragedies of Aeschylus*, engraved by Piroli, London 1795: a French edition by Piroli of Hesiod, s.a.: the 1802 edition by Piroli of *La Divina Comedia*, and the same re-engraved by Fil. Pistrucci, Milano 1823.

6 Carl Ludwig Fernow: *Leben des Künstlers Asmus Jakob Carstens*, Leipzig 1806, pp. 218-19.

7 Thorvaldsen and Koch both did drawings of *Dante and Virgil on Geryon* in a manner quite close to Flaxman's rendering of the subject (*Divina Comedia*, 1802, tab. 18). Thorvaldsen's version became very popular : he had to repeat it several times and it was etched by the Riepenhausen brothers. Koch made a large watercolour copy of it which belonged to Thorvaldsen (The Thorvaldsen Museum, inv. no. D 685).

8 Flaxman's influence on Thorvaldsen was pointed out by P. Johansen: *Før Thorvaldsen, Rom-København*, Copenhagen, 1910, pp. 46-54. See also Dora Wiebenson: 'Subjects from Homer's Iliad in Neoclassical Art', *The Art Bulletin*, vol. XLVI, 1, March 1964.

9 Bjarne Jørnæs: 'Thorvaldsens "klassiske" Periode 1803-1819', in: *Bertel Thorvaldsen, Untersuchungen zu seinem Werk und zur Kunst seiner Zeit*, Kölner Berichte zur Kunstgeschichte, Köln 1977, p. 56.

10 Reproduced in Dyveke Helsted: *Thorvaldsen – Drawings and Bozzetti*, Autumn Exhibition, Heim Gallery (London), Copenhagen 1973, cat. no. 10.

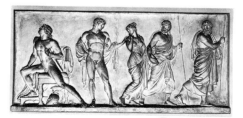

Ill. 87 Thorvaldsen, *Achilles and Briseis*, plaster, 1803, Thorvaldsen Museum, Copenhagen

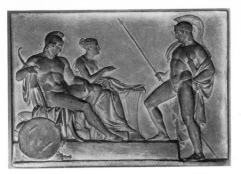

Ill. 88 Thorvaldsen, *Hector with Paris and Helen*,
Thorvaldsen Museum, Copenhagen

1809 (ill. 88) is quite close. It takes over
Flaxman's staging of the scene with Hector to
the right and Paris and Helen to the left, but
in the relief Paris is sitting down, thus render-
ing the composition less staccato than its
model.

Flaxman and Thorvaldsen did not meet
and the Dane never went to England, although
he received many commissions by English
collectors. H.W. Janson has pointed out a
very interesting parallel between the two
sculptors, describing it as the use of the 'full-
bodied soul' in some of their tomb reliefs.[11]
This iconographical innovation was ap-
parently due to Flaxman, and was inspired
by Swedenborg's ideas. Janson argues that
Thorvaldsen came to represent the soul of the
deceased through the living body rising up-
wards because he had known some of Flax-
man's early reliefs, but proves that he also
saw engravings of such tombs as Sarah
Morley's of 1784 in Gloucester Cathedral
and Agnes Cromwell's of 1800 in Chichester
Cathedral. It must be assumed that Thor-
valdsen's patrons were responsible for such
iconography.

Thorvaldsen was a major factor in the lives
of young Danish artists studying in Rome,
from his creation of *Jason* in 1803 until the
time he left the city in 1838. He helped them
in both economic and artistic matters, often
lending them a hand with compositions.[12]
Some of these young artists became his friends
and were allowed to use his library and
browse through his collections of prints and
drawings. Thus they too had access to the
engravings after Flaxman, and indeed his
influence is apparent in works done in Rome
by such artists as J.L. Lund (1777-1867),
C.G. Kratzenstein Stub (1783-1816) and
C.W. Eckersberg (1783-1853).

Flaxman's influence is the least obvious in
the case of Lund. He had been a pupil of
David in Paris before he came to Rome, where
he met Thorvaldsen, and French Neo-

classicism accounts for much of his artistic
personality. Kratzenstein Stub was also influ-
enced by French Neoclassicism, but by that
of the generation younger than David (e.g.
Gérard and Prud'hon). Some drawings
ascribed to him, intended as models for
engravings, are almost pastiches of Flaxman.
This is also true of some of his illustrations
to Ossian,[13] although Flaxman did not pub-
lish any drawings of that subject.

C.W. Eckersberg lived in the same pensione
as Thorvaldsen during his stay in Rome
1813-16, the famous Casa Buti. He too had
been a pupil of David in Paris and the influ-
ence of both the French painter and Thorvald-
sen is evident in a painting like *Hector Taking
Leave of Andromache* in the Thorvaldsen
Museum. It is a free copy of an earlier draw-
ing by the Danish sculptor,[14] painted in the
manner he had learned in Paris. The com-
position of *Ulysses Killing the Suitors of
Penelope* recalls the treatment of the same
scene by Flaxman and represents an influence
which may have been transmitted to him
through Thorvaldsen.

Flaxman continued to inspire Thorvaldsen
until quite late in his life. When in 1837-38
Thorvaldsen had to design a large number of
decorative reliefs for the Palazzo Torlonia, he
sometimes resorted to his collection of en-
gravings after Flaxman.[15] It is not known
whether Thorvaldsen knew of Flaxman's
work for Wedgwood, but there is a parallel
between the two artists in the use to which
industry put their designs. Thorvaldsen's
works were translated into two-dimensional
pictures and used as decoration on countless
adornments in the shape of vases, bowls, etc.
But he only designed directly for medallists
and never, as Flaxman did, for pottery
manufacturers or for silver- or goldsmiths.
Nevertheless he might have approved of the
Royal Copenhagen Factory, and later Bing &
Grøndahl, reproducing his work in reduced
copies in biscuit. This became a large industry
in the second half of the nineteenth century,
and some of the models are being reproduced
to this day.[16] These copies in biscuit were
still relatively close to the originals, their
models being made by young artists in front
of the original work, but poor results were
sometimes achieved with absurdly reduced
copies in kallipasta or galvanoplastic tech-
niques, cheap versions of the more expensive
copies in biscuit. The enormous distribution
of these low-quality copies, which were mass-
produced, led to a vulgarisation of Thorvald-
sen's original works, which in turn diminished
the appreciation of his art until the general
re-evaluation of Neoclassicism which has been
occurring during the last decades.

11 H.W. Janson: 'Thorvaldsen and England', in: *Bertel
Thorvaldsen, Untersuchungen zu seinem Werk und
zur Kunst seiner Zeit*, Kölner Berichte zur Kunst-
geschichte, Köln 1977, pp. 107-28.

12 Bjarne Jørnæs: 'Thorvaldsen-malernes ven', in: *En
bog om kunst til Else Kai Sass*, Copenhagen 1978, pp.
290-308.

13 *Ossian und die Kunst um 1800*, Hamburger Kunsthalle
1974, cat. nos. 48-50.

14 A series of drawings by Thorvaldsen representing
Hector taking leave exists in the Thorvaldsen
Museum, nos. 424-29, they can be dated to the first
decade of the nineteenth century.

15 Jørgen Birkedal Hartmann: *La vicenda di una
dimora principesca romana*, Rome 1967, p. 53.

16 Bredo Grandjean: *Biscuit efter Thorvaldsen*, Copen-
hagen 1978 (edited by the Thorvaldsen Museum).

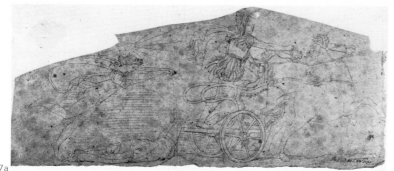

237a

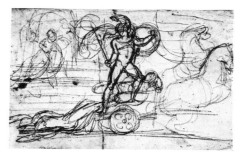

237b

238

Bertel Thorvaldsen

237a Tracing after Flaxman

pencil: 155 x 395
Copenhagen, Thorvaldsen Museum

A collection of 18 tracings after Flaxman's *Iliad* and *Odyssey* is kept in the Thorvaldsen Museum. It belonged to the painter J.L. Lund and is contained in a sheet with an old inscription: 'Gjennemtegninger af Thorvaldsen efter Flaxman' (Tracings by Thorvaldsen after Flaxman). The exhibited tracing was made over Piroli's engraving after Flaxman's drawing of *Achilles dragging the body of Hector around the Walls of Troy* (*Iliad*, pl. 32), which also inspired Thorvaldsen to do the drawing below.

237b Achilles dragging the body of Hector around the Walls of Troy 1804 (?)

black chalk: 221 x 340
Copenhagen, Thorvaldsen Museum
lit: Thiele 1851, p. 250

This vivid rendering of Achilles' revenge on Hector's dead body derives its composition from two British works of art. Achilles' stance is inspired by Gavin Hamilton's painting of the same subject, engraved by Cunego in 1766, although Hamilton's Achilles is clothed. Apart from the figure of Achilles, however, the composition is closer to Flaxman's version of the scene in his *Iliad* of 1793 (pl. 32). Thorvaldsen uses the same frieze-like arrangement of the figures and horses and even includes the flying figure of Apollo, not seen in Hamilton. The drawing can be dated to about 1804, as Thorvaldsen, according to his biographer J.M. Thiele, worked on this theme and other Homeric motifs in that year. It is close in style to other Homeric drawings, published and dated to around 1804 by Dyveke Helsted (Helsted 1973, cat. nos.9 and 10).

Bertel Thorvaldsen

238 The Judgment of Paris *c.* 1813 (?)

pen: 150 x 235
Copenhagen, Thorvaldsen Museum
lit: Repholtz 1920, pp. 21, 73: Sass 1945, pp. 69, 81: Helsted 1973, cat. no. 34

Dyveke Helsted relates this drawing to Thorvaldsen's life-size statue of *Venus* which he began in 1813, and finished in 1816. The central figure of Venus looks very much like sketches for the statue in question (Helsted, 1973, cat. no. 35). The drawing owes something to Flaxman's rendering of the scene, known to Thorvaldsen through one of the supplementary illustrations to the *Iliad* (not in the 1793 edition). Thorvaldsen uses the same rhythm and shows the *dramatis personae* in the same order as Flaxman.

Bertel Thorvaldsen

239 Ulysses killing the suitors of Penelope 1814 (?)

pen: 187 x 215
Copenhagen, Thorvaldsen Museum
lit: Jørnaes 1978, pp. 302-04

This drawing clearly derives from Flaxman (*Odyssey*, pl. 26) and may be a compositional sketch made to help Thorvaldsen's painter friend, C.W. Eckersberg (no. 241). Like Michelangelo, Thorvaldsen helped young painters by suggesting compositions or by allowing them to copy his drawings. He did this for the Danish painters J.G. Wahl, C.F. Høyer, C.G. Kratzenstein Stub and C.W. Eckersberg.

239

Ill. 89 *Ulysses killing the Suitors*, line engraving

Johan Ludvig Gebhard Lund

240 Grieving woman on a clismos chair
 1802-10 (?)
 From sketchbook, inv. no. 3793

pen over pencil: *c.* 330 x 226
Copenhagen, Kobberstiksamling

For a period after his apprenticeship to David in Paris, from 1800-02 until he left Rome in 1810, Lund was the most severe classicist among the Danish painters. This drawing, found in an album of drawings after Italian primitives, was probably executed during his first stay in Italy, and so may also be dated to this period. It shows the influence of David on the one hand (cf. the seated woman on the left of *The Oath of the Horatii*) and of Flaxman on the other (*Odyssey*, pl. 23), without copying either of them directly.

The drawing can perhaps be related to motifs from Homer, as Lund executed two large paintings from this source in Rome, *Andromache bewailing the body of Hector*, 1807 (Royal Danish Embassy, Rome) and *Pyrrhus and Andromache before Hector's Tomb*, 1810 (Royal Museum of Fine Arts, Copenhagen). Both Flaxman and Lund showed an early interest in Italian trecento art and copied it in drawings.

240

Christopher Wilhelm Eckersberg

241 Ulysses killing the suitors of Penelope
 1814

oil on canvas: 230 x 415
Copenhagen, Den Hirschsprungske Samling
lit: Hannover 1898, p. 98, no. 143:
Meddelelser 1973, pp. 24, 45, 53: Jørnaes 1978, pp. 302-04

This unfinished painting shows much of what Eckersberg had learned from David during his stay in Paris from 1801 to 1813. He mentions it in his diary for 21 March 1814, as being begun that day, and again in a letter to Herman Schubart of 16 June the same year. Here he tells that he has to stop work on two paintings, one of *The Daughters of Cecrops*, the other of *Ulysses killing the suitors*, as he cannot afford the models for them. This accounts for why this painting is unfinished, but Eckersberg does not mention anything about the composition of the painting, which is worked out rather in detail. In fact he derived the composition from Flaxman (*Odyssey*, pl. 26), perhaps through Thorvaldsen's intervention.

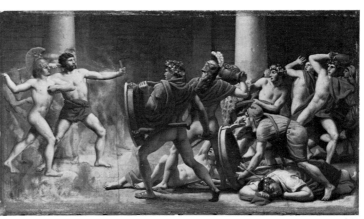

241

Christian Gottlieb Kratzenstein Stub

242 Alcyone's Dream 1810

pen, gray and black ink: 186 x 217
Copenhagen, Kobberstiksamling
lit: Catalog 1816, no. 5: Brun 1817, p. 275:
Haandtegninger 1844, p. 12, no. 8

The story of Ceyx and his wife Alcyone (Ovid, *Metamorphoses*, XI) is not common in art but it is, strangely enough, the subject of some important works by two Danish painters, executed during their stay in Rome. Kratzenstein Stub painted his *Alcyone looking out over the sea* (Royal Museum of Fine Arts, Copenhagen) in 1810, and Eckersberg did his *Alcyone by the sea* (Royal Museum of Fine Arts, Copenhagen) and *Alcyone's Dream* in 1813. Only a fragment is known of the last-mentioned picture, a sleeping woman in antique dress, the so-called 'Alcyone's nurse', in the Thorvaldsen Museum.

Kratzenstein Stub's *Alcyone* painting owes a great deal to French art (Jørnaes 1978, p. 298): but the drawing is stylistically inspired by Flaxman. It shows Alcyone receiving a dream of her husband's drowning, and it was engraved by H. Wensler for an edition of some of Kratzenstein Stub's drawings published by a friend of his, C. Chr. Bang (*Haandtegninger* 1818). The date of the drawing, 1810, is taken from the catalogue of the commemorative exhibition held in 1816, shortly after the artist's death (Catalogue 1816), also written by C. Chr. Bang.

242

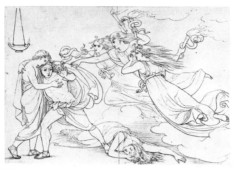

243

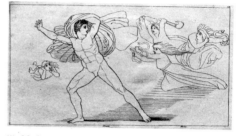

Ill. 90 *Orestes pursued by the Furies,* line engraving

Christian Gottlieb Kratzenstein Stub

243 Orestes pursued by the Furies 1814 (?)

pen: 222 x 308
Copenhagen, Kobberstiksamling
lit: Catalog 1816, no. 18: Haandtegninger 1844, p. 10, no. 5

The commemorative exhibition catalogue from 1816 dates this drawing 1814. It is clearly derived from Piroli's engravings after Flaxman's illustrations to *Choephorae* (Aeschylus, pl. 22) and *Furies* (Aeschylus, pl. 26). This drawing seems to have been made as a model for an engraving and it is found in *Haandtegninger* 1818, the volume of engravings after Kratzenstein Stub's drawings. However, it is not quite certain whether he, the engraver H. Wensler or a third person did these drawings.

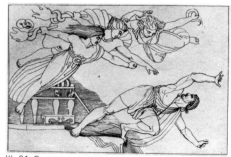

Ill. 91 *Orestes pursued by the Furies,* line engraving

173

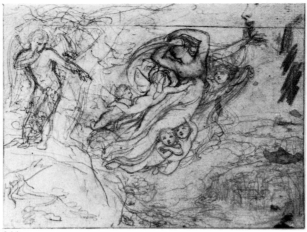

244

Christian Gottlieb Kratzenstein Stub

244 Psyche carried away by Zephyres
1815 (?)

pencil: 156 x 197
Copenhagen, Kobberstiksamling
lit: Catalogue 1816, no. 20: Müller 1816, p. 147: Brun 1817, p. 281: *Haandtegninger* 1844, p. 9, no. 1

Together with Ossian, the story of Cupid and Psyche belonged among Kratzenstein Stub's favourite subjects, as contemporaries such as P.E. Müller noted. He twice painted *Cupid reviving Psyche* (Jørnaes 1978, p. 300), and executed several sketches in oil and a number of drawings of the Cupid and Psyche legend. The Psyche in this drawing is close to Flaxman's rendering of soaring female figures in the Piroli engravings after his drawings. She even resembles women in his tomb reliefs, like Agnes Cromwell (1800) in Chichester Cathedral. In the catalogue of 1816 this drawing is dated 1815. It was engraved by H. Wensler.

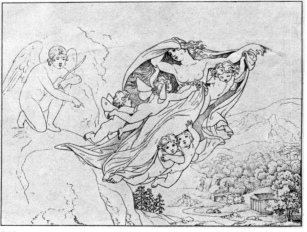

245

Heinrich Wensler (Wentzler)

245 Psyche carried away by Zephyres 1818

engraving: 240 x 320
Copenhagen, Thorvaldsen Museum
lit: *Haandtegninger* 1818: *Haandtegninger* 1844, p. 1, no. 1

This engraving probably reproduces a less sketchy and slightly different drawing from the previous entry, which is unknown today. The engravings after a choice of Kratzenstein Stub's drawings were done by H. Wensler, born in Strasbourg and active in Denmark from the first years of the nineteenth century; after 1820 nothing is known of him. He was a pupil of Alois Senefelder and introduced lithography to Denmark.

Johann Heinrich Wilhelm Tischbein

246 Collection of engravings after ancient vases . . . now in the possession of Sir Wm. Hamilton
Published by Mr Wm. Tischbein, Naples. (Vol 1) 1791, (Vols. 2 & 3) 1795, (Vol. 4) 1803.

Royal Academy of Arts, London
lit: Landsberger 1908, pp. 127-31:
Sörrensen 1910, pp. 88-92: Wiebenson 1964, pp. 33 ff.: Grubert 1975, pp. 10-11

Flaxman is certain to have encountered Tischbein's work in Rome, as it appeared two years before his own ancient compositions. This links the origins of Flaxman's outlines with the archaeological publications of his time. Tischbein's publication stands between exact reproduction of ancient art and the independent outline drawing as achieved in Flaxman's works.

H.H.

246

Johann Heinrich Wilhelm Tischbein

247 'Homer' drawn after the Antique

Hamburg, Kunsthalle Library
lit: Landsberger 1908, pp. 132-4:
Sörrensen 1910, pp. 93-102: Rosenblum 1956, p. 177 with ill.; Wiebenson 1964, p. 36 with ill.; Grubert 1975, with ill.

Tischbein's *Homer* was published in six fascicles between 1801 and 1804/5 with explanatory texts by the well-known classical scholar Heyne, from Göttingen. Only in 1821-23 could Tischbein publish issues 7-9 of the publication, which was originally planned as 10 issues. The explanatory texts, now by Ludwig Schorn (see pp. 30-2), were aimed more at scientific proof and practical application. Tischbein's intention was not, as Flaxman's was, to create a continuous imaginative illustration of Homer's works, but rather an up-to-date corpus of ancient sculptures, reliefs, cameos and vase painting in which one could recognize Homeric scenes. Homer's epics are not illustrated scene by

247

scene but by ideal figures who are presented as the eternal embodiment of virtues valued by all ages.

Tischbein had been guided in this interpretation not only by Winckelmann's writings but also by Lavater's *Physiognomy*. He attempted to connect an ideal beauty of form with the correct expression. This can be seen in the picture of the seven heroes of the *Iliad*, in which the heads are grouped together. Heyne describes them as the portraits and characters of (from left to right) Agamemnon, Achilles, Nestor, Ulysses, Diomedes, Paris and Hercules.

H.H.

August Wilhelm Schlegel

248 On Drawings to Poems and John Flaxman's Outlines

from *Athenaeum*, a magazine by August Wilhelm and Friedrich Schlegel, 2nd volume, Berlin 1799 (pp. 193-246)
Hamburg, State and University Library

Having been given a rare first edition of Flaxman's Dante illustrations of 1793 by an architect friend who had spent some time in Rome, Schlegel wrote this detailed analysis of Flaxman's outlines, making the Dante illustrations the central example. Schlegel also refers to the Homer and Aeschylus illustrations, although his emphasis on the importance of Flaxman's choice of subjects to illustrate fails to take into account the exigencies of Flaxman's patrons. Schlegel's essay is the most important critical assessment of Flaxman's work to appear before the nineteenth century. Schlegel knew little or nothing about Flaxman's sculpture and when the two men met in London in the 1820s, shortly before the artist's death, the German writer was surprised to learn of Flaxman's eminence as a tomb designer in England. In this essay Schlegel undertakes a searching examination of all the illustrations and concludes with an intuitive assessment of Flaxman's stylistic innovations. For Schlegel, the comparatively insignificant genre of the printed illustration had suddenly become distinctive, with the appearance of Flaxman's work: the English artist's outlines were different from anything Schlegel had seen before, and he consequently dismissed the illustrative works of artists such as Hogarth and Chodowiecki as prosaic and crude. Schlegel asserts that when figurative art stops short at what he calls 'the primary, uncomplicated hieroglyph' it comes nearer to poetry. However, the rigorous austerity of Flaxman's outlines was not the only quality which Schlegel admired: he also noticed how Flaxman distorted the forms, especially those of human figures. This Schlegel attributed to a attempt on Flaxman's part to render the pictorial effect more strongly. The supreme example of such expressionistic distortion Schlegel saw as the *Paolo and Francesca* plates (see ills. 77, 78), especially plate 6 in which Flaxman draws Dante lying in a swoon of horror. The body of the figure is elongated beyond a man's normal length and Schlegel is intrigued by the dramatic possibilities of the line itself. He is thus an amazingly intuitive writer, who foresees the enduring popularity of Flaxman's imagery among artists and collectors, especially the *Paolo and*

Francesca designs. And Schlegel's essay, with its revolutionary new ideas about representation, was read by many of the writer's contemporaries, including Goethe and Runge. In 1849, while trying to gain support for the Flaxman Gallery at University College, London, Henry Crabb-Robinson wrote to Prince Albert, saying how '. . . Flaxman's genius was essentially German in its character, as his fame has been in no country so widely proclaimed as by a German critic. There is nothing in English, or I believe, any other language, that is to be compared with Schlegel's paper on Flaxman's Umrisse in the Athen. of 1798 (*sic*). . . .'

S.S.

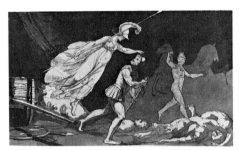
249

Philipp Otto Runge

249 Diomedes, Ulysses and Pallas Athena 1800

pen and wash on paper: 207 x 335
Hamburg, Kunsthalle
lit: Berefelt (1961), pp. 130, 140, 199 ff., 235, Traeger, 1975, no. 129

This drawing is composed from designs in both *Iliad* and *Odyssey* illustrations by Flaxman, and must, consequently, have been drawn just after Runge obtained one of the rare early copies of the *Odyssey*, in September 1800. A month earlier Runge had written rapturously to his brother Daniel, thanking him for the gift of a copy of Flaxman's *Iliad* and Aeschylus illustrations: 'Die Flaxmanischen Umrisse – dafür danke ich dir mit Thränen. Mein Gott, so etwas habe ich doch in meinem Leben nicht gesehen: die Umrisse den Hetrurischen Vasen, die ich von der Br. habe, fallen doch dagegen ganz weg.' Runge added a request for a commentary to the Aeschylus, and was to write his own detailed, critical account of Flaxman's *Odyssey* illustrations in a letter to his brother, written in October 1800.

S.S.

Philipp Otto Runge

250 Starno and Swaran 1804-05

pen over black chalk: 742 x 525
Hamburg, Kunsthalle
lit: Berefelt, 1961

At the end of 1804 Runge was commissioned to make a set of Flaxmanesque illustrations to the apocryphal Celtic ballads of Ossian. This scene is from *Fingal*, Book VI, one of Ossian's 'ancient epic poems', and Runge's drawing forms one of the most fascinating in the series. Runge makes his borrowings from Flaxman quite explicit. Although he uses pure outline, Runge gives each stroke an emphatic distinctness which lends the images an unusual weight and solidity. The German artist can change the thickness of a line at speed without appearing to lift the pen or brush from the paper. In Ossian's poem the battle scenes are always set in wild, rocky landscapes and here Runge has chosen to transcribe one of Flaxman's linear landscapes from Dante's *Inferno* illustrations: the spiky trees, their boughs sharply incised against the blank background, come from the stunted trees which Flaxman drew for the *Inferno*, canto 13, plate 14, *The Forest of Harpies* (ill. 92), and the distant giant on the right is a copy of Flaxman's *Inferno*, canto 14, plate 15.

S.S.

250

Ill. 92 *Forest of the Harpies*, line engraving

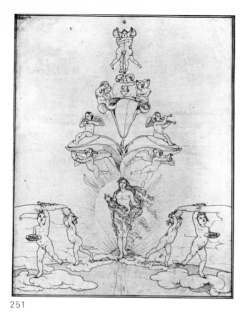

Philipp Otto Runge

251 Morning 1807-08

pen over traces of pencil: 840 x 633
Hamburg, Kunsthalle
lit: Berefelt, 1961, p. 171: Traeger 384

Many sources have been cited for this delicate image. This preparatory study for the *Kleiner Morgen*, forms a part of Runge's famous cycle of *The Four Times of Day*. It is possible that a figure in one of Flaxman's outline designs to Homer's *Odyssey*, that of the goddess Leucothea, may have contributed to Runge's original idea. Writing to his brother in October 1800, Runge said that he was particularly struck by Flaxman's nude goddess, drawn in pure outline: 'Die ganze Idee ist sehr überraschend und leicht.'

S.S.

251

Ill. 93 *Leucothea pursuing Hercules*, line engraving

Philipp Otto Runge

252a Fall of the Fatherland 1809

later inscription, written in pencil: 1809
lithograph: 193 x 134
Hamburg, Kunsthalle
lit: Traeger, 467

This lithograph, originally intended as a frontispiece planned for the cover of the periodical *Vaterländisches Museum*, is one of Runge's designs which reveals most strongly the influence of English early nineteenth-century artists. The supine figure at the bottom of the work derives probably from Henry Fuseli's design of *The Dead Abel*, although it is also very similar to a figure in one of William Blake's illustrations to William Hayley's ballads, *The Hermit's Dog*, published in 1805. However, this same figure, with its outstretched arms, also resembles Flaxman's drawing, suggesting, perhaps, that both artists worked from the same source.

S.S.

252a

John Flaxman

252b A Woman Weeping over a Dead Man

pen and wash: 95 x 164
Hamburg, Kunsthalle
lit: *Runge*, exhibition catalogue, 1977, no. 80A

252b

S.S.

253

Ill. 94 *The Pit of Disease*, line engraving

Friedrich Overbeck

253 The Wise and Foolish Virgins 1846

dated and signed with monogram: FO 1846
pen over pencil on tracing paper: 256 x 596
Lübecker Graphiksammlung

This outline drawing depicts a subject often treated by early nineteenth-century Romantic artists, notably William Blake, who made many versions of it. Overbeck's drawing is basically derived from plate 31, *The Pit of Disease*, one of Flaxman's illustrations to Dante's *Inferno*. Overbeck uses the central motif of the elliptically-shaped bridge, juxtaposed with the large, heaped-up figures in the foreground and the two, much smaller figures, looking down from the bridge.

s.s.

Asmus Jacob Carstens

254 The Voyage of the Argonauts 1799

24 plates. inventées et Dessinées par
Asmus-Jacques Carstens, et Gravées par
Joseph Koch, 1799
Hamburg, Kunsthalle Library
lit: Andresen 1866, p. 34; Fernow 1867,
pp. 147 ff., 382 ff.; Jaffé 1905, pp. 27-8, 129;
Heine 1928, pp. 149 ff.; Honour 1969, p. 114
with ill.; Rosenblum 1976, pp. 182-83, 186

When Carstens died in Rome in 1798, twenty-four preliminary drawings, to a graphic cycle of the Argonaut tale, unfinished in part, were found in his estate. Koch acquired them (he later gave them to Thorvaldsen) and in gratitude to his admired friend for having taught him 'to shake off the dust of academic stupidity', completed them in a series of etchings, publishing it with French captions.

Carstens' drawings (today in the Royal Print Room, Copenhagen) show that Koch, as he himself writes, added to the prototypes in certain places, above all in the landscape backgrounds. But Koch resisted the suggestion of Fernow, Carstens' biographer, that Koch had inadvertently brought them closer to Flaxman's outlines. Carstens himself, according to Fernow, had 'wanted them etched in copper with indications of light and shade'. And above all, he maintained, they were conceived by the artist with a view to a 'painterly execution'.

Furthermore, unlike Flaxman, Carstens proceeds from solid figures and a pictorial stage which recall in their box-like simplicity works of the Italian 'primitives'.

H.H.

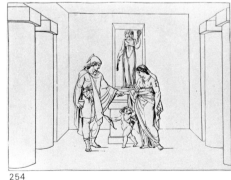

254

Joseph Anton Koch

255 Dante and Virgil on the Back of Geryon
c. 1802

exhibited Hamburg and Copenhagen only
pen: 360 x 287
Private collection
lit: Volkmann 1897, pp. 100 ff.: Jaffé 1905,
pp. 33 ff.: Volkmann 1906: Schneider 1938,
pp. 202, 204: Lutterotti 1940, pp. 32 ff., 142,
261, no. 401 with ill.: Hartmann 1969,
pp. 162 ff.

In 1802 the first thirty sheets of the *Inferno*
had already been produced 'in contour'. At
this time Koch planned a series of etchings of
one hundred scenes. That he saw himself as
Flaxman's rival and superior is shown in a
letter to the art dealer and publisher Frauen-
holz in Nuremberg: 'The Englishman Flax-
man has likewise had the *Divine Comedy*
engraved by Thomas Piroli, along with the
Odyssey and the *Iliad*, many years ago, and
this was bought by Mr Hopp (*sic*). I am cer-
tain that my compositions will not have the
least similarity to those of Flaxman, for these
are in the Etrurian vase taste and never is the
whole subject represented, only individual
groups from it, and were I to engrave the
work, or have it engraved, it must be engraved
with shadow and light.' With these remarks
Flaxman's manner of catching in concise and
clear pictorial form the inventions of, as
Koch says, 'the sublime poet whose speech
is the speech of thunder', is accurately

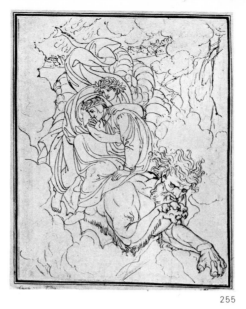

255

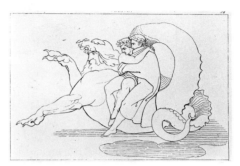

Ill. 95 *Dante and Virgil on the back of Geryon,*
line engraving

characterized. As in his Ossian illustrations,
Koch wants to give a more complete presenta-
tion both of individual scenes and of the
whole poem, yet this did not prevent him
from borrowing certain motifs from Flaxman.

In contrast to their sentimental and classi-
cising transformation of antique subjects and
style, Koch reaches back in a romantic and
historicising way to early Italian models: to
Giotto, to Orcagna and to the Campo Santo
in Pisa, since he finds 'that Dante's poetry is
most closely attached to the art of the Middle
Ages'. The drawing of *Dante and Virgil on
the back of Geryon* refers to canto 17 of the
Inferno, in which the two poets are flown into
the circle of usurers by a strange hybrid
creature (ill. 95). Koch has, as it were, trans-
posed Flaxman's pictorial theme into space
and set it in a landscape. In so doing he retains
the outline style of the *Argonaut* cycle (no.
254).

H.H.

Joseph Anton Koch

256 Ugolino and his Sons *c.* 1802

exhibited Hamburg and Copenhagen only
pen: 370 x 296
Private collection
lit: Comp. Cat. no. 266; V. Schneider 1938,
III, p. 272; Lutterotti 1940, p. 269, no. 419
with ill; Exhib. Cat. Paris 1976, no. 124 with
ill.; Yates 1951

Koch here depicts the death of Count Ugolino
of Pisa (canto 33, *Inferno*). Ugolino was cast
into a tower by his opponent, the Archbishop
Ruggiero, and subjected to starvation. His
thoughts are indicated by the themes on the
medallions: to the left the Archbishop, to the
right Ugolino's dream, in which the Ghibel-
lines appeared before him as hunters who
chased his sons and himself to death. His
dream was fulfilled upon awakening – the
entrance to the tower was nailed shut.

H.H.

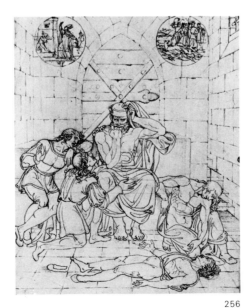

256

Ill. 96 *Ugolino and his sons,* line engraving

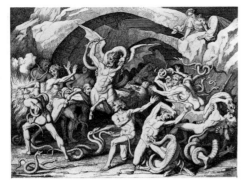

257a

257b

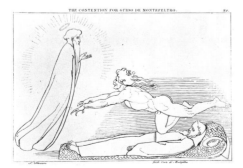

Ill. 97 *The Fight with Satan over St Francis*, line engraving

Joseph Anton Koch

257a The Punishment of the Thieves *c.* 1808

etching: 298 x 374
Hamburg, Kunsthalle
lit: Comp. Cat. no. 266 · Andresen 1886, p. 31, no. 25: Lutterotti 1940, p. 35

In his preoccupation over the years with Dante, Koch increasingly departed from the classical style in favour of late medieval prototypes. He intended in 1808 to reproduce his illustrations 'in the manner of Düreresque woodcuts' 'with as much variety as possible'. Nevertheless only five etchings executed by Koch himself were realized, as no publisher was found for them.

His representation of *The Punishment of the Thieves*, from cantos 24 and 25 of the *Inferno* takes up the motif of the two poets looking down from a rock bridge as in Flaxman's Dante compositions (comp., ill. 94) and in fight scenes from its sheets 26 and 28. Dante and Virgil see how the thieves, who have stolen from others, are now robbed of their very own bodies.

H.H.

Joseph Anton Koch

257b Satan's dispute with St Francis over the soul of Guido da Montefeltro *c.* 1808

etching: 373 x 300
Hamburg, Kunsthalle
lit: Comp. Cat. no. 266: Andresen 1886, p. 30: Lutterotti 1940, pp. 35 ff.

In canto 27 Dante portrays the Eighth Circle of Hell, the residence of the givers of evil advice. There the 'flame' of Count Guido da Montefeltro tells the two poets of his earthly end: Guido had given some clever but pernicious advice, while tempted by Pope Boniface. Thus even the saint, in whose order he had sought shelter, without truly repenting, could not save him from the grip of the 'black cherub'.

Even more clearly than in the previous sheet, Koch, who changed the arrangement of the three main figures and the pattern of the plaited bed mat from Flaxman's equivalent representation (ill. 97), has transposed this into 'old German'. He transfers the scene from a spacious, non-specific, setting into late Gothic sacred architecture with a procession of monks and angels and devils above. Edges inscribed with excerpts from Dante underline the medieval narrative style.

The overall appearance of the etching, with its small worked-through sections of light and shadow, reminds one of early German prints and, in its multitude of figures and attempted fantasy, of Dürer's *Apocalypse*.

H.H.

Buonaventura Genelli

258 Outlines to Homer

Stuttgart and Tübingen (Cotta) 1844
here exhibited: New edition. With comments by Dr Ernst Förster, Stuttgart (Cotta) 1883
Hamburg, Kunsthalle Library
lit: Speckter 1846, Vol. 1, pp. 255-56: Christoffel 1920, pp. 74 ff.: Christoffel 1922, pp. 16 ff.: Ebert 1971, pp. 25, 86 ff.: Stubbe 1977, Vol. 1, pp. 91 ff., Vol. 2, ill. 138

In 1837 Genelli received a commission from from the Cotta bookshop for 12 compositions from the *Iliad*, for which he eventually produced 49 from the *Iliad* and the *Odyssey*, engraved by Genelli himself in 1844 and published by Hermann Schütz. The preparatory work for this may have extended back to the artist's Rome period, when he had probably become acquainted with Flaxman's Homer illustrations.

The verdict of the Hamburg artist Erwin Speckter, spoken as a Nazarene, that Genelli had 'a masterly genius' in so-called theft', 'whereby many figures and groups exactly copied from other subjects are found in his work but so fused and adapted that all seem to have been produced by *one* spirit' is confirmed by Genelli's borrowings from Flaxman. Nevertheless, Genelli and Flaxman were united, apart from format, in wanting these to be more than mere illustrations, no text being included. As with Piroli's transpositions of Flaxman's works, much of the original liveliness of Genelli's drawing has been lost in the engraved reproductions.

Genelli's borrowings from Flaxman are recognizable in the almost literal adoption of plate 14 of the Iliad (25 in Flaxman), in which Sleep and Death carry back to his homeland the corpse of Sarpedon, a son of Zeus, who was slain by Patroclus; at the same time he varies several individual motifs. But it is precisely this comparison of their similarities that highlights the different interpretation of the antique by both artists. Genelli disregards the adherence to the surface, so important to the outline style, and thereby underlines his distance in time from art around 1800.

H.H.

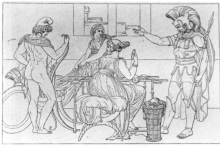

258

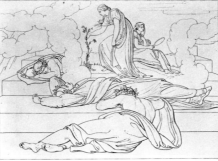

259

Ill. 98 *The Poet Sleeping*, line engraving

Buonaventura Genelli

259 Outlines to the Divine Comedy

Munich (Literary-artistic Institution)
1846-49
here exhibited: New Edition Leipzig (Dürr)
1867, pub. Max Jordan
Hamburg, Kunsthalle Library
lit: Volkmann 1897, pp. 106 ff. with ill.;
Locella 1913, pp. 149 ff. with ill.;
Christoffel 1920, pp. 74 ff. with ill.; Stubbe
1977, Vol. 1, pp. 91 ff.

The idea for this cycle probably goes back to
Genelli's friendship with Koch and his con-
cern with this kind of subject-matter. That at
least in formal respects Flaxman's Dante
illustrations were the model for Genelli is
shown by thematic borrowings, primarily
from scenes which were especially popular
with other admirers of Flaxman: the hypo-
crites under the load of their leaden cowls
which were gilded on the outside (comp. ill.
73), and the love scene between Paolo and
Francesca. In plate 28 of the series Genelli
combines themes from Flaxman's representa-
tions on sheets 31 and 32 of the *Purgatory*,
27 (ills. 98, 99).

H.H.

Ill. 99 *Lea (Matilda), the active life*, engraving

Johann Heinrich Ramberg

**260 Homer's Iliad, serious and comic in
twenty-one engraved sheets** 1827-28

copy of the Gera edition, 1874
Hamburg, Kunsthalle Library
lit: Hoffmeister 1877, pp. 3-4, 44-5;
Stuttmann 1929, pp. 44-5; Forster-Hahn
1963, pp. 121 ff., 213 ff.; Stubbe 1977, Vol. I,
pp. 114-15, Vol. 2, ill. 132

Like Flaxman's outlines, with which it shares
a large oblong format, Ramberg's *Iliad*
appeared as an independent series of illustra-
tions with only short explanations. The year
of publication of the first edition is taken as
1828, as some of the etchings in the diagrams
are dated 1827, some 1828. After a title page
with the figure of Comus, who is trying to
get the epic muse to smile by tickling her feet,
there follow ten pairs of pictures in which the
same scene is first interpreted 'seriously' and
then 'comically'.

E. Forster-Hahn has shown the origin of
Ramberg's persiflage to be the literary
travesties of classical heroic epics since the
seventeenth century and the caricatures of
antiquity since the eighteenth, and has
positively established that Ramberg's shame-
less misinterpretation is not directed against
the ancient myth itself but against Neo-
classicism's idealistic, one-sided view of it and
against its academic, dry, empty canon of
form.

In any case Ramberg pursues with ironic
consistency his conception of the ancient
gods and heroes as men, indeed he uncovers in
the humanity of their figures, behaviour and
intrigues something all too human, which,
nevertheless, also reveals the remoteness of the
gods from the human world. This is revealed
in the opposition of the 'serious' and 'comic'
versions, through which at the same time
classicising pictorial form is parodied.

H.H.

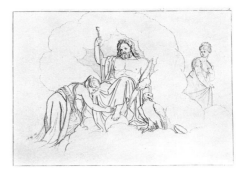

260

260

Acknowledgments

Entries refer to exhibit numbers

Her Majesty Queen Elizabeth II 186, 187, 188, 189

Barlaston, The Trustees of the Wedgwood Museum 19a, 21, 22, 23a, 24, 25-9, 30a, 31, 32a, 34a (loan from Keel University Library), 35, 36, 44, 45, 48, 49, 50, 51, 52b,c,d, 53, 54, 55a,b, 56-61, 63

Birmingham, City Museum and Art Gallery, 20

Bolton, Bolton Museum and Art Gallery 17

Cambridge, Fitzwilliam Museum 9, 10, 11, 12, 13, 88, 112, 140, 143, 167, 176, 181, 203, 207, 233b

Hales Owen, The Earls High School 2

Liverpool, Merseyside County Museums 184

London, British Museum 4b, 7, 15, 18, 32b, 37, 41, 65, 73, 78, 82b, 83, 89, 90, 95, 105, 128, 132b,c,d,e, 134, 139a, 141, 145, 149, 150, 153, 156, 157, 174, 175, 176, 177, 178, 180, 192, 194b, 196, 210

 Courtauld Institute of Art 87, 104, 111b

 Diocese of London 117

 National Portrait Gallery 1

 Royal Academy of Arts 96, 97, 98, 99, 101, 102, 103, 106, 107, 108, 109, 110, 114, 170, 171, 172

 Tate Gallery 198, 217

 University College 3, 64, 66, 67, 68, 69, 70, 71, 72, 74, 75, 76, 77, 79, 80, 84, 115, 116a,b, 119, 120, 121, 123, 124, 125, 126, 127, 129, 133b, 144, 154

 Victoria and Albert Museum 4a, 16, 30b, 38, 47, 85, 86, 136, 139b, 159, 168, 173, 182, 190, 191, 193, 195

Wellington Museum 183

The Worshipful Company of Goldsmiths 185a

John Baskett, Esq. 160

Dr David Bindman 81, 94b, 100b, 155, 161

David Fuller, Esq. 132h

The Hon. Christopher Lennox-Boyd 52a

Christopher Powney, Esq. 6, 8, 113, 146, 147, 152, 194a

Jason Shenai, Esq. (Sidgwick and Jackson) 117

Manchester, Whitworth Art Gallery 82a, 132a, 148, 151

Nottingham, City Museum and Art Gallery 19b, 23b, 52e, 62

Port Sunlight, Lady Lever Art Gallery 43

Stoke-on-Trent, City Museum and Art Gallery 46

York, City Art Gallery 14, 142, 197

Copenhagen, Den Hirschsprungske Samling 178, 241

 Ny Carlsberg Glyptotek 122

 Statens Museum for Kunst, Den kongelige Kobberstiksamling 240, 242, 243, 244

 Thorvaldsen Museum 118, 205, 215b, 216, 237a,b, 238, 239, 245

Bremen, Kunsthalle 233a,

Hamburg, Hamburger Kunsthalle 133a, 135, 137, 162, 163, 164, 165, 166, 214, 219, 220, 230, 247, 249, 252a,b, 254, 257a,b, 258, 259, 260

Staats-und Universitätsbibliothek 248

Lübeck, Museum für Kunst und Kulturgeschichte, Graphische Sammlung 253

München, Zentralinstitut für Kunstgeschichte, Bibliothek 229

Stuttgart, Staatsgalerie, Graphische Sammlung 221

Wolfenbüttel, Herzog August Bibliothek 111a

Angers, Galerie David et Musées d'Angers 179

Dijon, Musée des Beaux-Arts 231

Montauban, Musée Ingres 208, 212, 213, 222, 226, 227

Paris, Musée Gustave Moreau 209

 Musée National du Louvre, Cabinet des Dessins 218, 225a,b,c, 228

Pontoise, Musée Tavet-Delacour 204

Leiden, Kunsthistorisch Instituut der Rijksuniversiteit te Leiden, Prentenkabinet 91, 92, 93

Innsbruck, Tiroler Landesmuseum Ferdinandeum 206

Madrid, Biblioteca Nacional 199, 232, Museo del Prado 200, 202, 235, 236

Basel, Kunstmuseum 224

Zürich, Dr Peter Nathan 211

Boston, Mass., Museum of Fine Arts, Department of Prints and Drawings 5, 130, 131

and numerous private lenders

With the following table a first survey of the bewildering multiplicity of Flaxman's compositions for classical literature should be made easier for the user of this catalogue. At the same time the spread and sustained intensity of the European reception of Flaxman can be documented, by its quantity if not by its quality: the listing of editions provides, as it were, 'statistical' proof for the overall availability of the themes of the English artist.

It should first be mentioned that simple reprints of the plates are only mentioned here exceptionally, on a change of place or publisher – it will suffice to point out that, for example, the London edition of the *Odyssey* was reprinted from the unchanged copper plates dated 1805 no less than ten times up to 1840.

The year and place of publication, the engraver of the reproductions and the number of plates contained are mentioned in as many entries as possible. The majority of the dates used here could be drawn from the fundamental bibliographic investigation of Gerald E. Bentley Jr. (see Bentley, 1964) and the figure appearing in square brackets after an entry corresponds with the numbering under which the detailed description of the respective edition is found in it. I have not seen those Dante volumes marked with [L.V.]. Their dates are taken from Volkmann (1897: p. 96), while Sarah Symmons kindly contributed those details marked with her initials. Further material has been taken from a manuscript of mine which was made available to Professor Bentley for the new and greatly expanded edition of *The Early Engravings of Flaxman's Classical Designs* which will shortly be published.

	ODYSSEY	*ILIAD*	*DANTE*	*AESCHYLUS*	*HESIOD*
1793	*Rome*. Thomas Piroli. I + 28 plates. The duplicate of the plates intended for London were lost. [1 & 2]	*Rome*. Thomas Piroli. I + 34 plates. [1]	*Rome*. Thomas Piroli. I + 110 plates. [1]		
1795		*London*. Thomas Piroli. I + 34 plates. [2]		*London*. Thomas Piroli. 31 plates (also published in Edinburgh as book illustrations). [1 & (3)]	
				Rome. Thomas Piroli. 31 plates. [2]	
1802			*Rome and Paris*. Thomas Piroli. I + 110 plates. [2 & 3]	*Hamburg*. Gerd Hardorff. 16 plates. [<]	
1803	*Paris*. Michel Nitot. Dufresne. I + 28 plates. [3]	*Paris*. Michel Nitot. Dufresne. I + 34 plates. [3]		*Paris*. Michel Nitot. Dufresne. I + 30 plates. [5]	
1804	? *Göttingen*. Ernst Ludwig Riepenhausen. I + 28 plates.	? *Göttingen*. Ernst Ludwig Riepenhausen. I + 34 plates.	*Penig*. Johann Erdmann Hummel. 39 plates to *Inferno*		
		Leipzig. Hans (Johann) Veit Friedrich, Ludwig Ferdinand & Julius Schnorr von Carolsfeld. 34 plates, reduced. [4 & 5]			
1805	*London*. James Parker & James Neagle. I + 34 plates. [4]	*London*. Thomas Piroli, James Parker & William Blake. I + 39 plates. [6]			
1807	*Leipzig*. Hans (Johann) Veit Friedrich & Julius Schnorr von Carolsfeld. I + 28 plates, reduced. [5]		*London*. Thomas Piroli. I + 110 plates. [5 (see also 4)]		

	ODYSSEY	ILIAD	DANTE	AESCHYLUS	HESIOD
1809			*Amsterdam*. Reprint of the Hummel plates in conjunction with Kannegiesser's Dante translation.		
1813			*Paris*. [S.S.]		
1815 (-16)			*Rome*. Reprint of the Piroli plates[3]as illustrations to a multivolume Dante edition.		
1817	*Berlin*. The first of at least 3 demonstrable new editions of the Riepenhausen engravings. [see 6, 9 & 11]	*Berlin*. The first of at least 3 demonstrable new editions of the Riepenhausen engravings. [see 8, 10 & 11]			*London*. William Blake. 1 + 37 plates. [1]
1818	? *Rome*. Thomas Piroli. 1 + 28 plates. [7]	? *Rome*. Thomas Piroli. 1 + 34 plates. [9]		? *Rome*. Thomas Piroli. 1 + 30 plates. [6]	? *Rome*. Thomas Piroli. 37 plates. [2]
1821					*Paris*. Mme Soyer. [3 & 4]
1822			*Milan*. Filippo Pistrucci. 1 + 100 + 10 plates (increased by 10 designs by Pistrucci). [7]		
1823	*Milan*. 1 + 28 plates. [8]	*Milan*. (> Biblioteca classica pittorica). [L.V.]			
1828	*Karlsruhe*. Edouard Schuler. 1 + 34 plates, greatly reduced.	*Karlsruhe*. Edouard Schuler. 1 + 39 plates, greatly reduced.			
1830 (-41)			*Florence*. Lasino the Younger. Book illustrations. [L.V.]		
1831				*London*. Thomas Piroli & Frank Howard. 36 plates. [7]	
1833 (-35)			*Karlsruhe, Paris and London*. 1 + 76 plates in three numbers, greatly reduced.		
1833 (-36)	*Oeuvre Complet de Flaxman*. Recueil de ses compositions gravées au trait, par Reveil. In 268 plates it contains the outlines to the *Odyssey*, *Iliad*, Dante, Aeschylus and Hesiod in reduced format as well as fourteen 'Statues et bas-reliefs'.				
1842			*St Petersburg*. 34 plates to a book edition of *Inferno*.		
1844			*Paris*. [L.V.]		
1845			*New York*. Book illustrations [L.V.]		

Detlef W. Dörrbecker **Bibliography of works quoted in the text**

I Flaxman and England

Adrian 1831 [?Johann Valentin] Adrian, 'John Flaxman', *Morgenblatt für gebildete Stände – Kunst-Blatt*, Vol. 25 [Kunst-Blatt No. 66, 18 August 1831, pp. 261-264. Follows the *Biography 1828*]
The Age of Neo-Classicism, exhibition catalogue, Victoria and Albert Museum and the Royal Academy, London 1972
Bell & Keynes 1945 C.F. Bell and Geoffrey L. Keynes, 'Blake and Flaxman', *The Times Literary Supplement*, 31 March 1945, p. 151
Bentley 1958 Gerald E. Bentley, Jr., 'A.S. Mathew, Patron of Flaxman and Blake', *Notes and Queries*, Vol. 203, 1958, pp. 168-178
Bentley 1959 Gerald E. Bentley, Jr., 'Blake's Engravings and His Friendship with Flaxman', *Studies in Bibliography*, Vol. 12, 1959, pp. 161-188
Bentley 1964 Gerald E. Bentley, Jr., *The Early Engravings of Flaxman's Classical Designs: A Bibliographical Study*, with a Note on the Duplicating of Engravings by Richard J. Wolfe, New York 1964 (first published in two parts as 'Notes on the Early Editions of Flaxman's Classical Designs' in *Bulletin of the New York Public Library*, Vol. 68, 1964, pp. 277-307 and 361-383)
Bentley 1965 Gerald E. Bentley, Jr., 'Blake's Hesiod', *Library*, 5th series, Vol. 20, 1965, pp. 315-320
Beutler 1910 Ernst Beutler (ed.), *John Flaxmans Zeichnungen zu Sagen des klassischen Altertums*, Leipzig 1910
Bindman 1973 David Bindman, 'John Flaxman's Funerary Monuments', in: *Neoclassicismo* (Atti del convegno internazionale dal Comité International d'Histoire de l'Art), Genoa 1973, pp. 9-13
Bindman 1977 David Bindman, *Blake as an Artist*, Oxford 1977
Biography 1828 [Anon], in: *The Annual Biography and Obituary for the Year 1828*, Vol. 12, London 1828, pp. 20-51
Birnbaum 1918 Martin Birnbaum, 'An Essay on John Flaxman with Special Reference to His Drawings', *The International Studio*, Vol. 65, 1918, pp. 65-72
Bishop 1951 Morchard Bishop, *Blake's Hayley: The Life, Works and Friendships of William Hayley*, London 1951
Blake 1975 *William Blake 1757-1827*, exhibition catalogue, Hamburg 1975
Blake 1978 Martin Butlin, *William Blake*, exhibition catalogue, Tate Gallery, London 1978
Blunt 1959 Anthony F. Blunt, *The Art of William Blake*, New York & London 1959
Cameron 1959 Roderick Cameron, 'Flaxman et Wedgwood', *L'Oeil*, 1959, No. 53, pp. 48-55

Campbell 1958 M. Campbell, 'Alternative Designs for a Commemorative Monument by John Flaxman', *Princeton Museum Record*, Vol. 17, 1958, pp. 65-73
Cat. Flaxman auction 1828 *A Catalogue of a Valuable Assemblage of Engravings . . . by Ancient and Modern Masters . . . Various Carvings and a . . . Collection of . . . Music . . .*, the property of the late J. Flaxman which will be sold by auction . . ., London 1828
Colvin 1876 Sidney Colvin, *Drawings of Flaxman in the Gallery of University College, London*, London 1876
Constable 1927 William G. Constable, *John Flaxman 1755-1826*, London 1927
Croft-Murray 1939-1940 Edward Croft-Murray, 'An Account Book of John Flaxman, R.A.', *Walpole Society*, Vol. 28, 1939-1940, pp. 51-101
Cunningham 1830 Allan Cunningham, 'John Flaxman', in *The Lives of the Most Eminent British Painters, Sculptors, and Architects*, Vol. 3, London 1830, pp. 274-367
Dobai 1977 Johannes Dobai, *Die Kunstliteratur des Klassizismus und der Romantik in England*, Vol. 3, 1790-1840, Berne 1977
Ely 1900 Talfourd Ely, *Catalogue of the Works of Art in the Flaxman Gallery University College, London*, London 1900
Erskine 1912 Mrs. Stewart Erskine, 'Some Flaxman Relics', *The Art Journal*, 1912, pp. 81-86
Esdaile 1924 K.A. Esdaile, 'Flaxman's Design for the Monument to Lord Mayor Beckford at the Guildhall', *The Burlington Magazine*, Vol. 45, 1924, pp. 81-87
Essick & La Belle 1977 Robert N. Essick & Jenijoy La Belle (ed.), *Flaxman's Illustrations to Homer*, New York 1977
Farington 1922-1928 James Greig (ed.), The Farington Diary, 8 vols., London 1922-1928
Flaxman 1799 John Flaxman, *A Letter to the Committee for Raising the Naval Pillar, or Monument*, London 1799
Flaxman 1829 John Flaxman, *Lectures on Sculpture*, London 1829 (2nd edition, London 1838)
Flaxman 1958 *John Flaxman, R.A., Sculptor*, exhibition catalogue, Hatton Gallery, King's College, University of Durham, Durham 1958
Flaxman 1976 David Bindman, Christopher Powney and others, *John Flaxman*, exhibition catalogue, Heim Gallery, London 1976
Gaunt 1963 William Gaunt, 'A Set of Drawings by John Flaxman', *Connoisseur*, Vol. 153, 1963, pp. 250-254
Gunnis 1953 Rupert Gunnis, 'Flaxman, John, R.A.', in *Dictionary of British Sculptors 1660-1851*, London 1953, pp. 147-151
Hayley 1791 William Hayley, *The Eulogies of*

Howard, a Vision, London 1791
Hayley 1800 William Hayley, *An Essay on Sculpture: in a Series of Epistles to John Flaxman*, London 1800
Hayley 1809 William Hayley, *The Life of George Romney*, Chichester 1809
Hayley 1823 William Hayley, *Memoirs of the Life and Writings of William Hayley*, ed. John Johnson, 2 vols., London 1823
Honour 1968 Hugh Honour, *Neo-classicism*, ('Style and Civilization'), Harmondsworth, Middlesex 1968
Howard 1786 [Anon.], *The Triumph of Benevolence: Occasioned by the National Design of Erecting a Monument to John Howard*, London 1786
Irwin 1959 David Irwin, 'Flaxman: Italian Journals and Correspondence', *The Burlington Magazine*, Vol. 101, 1959, pp. 212-217
Irwin 1959 (2) David Irwin, 'Reviving Interest in Flaxman', *Connoisseur*, Vol. 144, 1959, pp. 104-105
Irwin 1966 David Irwin, *English Neoclassical Art: Studies in Inspiration and Taste*, London 1966
Kelly 1965 Alison Kelly, 'Decorative Wedgwood, in Architecture and Furniture', *Country Life*, 1965
Klingender 1968 Francis D. Klingender, *Art and the Industrial Revolution*, 2nd revised edition, ed. Arthur Elton, London 1968
Krueger 1971 Ingeborg Krueger, *Illustrierte Ausgaben von Homers Ilias und Odyssee vom 16. bis ins 20. Jahrhundert* (Dissertation, Tübingen), Ulm 1971, pp. 47-60
Kugler 1854 Franz Kugler, *Kleine Schriften über neure Kunst und deren Angelegenheiten*, 'Kleine Schriften und Studien zur Kunstgeschichte', Vol. 3, Stuttgart 1854, pp. 41 ff., 61, 77 ff.
Lipking 1970 Lawrence Lipking, *The Ordering of the Arts in Eighteenth Century England*, Princeton 1970
Meteyard 1873 Eliza Meteyard, *Wedgwood and His Works: A Selection of His Plaques, Cameos, Medallions, Vases . . . from the Designs of Flaxman and Others*, London 1873
Meteyard 1879 Eliza Meteyard, *Choice Examples of Wedgwood Art: A Collection of Plaques, Cameos, Medallions, Vases . . . from the Designs of Flaxman and Others*, London 1879
Morris 1915 H.N. Morris, *Flaxman Blake Coleridge and Other Men of Genius Influenced by Swedenborg* (together with Flaxman's Allegory of the 'Knight of the Blazing Cross'), London 1915
Palliser 1872 Fanny Bury and M.A. Palliser, *Mottoes for Monuments, or Epitaphs . . . Illustrated with Designs by Flaxman and Others*, London 1872
Panofsky 1962 Dora and Erwin Panofsky, *Pandora's Box: The Changing Aspects of a*

Mythical Symbol, 2nd revised edition ('Bollingen Series'), New York 1962, pp. 92-102

Penny 1977 Nicholas Penny, *Church Monuments in Romantic England*, New Haven, Conn. & London 1977

Philadelphia 1968 Frederick Cummings and Allen Staley, *Romantic Art in Britain: Paintings and Drawings 1760-1860*, exhibition catalogue, Detroit Institute of Arts and Philadelphia Museum of Art, Philadelphia 1968

Physick 1969 John Physick, *Designs for English Sculpture*, London 1969, pp. 165-175

Reilly and Savage 1973 Robin Reilly and George Savage, *Wedgwood: The Portrait Medallions*, London 1973

Robertson 1833 William Robertson, *Anatomical Studies of the Bones and Muscles for the Use of Artists from Drawings by . . . J. Flaxman* (engraved by H. Landseer), London 1833

Romney 1830 John Romney, *Memoirs of the Life and Works of George Romney*, London 1830

Romney 1977 Patricia Jaffé, *Drawings by George Romney from the Fitzwilliam Museum, Cambridge*, exhibition catalogue, Cambridge 1977

Rosenblum 1956 Robert Rosenblum, *The International Style of 1800, A Study in Linear Abstraction*, dissertation, New York 1956

Rosenblum 1957 Robert Rosenblum, 'The Origin of Painting: A Problem in the Iconography of Romantic Classicism', *The Art Bulletin*, Vol. 39, 1957, p. 279

Rosenblum 1967 Robert Rosenblum, *Transformations in Late Eighteenth Century Art* (1967), 3rd edition, Princeton 1974

Rump 1974 Gerhard Charles Rump, *George Romney (1734-1802): Zur Bildform der Bürgerlichen Mitte in der Englischen Neoklassik*, 2 vols., Hildesheim & New York 1974 ('Studien zur Kunstgeschichte', Vol. 1)

Sauerlandt 1908 Max Sauerlandt, 'John Flaxman', *Zeitschrift für bildende Kunst*, new series, Vol. 19, 1908, pp. 189-197

Saxl and Wittkower 1948/1969 Fritz Saxl and Rudolf Wittkower, *British Art and the Mediterranean* (1948), 2nd edition, Oxford, London & New York 1969

Scheidemantel 1968 Vivian J. Scheidemantel, 'The "Apotheosis of Homer": A Wedgwood and Bentley Plaque', in: *Festschrift Ulrich Middeldorf*, ed. Antje Kosegarten and Peter Tigler, Berlin 1968, Vol. 1, pp. 517-522 and Vol. 2, illustrated in plates 224-225

Schorn 1827 Ludwig Schorn, 'Besuch bey Flaxman im Juli 1826', *Morgenblatt für gebildete Stände – Kunst-Blatt*, Vol. 21 (Illustration page numbers 29-31 of 9, 12 and 16 April 1827), 1827, pp. 113-115, 118-120 and 123-124

Smith 1828 John Thomas Smith, *Nollekens and His Times . . . And Memoirs of Several Contemporaries of Fuseli, Flaxman, and Blake*, Vol. 2, London 1828, pp. 434-453 passim

Steegman 1968 John Steegman, *The Rule of Taste: From George I to George IV*, 2nd edition, London 1968

Stretton 1956 N. Stretton, 'Some Notes on the Flaxman Chessmen', *Proceedings of the Wedgwood Society*, Vol. 1, 1956

Symmons 1971 Sarah Symmons, 'John Flaxman and Francisco Goya: Infernos Transcribed', *The Burlington Magazine*, Vol. 113, 1971

Symmons 1973 Sarah Symmons, 'French Copies after Flaxman's Outlines', *The Burlington Magazine*, Vol. 115, 1973, pp. 5 ff

Symmons 1973 (2) Sarah Symmons, 'Géricault, Flaxman and "Ugolino"', *The Burlington Magazine*, Vol. 115, pp. 671-672

Symmons 1975 Sarah Symmons, 'The Spirit of Despair: Patronage, Primitivism and the Art of John Flaxman', *The Burlington Magazine*, Vol. 117, 1975, pp. 644-650

Teniswood 1867 and 1868 C.F. Teniswood, 'Memorials of Flaxman', *The Art Journal*, 1867 and 1868, passim

Teniswood 1872 C.F. Teniswood, 'Flaxman as Designer', *The Art Journal*, 1872, passim

Thomas 1955 John Thomas, 'John Flaxman', *Journal of the Royal Society of Arts*, Vol. 104, 1955, pp. 43-66

Volkmann 1897 Ludwig Volkmann, *Iconografia Dantesca: Die bildlichen Darstellungen zur göttlichen Komödie*, Leipzig 1897, pp. 95-100 and passim

Wark 1970 Robert R. Wark, *Drawings by John Flaxman in the Huntington Collection*, San Marino 1970

Watkin 1968 David Watkin, *Thomas Hope 1769-1831 and the Neo-Classical Idea*, London 1968

Watson 1955 Francis Watson, 'Flaxman: The Bicentenary of an English Neo-Classicist', *Architectural Review*, Vol. 118, 1955, pp. 285-289

Watson 1957 Francis Watson, 'Canova and the English', *Architectural Review*, Vol. 122, 1957, pp. 403-406

Whinney 1956 Margaret Whinney, 'Flaxman and the Eighteenth Century: A Commemorative Lecture', *Journal of the Warburg and Courtauld Institutes*, Vol. 19, 1956, pp. 269-282

Whinney 1964 Margaret Whinney, 'John Flaxman', in *Sculpture in Britain 1530 to 1830*, ('The Pelican History of Art'), Harmondsworth, Middlesex 1964, pp. 183-195

Whinney 1965 Margaret Whinney, 'Flaxman at Covent Garden', *About the House*, Vol. 1, 1965, p. 24 (in issue No. 10)

Whinney 1971 Margaret Whinney, *English Sculpture 1720-1830* ('Victoria & Albert Museum Monograph', No. 17), London 1971, pp. 137-145

Whinney and Gunnis 1967 Margaret Whinney and Rupert Gunnis, *The Collection of Models by John Flaxman R.A. at University College London*, London 1967

Wick 1958 Peter A. Wick, 'Flaxman as a Draughtsman', *Proceedings of the Wedgwood International Seminar*, Vol. 3, 1948

Wiebenson 1964 Dora Wiebenson, 'Subjects from Homer's Iliad in Neoclassical Art', *The Art Bulletin*, Vol. 46, 1964, pp. 23-37

Williams 1960 Iolo Williams, 'An Identification of Some Early Drawings by John Flaxman', *The Burlington Magazine*, Vol. 102, 1960

Yates 1951 Frances A. Yates, 'Transformation of Dante's Ugolino', *Journal of the Warburg and Courtauld Institutes*, Vol. 14, 1951, pp. 92-117

II Specialist Publications on Coins, Medals and Silverwork

Brettauer 1937 E. Holzmair, *Katalog der Sammlung Brettauer, Medicina in nummis*, Vienna 1937

Bury 1966 Shirley Bury, 'The Lengthening Shadow of Rundell's' [Part 2], *Connoisseur*, Vol. 161, 1966

Chesneau 1934 G. Chesneau, *Les oeuvres de David d'Angers*, Angers 1934

Forrer 1904-1930 L. Forrer, *A biographical dictionary of medallists*, 8 vols., London 1904-1930

Hocking 1910 W.J. Hocking, *Catalogue of the Coins, Tokens, Medals, Dies and Seals in the Museum of the Royal Mint*, Vol. 2: Dies, Medals and Seals, London 1910

Jones 1911 E. Alfred Jones, *The Gold and Silver of Windsor Castle*, Letchworth 1911

London 1954 *Royal Plate from Buckingham Palace and Windsor Castle*, exhibition catalogue, Victoria and Albert Museum, London 1954

Milford Haven 1909 Marquess of Milford Haven, *British Naval Medals*, London 1909

Oman 1965 Charles Oman, *English Silversmiths' Work, Civil and Domestic: An Introduction*, London 1965

Pollard 1970 J. Graham Pollard, 'Matthew Boulton and Conrad Heinrich Küchler', *Numismatic Chronicle*, 1970, pp. 259-318

Pyke 1973 E.J. Pyke, *A Biographical Dictionary of Wax Modellers*, Oxford 1973

Schazmann 1973 P.E. Schazmann, *David d'Angers, profils de l'Europe*, Geneva 1973

Wood 1913 H.T. Wood, *A History of the Royal Society of Arts*, London 1913

III References to the chapters 'Flaxman and Denmark' and 'Flaxman and Germany'. (Titles listed under section I will not be repeated here.)

Andresen 1866 Andreas Andresen, *Die deutschen Maler-Radierer des neunzehnten Jahrhunderts*, Vol. 1, Leipzig 1866

Becker 1971 Wolfgang Becker, *Paris und die deutsche Malerei 1750-1840* (Studien zur Kunst des 19. Jahrhunderts, 10), Munich 1971

Benz 1941 Richard Benz, *Goethe und die romantische Kunst*, Munich 1941

Berefelt 1961 Gunnar Berefelt, *Philipp Otto Runge. Zwischen Aufbruch und Opposition*, Stockholm, Göteborg, Uppsala 1961

Brun 1817 Friederieke Brun, 'Om Krazenstein Stub of hans efterladte Konstvaerker', *Athene*, Vol. 8, January-June 1817, pp. 271-286

Christoffel 1920 Ulrich Christoffel, *Die romantische Zeichnung von Runge bis Schwind*, Munich 1920

Christoffel 1922 Ulrich Christoffel (ed.), *Buonaventura Genelli. Aus dem Leben eines Künstlers*, Berlin 1922

Ebert 1961/62 Hans Ebert, 'Uber Buonaventura Genellis Umrisszeichnungen zu Dantes

Göttlicher Komödie in Dresdener Kupferstich-kabinett', *Jahrbuch 1961/62. Staatliche Kunst-sammlungen Dresden.* pp. 91-114

Ebert 1971 Hans Ebert, *Buonaventura Genelli. Leben und Werk*, Weimar 1971

Fernow 1867 Karl Ludwig Fernow, *Carstens, Leben und Werke*, ed. and supplemented by Herman Riegel, Hanover 1867

Forster-Hahn 1963 Franziska Forster-Hahn, *Johann Heinrich Ramberg als Karikaturist und Satiriker*, offprint from the 'Hannoverschen Geschichtsblättern', new series, 17, 1963

Frankfurt 1977 *Die Nazarener*, exhibition catalogue, Frankfurt (Stadel) 1977

Grubert 1975 Beate Grubert, *Johann Heinrich Wilhelm Tischbein*, 'Homer nach Antiken gezeichnet', dissertation, Bochum 1975

Haandtegninger 1818 *Haandtegninger af C.G. Kratzenstein Stub ...*, 'Udgiven efter hans Dod af hans Ven C. Chr. Bang, stukne af Wentzler', Copenhagen 1818 [Wentzler − H. Wensler]

Haandtegninger 1844 *Haandtegninger af Kratzenstein Stub*, Paany udgivner 1844. Accompanying text to the new edition of Haandtegninger 1818

Hamburg 1974 *Ossian und die Kunst um 1800 (Kunst um 1800)*, exhibition catalogue, Hamburg 1974

Hannover 1898 Emil Hannover, *Maleren C.W. Eckersberg*, Copenhagen 1898

Hartmann 1968/69 Wolfgang Hartmann, 'Dantes Paolo und Francesca als Liebespaar', *Jahrbuch 1968/69. Schweizerisches Institut für Kunstwissenschaft*, pp. 7-24

Hartmann 1969 Wolfgang Hartmann, *Die Wiederentdeckung Dantes in der deutschen Kunst. J.H. Füssli – A.J. Carstens – J.A. Koch*, dissertation, Bonn 1969

Heine 1928 Albrecht-Friedrich Heine, *Asmus Jakob Carstens und die Entwicklung des Figurenbildes*, Strasbourg 1928

Hirschberg 1925 Leopold Hirschberg, *Moritz Retzsch. Chronologisches Verzeichniss [sic] seiner graphischen Werke*, Berlin 1925

Hoffmeister 1877 Jacob Christoph Carl Hoffmeister, *Johann Heinrich Ramberg in seinen Werken*, Hanover 1877

Jaffé 1905 Ernst Jaffé, *Joseph Anton Koch. Sein Leben und sein Schaffen*, Innsbruck 1905

Jensen 1968 Jens Christian Jensen, *Die Zeichnungen Overbecks in der Lubecker Graphiksammlung (Lübecker Museumshefte 8)*, 1968

Jørnaes 1978 Bjarne Jørnaes, 'Thorvaldsen – malernes ven', *En bog om kunst til Else Kai Sass*, Copenhagen 1978, pp. 290-308

Kamphausen 1941 Alfred Kamphausen, *Asmus Jakob Carstens*, Neumünster 1941

Kratzenstein Stub 1816 *Catalog over de af Kratzenstein Stub undforte Malereier og Haandtegninger, udstillede til Skue ...*, Copenhagen 1816

Kugler 1854 Franz Kugler, *Kleine Schriften und Studien*, 3 vols., Stuttgart 1854

Landsberger 1908 Franz Landsberger, *Wilhelm Tischbein. Ein Kunstlerleben des 18. Jahrhunderts*, Leipzig 1908

Locella 1913 Marie Locella and Guglielmo Locella, *Dantes Francesca da Rimini in der Literatur, bildenden Kunst und Musik*, Esslingen 1913

Lutterotti 1940 Otto R. von Lutterotti, *Joseph Anton Koch 1768-1839*, Berlin 1940

Marquardt 1964-1967 Hertha Marquardt, *Henry Crabb Robinson und seine deutschen Freunde*, 2 vols., Göttingen 1964/1967

Minder 1936 Robert Minder, *Die religiöse Entwicklung von Karl Philipp Moritz auf Grund seiner autobiographischen Schriften*, Berlin 1936 (new edition under the title 'Glaube, Skepsis und Rationalismus', Frankfurt, Main 1974)

Meddelelser 1973 *Meddelelser fra Thorvaldsens Museum 1973*, Copenhagen 1974 [Ekkersbergs Tagebücher und Briefentwürfe, Rome 1813-1816]

Müller 1816 P.E. Müller, 'Kratzenstein Stubs Minde', *Athene*, Vol. 7, July-December 1816, pp. 142-150

Paris 1976 *La peinture allemande a l'époque du Romantisme*, exhibition catalogue, Paris 1976/1977

Rehm 1931 Walter Rehm, 'Götterstille und Göttertrauer', *Jahrbuch des freien deutschen Hochstifts* 1931, pp. 208-297. Cited here from the reprint in: W.R., *Götterstille und Göttertrauer. Aufsätze zur deutsch-antiken Begegnung*, Munich 1951, pp. 101-182

Rehm 1936 Walter Rehm, *Griechentum und Goethezeit*, 1936, 4th edition, Berne, Munich 1968

Repholtz 1920 A. Repholtz, *Thorvaldsens Tegninger*, Copenhagen 1920

Rümann 1930 Arthur Rümann, *Das illus-trierte Buch des 19. Jahrhunderts in England, Frankreich und Deutschland*, Leipzig 1930

Runge 1977 *Runge in seine Zeit (Kunst um 1800)*, exhibition catalogue, Hamburg 1977/1978

Sass 1945 Else Kai Sass, 'Tiden 1800-1850', *Danske Tegninger fra Melchior Lorck til Fynboerne*, Vol. 1, Copenhagen 1945

Schlegel 1805 August Wilhelm Schlegel, 'Schreiben an Goethe über einige Arbeiten in Rom lebender Künstler', *Jenaische Allgem. Literatur-Zeitung* 1805. Revised in: *Kritische Schriften*, Vol. 2, Berlin 1828

Von Schneider 1938 Arthur von Schneider, 'Die Briefe Joseph Anton Kochs an den Freiherrn Karl Friedrich von Uexküll', *Jahrbuch der Preussischen Kunstsammlungen*, Vol. 59, 1938, pp. 186-208, 258-280

Sörrensen 1910 Wolfgang Sörrensen, *Joh. Heinr. Wilhelm Tischbein. Sein Leben und seine Kunst*, Berlin, Stuttgart 1910

Speckter 1846 Erwin Speckter, *Briefe eines deutschen Künstlers, aus Italien. Aus den nachgelassenen Papieren von Erwin Speckter aus Hamburg*, Vol. 2, Leipzig 1846

Strich 1910 Fritz Strich, *Die Mythologie in der deutschen Literatur von Klopstock bis Wagner*, 2 vols., Halle a.d. Saale 1910, reprinted Berne, Munich 1970

Stubbe 1977 Wolf Stubbe, 'Illustrationen und Illustratoren', in Ernst L. Hauswedell and Christian Voigt (ed.), *Buchkunst und Literatur in Deutschland 1750 bis 1850*, Maximilian-Gesellschaft Hamburg 1977

Thorvaldsen 1973 *Thorvaldsen – Drawings and Bozzetti*, exhibition catalogue, Heim Gallery, London 1973

Traeger 1975 Jörg Traeger, *Philipp Otto Runge. Monographie und kritischer Katalog*, Munich 1975

Stuttmann 1929 Ferdinand Stuttmann, *Johann Heinrich Ramberg*, Munich 1929

Thiele 1851 Just Mathias Thiele, *Thorvaldsens Ungdomshistorie 1770-1804, Thorvaldsens Biographi I*, Copenhagen 1851

Volkmann 1906 Ludwig Volkmann, 'Joseph Anton Kochs Dante-Werk', *Zeitschrift für bildende Kunst*, new series, Vol. 17, 1906, pp. 33-38

Wegner 1962 Wolfgang Wegner, *Die Faustdarstellung vom 16 Jahrhundert bis zur Gegenwart*, Amsterdam 1962